Pelican Books

P9-EGN-288

Style and Civilization | Edited by John Fleming and Hugh Honour

Realism *by Linda Nochlin*

Linda Nochlin was born in 1931 and educated at Vassar College and Columbia University. She then took a Ph.D at the Institute of Fine Arts, New York University. She has done research in France and written several monographs on mid-nineteenth-century continental painting, and is planning a book on Gustave Courbet.

She is at present Mary Conover Mellon Professor of Art History at Vassar College and Visiting Professor at Hunter College, City University, New York. Her special field is women and art, and her article entitled *Why Have There Been No Great Women Artists?* is a prelude to a book of essays she is writing on the image of women in art.

Professor Nochlin is married and has two children.

Linda Nochlin

Realism

Penguin Books

Penguin Books Ltd, Harmondsworth,
Middlesex, England
Penguin Books, 625 Madison Avenue,
New York, New York 10022, U.S.A.
Penguin Books Australia Ltd, Ringwood,
Victoria, Australia
Penguin Books Canada Limited, 2801 John Street,
Markham, Ontario, Canada L3R 1B4
Penguin Books (N.Z.) Ltd, 182–190 Wairau Road,
Auckland 10, New Zealand

First published 1971
Reprinted 1972, 1973, 1975, 1976, 1977

Library of Congress catalog card number: 71–149557

Printed in the United States of America by
The Murray Printing Company, Westford, Massachusetts
Set in Monophoto Garamond

Designed by Gerald Cinamon

Contents

Editorial Foreword 7

Acknowledgements 9

1 *The Nature of Realism* 13

2 *Death in the Mid Nineteenth Century* 57

3 *'Il faut être de son temps' :*
 Realism and the Demand for Contemporaneity 103

4 *The Heroism of Modern Life* 179

Epilogue 209

Catalogue of Illustrations 249

Books for Further Reading 271

Index 275

Editorial Foreword

The series to which this book belongs is devoted to both the history and the problems of style in European art. It is expository rather than critical. The aim is to discuss each important style in relation to contemporary shifts in emphasis and direction both in the other, non-visual arts and in thought and civilization as a whole. By examining artistic styles in this wider context it is hoped that closer definitions and a deeper understanding of their fundamental character and motivation will be reached.

The series is intended for the general reader but it is written at a level which should interest the specialist as well. Beyond this there has been no attempt at uniformity. Each author has had complete liberty in his mode of treatment and has been free to be as selective as he wished – for selection and compression are inevitable in a series such as this, whose scope extends beyond the history of art. Not all great artists or great works of art can be mentioned, far less discussed. Nor, more specifically, is it intended to provide anything in the nature of a historical survey, period by period, but rather a discussion of the artistic concepts dominant in each successive period. And, for this purpose, the detailed analysis of a few carefully chosen issues is more revealing than the bird's-eye view.

Acknowledgements

I should like to thank my friends and colleagues in the field of nineteenth-century studies for their generous gifts of information and ideas. Among those with whom I have discussed problems or from whom I have received information are: Professors Albert Elsen, Ann Coffin Hanson, Robert L. Herbert, Fred Licht, Theodore Reff, Robert Rosenblum and Allen Staley. I should like to extend special thanks to Robert Rosenblum for opening my eyes to some of the hidden splendours of Victorian painting in the course of visits to several exhibitions undertaken in his company. Many of the ideas, and the basic insights, developed in the course of these pages go back to my days as a graduate student at the New York University Institute of Fine Arts, where I was privileged to study under the late Walter Friedlaender and to write a doctoral dissertation on Courbet and Realism under the direction of Professors H. W. Janson and Robert Goldwater. In addition, I am indebted to the various people who helped me to obtain photographs or information about the current whereabouts of works of art, particularly the staff of the Witt library in London, and M. Pierre Rosenberg in Paris. My gratitude to my loyal and industrious assistants, Sherry Chayat Nordstrom and Alison Hilton, knows no bounds. Edith Tonelli helped with the task of proof-reading. Special thanks must go to my husband, Richard Pommer, who provided moral support and sound advice at every stage of the way, especially on architectural matters. My mother, Mrs Elka Heller, and my mother-in-law, Mrs Reba Pommer, my daughter Jessica and my housekeeper, Mrs Eleanor Lezon, offered invaluable domestic assistance. I can only add that my warmest thanks must be reserved for my two editors, John Fleming and Hugh Honour, who were models of patience, attentiveness and encouragement at all times during the preparation of this manuscript.

L.N.
Poughkeepsie, N.Y.
November 1970

Realism

I

The Nature of Realism

Realism, as an historical movement in the figurative arts and in literature, attained its most coherent and consistent formulation in France, with echoes, parallels and variants elsewhere on the Continent, in England and in the United States. Preceded by Romanticism and followed by what is now generally termed Symbolism, it was the dominant movement from about 1840 until 1870–80. Its aim was to give a truthful, objective and impartial representation of the real world, based on meticulous observation of contemporary life. This definition will determine the direction of the present study, but it inevitably raises a number of questions. For whereas such terms as Mannerism, Baroque or Neo-classicism – whatever difficulties they may present – are generally used to define stylistic categories, proper to the visual arts, the word Realism is also closely connected with central philosophical issues. In order to isolate the peculiar implications of Realism, considered as an historical, stylistic movement or direction in the arts, we must first consider some of the problems arising out of the different and sometimes diametrically opposed senses in which the term can be used.

REALISM AND REALITY

A basic cause of the confusion bedevilling the notion of Realism is its ambiguous relationship to the highly problematical concept of reality. A recent exhibition at the Museum of Modern Art in New York and at the Tate Gallery in London, for example, was entitled 'The Art of the Real' and consisted not – as the uninitiated might have expected – of recognizable views of people, things or places, but of large striped or stained canvases and mammoth constructions of plywood, plastic or metal. The title chosen by the organizer was neither wilfully mystifying nor capricious. It was a contemporary manifestation of a long philosophical tradition, part of the main-stream of Western thought since the time of Plato, which opposes 'true reality' to 'mere appearance'. 'All things have two faces', declared the sixteenth-century theologian, Sebastian Franck, 'because God decided to oppose himself to the world, to leave appearances to the

latter and to take the truth and the essence of things for himself.' This is an extreme statement of a notion which echoes down through the aesthetic theory of the eighteenth and nineteenth centuries. 'True reality lies beyond immediate sensation and the objects we see every day', said Hegel. 'Only what exists in itself is real. . . . Art digs an abyss between the appearance and illusion of this bad and perishable world, on the one hand, and the true content of events on the other, to re-clothe these events and phenomena with a higher reality, born of the mind. . . . Far from being simple appearances and illustrations of ordinary reality, the manifestations of art possess a higher reality and a truer existence.' Later in the century Baudelaire maintained, in his sketch for a critique of Realism, that, in contradistinction to Realist doctrine, poetry itself was most real and was 'only completely true in another world' since the things of this world were merely a 'hiero-glyphic dictionary'. Many of the most vociferous opponents of Realism based their attacks on these grounds: that it sacrificed a higher and more permanent for a lower, more mundane reality. *

The commonplace notion that Realism is a 'styleless' or trans-parent style, a mere simulacrum or mirror image of visual reality, is another barrier to its understanding as an historical and stylistic phenomenon. This is a gross simplification, for Realism was no more a mere mirror of reality than any other style and its relation *qua* style to phenomenal data – the donnée – is as complex and difficult as that of Romanticism, the Baroque or Mannerism. So far as Realism is concerned, however, the issue is greatly confused by the assertions of both its supporters and opponents, that Realists were doing no more than mirroring everyday reality. These statements derived from the belief that perception could be 'pure' and unconditioned by time or place. But is pure perception – perception in a vacuum, as it were – ever possible?

In painting, no matter how honest or unhackneyed the artist's vision may be, the visible world must be transformed to accommodate

* A philosopher would distinguish more sharply than I have done here between the various meanings that have been given to the term 'realism' even in the discussion of art: (a) as implying a close correspondence between the depiction and the depicted object or between a description and what it describes; (b) as implying that mere imita-tion or mirroring of actual objects is surpassed and we confront the thing itself; (c) as implying that what is represented is an 'idea' or norm or unchanging prototype of the actual things in the world, and that it eliminates whatever is particular or peculiar to an actual object which instantiates the 'idea'. Closely connected with this view is the criticism of art that it can never in fact make manifest such super-sensible ideas.

Hegel attempted to bridge the gap between 'idea' and 'actuality' as, later, did Baudelaire with his notion of 'nature transposed into a more lucid medium'.

it to the flat surface of the canvas. The artist's perception is therefore inevitably conditioned by the physical properties of paint and linseed oil no less than by his knowledge and technique – even by his choice of brush-strokes – in conveying three-dimensional space and form on to a two-dimensional picture plane. Even in photography, which comes closer to fulfilling the demand for 'transparency', the photographer's choice of viewpoint, length of exposure, size of focal opening and so on, intervene between the object and the image printed on the paper. Similarly in literature, the most vividly convincing nineteenth-century Realist novels interpose the barriers of 'he said' and 'she whispered meaningfully', between reader and experience. Or they alternate lengthy, if objective, descriptions of clothing and furniture with set passages of conversation, in a manner opposed to our actual more free-flowing consciousness of experience which was only later developed by such writers as Proust, Virginia Woolf, Joyce or Robbe-Grillet. The cinema has been described by André Bazin as 'a re-creation of the world in its own image, an image unburdened by the freedom of interpretation of the artist or the irreversibility of time'. Yet, even the cinema fails to realize the time-honoured dream of capturing reality and capturing it whole which has been one of the aspirations of art since at least as early as the time of Pliny.

Although it is hard to believe that Parrhasios' grapes could have deceived even the most gullible of birds, the old story reveals, like the bravado of *trompe l'œil* painting and ingenious experiments with the *camera obscura*, that perennially obsessive desire of artists to bring reality back alive, to escape from the bonds of convention into a magic world of pure verisimilitude. If mid twentieth-century artists and writers are sceptical about the possibility of attaining this aim, is it not partly because of their and our – equally obsessive – preoccupation with and self-consciousness about the *means* of art: the formal demands of paint and canvas, the self-generating power of the structure of language whether literary or visual? The very aspirations of realism, in its old naïve sense, are denied by the contemporary outlook which asserts and demands the absolute independence of the world of art from the world of reality and, indeed, disputes the existence of any single, unequivocal reality at all. We no longer accept any fixed correspondence between the syntax of language, or the notational system of art, and an ideally structured universe.

In the mid nineteenth century, however, scientists and historians seemed to be revealing at breakneck speed more and more about reality past and present. There were no apparent limits to the discovery of what could be known about man and nature. Realist

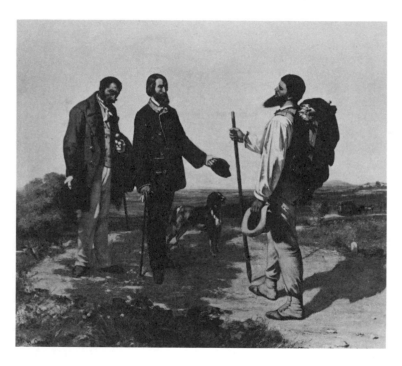

1. *The Meeting*, 1854. Gustave Courbet

writers and artists were likewise explorers in the realm of fact and experience, venturing into areas hitherto untouched or only partly investigated by their predecessors. For although the notion of a 'styleless style' may be itself part of the self-created myth of the nineteenth century, the role played by actual objective investigation of the external world in the creation of Realism cannot be ignored. The history of art is more than a succession of stylistic and iconographic conventions modified by occasional 'comparisons' with perceived reality – 'stylistic rectifications' as André Malraux has called them. Courbet's *Meeting* [1], for example, was clearly based on a prototype in popular imagery [2]: yet Courbet observed the country-

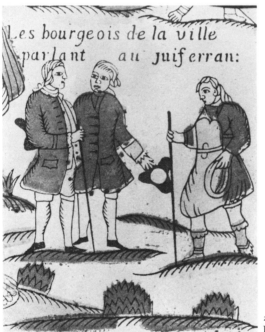

Les bourgeois de la ville parlant au juif errant:

2. *The Wandering Jew*, n.d. Popular print

side around Montpellier with scrupulous attention to its peculiarities and he recorded the local flora, the bright clear atmosphere of the Midi, as well as the appearance of himself, Bruyas and his servant, with striking and convincing accuracy. What is more, he succeeded in achieving his aim: creating an image that looks like and was for long held to be an objective, almost photographic, record of an actual event.

If one takes the opposition between convention and empirical observation in art as a relative rather than an absolute criterion, one can see that in Realism the role played by observation is greater, that by convention smaller. John Constable's cloud studies of 1821-2 are

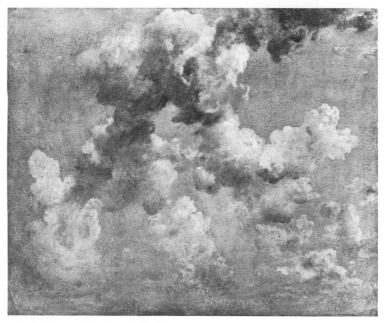

3. *Cloud Study, c.* 1822. John Constable

a case in point [3]. As Ernst Gombrich has shown, they were partly based on engravings by the eighteenth-century water colourist Alexander Cozens. But they were still more intimately connected with Constable's own observations of the sky, both as a miller and a painter, and were also influenced by the meteorologist Luke Howard who investigated and classified cloud forms. However much he may have depended on the pre-existing *schemata* provided by Cozens – as Gombrich claims – Constable used Cozens's prototypes not as ready-made formulae, which with a few judicious alterations would serve to fill the top of a landscape, but as *aides mémoires* – or, rather, *aides recherches* – for his own far more precisely observed representations. His cloud studies are, in fact, classified as cirrus or strato-cumulus formations and the time and place of their execution are indicated in many cases.

Constable may not have been aiming for scientific accuracy alone; but by accepting natural phenomena as the appropriate object for representation in his cloud studies, by restricting his experience to the phenomenon itself and neither interpreting it symbolically nor using it as a medium to express an *état d'âme*, he was very much an artist of the nineteenth century and one who points the way to later developments within the Realist movement. It is no accident that advanced French landscape painters like Corot and Huet admired him in the thirties and forties.

Degas, according to Gombrich, 'dismissed the excited talk of his impressionist friends with the remark that painting was a conventional art and that they would better occupy their time by copying drawings by Holbein'. But this is only part of the story. In his notebooks, Degas reiterated in both words and sketches his passion for concrete, direct observation and notation of ordinary, everyday experience: 'Do every kind of worn object . . . corsets which have just been taken off . . . series on instruments and instrumentalists . . . for example, puffing out and hollowing of the cheeks of bassoons, oboes, etc. . . . On the bakery, the bread: series on journeyman bakers, seen in the cellar itself or through the air vents from the street. . . . No one has ever done monuments or houses from below, from beneath, up close, as one sees them going by in the streets.' [4] For Degas there was no necessary contradiction between copying Holbein and re-

4. *Building Seen from Below, c.* 1874-83. Edgar Degas

cording the novel themes of his own time in his own way. Nor need there ever be any conflict between an interest in draughtsmanship or the great masters of the past and a preoccupation with the present and the development of a system of notation appropriate to it. As George Moore pointed out, Degas chose unusual themes such as the ballet girl, the washerwoman, the housewife bathing herself [5], precisely because 'the drawing of the ballet girl and the housewife is less known than that of the Nymph and the Spartan youth'. And he added: 'Painters will understand what I mean by the drawing being "less known" – that knowledge of form which sustains the artist like a crutch in his examination of the model, and which as it were dictates to the eye what it must see.' Moore, and other critics sympathetic to the Realists, regarded convention and *schemata* merely as crutches, not as necessary components of art and, furthermore, crutches which could be, and sometimes were, dispensed with. This may be part of Realist myth – yet it is also part of Realist reality.

The history of late eighteenth- and nineteenth-century art is indeed, as Gombrich declares, the story of the struggle against *schemata*; and the major weapon in this struggle was the empirical investigation of reality. When Constable said that he tried to forget that he had ever seen a picture as he sat down to paint from nature, or Monet that he wished he had been born blind and then suddenly received his sight, they were not merely placing a high premium on originality. They were stressing the importance of confronting reality afresh, of consciously stripping their minds, and their brushes, of secondhand knowledge and ready-made formulae. So radical and extreme an approach was new. And its success is attested by their works – whether or not we consider fidelity to reality (however understood) to be an aesthetic criterion.

Yet one may well ask to what extent this was, in fact, a new approach. Was it not merely another manifestation of a recurrent trend in European art? What of the scrupulous exactitude of Jan van Eyck, the visual veracity of Velasquez, the relentless recording of varicose veins and dirty feet by Caravaggio, the meticulously observed still-lifes and interiors by the Dutch 'little masters' of the seventeenth century? Disregarding, for the present, the complex relationship of Realism to the art of the past, it would be difficult to demonstrate that Manet's portraits are in any sense more faithful than those of Velasquez or that Renoir's *Le Pont des Arts* [6] is a closer record of a specific place at a specific time than Vermeer's *View of Delft* [7]. But important though it might be, fidelity to visual reality was only one aspect of the Realist enterprise; and it would be

5. *Le Tub*, *c.* 1886. Edgar Degas

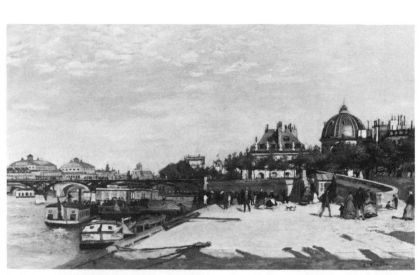

6. *Le Pont des Arts, Paris, c.* 1868. Auguste Renoir

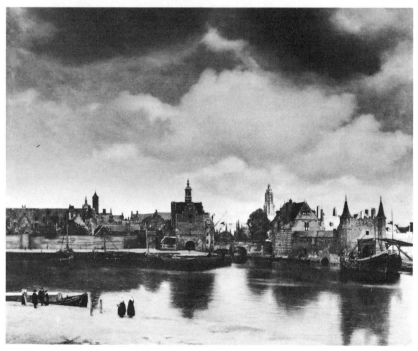

7. *View of Delft, c.* 1660. J. Vermeer

erroneous to base our conception of so complex a movement on only one of its features: verisimilitude. To understand Realism as a stylistic attitude within its period, we must therefore turn to some of the Realists' other aspirations and achievements.

REALISM, HISTORY AND TIME

A new and broadened notion of history, accompanying a radical alteration of the sense of time, was central to the Realist outlook. Furthermore, new democratic ideas stimulated a wider historical approach. Ordinary people – merchants, workers and peasants – in their everyday functions, began to appear on a stage formerly reserved exclusively for kings, nobles, diplomats and heroes. 'Give up the theory of constitutions and their mechanism, of religions and their system', demanded Hippolyte Taine, apostle of the new historical approach, 'and try to see men in their workshops, in their offices, in their fields, with their sky, their earth, their houses, their dress, tillage, meals, as you do when, landing in England or Italy, you remark faces and gestures, roads and inns, a citizen taking his walk, a workman drinking.' This insistence on the connection between history and experienced fact is characteristic of the Realist outlook. As Flaubert pointed out in a letter of 1854: 'The leading characteristic of our century is its historical sense. This is why we have to confine ourselves to relating the facts.' A true understanding and representation of both past and present was now seen to depend on a scrupulous examination of the evidence, free from any conventional, accepted moral or metaphysical evaluation. Indeed, in the radical if rather coarsely materialistic view of Comte or Taine, the morals and ideas of past and present were simply one kind of evidence, in no way different from physical evidence, to which indeed they might be reduced. 'Vice and virtue are products, like vitriol and sugar', wrote Taine. 'Let us then seek the simple phenomena for moral qualities as we seek them for physical qualities.' Applying this attitude to art, Courbet declared in 1861 that 'painting is an essentially *concrete* art and can only consist of the presentation of *real and existing things*. It is a completely physical language, the words of which consist of all visible objects; an object which is *abstract*, not visible, non-existent, is not within the realm of painting.'

It is hardly paradoxical that the era in which history was canonized as a scientific (or pseudo-scientific?) discipline also saw the end of History Painting – that time-honoured pictorial assertion of permanent values and eternal ideals centred around the nexus of heroic antiquity. Painters did not cease to paint subjects from Greek and

Roman history: far from it. And certain critics urged a return to the appropriate 'grand manner'. But what they now produced were, for the most part, historical genre paintings: scenes from the everyday life of Greece and Rome, scrupulously accurate in costume and setting, and as devoid of elevated sentiment as of noble form. In other words, History painters had become anecdotal painters of history, and most of them found the décor and picturesque costumes of the Middle Ages or the Renaissance more sympathetic than those of the ancient world. Delacroix, who had extended his own range of historical and literary sources, criticized modern painters who 'call themselves history painters. That claim must be totally refuted', he wrote, 'The history-painter is he who represents heroic deeds, and these lofty deeds are to be found exclusively in Greek and Roman history ... subjects drawn from other eras produce nothing but genre paintings.'

Whether the painting of historical subjects had been degraded or enriched by this new concept of history is a matter of opinion; but there can be no dispute that it had been irrevocably altered by the mid nineteenth century. And indeed some academic painters were affected by it no less than their opponents, the Realists. Gérôme's *Death of Caesar* [8] and Poussin's *Death of Germanicus* are both set in

8. *Death of Caesar*, 1865(?). J.-L. Gérôme

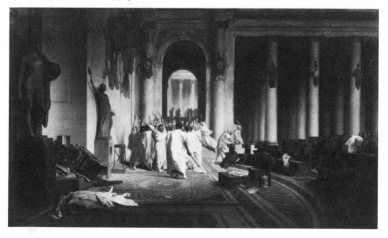

the ancient world; but Gérôme's photographic veracity and insistence on the concreteness of a specific historical event could hardly be further removed from Poussin's elevated generalization and moral distancing. No matter what his choice of subject or his professed

attitude to the nature of art, Gérôme would seem, on the evidence of his work, to have shared Courbet's view that painting was essentially an *art concret* and demanded a similarly *concret* visual language. From this point of view it is simply Courbet's insistence on contemporaneity as a necessary condition of the concrete that separates the academic artist from the innovator.

As the treatment of historical subjects became more factual and mundane towards the mid century, so the chronological range available to artists was expanded. The limits of time itself were being gradually pushed back from Archibald Ussher's judicious starting-point in 4004 B.C. The fluid relativism of a perpetually revised scientific hypothesis replaced the story of Creation and the metaphysical absolute it implied. History and value, history and faith, which had been inseparable since the earliest creation myths and integrated in the doctrine of the Christian Church, were irremediably torn asunder by the Higher Criticism and the New Geology. What was left was history as the facts, in a vast landscape extending from the mists of prehistoric times to the Comtean precincts of present-day experience. Fernand Cormon's *The Stone Age*, Alma-Tadema's *Apodyterium*, Gérôme's *Louis XIV and Molière at Dinner*, and Renoir's *Le Moulin de la Galette* [9, 10, 11, 12] – unlikely companions though they may be from a purely aesthetic standpoint – are vivid examples of this newly expanded historical sense. All four paintings share a common attempt to place the daily life of a given chronological period in a convincing and objectively accurate milieu. The Realist, of course, insisted that only the contemporary world was a suitable subject for the artist since, as Courbet put it, 'the art of painting can only consist of the representation of objects which are visible and tangible for the artist', and the artists of one century were therefore 'basically incapable of reproducing the aspect of a past or future century'. But artists who kept to subjects from the past were by no means unaffected by considerations of factual accuracy and freedom of choice of subject quite similar to Courbet's. As Gerald Ackerman has pointed out, many mid nineteenth-century painters of historical scenes attempted to satisfy Taine's demand for actuality as the *sine qua non* of history, through a sense of probability, painting them as if they had been present. It is the demand for contemporaneity and nothing but contemporaneity, which here separates the Realists from their fellow artists. If Alma-Tadema's painting might be called a 'genre painting of antiquity', Courbet's might equally well be termed a 'history painting of contemporary life'. By the mid nineteenth century the distinction had become a very slender one; but, as we shall see, for the Realist it was the crucial distinction.

9. *Return from a Bear Hunt During the Stone Age*, 1882. Fernand Cormon

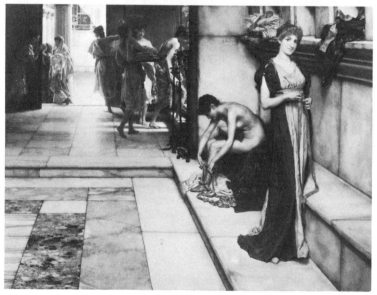

10. *An Apodyterium*, 1886. L. Alma-Tadema

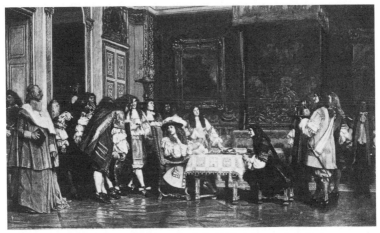

11. *Louis XIV and Molière at Dinner*, 1863. J.-L. Gérôme (engraving after)

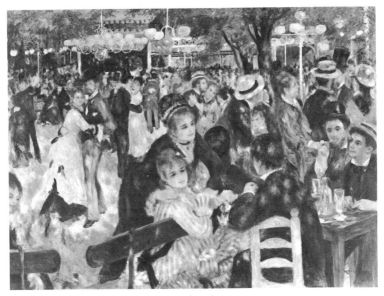

12. *Le Moulin de la Galette*, 1876. Auguste Renoir

The Realists held that the only valid subject for the contemporary artist was the contemporary world. *'Il faut être de son temps'* became their battle-cry. 'I hold the artists of one century basically incapable of reproducing the aspect of a past or future century', wrote Courbet. 'It is in this sense that I deny the possibility of historical art applied to the past. Historical art is by nature contemporary. Each epoch must have its artists who express it and reproduce it for the future ... The history of an era is finished with that era itself and with those of its representatives who have expressed it'. And his major supporter in the *'bataille réaliste'*, Champfleury, maintained that the 'serious representation of present-day personalities, the derbies, the black dress-coats, the polished shoes or the peasants' sabots', had a far greater interest than the frivolous knick-knacks of the past.

The moral implications of 'contemporaneity' were suggested by the critic Castagnary who, in his Salon of 1863, praised the 'naturalists' for 'putting the artist back into the midst of his era, with the mission of reflecting it', and French society for producing painting 'that describes its own appearances and customs and no longer those of vanished civilizations'. But artists with this belief sometimes had to make sacrifices for it. On the eve of the 1866 Salon the young Bazille told his parents: 'I have chosen the modern era because it is the one I understand best, that I find most alive for living people', adding the rueful postscript '– and that is what will get me rejected'. In his Salon of 1868 Zola called the young Monet, Bazille and Renoir *Les Actualistes* – 'the painters who love their times from the bottom of their artistic minds and hearts. . . . They do not content themselves with ridiculous *trompe l'œil*; they interpret their era as men who feel it live within them, who are possessed by it, and who are happy to be possessed by it. . . . Their works are alive because they have taken them from life and they have painted them with all the love they feel for modern subjects.'

As Realism evolved, the demand for – and conception of – contemporaneity became more rigorous. The 'instantaneity' of the Impressionists is 'contemporaneity' taken to its ultimate limits. 'Now', 'today', 'the present', had become 'this very moment', 'this instant'. No doubt photography helped to create this identification of the contemporary with the instantaneous. But, in a deeper sense, the image of the random, the changing, the impermanent and unstable seemed closer to the experienced qualities of present-day reality than the imagery of the stable, the balanced, the harmonious. As Baudelaire said: 'modernity is the transitory, the fugitive, the contingent'.

This insistence on catching the present moment in art – whether the encounter of Courbet and his patron on the road to Sète in *The Meeting*

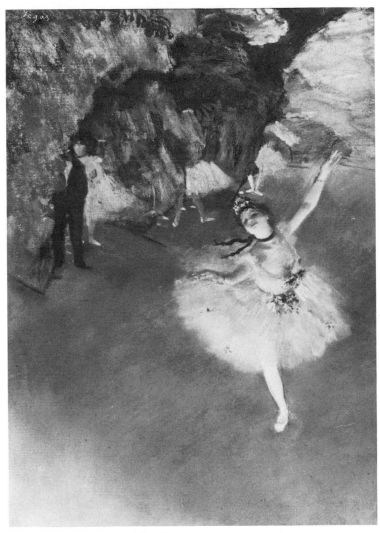

13. *Dancer on the Stage*, 1878. Edgar Degas

[1], the *corps de ballet* making a *révérence* in a Degas or a chance effect of light or atmosphere in a Monet landscape – is an essential aspect of the Realist conception of the nature of time. Realist motion is always motion captured as it is 'now', as it is perceived in a flash of vision.

Earlier painters had, of course, often represented physical movement. But even so dynamic a picture as *La Ronde* by Rubens shows how little they were concerned with capturing a specifically observed instant of action. Instead, Rubens constructed a kind of generalized, eternal paradigm of violent physical action, with a beginning, middle and end within the context of the pictorial space, each pose carefully calculated to link with the next in an unbroken chain. He depicted the general idea of movement – movement as a permanent ideal entity – rather than a perceived moment of specific activity. In pre-nineteenth-century art, time was never a completely isolated instant but always implied what preceded and what would follow. In classical art and all *schemata* based upon it, the passage of time is condensed and stabilized by means of a significant kinetic summary.

A Realist, like Degas, destroyed this paradigm of temporal continuity in favour of the disjointed temporal fragment. In such a work as the *Dancer on the Stage* [13], Degas showed no interest in conveying any ideal image of movement but concentrated on creating the equivalent of a concrete instant of perceived temporal fact – an isolated moment. The poses of the figures, far from leading step by step to a climax, are deliberately disconnected from one another; the directions

14. *The Execution of the Emperor Maximilian*, 1867. Édouard Manet

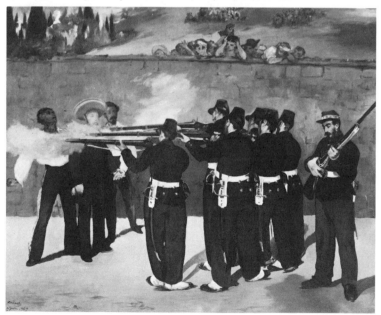

of movement diverge from rather than converge on a point of motion and significance. The appearance of a single moment is painted from a viewpoint which makes its discreteness, its lack of significant compositional or psychological focus most apparent. Time is seen as the arrester of significance not – as in traditional art – the medium in which it unfolds.

This emphasis on the temporal fragment as the basic unit of perceived experience, like the equation of concrete fact with reality itself, accompanied the elimination or reduction of traditional moral, metaphysical and psychological values in Realist works. Adversaries were quick to accuse the Realists of producing works emotionally and morally, as well as formally, lacking in continuity and coherence. The acceptance of what is immediately experienced, and of nothing beyond it, as the entire meaning of the event depicted – characteristic, for example, of Manet's *Execution of the Emperor Maximilian* [14] – led critics to accuse the artist of lack of feeling, of inability to comprehend, or at least to create, a pictorial equivalent for the moral and psychological implications of a chillingly brutal subject, as had Goya in his *Third of May* [15]. Yet the sense of detachment, the lack of metaphysical overtones in Manet's painting came from no moral unconcern at the

15. *The Third of May, 1808*, 1814, Francisco de Goya

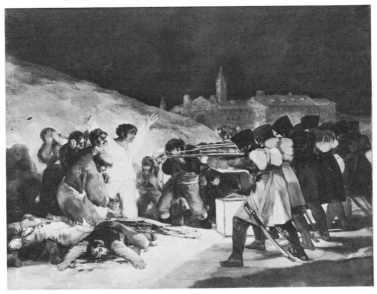

event, still less from political indifference or artistic ineptitude. Manet must have reacted to the outrage as much as any other staunch republican. His sense of its importance is revealed simply by his careful attention to the actual details of the execution, his painstaking compilation of eye-witness reports and photographs, and his repeated large-scale recreations of the scene from life in his studio. Manet, unlike Goya, carefully contrived to rivet the 'meaning' of his painting to firm, concrete facts – the momentary appearance of the execution of the Emperor, a particular, documented historical event – rather than transforming it into a more generalized commentary about the eternal inhumanity of man to man like Goya's *Third of May*.

This difference is due, at least in part, to the difference in the temporal attitudes controlling each work. For Goya, meaning unfolds, within the pictorial world, in time and space, progressing from the grey undifferentiated background of 'before' to the stark, light-revealed climax of the men being executed – 'now' – to the lumpish, blood-encrusted fallen figures at the very boundary of the pictorial world – 'afterwards'. This progression in time – emphasized by light, by intensification of colour saturation, and by the degree of materiality of the paint surface itself – is bound to an underlying moral conviction of the senselessness and bestiality of such events. The intimation that we are confronted by the same group of victims in three stages of their agony intensifies its pathos and our sense of its inevitability and hopelessness. There is more than a little reminiscence of the Stations of the Cross in these anonymous figures, as is hinted at by the open-armed gesture of the man in the centre. The rebels of Madrid, struck down by their grey, faceless executioners, are assimilated to a humanized up-dating of Christ's Passion. The contrast between light and shade, between human disorder and mechanized regularity, from left to right, intensify the moral and metaphysical impact of Goya's masterpiece.

In Manet's painting there is none of this temporal-emotional un-folding, no sense of the confrontation of a climactic moment of truth, prepared for by almost inchoate intimations and followed by a harrowing aftermath within the painting itself, none of the pictorial analogies or contrasts that make Goya's painting a paradigm of an eternal, and recurrent, human situation. Maximilian's death takes place in historical rather than metaphysical time. The time is the present, the place is Queretaro, Mexico, the victims are neither more nor less human than their executioners, the spectators are anonymous observers, as are we who observe the painting itself. The event is a terrible one, but Manet, the painter, refrains from any overt pictorial judgement: it is what it is, when it is, where it is, nothing more. The

horror is contained within the fact, as in an instantaneous war-news photograph. For the Realist, horror – like beauty or reality itself – cannot be universalized: it is bound to a concrete situation at a given moment of time.

THE NEW RANGE OF SUBJECT-MATTER

If the Realists contracted their field of vision in temporal and emotional terms, they expanded it to take in a vastly wider range of experience. A new demand for democracy in art, accompanying the demand for political and social democracy, opened up a whole new realm of subjects hitherto unnoticed or considered unworthy of pictorial or literary representation. While the poor might always have been with us, they had hardly been granted a fair share of serious artistic attention before the advent of Realism – nor had the middle classes, who were now the dominant force in society. For the Realists, ordinary situations and objects of daily life were no less worthy of depiction than antique heroes or Christian Saints: indeed for the *'peintre de la vie moderne'* the noble and beautiful were less appropriate than the commonplace and undistinguished. The very boundary-line between the beautiful and ugly had to be erased by the advanced artist. Could any subject in and of itself be considered ugly and therefore be rejected?

'If a painter is possessed of an original feeling for nature and a personal manner of execution,' declared the brilliant left-wing critic Théophile Thoré, 'even if he applies them to the most inferior objects, he is master of his art and in his art. Murillo in his *Young Beggar* is as much a master as in his *Assumption of the Virgin*. Brouwer and Chardin painting pots are as much masters as Raphael painting Madonnas.' And, in a review of the Salon des Refusés of 1863 the same critic maintained: 'It is good to descend, or, if you will, rise once more to the classes that scarcely ever had the privilege of being studied and put into the light by painting. . . . The portrait of the worker in his smock is certainly worth as much as the portrait of a prince in his golden robes.' For the Realists there were no ready-made literary or artistic subjects. One of their chief proselytizers, Duranty, declared: 'In reality nothing is shocking; in the sun, rags are as good as imperial vestments.' Claude Lantier, Zola's Realist artist-hero preferred a pile of cabbages to all the picturesque medievalism of the Romantics and proclaimed that a bunch of carrots, directly observed and naïvely painted on the spot was worth all the eternal confections of the *école* – 'the day is coming when a single original carrot will be pregnant with revolution' – and he found a *'tableau tout fait'* in a group

of workers gulping down their midday soup beneath the iron and glass roof of Les Halles.

The Realists placed a positive value on the depiction of the low, the humble and the commonplace, the socially dispossessed or marginal as well as the more prosperous sectors of contemporary life. They turned for inspiration to the worker, the peasant, the laundress, the prostitute, to the middle-class or working-class café or *bal*, to the prosaic realm of the cotton broker or the modiste, to their own or their friends' *foyers* and gardens, viewing them frankly and candidly in all their misery, familiarity or banality. Courbet said that the goal of the Realist was to translate the customs, the ideas, the appearance of his own epoch in his art, and thus, the social dimension automatically acquired importance, whether the artist was a self-conscious political radical, like Courbet himself, or an equally self-conscious, cynical anti-democrat like Jules or Edmond Goncourt. Indeed, it is the Goncourts who state the issue most strongly, in their famous preface to *Germinie Lacerteux* of 1864:

Living in the nineteenth century, in a time of universal suffrage, democracy, liberalism, we asked ourselves whether what one calls 'the lower classes' have no right to the Novel; whether this society, below society, the common people, had to remain under the weight of literary interdict and of the scorn of writers who have, up to now, kept silence on the heart and spirit it might have. We asked ourselves whether there should still exist, be it for writer or reader in these times of equality, classes too unworthy, sufferings too low, tragedies too foul-mouthed, catastrophes whose terror is not sufficiently noble. We began to wonder whether . . . in a country without caste or legal aristocracy the sufferings of the poor and humble could touch our interest, our pity, our emotions, as sharply as the sufferings of the rich and mighty . . .

In England, Walter Bagehot said that 'the character of the poor is an unfit topic for continuous art' and attacked Dickens because his poor people were 'poor talkers and poor livers, and in all ways poor people to read about'. Similarly the critic Enault condemned the characters in Courbet's *Burial at Ornans* [39] as 'common, trivial and grotesque'. But, despite all opposition, Realists in England and on the Continent continued to affirm the right of the lower classes to literary and artistic status. Stone-breakers, rag-pickers, beggars, street-walkers, laundresses, railway workers and miners now began to appear in paintings and novels, not as picturesque background figures but in the centre of the stage.

But of course an artist did not become a Realist merely by depicting a peasant with a hoe or a shepherdess with a lamb: his commitment went deeper – to tell the truth, the whole truth and nothing but the

truth. This demand became a moral as well as an epistemological or aesthetic imperative. In the words of G. H. Lewes, writing on *Realism in Art* in 1858:

Realism is . . . the basis of all Art, and its antithesis is not Idealism, but *Falsism*. When our painters represent peasants with regular features and irreproachable linen; when their milkmaids have the air of Keepsake beauties, whose costume is picturesque, and never old or dirty; when Hodge is made to speak refined sentiments in unexceptionable English, and children utter long speeches of religious and poetic enthusiasm; . . . an attempt is made to idealize, but the result is simply falsification and bad art. . . . Either give us true peasants, or leave them untouched; either paint no drapery at all, or paint it with the utmost fidelity; either keep your people silent, or make them speak the idiom of their class.

The passage reminds one how close George Eliot was to the Realists, though she is seldom numbered among them.

Courbet fulfilled such a demand for truth in art. His peasants, with their craggy features and reprehensible linen and gauche postures, his apparently artless, clumsy and naïvely additive compositions, could be equated by his admirers with an honest attempt to express the truth of his subject matter, and by his enemies with a deplorable lack of delicacy and decorum. Indeed, it was not to Courbet's subjects that some of his most violent opponents objected, but to his coarse, unvarnished and unselective manner of presenting them. When Champfleury complained that Courbet was treated as 'seditious because in all good faith, he has represented bourgeois, peasants and village women in natural size', the conservative critic Perrier replied: 'it is not because he has painted bourgeois or peasants that M. Courbet is treated as seditious, but because he has presented them in a way that is contrary to human nature. Nobody,' Perrier insisted, 'could deny that a stone-breaker is as worthy a subject in art as a prince or any other individual. . . . But, at least, let your stone-breaker not be an object as insignificant as the stone he is breaking.' The same point was made by Louis de Geoffroy in discussing the *Burial at Ornans*: 'the funeral of a peasant is not less touching to us than the convoy of Phocion. The important thing is to avoid localizing the subject, and in addition, to emphasize the interesting portions of such a scene.' Though it is difficult sometimes to take these critics' protestations of admiration for lower-class themes at face value there can be little doubt that, both in their own eyes and in those of their critics, the Realists were aiming for far more than a mere expansion of subject-matter. The premium placed on that most controversial of all entities

- truth - rose dramatically towards the middle of the nineteenth century, and the word 'sincerity' became a Realist battle-cry.

For although the Realist refrained from moral comment in his work, his whole attitude towards art implied a moral commitment, to the values of truth, honesty and sincerity. In his very refusal to idealize, elevate or in any way embellish his subject, in his stalwart dedication to objective, impartial description and analysis, the Realist took a moral stand. Never before had the qualities of sincerity and truthfulness been asserted so forcefully as the basis of artistic achievement. 'The beautiful, the true and the good is a fine slogan and yet it is specious. If I had a slogan it would be the true, the true alone,' wrote Sainte-Beuve. 'Seek in works what is contrary to or in conformity with this law of sincerity', demanded the critic Duranty in the pages of his short-lived periodical *Le Réalisme*, 'and emphasize the superiority of the one over the other.' For Champfleury, the essential Realist formula was 'sincerity in art' - the artist's duty to represent only what he had seen or experienced, without any alteration and without any conventional response or aesthetic affectation. To accusations of literalism, or mere photographic accuracy, he replied that 'the reproduction of nature by man will never be a reproduction and imitation, but always an interpretation . . . since man is not a machine and is incapable of rendering objects mechanically'. And Manet characterized his own art as, above all, sincere. 'The artist does not say today "Come and see faultless work", but "Come and see sincere work",' he asserted in 1867.

The artist striving for truth or sincerity had to guard his spontaneous vision against distortion or alteration by aesthetic conventions or preconceptions. Naïveté of vision - what Castagnary called a mind 'free from the prejudice of education' - came in this way to be considered a necessary concomitant of sincerity and truthfulness. 'He knows neither how to sing, nor how to philosophize', wrote Zola in praise of Manet. 'He knows how to paint, and that is all.' Some critics and artists went so far as to assert that sheer ignorance or lack of formal training were positive assets for the artist. Laforgue proposed that the academies should be shut; Courbet refused to set himself up as a professor, declaring that art could not be taught; Pissarro, in an unguarded moment, even suggested that they burn down the Louvre. Yet what the Realists generally meant by 'naïveté' - a term used with greater frequency than precision - was not merely, or not always, a childlike innocence of perception, which might also be valued, of course, but the intuitive grasp of truth of Rousseau's uncorrupted man combined with the ruthless and disciplined quest for objective reality characteristic of the new man of science. Sincerity (which for

the Realist, was more like the modern existentialist concept of 'authenticity' than its looser, present-day meaning) and truth required of the artist a ceaseless effort to divest himself of the impedimenta of traditional training and *poncif*, a lifetime's self-purgation of received ideas.

Mockery proved a formidable weapon for tearing away the protective covering of conventional sentiment or artifice from reality. Daumier's incisive deflation of the petty pretences of the bourgeoisie, or his parodies of the classical ideal in his *Histoire ancienne* lithographs

16. *Menelaus Victorious*, 1841. Honoré Daumier

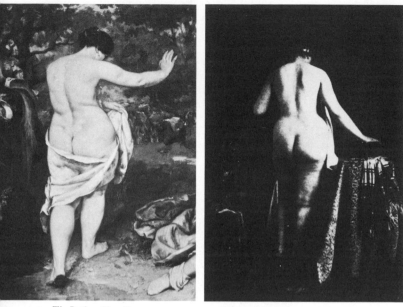

17. *The Bathers* (detail), 1853.
Gustave Courbet

18. *Nude Study*, photograph *c.* 1853.
J. V. de Villeneuve

[16], Courbet's ludicrous carousing priests in *The Return from the Meeting* or his grossly fleshy *Bathers* [17], naked rather than nude, are samples of the genre. A subtler but no less telling vein of irony marks Flaubert's devastating stichomythia of bureaucratic platitude and amorous dalliance in the *'commices agricoles'* sequence in *Madame Bovary* or Manet's straight-faced juxtaposition of classical elevation and contemporary banality in *Le Déjeuner sur l'herbe* [19].

But the artist had a hard struggle to rid himself of preconceptions and time-honoured formulae, to liberate both his vision and notation from outward idealism and established *poncif* to create a new, more honest equivalent for his hard-won fresh experience. Max Buchon said that Courbet produced masterpieces as simply as an apple-tree produces apples, and that his great natural gift was his rich spontaneity. But this borders on Realist myth. For most Realists the necessary task of divestment was a difficult and painful prelude to the creation of sincere and truthful work. 'I seek above all to render my impressions sincerely in the simplest language', wrote Champfleury, one of the guiding spirits of the early stages of French Realism, in his preface to his *Contes domestiques* of 1852. 'What I see in my head

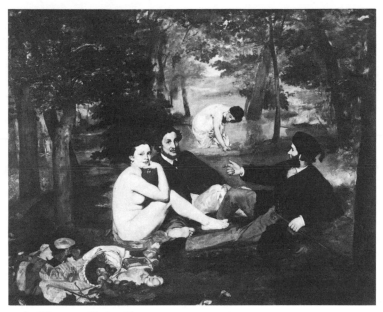

19. *Le Déjeuner sur l'herbe*, 1863.
Édouard Manet

descends into my pen, and becomes what I have seen. The method is simple, within anybody's reach. But how much time is necessary to get rid of memories, imitations, the milieu in which one lives, and to rediscover one's own nature.' For Jules Laforgue, writing about thirty years later, the successful Impressionist was one who 'forgetting the pictures amassed through centuries in museums, forgetting his optical art-school training – line, perspective, colour – by dint of living and seeing frankly and primitively . . . has succeeded in re-making for himself a natural eye, and in seeing naturally and painting as simply as he sees'. Flaubert told Louise Colet in 1852, 'I believe . . . that all rules are on their way out, that barriers are crumbling, that a general work of demolition is in progress', but added in the same letter: 'What trouble my *Bovary* is giving me! Never in my life have I written anything more difficult than what I am doing now – trivial dialogue.'

Courbet is said to have been able to paint an object without even knowing what it was – his friend Francis Wey recorded that on one occasion it was a distant bunch of faggots – but most artists found the task of capturing the direct appearance of nature freshly and im-

mediately on canvas very much more difficult and frustrating. 'I look at nature ceaselessly without seeing it', complained Monet's early mentor, Eugène Boudin, who referred to the 'torment of having to reproduce' – 'the impossibility of recreating in painting, with such restricted means' – the splendours of sky and earth. The vexations involved in capturing external reality on canvas are conveyed over and over again by Monet. 'I want to struggle, to scrape out, to begin again', he told a fellow-artist in 1864. 'It seems to me that when I see nature, I see it ready-made, completely written – but then, try to do it!' In 1890 he was still complaining: 'I have once more taken up things that can't be done; water with grasses weaving on the bottom. . . . It's wonderful to see, but it's maddening to try to paint it.'

To meet the subtlest demands of each new situation Realists had to reinvent their language. The intolerable wrestle with material and formal means became as highly fraught with significance as Jacob's combat with the Angel: defeat was literally artistic death. Far from ignoring form, or the technical possibilities and limitations of his medium, the Realist was acutely aware of them – but as means, not as ends in themselves. For in Realist art, unlike politics, ends are the only justification of means, from which they are ultimately inseparable. When Flaubert declared that 'whatever you want to say, there is only one word to express it, one verb to animate it, and one adjective to qualify it', he was not talking about sheer beauty of expression or words for words' sake. As Harry Levin points out, he was attempting to 'clarify particulars and specify nuances that more casual novelists indicate by opaque generalizations and vague clichés'. Flaubert's achievement was marked by a 'devotion to the word, not as dogma but as the medium in which the artist creates, and by which he approximates reality'. With only a slight change of wording the same might be said of all great Realist artists.

REALISM AND SCIENCE

How closely related was Realism to the methods and achievements of contemporary science? No simple, unequivocal answer is possible. In the strict sense, of course, no form of art or literature may be termed truly 'scientific' – if we mean to imply that it confines itself to the scientific method, i.e. the formulation of hypotheses liable to more or less stringent confirmation on the evidence of relevant factual observation. Certainly Seurat, with his search for a 'formula for optical painting' based on repeated, systematic observation of the activity of colour and light, came closer to the hypothetico-deductive methods of the natural sciences than did the Realists and Impressionists.

Yet, in a more general sense, the Realists, if not strictly scientific in their methods, were nevertheless scientific in their attitudes towards nature and reality. In making truth the aim of art – truth to the facts, to perceived and experienced reality – their outlook evinced the same forces that shaped the scientific attitude itself. Above all, they shared the scientist's respect for facts as the basis of truth. 'The wind blows in the direction of science', declared Zola at the 1866 Salon; 'Despite ourselves, we are pushed towards the exact study of facts and things.' And the following year, in his long study of Manet, he once more declared the universal implications of the contemporary scientific revolution: 'Since science required a solid foundation and returned to the exact observation of the facts, everything is called in question. This movement has occurred not only in the scientific world. All fields of knowledge, all human undertakings look for constant and definite principles in reality.'

It is hard to realize today the scope and bravado of the scientific revolution in the nineteenth century; so many of its temerities have by now been absorbed into the invisible substructure of our automatic assumptions about the world. In the last century, science was more optimistic, more generally ambitious and more radically universal in the scope of its aims and aspirations than are the various specialized disciplines today. Indeed, we might say that men like Comte, Taine, Zola or Renan ultimately came to confuse science with scientism and materialism, replacing the old metaphysics with a new one: religious trust in science. For Taine, science provided direct knowledge of reality itself, and thus, as a corollary, reality was only what science could know – and nothing else: shades of Courbet, who proclaimed, with similar logical nonchalance, that since painting should be concerned only with the representation of real and existing things, nothing abstract (i.e. not visible or non-existent) should, or could, come within its realm. Both Comte and John Stuart Mill were concerned to make all areas of human experience the subject of exact empirical science, based on that which was observable, and Mill himself, in 1854, admitted that the ultimate aim of his *Logic* went far beyond its purported scope in order to place 'metaphysical and moral science on a basis of analysed experience, in opposition to the theory of innate principles'. Comte's position, analytic and historical, was based upon the proposition that all general knowledge must be scientific, founded upon observation and experiment, and this view was widely popularized by Littré, the leading propagandist of positivism during the Second Empire.

Not a single area of endeavour was unaffected by the scientific outlook, as Zola indicated. For Comte and Taine, man himself was

to be studied from the exterior, with the cold-blooded methods of analysis, and mental phenomena dissected like physical ones. Renan and the proponents of the Higher Criticism in Germany and in England confronted the Christian faith and the Holy Scriptures with the positivistic weapons of verifiability and consistency, leaving behind an all-too-human Jesus and a tenuous fretwork of subjective response and poetic idealism as the basis of personal belief. Like Taine, Fustel de Coulanges in his *La cité antique* of 1864, gave impetus to the advance of the impartial historical method in the study of the past: history freed from preconceived theories, ideals and all wishful thinking; history dependent upon careful scrutiny and critical analysis of the documents and factual evidence of the period. Sainte-Beuve referred to his literary criticism as the *'histoire naturelle des esprits'* while, at the same time, Théophile Thoré founded the discipline of art history as a positive or scientific enterprise. Believing with his colleagues in other fields that the theoreticians of the beautiful had had their day, Thoré set about the gigantic task of laying the foundations for a general, scientific history of art by accumulating facts, dates and other evidence. Even politics were to be submitted to the rigours of scientific method, according to Flaubert who wrote, in a letter to George Sand of 1869, that 'it is no longer a question of striving for the best form of government, since one form is as good as another, but of making Science prevail. . . . Politics will continue to be absurd until it becomes a province of science.' Nor was the enthusiasm for science confined to the lofty province of great minds. Popular evening courses were given to workingmen on both sides of the Channel, with such luminaries as Comte and T. H. Huxley at the lectern.

Thus in literature and the arts, when a writer like Flaubert declared that 'the time for Beauty is over' and that 'the more art develops, the more scientific it will be, just as science will become artistic. Separated in their early stages, the two will become one again when both reach their culmination', or when Castagnary, in his 1863 Salon, described the naturalist (i.e. Realist) school as 'truth bringing itself into equilibrium with science', they were very much at one with their contemporaries in other fields. To Realist writers and artists, the natural sciences seemed to offer a precedent for that stripping away of the clothing of illusion from the base flesh of reality, that divesting of experience of the falsehood of spiritual or metaphysical accretions, which was their goal. For Flaubert, who maintained that science and history were the 'two muses of modern times', it was precisely this rejection of illusion about the existence of a superior spiritual value that enabled science to arrive at reality itself: 'What is so fine about the natural sciences is that they don't wish to prove anything. What a

wealth of facts they enjoy, and what an immense field of thought! Human beings must be treated like mastodons and crocodiles; why get excited about the horn of the former or the jaw of the latter? Display them, stuff them, bottle them, that's all – but appraise or evaluate them: no!' How close such a statement comes, in its underlying attitude if not in its vivid concreteness of expression, to Comte's prediction in the *Cours de philosophie positive*, that the theological and metaphysical stages of civilization would be transcended when knowledge was obtained by observation – observation aimed not at the discovery of 'first causes' but simply of the relation between phenomena. 'Positivism', proclaimed Comte, 'signifies at once real, useful, certain, precise, organic, relative . . .'

If the Realists, then, did not actually proceed by the methods of natural science, or if they failed to understand its goals adequately, they nevertheless shared in, admired and sought to imitate many of its attitudes and these largely determined the character and quality of their work: impartiality, impassivity, scrupulous objectivity, rejection of *a priori* metaphysical or epistemological prejudice, the confining of the artist to the accurate observation and notation of empirical phenomena, and the descriptions of how, and not why, things happen.

Within the context of nineteenth-century arts and letters, the scientific analogy is used over and over again, by both the supporters and adversaries of Realism, while the Realists themselves often did rather painstaking research to document the 'scientific' aspects of their works. For Sainte-Beuve in 1857, the author of *Madame Bovary* has become, like the man of science, a completely impersonal observer. 'He is only there to see everything, to show everything and to say everything.' Flaubert is likened to a doctor, in his procedure. 'Son and brother of distinguished doctors, M. Gustave Flaubert holds the pen as others do the scalpel.' Indeed, Flaubert himself had acted out the part, going to extraordinary pains to gather accurate data on the precise symptoms of croup or arsenic poisoning, just as did the Goncourt brothers in order to set their novel of medical life, *La Soeur Philomène*, in a décor of, often gruesome, clinical accuracy. Zola approached Manet, whom he styled 'a child of our times' and 'an analytic painter', with much the same sort of outlook, depending upon the same sort of scientific reference and joining the enterprise of the modern painter with those of his scientific contemporaries in their mutual insistence upon dispassionate investigation of reality as both method and goal. Zola, however much his bellicose propaganda for the *roman expérimental* and a more truly scientific variety of Realism he termed 'naturalism' may have differed from the richly imaginative epic sweep of his novels, nevertheless relied heavily upon the positiv-

istic methodology provided by the brilliant physiologist Claude Bernard in his *Introduction à l'étude de la médecine expérimentale* of 1865, and, in 1866 defined the novelist as a 'doctor of moral sciences' and the novel itself as 'a treatise on moral anatomy, a compilation of human data, an experimental philosophy of the passions'.

Realism was, of course, attacked for its ostensible reduction of the human situation to that of the experimental laboratory. As early as 1843, Hippolyte Babou criticized Balzac and the school of the *roman d'analyse* for transforming the novel into 'moral chemistry'. And later, many critics condemned the scientific aspect of Realism for its gross materialism, terming it 'the reproduction of the material world with all its most strikingly materialistic qualities', while others, with more precise and up-to-date terminology, condemned the alliance of Realism and modern science by likening the procedures of the Realists to those of the 'scientifically' objective and mechanically accurate methods of the daguerrotypist or photographer. 'It is the jeering, trivializing fidelity of the Daguerre method applied to the reproduction of the ridiculous and the odious,' declared one critic of the verism of Henry Monnier. Merimée was criticized for his 'photographic method' and for 'daguerreotyping' his characters; and the Realists as a whole were accused of making 'a sort of daguerrean counter-proof of daily life' or of simply photographing nature. Baudelaire, of course, condemned outright the photographer and his mechanical – scientific impassivity as a threat to genuine artistic creation.

The Realists and Impressionists certainly used photographs, as indeed did Baudelaire's paragon of the imaginative painter, Delacroix. But they used photographs as an aid in their attempts to capture the appearance of reality. Courbet, for example, used photographs for the standing female in *The Bathers* [17] and in *The Painter's Studio* [71], for his illustrations to Baudry's *Le Camp des bourgeois* (1868) and for his posthumous portrait of Proudhon [115]; Manet used photographic portraits for his etchings of Baudelaire and Poe, as well as requiring at least four photographic proofs for documenting his *Execution of the Emperor Maximilian* [14], and Degas made extensive use of photographs, indeed he was enthralled by the whole photographic process. Degas, more than any other Realist, looked upon the photograph not merely as a means of documentation, but rather as an inspiration: it evoked the spirit of his own imagery of the spontaneous, the fragmentary and the immediate. Thus, in a certain sense, critics of Realism were quite correct to equate the objective, detached, scientific mode of photography, and its emphasis on the descriptive rather than the imaginative or evaluative, with the basic qualities of Realism itself. As Paul Valéry pointed out in an important though little known

article: 'the moment that photography appeared, the descriptive genre began to invade Letters. In verse as in prose, the décor and the exterior aspects of life took an almost excessive place. . . . With photography . . . realism pronounces itself in our Literature' and, he might have said, in our art as well.

All these manifestations of the scientific attitude might also, perhaps, be considered as part of that broader outlook of 'epistemological agnosticism' with which George Lukács characterizes nineteenth-century Western ideology as a whole. For one of the ways in which Realism differs from all the older arts concerned with verisimilitude is this important and all-embracing one: realism of this particular kind and degree was not possible or even conceivable until the nineteenth century. Van Eyck painting Arnolfini or Caravaggio his Magdalene, no matter how scrupulous they might have been in reproducing the testimony of visual experience, were looking through eyes, feeling and thinking with hearts and brains, and painting with brushes, steeped in a context of belief in the reality of something other and beyond that of the mere external, tangible facts they beheld before them. And even if certain artists, such as Velasquez or Vermeer, tried to break free of existing *schemata* of representation – which they certainly did, to a greater or lesser extent, in order to look at nature for themselves – they were still bound by the often unconscious ideological limitations of their own era, as indeed were the nineteenth-century Realists themselves, of course. But it was not until the nineteenth century that contemporary ideology came to equate belief in the facts with the total content of belief itself: it is in this that the crucial difference lies between nineteenth-century Realism and all its predecessors.

REALISM AND THE SOCIAL ISSUE

How closely was Realism related to the social and political issues of its day? This is as complex and delicate a question as that of the relation of Realism and science. All art is, of course, an integral part of the social structure: to affirm this is to say everything – and nothing. The cathedrals of the Middle Ages, the most recondite passages in *Euphues*, the idealized antiquity of Raphael or Poussin, the hermetic dream-creations of Redon or the Surrealists, the blank page of Mallarmé or the black canvas of Ad Reinhardt – all are as inextricably enmeshed in the social fabric of which they are a part as the most blatantly propagandistic *machine* of a Soviet party hack. Yet it is evident that an art whose explicit goal is the depiction and analysis of contemporary life and whose point of reference is the changing yet concrete appearances

of the contemporary world, will be more directly and materially involved with the social conditions of its times than would an art which is concerned with ideals and symbols.

Born in the wake of the progressive upheaval of 1848 and reaching maturity in the period of social cynicism and political disillusionment following after it – the period of the Second Empire – the French Realist movement in its dual character of protest against, yet expression of, a predominantly bourgeois society, was internally marked with the stamp of ambivalence. On the one hand, it might be considered – and indeed was considered at its inception – to be an expression of the new, radical social forces unleashed by the revolution itself. For Courbet and his supporters, for example, Realism was 'democracy in art'; for Castagnary, naturalism sprang 'from our politics, which, by positing as a principle the equality of individuals and as a *desideratum* the equalizing of conditions, has caused false hierarchies and deceptive differentiations to disappear from the mind'; and one outraged critic of the Goncourts' ill-starred play *Henriette Maréchal* went so far as to declare that Realism led to 'materialism and the socialism of Proudhon', strong terms indeed in the days when the spectre of anarchism or worse hung heavily over the well-censored battlements of Louis Napoleon's 'liberal' Empire.

Yet, on the other hand, when we turn to Realist works themselves the connection between art and specific social attitudes becomes more amorphous. The precise degree to which Courbet's major paintings of the 1850s actually reflect his left-wing political convictions is debatable. For his friend and supporter, P.-J. Proudhon, the anarchist, philosopher and coiner of the phrase 'property is theft' (and the *bête-noire* of both Marx and the bourgeoisie), *The Stone-breakers* [58] might indeed have been an 'irony directed against our industrial civilization' and the *Bathers* [17] a critique of the 'fleshy, comfortable bourgeoisie', but it is unlikely that Courbet had any such overt propaganda in mind when he painted them. Certainly, works like Jeanron's *Scene of Paris*, with its starving workman pleading for bread for his family, Alexandre Antigna's numerous canvases devoted to disasters in the lower strata of society – floods, fires, dispossession and beggary [20] – or Tassaert's melancholy representations of suicides in fetid attics, sickly, undernourished children and freezing orphans, raised the social issue, and spoke out against the social injustices of the period, far more explicitly than did Courbet's stone-breakers or bathers.

Courbet's paintings were socially inflammatory not so much because of what they said – they contain no overt message at all – but because of what they did not say. His unidealized, startlingly direct and matter-of-fact representations of contemporary lower-class sub-

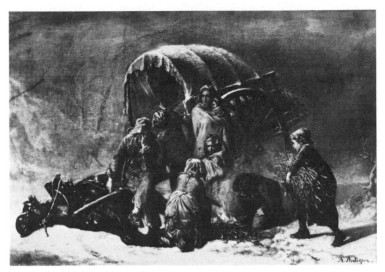

20. *The Forced Halt*, 1855. A. Antigna

jects, utterly devoid of the small-scale, patronizingly picturesque
charm which had made genre painting of similar themes acceptable,
even if not theoretically admirable, in the eyes of right-thinking
Frenchmen, made their Salon début in 1850–51, at the very moment
when the triumphant bourgeoisie had deprived these very lower
classes of most of the advantages they had won on the barricades of
1848. In 1851 the socialist menace was still a frightening memory,
even a threatening possibility. Courbet's supporter, Castagnary, gives
us some idea of the situation at this time: 'They had dissolved the
National Workshops, they had defeated the proletariat in the streets
of Paris . . . they had purged universal suffrage: . . . and here was that
"vile multitude" chased out of politics, reappearing in painting!
What did such effrontery mean? Where did these peasants and stone-
breakers come from, these starvelings, these ragamuffins whom one
saw silently pressing forward among the cherished divinities of
Greece and the be-plumed gentlemen of the Middle Ages? Were these
not the sinister vanguard of those "Jacques" whom an anxious public
imagined rising, with torches in their hands and knapsacks on their
backs, to the assault of the elections of 1852?' Thus Courbet's 1850–51
Salon paintings, simply because of their scale, their style and their
subject matter, were seen as a threat to the as yet shakily re-established
power of the middle-classes. Though far from being out-and-out

47

statements of social principles, they were intimately connected with the left-wing outlook of his day because of their radical pictorial innovations. As Thoré pointed out, not only did they take contemporary lower-class subjects *au sérieux*, but they treated them as worthy of a monumental scale. And, furthermore, they were directly related to the 'art of the people' itself, since it was to popular art and the popular traditions of Holland, Spain and France – forms recently 'discovered' by socially conscious art-critics in Paris – that Courbet had turned for inspiration. In the eyes of his supporters, Courbet was thus fulfilling the demand for an art that was, simultaneously, both socially significant and stylistically innovating.

A reflection of the social ideals of 1848 could be seen in the very pictorial structure of such a work as the *Burial at Ornans* [39]. By its seemingly casual and fortuitous arrangement – without beginning, middle or end – by its lack of selectivity and hence its implied rejection of any accepted hierarchy of values, by its uniform richness of detail which tends to give an equal emphasis to every element and thus produces, as it were, a pictorial democracy, a compositional *égalitarisme*, by its simplicity, awkwardness and lack of all Establishment rhetoric, it could be seen as a paradigm for the *quarante-huitard* ideal itself. As exemplified in such works, both Realism and Democracy were expressions of the same naïve and stalwart confrontation of – and challenge to – the status quo.

Viewed from the opposite camp, Courbet's artistic licence and lack of decorum were, of course, immediately equated by his enemies with political lawlessness and Radicalism. All forms of Realism fell under the same condemnation. Walter Bagehot, for instance, in a stringent critique of the besetting matter-of-factness and growing materialism of modern society, identified Realism with what he termed social 'utilitarianism'. 'The *réalisme impitoyable* which good critics find in a most characteristic part of the literature of the nineteenth century, is also to be found in its politics. An unostentatious utility must characterize its creations', he wrote in *The English Constitution* of 1867. At about the same time in France, Baudelaire was fulminating against the 'universal bestiality' of his day, a 'brutalized and gluttonous' society 'in love only with material possessions', and, in the same breath, against 'a certain literary method called *realism* – a disgusting insult thrown in the face of every rational person, a vague and elastic word which signifies for the vulgar not a new method of creation but a minute description of trivialities'.

Not all Realists shared Courbet's well-defined radical views. But their antagonism to the increasing democratization – some would have called it debasement – of society was no bar to their depicting it

in all its vivid actuality. For, as Alfred de Vigny had prophetically announced in his *Réflexions sur la vérité dans l'art*: 'in letters today a study of the general destiny of societies is no less necessary than an analysis of the human heart.' Flaubert, who disclaimed any affiliation with the Realist movement – 'I hate what is conventionally called realism, though people regard me as one of its high priests' – was openly scornful of the mediocre pretensions and nauseating afflatus of the lower-middle-class banqueters of 1848 and took no active part in any of the events of his day, contenting himself with having been present 'as a spectator' at nearly all the riots of his time. Yet it was Flaubert who created the most striking and veristic image of the revolutionary epoch in *L'Éducation sentimentale*.

Courbet frankly admired the provincial virtues of his native Franche-Comté, going so far as to imitate the countryman in the brusqueness and vigour of his own manners. Millet, at his worst, bathed the farm hand in an aura of bucolic platitude, and at his best conveyed a real sense of how it felt to be chained like a beast of burden

21. *Two Peasants Tilling the Soil, c.* 1844–8. J.-F. Millet

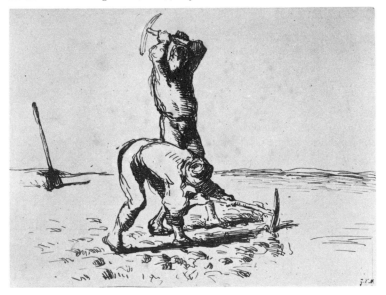

to the soil and the seasons [21]. Zola descended to the lowest depths of society in order to demonstrate the inevitable effects of heredity and the inexorable depredations of an unjust social system. But again, it was Flaubert who, despising the mob and all its works, nevertheless

49

created his few sympathetic characters in its image: Dussardier, the selfless and unselfconscious leftist worker in *L'Éducation sentimentale*; Cathérine Leroux the mutely-stoical old peasant woman who receives a derisory award for a life-time of service at the agricultural fair in *Madame Bovary*; and the unforgettable Félicité, antiheroine of *Un Cœur simple*, unquestioningly accepting her life's burden of anonymous servitude, redeemed only by the penultimate vision of a cherished stuffed parrot.

Those fastidious snobs, the de Goncourts, as jealous of their *particule* as of their *recherché* art collection, no less than the democratic, ultimately socialist Zola, sought their documentation in the seamier sides of Parisian life – though their motives may be questioned. In the pages of their *Journal* the Goncourts constantly eulogized their own most intimate contact with the 'people' – their faithful maid-servant, until she had the indelicacy to involve them in her sordid private life, at which point she served as the unwitting model for the heroine of their study of beneath-stairs society, *Germinie Lacerteux*. The apolitical Monet and Degas, the latter, if anything, reactionary, were as much concerned to 'translate the customs and appearances of their epoch' in the 1860s and 1870s as Courbet had been in the 1850s. And it is surely no coincidence that Baudelaire, the Goncourts and Flaubert – and not only the left-wing Daumier, Courbet, Zola and Manet – were all involved in more or less serious encounters with the legal powers of the Establishment.

The social engagement of Realism did not necessarily involve any overt statement of social aims or any outright protest against intolerable political conditions. But the mere intention 'to translate the appearances, the customs' of the time implied a significant involvement in the contemporary social situation and might thus constitute a threat to existing values and power structures as menacing as the throwing of a bomb. Police censorship prevented Manet from exhibiting his perfectly 'objective' *Execution of the Emperor Maximilian* or circulating lithographs of the same subject. 'The anarchist painter is not the one who will create anarchist pictures', wrote Signac in 1891, 'but he who, without concern for wealth, without desire for recompense, will fight with all his individuality against official bourgeois conventions by means of a personal contribution.' Although the aesthetic, no less than the political, situation had radically altered by this time, the implications of Signac's statement hold good for the earlier period. In the age of Realism the personal contribution was, by definition, a social one.

Realism has sometimes been regarded as a progressive and perennial phenomenon evolving and developing through the centuries to attain its most serious and concentrated form in the nineteenth century. Eric Auerbach, in his remarkable *Mimesis*, for example, traces its development from the time of Homer and the Bible onwards. Many writers and artists have imagined they were realistic. Nietzsche said that all good artists always have done so - and that realism in art is just an illusion. It is doubtless true that in so far as the Realist writers were concerned with man's reality, they shared this concern with the great writers of every other age. And in a sense, as we have already seen, the term 'Realism' merely betrays an illusion peculiar to the mid nineteenth century - the illusion that it had found a key to what really is. Yet nineteenth-century Realism is marked by certain characteristics which set it off, qualitatively and quantitatively, from all earlier and later manifestations. Even if one agrees that each generation must re-invent the modalities of reality anew - as so many have believed from the time of Wordsworth and Constable to that of Alain Robbe-Grillet and Rauschenberg - one is bound to admit that the self-consciousness and single-mindedness of its practitioners made mid nineteenth-century Realism both a landmark and a paradigm for all subsequent endeavours. All forms of realism, regardless of time or place, are marked by a desire for verisimilitude of one kind or another. But there can be no perception in a cultural vacuum, and certainly no notational system for recording it, unaffected by both the coarser and subtler variants of period, personality and milieu. Even within the nineteenth-century movement itself, a sincere desire to record the verities of nature *en plein air* led Monet to convey his perceptions with open brushwork and blurred contours, while, at almost the same time in England, Ford Madox Brown was trying to do the same thing under the same conditions by means of precise outlines and minute *facture*.

The Realists' endeavour to see things as they are was inseparable from their general beliefs, their world, their heritage and the very quality of what they were divesting themselves of and rebelling against. Revolutions are as much shaped by the status quo they rise against as by the purported goals towards which they strive. And even if we beg the question by saying that a style - any style - is by definition no more than a series of conventions, we must still admit that the Realists made a very stringent effort to fight clear of existing ones and to battle their way through to new, less shopworn and more radically em-

pirical formulations of their experience. Yet, as we have seen, one must be wary of accepting totally the Realist myth of a value-free world view, along with its corollary, the style-free or transparent style, no matter how often or how urgently their contemporaries, both favourable and hostile to the movement, may have proclaimed them.

It is the professed aim of certain present-day art historians to 'let the age speak for itself' and hence to accept the evaluations of an artist's contemporaries as inherently more valuable than the judgements of later students of his work. Such a notion has a certain spurious attractiveness, an aura of scholarly objectivity, which conveniently obscures the more pedestrian fact that what these historians are engaged in is not really history at all but an up-to-date version of antiquarianism. The theoretical discourses of a period, or its heartfelt diatribes, are no more nor less raw material for the art historian than its artefacts or its statistics, important though they may be *as* raw material. An age no more 'speaks for itself', in the sense of explaining itself, than does the painting or the poem produced in it. If it does speak, its pronouncements are generally veiled in a Delphic opacity, the full meaning of which can be penetrated or tested for validity only by interpreters who, with the sheer passage of time, have gained a certain perspective – that sense of context and coherence essential to the historian's task.

To accept, for example, a sixteenth-century theorist's views of the nature and goals of *maniera* as the only all-sufficient explanation of the complex phenomenon of Mannerism is as unsatisfactory as accepting the compulsive hand-washer's explanation that all he wants to do is to keep very, very clean. In both cases, the statements provide necessary starting points but hardly provide a complete explanation which would necessitate a great deal of further searching beneath the surface as well as examination of the surface itself. By the same token, one may safely accept Max Buchon's statement that Courbet painted his portrait of 1854 on a visit to Switzerland. But we should certainly be more sceptical of his contention that Courbet had no formal training and produced his works as spontaneously as an apple-tree produces apples. Further investigation reveals that this contention is as much part of the fabric of Realist 'ideology' as the paintings or novels produced by the movement and, as such, is to be subjected to the same sort of critical scrutiny and analysis. Sometimes, indeed, the contemporary spokesman for a movement is at a considerable disadvantage in judging it, simply because he *is* a contemporary and thus inevitably swayed by both his conscious passions and his unconscious assumptions about the nature of his subject.

As a case in point, certain modern writers seem to accept the nineteenth-century view, generally widespread among both the Realists' supporters and echoed in darker tones by their opponents, that their's was an age without values, without a cohesive system of belief, an age which had lost the past but not yet re-erected a present or laid the foundations for the future, despite its undeniable material and technological progress. Some, like the Goncourts, accepted this unhappy fact with cynicism and nostalgia. Baudelaire raged against it with apocalyptic despair. Pissarro and Manet appreciated the new openness of possibility it offered the artist. Others, like Comte or Fourier, consciously set about building up complex, improved, secular systems of value which they thought more appropriate to the needs of the time than outworn religious creeds. In England, Germany and France there were remarkably coherent attempts to erect new, rational, yet emotionally satisfying 'secular religions' or ideological systems: Positivism, Socialism, Anarchism, Fourierism. What with these and the fervour of Carlyle, the radical transvaluation of values of Nietzsche, the missionary zeal of Ruskin and Morris – was there ever a century which so insisted, and so self-consciously and vociferously, on values and their re-establishment on more rational, or alternatively or concomitantly, more humanly-satisfying grounds than those which had previously existed? If the period of Realism saw the triumph of science and the historical-critical method, it also saw the creation of the Religion of Humanity and Dialectical Materialism, world views which are based on the premise that critical observation and the testing of experience are themselves values, and means to greater human freedom and richness of possibility.

The absence of overtly formulated credos from creative work or theoretical pronouncements does not necessarily betoken the want of an underlying scheme of values or beliefs. The works of the Impressionists, as much as those of any medieval craftsman or renaissance Humanist, are related to a world view, a context of interdependent beliefs and ideas about what is good and bad, true and false, the nature of existence and the means for investigating it. There are no 'value vacuums' in human history, no 'intermediary periods', only periods which are more or less unified, more or less amenable to the procedures, and temperaments, of historians. The mid nineteenth century is a particularly complex moment. But this complexity should not force us to accept uncritically the raw materials of history as history. In historical reality there are no *tabulae rasae* even for those who most wish that there were or might be – like Monet wishing that he had been born blind, or Pissarro demanding the destruction of the

Louvre. Merely to state such a desire implies a whole series of under-lying presuppositions which, though unvoiced and perhaps un-systematized, are no less relevant to the work of art in question than Fra Angelico's belief in the divinity of Christ. An artist's silence or incompleteness of expression of a viewpoint is proof of neither neutrality nor inchoateness.

The new crypto-religious and other values of the nineteenth century were, it is true, often difficult for artists to realize directly with any degree of aesthetic or intellectual adequacy. Allegorical representations of Electricity may be more direct manifestations of the scientific spirit than an Impressionist landscape, but they are hardly more adequate. Similarly, a wildly partisan novel about starving workers is not necessarily a more adequate expression of social realities than *Madame Bovary*. The situation becomes still more complicated when we remember that Realist works (and the Realist outlook) are themselves a part of the social structure of their period, emblems of the beliefs of the time, and not merely effects of an abstract cause. *Madame Bovary* and the Impressionist landscape are both as much a part of the social reality of the nineteenth century as the 1848 Revolution or the Communist Manifesto and similarly shaped the way men thought about themselves and looked at reality. It is in fact hard to think of the nineteenth century at all without borrowing the imagery of a Monet or a Renoir view of Paris, a Dickensian descrip-tion of a London slum, a Courbet or a Millet peasant.

The problem of why the Realists chose to paint what they did and rejected other possibilities, and why they chose to paint what they did the way they did, is crucial. It was not merely because street scenes, or peasants or everyday subjects were available – the papal kitchen had, after all, been available as subject matter to Raphael. Nor was it because the older, more traditional subjects were 'outworn' or 'no longer relevant' – that is simply an easy way of saying that they were no longer being painted. Painters chose as they did because of certain attitudes of mind, stated or unstated, often unconsciously assimilated as though breathed in with the air of the times. The advanced painters of the fifties and sixties were certainly not seeking for some meta-physical doctrine or coherently formulated mythology which would immediately supply a ready-made iconography. Such crude determin-ism, dangerous when applied to earlier epochs, is wholly inappropriate in the mid nineteenth century when a mistrust of abstract generaliza-tions and a pooh-poohing of intellectual formulae as 'insincere' were central to the Realist outlook.

The question of why Monet insisted on painting his 1866-7 *Women in the Garden* [22] completely out of doors is no less closely related to

22. *Women in the Garden*, 1866-7. Claude Monet

mid nineteenth-century intellectual history than the learned and arcane scheme of social palingenesis which Chenevard worked out in his sketches for the Panthéon murals, although, on the surface, Monet's painting has no 'intellectual content' at all. Yet why, at this moment, did it become so important to paint a large scale canvas *en plein air*, to create a unified and accurate light effect of figures and setting, using only intimates or close relations as models? It is, of course, essential to know a great deal more about the internal charac-

ter of the artistic world of the period as well as a great deal about Monet's previous career, to answer this question. But these important sources of information will not tell the whole story and cannot supply an entirely satisfactory answer. They leave us asking why perception and its accurate notation was so important to a young and unconventional artist in the 1860s. This had certainly not been the case for the adventurous and innovating Delacroix in the twenties. Why light and not line? Why casualness rather than formality? Why the contemporary scene and not an exotic or literary subject? These are but a few of the questions posed by Realist works of art - and we shall misunderstand them if we take them at face value - or even at the valuation put on them by their contemporaries.

Death in the Mid Nineteenth Century

'Don't miss the Christ by M. Manet, or "The Poor Miner Pulled out of the Coal Mine" painted for Renan', the critic of *La Vie Parisienne* advised the Salon visitor of 1864. Manet's starkly 'plebeian' figure style [23] and his rejection of all the elevated, transcendental rhetoric

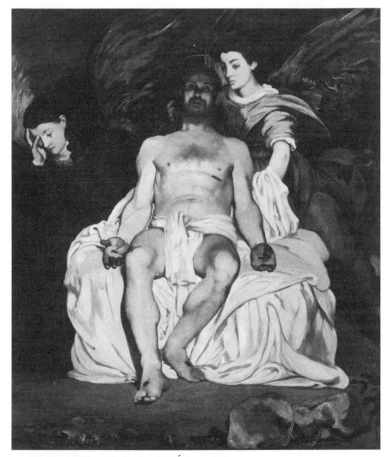

23. *The Dead Christ with Angels*, 1864. Édouard Manet

customary when dealing with such high themes, was thus sarcastically, and not incorrectly, equated with the revolutionary secular – historical approach of Ernest Renan in his immensely popular *La Vie de Jésus* of the year before. This question of the trivialization of the profound and serious is a familiar one to students of the nineteenth century. Critics of the time frequently berated artists and writers for reducing the great themes of Western art and literature – the transcendental

24. *In the Sun*, 1875. C. É. de Beaumont

issues of life and death – to the banal level of mere commonplace, everyday actuality. Their complaints would often seem to have been justified: C. E. de Beaumont's *In the Sun* [24], for instance, a *reductio ad absurdum* of the portentous issue raised by Poussin in his *Et in Arcadia Ego*; or H. A. Bowler's *The Doubt: 'Can These Dry Bones Live?'*, with its prim young lady contemplating an open grave, the answer to her question being conveniently supplied on a tombstone marked '*Resurgam*', as well as in the whole imagery of the painting – a horse chestnut sending forth a new shoot, illuminated by a ray of sunlight, and a blue butterfly alighting upon the departed's skull. Such instances of banality, coyness or outright debasement of the solemn and noble are not hard to come by in the mid nineteenth century. But there is a vast difference between such trivializations and Manet's *Dead Christ* or Trübner's even more starkly factual and unidealized, almost brutal, conception of the same subject [25]. They and other realists – writers as well as painters and sculptors – had

25. *The Dead Christ*, 1874. H. W. Trübner

quite consciously and deliberately abandoned all the grandiloquent and elevating imagery, which had become traditional when depicting death, in order to create a new and more appropriate imagery for the simple, experienced, down-to-earth actuality of dying. Advanced artists and writers of the mid nineteenth century were keenly aware of the enormous change in attitude towards death which had come about during their own lifetimes. They attempted to grasp and convey in their works the mundane truth of dying – the bare truth, stripped of all transcendental meanings and metaphysical implications, but rich in the circumstantiality of psychological, physical and social detail.

'All that was solid and established crumbles away, all that was holy is profaned, and man is at last compelled to look with open eyes upon his conditions of life and true social relations,' proclaimed Karl Marx, rather sweepingly, in the Communist Manifesto. The Goncourts, who scarcely needed Marxian guidance in opening their eyes to the desacralization of society in their day, stated about fifteen years later that 'as societies advance or believe themselves to advance, to the degree that there is civilization, progress, so the cult of the dead, the respect for the dead, diminishes. The dead person is no longer revered as a living being who has entered into the unknown, consecrated to the formidable "je ne sais quoi" of that which is beyond life. In modern societies, the dead person is simply a zero, a non-value.' And similarly P.-J. Proudhon, when defending Courbet's *Burial at Ornans* [39] against charges of blasphemy by maintaining that it is merely a pitiless reflection of contemporary reality, declared that 'We have lost the religion of the dead; we no longer understand that sublime poetry with which Christianity, at one with itself, surrounded it. We have no faith in prayers and make fun of the Life Beyond. The death of man today, in universal thought, is like that of an animal . . . and despite the *Requiem*, despite the church and all its *decorum*, we treat the remains of the one like those of the other.' Such pronouncements are not themselves without a certain rhetorical exaggeration. But they forcefully express the attitude of mind which lay behind Realist depictions of death – that sense of the dead person as simply a zero, a non-value, and the artist's inner compulsion to embody this truth in his work, to capture in words, paint or marble the sheer phenomenology of dying.

It is no accident that the theme of the artist forced, despite himself, to record the appearance of a loved one on his or her death-bed, becomes a recurrent topic in Realist mythology. In Zola's *L'Oeuvre* the artist, Claude Lantier, is overcome, on the death of his little son, by a desire to record this harrowing subject and finally seizes his brushes and canvas and sets out to paint his dead child. 'For the first

few minutes, tears drowned his vision in a fog, but he kept on wiping his eyes and persisted in going on with a wavering brush. Work quickly dried his eyelids and steadied his hands, and soon, the dead body of his son became simply a model, a strange, interesting subject for him!' After five hours of continuous work he completes his *L'Enfant mort*, a little masterpiece of Realist actuality. The thirst for verisimilitude has triumphed over more traditional attitudes and, presumably, more natural feelings. Zola evidently had an actual painting in mind – Dubois-Pillet's *Enfant mort* – and he also had a literary precedent in Flaubert's *L'Éducation sentimentale*, where the painter, Pellerin, sets to work on a pastel of the pitiful little corpse of the hero's son *'aussi calme que s'il eût travaillé d'après la bosse'*. And the formulation of the image can no doubt be traced back to the eighteenth century, with such representations of compulsive genius as Eisen's *Signorelli Painting his Dead Son* of 1752 and on into the early nineteenth century with such works as Léon Cogniet's *Tintoretto Painting his Dead Daughter* [26] or Karl Girardet or Eleuterio Pagliano's versions of the same subject. The *exemplum* is, however, particularly appropriate to Realism, where it becomes a paradigm for the artist's compulsive need to record

26. *Tintoretto Painting his Dead Daughter, c.* 1846. Léon Cogniet

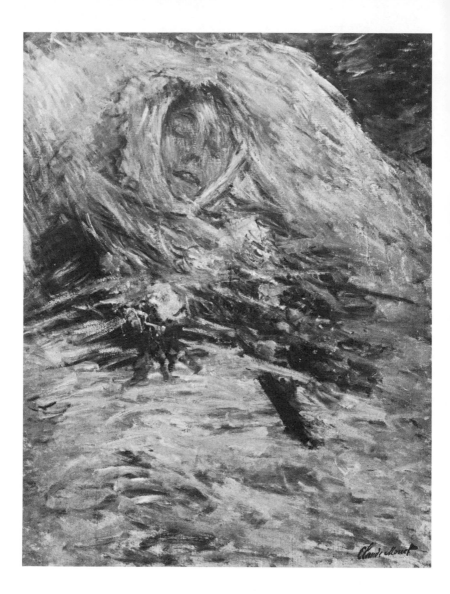

27. *Camille on her Death Bed*, 1879. Claude Monet

objective reality itself, that all-devouring thirst for truth to the facts as conveyed by sense perception.

Life, indeed, imitates art – or at least finds a parallel for it – in Monet's painting, *Camille on her Death Bed* [27] and in his account of the circumstances surrounding its creation in a conversation with his friend Clemenceau.

. . . One day, when I was at the death-bed of a woman who had been and still was very dear to me, I caught myself, my eyes fixed on her tragic forehead, in the act of mechanically analysing the succession of appropriate colour gradations which death was imposing on her immobile face. Tones of blue, of yellow, of grey, what have you? This is the point I had reached. Certainly it was natural to wish to record the last image of a woman who was departing forever. But even before I had the idea of setting down the features to which I was so deeply attached, my organism automatically reacted to the colour stimuli, and my reflexes caught me up in spite of myself, in an unconscious operation which was the daily course of my life – just like an animal turning his mill.

For Monet, the overwhelming impulse to record sense impressions, at the expense of feelings, psychological implications or even the creation of a recognizable image of his dead wife, carries Realist veracity to its ultimate conclusion: the scrupulous notation of isolated phenomena. Indeed, the pathos of the painting arises from precisely the contrast between the objective notation of sense perceptions which create the image and the understood context of emotional stress under which they must have been recorded: for the act of perception determines the imagery here, in the case of the dead Camille, just as it would for the poppy field or the water lily. The image of the dead woman hovers on the surface of the canvas as the water lily on the surface of the pond or the paint strokes themselves on the surface of the canvas: nothing more is implied beyond this surface.

The same scrupulous fidelity to the facts characterizes, in literature, Edmond de Goncourt's harrowing and unrelenting account of the slow degeneration and gradual decay of his brother, Jules, in the pages of his *Journal*, his love for his brother forcing itself into a paroxysm of objective notation. No detail is lacking in this thorough-going record of the Passion of the Brothers Goncourt, through the familiar byways of fashionable Paris. No detail of progressive decay is too insignificant to be recorded. Jules forgets how to spell 'Watteau'; he has difficulties in pronouncing certain consonants; he seizes his fork with both hands; he empties his salt cellar over the fish. The final crisis is recounted in that spirit of clinical precision characteristic of

the death-scenes of Realist writers, with their equation of truth with physiological concreteness.

In spite of three spoonfuls of potassium bromide taken in a little water, he cannot sleep a minute and his head tosses incessantly on his pillow from side to side . . . sending out through the corners of his mouth embryonic phrases, truncated words, half-formulated syllables. . . . Suddenly, throwing back his head, he let out a raucous, guttural, terrifying scream. . . . Instantly his handsome face was seized with convulsions which completely transformed it, deforming all his features, while terrible spasms jerked his arms as if they were being twisted in their sockets and his ravaged mouth emitted a trickle.

What is so striking about Edmond de Goncourt's whole account of his brother's death is his wilful dissociation of the facts of dying from any metaphysical context, any realm of superior value which might raise the specific instances of suffering and decay out of the world of immediate experience to that of redemptive meaning. This same isolation of the fact of death from a context of transcendental significance or value characterizes Manet's *Dead Toreador* [28], a work which, as we know it today, was quite literally severed even from its own pictorial context – a larger composition laconically entitled *Episode in the Bullfight* – by the artist himself. Yet the dead toreador exists perfectly well as an image in its own right, seeming to require no more amplification or justification than does Manet's painting of a dead salmon of the same year. Indeed, the French term for still life, *nature morte*, would seem to do just as well for the man as for the fish. In either case, death is treated simply as a visual fact, the dead man being concretely defined by his costume and a discreet patch of blood, as is the salmon by his scales and his parsley.

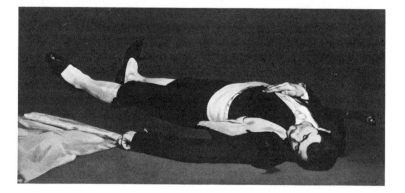

Even in tomb sculpture, traditionally the repository of transcendental or heroic values, the effigy came to be considered as a mere isolated fact within the space of the actual world. In François Rude's *Tomb of Godefroi de Cavaignac* [29] the 'monument' is simply a shrouded corpse laid out on a slab. We are confronted with neither mourners nor allegorical figures, but just with the finality of death as an ultimate fact. Although there is a reminiscence of Gothic tomb sculpture in the stark naturalism of the corpse, yet that essential accompaniment of the late Gothic *transi*, that ghastly reminder of earthly mortality, the image of the departed as an effigy endowed with everlasting life – the *représentation au vif* – is significantly missing in the mid nineteenth-century tomb. In the imagery of Gothic tomb sculpture the flesh withered, quite literally, in order that the spirit might flourish: the nineteenth-century sculptor, by removing the second half of the proposition and the upper level of the medieval tomb structure, leaves us with the withered flesh and nothing more, a monument which is simply an isolated image of death in its most clinical sense.

Yet at times it is not so much by the isolation of the image of death, but rather by embedding it so firmly and irrevocably in the context of contemporary daily experience – not just physiological or psychological but social as well – that the nineteenth-century artist or writer severs its transcendental connections and posits the non-value of the dead person and the meaninglessness of his experience. For the Realist, the imagery of death is weighed down to earth by an obsessive preoccupation with the triviality of the context in which it occurs. The dying person is firmly anchored to the here and now by an insistence on the social milieu in which he dies, the objects which surround him, the account of the daily round of events in which his

28 *(opposite)*. *The Dead Toreador*, 1864. Édouard Manet

29. *Tomb of Godefroi de Cavaignac*, 1845–7. François Rude

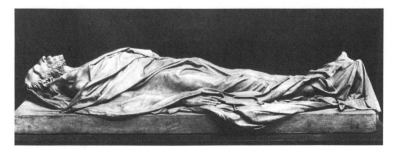

death, far from being a significant solemnity, constitutes no more than a distressing interruption. A classic example of this type of death scene, in which the impassive objectivity of the author seems perfectly to capture the utter self-interest and indifference of the subject-matter – the Norman peasantry – is the death of the 'pé' in Maupassant's story *Le Vieux*, where the peasants, in order to save time, start the funeral feast before the old man dies, and laconically, in their coarse dialect, berate him for finally dying before they have finished their funeral cakes. A similar merging of the experience of death with the banality of daily life occurs in Zola's *L'Assommoir*, in the section dealing with the death and funeral of Mère Coupeau, where it is mainly the expenses involved that preoccupy the survivors who again express themselves directly and in their unelevated argot, in scenes described by Zola with every detail of their circumstantial triviality.

For the Realist, the reduction of the vertical significance of death requires an expansion of its horizontal circumstantiality, so to speak. In the past, men had no doubt feared death, suffered excruciatingly in the course of it, died surrounded by bed-pans and medicine bottles and quarrelling relatives anxious to get down to the reading of the will and back to the business of daily life, yet the imagery of the act of dying was itself, in the seventeenth century, for example, elevated above and purified of all such petty, mundane details by a belief in a transcendental meaning lying beyond. Bossuet's account of the death of Michel le Tellier, although no doubt intended as an *exemplum* of courageous Christian dying, nevertheless also conveys a sense of the deeply felt value of death to the Christian. To Bossuet, death appears as a welcome visitor – like Donne's groom 'which brings a Taper to the outward room' – a necessary sacrifice leading, like all sacrifices consented to in the order of grace, to its ultimate fulfilment in the order of glory.

But if the joy experienced by Christians at the approach of death became almost a *thème à la mode* for seventeenth-century funeral orators like Bossuet, it is nevertheless obvious that for them and for their auditors this *thème* described a vivid reality as well as an example of virtue. For the nineteenth-century writer, on the other hand, the reality of death is simply that of a disagreeable bodily process: dying. And this process must be described in all its trivial detail to convey a sense of actuality. Tolstoy's Ivan Ilych, reduced by dying to a true 'non-value', gradually comes to realize that his friends and family are degrading 'this awful, solemn act to the level of their visitings, their curtains, their sturgeon for dinner. . . . The awful, terrible act of his dying was, he could see, reduced by those around him to the level of a casual, unpleasant, and almost indecorous incident (as if someone

entered a drawing-room diffusing an unpleasant odour) . . .' The very imagery of this passage, with its reference to curtains, sturgeons, drawing-rooms and bad odours, tends, at the same time as it reduces death to the banal process of dying, to transform the space in which death occurs to that of the actual world of ordinary events. Precisely what had been resolutely expunged from the classical space of death, most thoroughly in classical tragedy – the perceived details, the contingencies of social behaviour, what the French critic, Roland-Barthes, has called 'the trivial kitchenry of doing' – is returned to it by the Realists. Indeed these trivial facts are all that death is for the Realists. How different is the death of Ivan Ilych from that of Phèdre in Racine's tragedy. Phèdre expires talking coherently in Alexandrines; her death is conceived of as pure cause, and has its effects on the very structure of the tragic universe itself, restoring it to its natural order:

> *Et la mort, à mes yeux dérobant la clarté,*
> *Rend au jour, qu'ils souillaient, toute sa pureté.*

We are told nothing of her concrete surroundings, her physical symptoms, the differentiated reactions of those around her. The space of tragedy, the classical antechamber, like the space of Poussin's landscapes or his representations of the deaths of Germanicus or Eudamidas, has been purified, clarified and strictly delimited in order that meaning reveal itself, through language or form, within its stringently restricted confines. In Tolstoy's *Death of Ivan Ilych*, on the contrary, the space is amorphous, shapeless, crowded with concrete specifics, the space of ordinary, variegated middle-class comings and goings, gradually contracting to focus on a specific, minutely described bourgeois bedroom. The messy, heterogeneous phenomena of dying – the body's decay, the mind's alternate escapes from and realizations of the terrible but trivial circumstances of the inevitable, the brusque transitions from the present to the past, from inner awareness to external perception, medicines, diagnoses, social and physiological details, down to the most degrading – 'for his excretions . . . special arrangements had to be made, and this was a torment to him every time – a torment from the uncleanliness, the unseemliness, and the smell, and from knowing that another person had to take part in it' – all are included. Nothing is omitted, since to omit such petty details would be to deny the undeniable, all-inclusive fact of the process of dying itself. The space of reality has been transformed from the finite but universally meaningful classical antechamber – or the ladder of ascent to a realm of eternal beatitude, with its alternative of a fall into eternal torment – to that of a specific time, place and social milieu. The grand drama of death takes place on the stage of eternity:

the banal process of dying just happens in a chintz-upholstered bedroom.

A painting like Charles Cazin's *Death Chamber of Léon Gambetta* [30] is a near perfect image, paradigmatic in its sub-heroic banality, of the Realist space of dying. Despite the token submission to the traditional accoutrements of heroic death – the flag and the wreaths, and the pathetic touch of the bits of paper left on the floor by now-withered bouquets – these 'meaningful' elements seem strangely out of place, as though dropped by visiting masqueraders, within the context of cosy, middle-class bedroom furnishings. The dead hero himself has been tactfully omitted from this world of pure phenomena: we are left to empathize with an armchair, a pillow, a discarded hat and some scattered papers. While in Vincenzo Vela's *Tomb of*

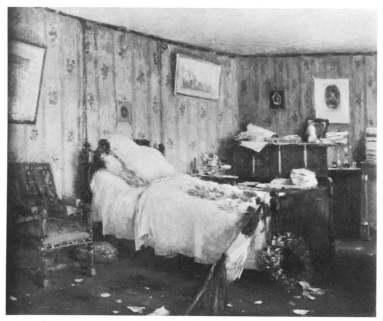

30. *The Death Chamber of Léon Gambetta*, c. 1882. J.-C. Cazin

Contessa d'Adda [31] the nature of the genre demanded the inclusion of the protagonist within the bedchamber, the effect is, if anything, even less transcendant, more earth-bound and circumstantial than in the Gambetta painting: one is far more aware of bedclothes, canopy and embroidered coverlets – discreet indications of the departed's

31. *Tomb of Contessa d'Adda*, 1849. Vincenzo Vela

social status – than of the significance of the overwhelmed little human object that threatens to disappear among their richly material profusion. Apart from the crucifix in her hand, there is nothing to hint that the Contessa is doing more than taking a peaceful nap amid tastefully luxurious surroundings. By the same token, the frock-

coated gentleman from the *Tomb of Vincenzo Drago* [32] might well be coming to pay an afternoon call, so muted are the references to his function as a mourning figure.

At times, it is not so much the object-filled space of death but rather the temporal brevity of its occurrence that constitutes the basis of Realist imagery. It is the instantaneousness of the image – dying as it appears to the eye at a given moment – which at once deprives this momentous occasion of its traditional significance and, at the same time, asserts truthfulness to the facts of immediate

experience in place of the outworn rhetoric of transcendental implication. We have already mentioned the sense in which the frozen instantaneity of Manet's composition in *The Execution of the Emperor Maximilian* [14] inhibits any traditional implications of heroism or of conventional emotional response – implications such as those made quite overt in a very different interpretation of another incident in the tragedy, J.-P. Laurens's *Last Moments of Maximilian*. The same might be said, with even greater justification, of Degas' monumental *Fallen Jockey* [33], a work which, in its scale and because of the number of

32 *(opposite)*. *Tomb of Vincenzo Drago*, (detail) *c.* 1880. A. Rivalta

33. *Steeplechase – The Fallen Jockey*, 1866. Edgar Degas

preparatory studies relating to it, was certainly considered an important undertaking by the artist, a slice of modern life raised to the status of history painting, rather akin, in its reference to death as an incident in the contemporary sporting world, to Manet's *Dead Toreador* [28]. Like Manet, Degas maintains a laconic distance from his subject. Nothing in the painting gives us any sense of either drama or tragedy – a result, of course, of Degas having chosen the very instant of the accident's occurrence for his representation. This sense of casualness and factual observation is conveyed by the ungainliness of the jockey's apparently fortuitous position (actually posed for Degas by his brother Achille), and the flying forms of the riders and horses continuing the steeplechase behind the fallen figure, as well as the free, open brushwork, which serves to heighten the transitory quality and to play down the dramatic aspects of the theme – aspects which had often served as a pretext for melodramatic treatment in English sporting prints and paintings.

The moment between life and death, the sensation of dying rather than the meaning of death, as the subject of a work of art, is found in its most distilled, prosaic and poignant form in Courbet's *Trout* [34]

34. *The Trout*, *c.* 1872. Gustave Courbet

where the animal is suspended between the hook and the stream, presented in all his scaly concreteness in the tightly restricted framework of compressed pictorial space, on the pebbly beach speckled with its blood. It is difficult, by definition, to make a fish, unless it be a

shark or a whale, dramatic. The same moment between life and death, in an animal painting of a traditionally 'noble' beast, *The Stag at Bay*, for instance, obviously based upon a prototype by Landseer, had given Courbet a rather different problem for which he found a different pictorial-expressive solution. Yet it is because this is a trout – associated with catching and eating, after all, rather than with nobility and drama – and because Courbet has reduced the setting and circumstances to such a bare minimum, or rather has condensed the maximum richness of concrete observation into a minimal framework – that we are hard pressed to decide whether or not this is simply a still life in the making or some sort of disguised and highly ambivalent self-image of the artist in prison or caught on the hook of circumstances of post-Commune retribution. In the end we accept it for what it is: a fish, captured in paint, at the moment between watery life and earthy death, something Courbet, who was an enthusiastic hunter and fisherman, would have been extremely familiar with and which he felt he wanted to record.

Not only death, but suicide, that perennially most crucial of existential themes – the only serious philosophical problem, according to Camus – is demoted to the rank of a simple, momentary incident or to that of a trivial, clinically described occurrence in Realist art and literature. In the past, suicide had been regarded as the only noble way to put an end to disgrace or as a declaration of personal liberty – depending on the author and period. But whereas Cleopatra dramatically applies an asp to her bosom, or Dido jumps off a romantic cliff, Anna Karenina meets her death under a prosaic railroad train, with Tolstoy expatiating on the extraneous element of her handbag. Madame Bovary's suicide is simply a concrete fact, like any other, in the incoherent structure of human existence. It is unstressed by the author as having any further significance, being clinically described in sequence: 'At once her lungs began to heave rapidly, her entire tongue protruded from her mouth, her rolling eyes turned pale like the globes of two fading lamps: she might well have been dead already but for the oscillations of her ribs, that shook with furious gusts . . .' While for a Romantic hero, like Goethe's Werther, suicide became a mystical liberation from a psychic malady, a return to the heavenly father, preluded by bread and wine and accompanied by that Romantic bible, Lessing's *Emilia Galotti*, for Flaubert, Madame Bovary's death is simply the departure for nothingness through the particular medium of arsenic poisoning. Nothing remains – no hope, no emotion, nor are there any moral or metaphysical questions raised by her self-chosen departure, which is neither heroic nor cowardly,

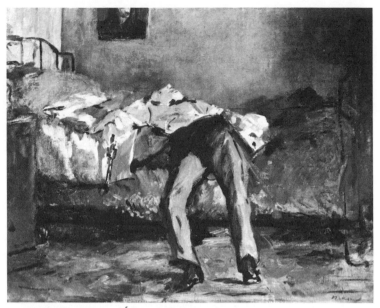

35. *The Suicide*, c. 1877-81. Édouard Manet

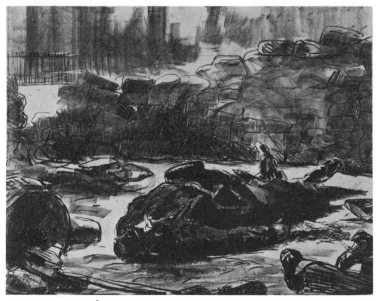

36. *Civil War*, 1871. Édouard Manet

but simply, what she did. Equally devoid of moral or emotional implication is Manet's *The Suicide* [35], where the contemporary figure, in evening dress – we suspect at once that this may have something to do with gambling debts – is sprawled on his iron bedstead in a simple room, at the very instant of death, the gun still clutched in his limp right hand, his legs in that ungainly, sprawling, foreshortened position characteristic of the Realist corpse, and used by Manet both for his *Dead Toreador* and also in his more circumstantial lithograph of the aftermath of a street execution following the repression of the Commune [36]. Once more, in Manet's *Suicide*, a painting posits the values of immediacy, truthfulness, directness, lack of bombast, melodrama or any falsification whatsoever: once more, if any emotion arises from the depiction, it comes from the juxtaposition of the casual pose, the free, spontaneous and open handling of the technique – the drops of blood sparkle like jewels of pure pigment on the surface of the canvas – and the inherent darkness and pathos of the situation depicted so apparently casually and directly, even callously.

Yet at times, the very circumstantiality, the very insistence on the banality of the surroundings in Realist imagery of death, may confer a certain significance upon it, although a significance very different, of course, from any conveyed by earlier iconography. This may occur simply because the setting contains within itself certain social, political or humanitarian implications – implications which the

37. *Rue Transnonain le 15 Avril, 1834*, 1834. Honoré Daumier

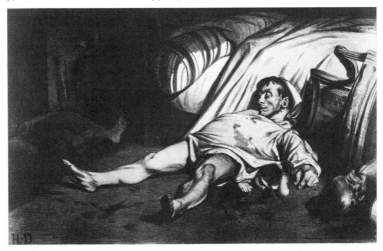

Realist's accurate localization and specificity of detail allow to emerge naturally and all the more potently and clearly for being so unforced. This is certainly the case in Daumier's *Rue Transnonain le 15 Avril, 1834* [37], where we are brought face to face with the immediate results of a socio-political outrage: anonymous, ordinary figures sprawled around in the wreckage of their very commonplace dwelling. How differently such a subject would have been treated only a few decades earlier! For while the Neo-classical imagery of death may have secularized the notions surrounding it, it in no sense trivialized it or deprived it of higher meaning. It simply shifted the emphasis from the rewards of an after-life to the more tangible area of earthly immortality. In the words of Diderot: 'Posterity is for the philosopher what the other world is for the devout.' If, in David's *Dead Marat*, the bare fact of death dominates the work, it is still death transfigured by implications of heroic martyrdom; and the realistically delineated details of packing-case, knife and bathtub, merely reinforce, by providing a physical counterpart to, the moral truth conveyed by the painting. David's *Marat* is indeed a secular, classicized *Pietà*, a revolutionary *Andachtsbild*, without overt reference to a specific time and place, in a generalized setting, where the veristic details lend added universal significance to this martyr of the new religion of reason.

How very far this is from the conception of martyrdom embodied in Daumier's *Rue Transnonain*! Indeed the very term 'martyr', implying an individual who heroically bears witness to and ultimately sacrifices himself for some transcendental ultra-personal cause, is hardly applicable to these anonymous, slaughtered victims of social forces beyond their control. If the *Marat* is an image of the secular hero, then *Rue Transnonain* is an image of the anti-hero. Marat may have been depicted dead in his bathtub with a towel round his head, but the bathtub has implications of a Christian tomb or antique sarcophagus, the towel has been transformed into a halo, the packing case assimilated to a tombstone, whereas the nightgown, the nightcap, the exposed bolster and the overturned chair in the rue Transnonain are simply what they are and nothing more. This is *reportage* – a *fait divers*, but a *fait divers* taken seriously as a concrete instance of a total situation of brutality and injustice, with light the revealer not of the eternal verities but of present-day actualities. It is an immediate social reality that is being depicted here, firmly rooted in the specific appearances of a given place at a given time in history.

This same notion of death as a social reality in the concrete setting of the modern world controls the imagery – admittedly far less poignant – of another depiction of the victims of social and political injustice: Adolph von Menzel's *Public Funeral of the Victims of the*

38. *Public Funeral of the Victims of the March Revolution*, 1848. Adolph von Menzel

March Revolution [38]. Menzel wrote in a letter of April 1848 that he approached his task 'with a beating heart and full of enthusiasm for the ideas for which the victims had fallen', but he nevertheless conceived his subject as a civic actuality and not as an heroic idealization. The painting is really one of a communal solemnity, in a specific place at a specific time, with its contemporary differentiation of social groups and concreteness really the essence of the depiction. Some of the figures may be portraits, but their main pictorial and expressive function is to exist as part of a richly-varied crowd. This civic-communal, anti-heroic and secular aspect of the work is reinforced by the strong reminiscence in its composition of that most famous of all such civic group paintings, Rembrandt's so-called *Night Watch*, which Menzel surely had in mind when painting the crowd of mourners. The setting is as factual as possible – the Berlin of his own day, in the Gendarmenmarkt, with the steps of the theatre cut off on the right and the Deutscher Dom, with its north portico draped in black and the coffins piled up on it, in the background. The crowd itself is composed of a mingling of women, students and middle-class citizens, accurately depicted. The heroic and religious implications of the occasion have been resolutely minimized: its civic and communal meaning has been firmly established as the point of the painting.

A similar rejection of all traditional notions of death – of death as the ultimate meeting of heavenly and earthly reality and the funeral as an occasion for the celebration of their eternal fusion, centred upon an individual human soul – was made by Courbet in his monumental *Burial at Ornans* [39]. He concentrates upon the purely secular import of the burial as an immanent occasion for the social community on earth. Who is being buried is really irrelevant; and so is the fate of the dead man's soul and its relation to the afterlife. Where he is being buried and the nature of the community which participates in this event is what the painting is about – nothing beyond this, but this in all its richness of social and pictorial realism. It is the concreteness, the here and now of the event, that concerns Courbet. In fact he later considered the *Burial* as one of a series of monumental paintings of the customs and events in the rural life of his native Franche-Comté, a series which included the *Toilet of the Bride*, the *Grain Sifters*, the *Return from the Fair* and a projected *Wake*; in other words, as a fulfilment of his declared intention to translate the customs, the ideas and appearance of his epoch in his art. As Proudhon pointed out,

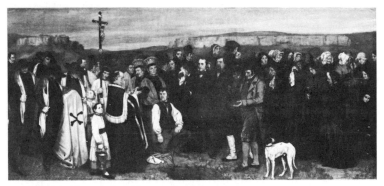

39. *A Burial at Ornans*, 1849. Gustave Courbet

Courbet is not being irreverent in this work. But what he reveres – or rather, what he considers to be real – differs very radically from the conception of previous painters who dealt with this portentous theme.

For El Greco, for example, in his *Burial of Count Orgaz* [40], the actual physical fact of the death of the Count and its earthly celebration – the whole subject in Courbet's gigantic work – merely occupies the lowest rung of an ordered hierarchy of being which ascends from the world of concrete, differentiated human individuals, through that of the disembodied soul, to the diaphanous realm of heaven itself. The

40. *The Burial of Count Orgaz*, 1586–8. El Greco

burial of Count Orgaz was not, for El Greco, the 'real' occurrence and the reception of his soul in heaven a kind of apparition or illusion, as is the case in such nineteenth-century academic–realistic paintings as Bastien-Lepage's *Joan of Arc* [41] where the heavenly 'voices', St Catherine and St Michael, hover like scientifically photographed ecto-plasmic manifestations, double-exposed, above the solidly material,

41. *Joan of Arc*, 1879. J. Bastien-Lepage

minutely naturalistic contemporary farm-girl depicted in the artist's own apple orchard. For El Greco, reality consisted precisely in the inseparable relation between the world of factual burials and that of heavenly apotheoses – a relation which he conceived as a ladder of ascent from earth to heaven and, at the same time, as a kind of im-manent intermingling of the two realms in an atemporal world in which the categories of past, present and future are annihilated. Thus, the *Burial of Count Orgaz* is not a mere representation of an actual event with an illusory apparition juxtaposed to it, but rather the pictorial embodiment of a miracle, a testimony to the actual penetration of the

divine into the realm of the natural, of the ascent of the natural to the supernatural, accepted as real in exactly the same way and to exactly the same extent as was the existence of the aristocratic mourners who bear witness to the event, or the richly-brocaded, minutely-described vestments worn by the saints.

Such a conception of death, and, of course, of reality itself, is completely foreign to the mid nineteenth-century artist. Courbet had, to borrow the words of his friend Proudhon, 'lost the religion of the dead' and certainly had no desire to surround his *Burial at Ornans* with the 'sublime poetry' of Christianity. The representatives of the church – priest, red-nosed beadles and a charming choir-boy or two – are no more poetic, no less prosaic than any of the other participants in the event, who include Courbet's father and sister, the mayor of Ornans and a handsome dog in the foreground. Yet, for Courbet, a man's death was still something more than the death of an animal – though his stag at bay, his dying fox or his unforgettable gasping trout might suggest the opposite. That 'something more' is clearly implied in the *Burial at Ornans* by the horizontal rather than the vertical relationships: it involves not the ascent of man's soul to heaven, but the joining together of men on earth in a specific and localized community, in memory of one of its members recently dead. The importance of the occasion, as implied by the scale and handling of the composition and its relation to those great secular communal celebrations of the past, the Dutch 'company' group portraits (e.g. Bartholomeus Van der Helst's *Captain Bicker's Company* of 1643 upon which Courbet in part based his composition), is not conferred upon it by any transcendant, heroic overtones, nor by any picturesque romantic pathos, but is inherent in the material immediacy of the imagery, in the localization of the costume and setting. In Courbet's history painting of contemporary life, the links in the chain of being are social and factual, going from one homely, black-clad Ornanais to the next, Courbet's friends, family and fellow-townsmen, simply aligned in an additive, horizontal procession across the canvas – an arbitrary segment of what might indeed be an inexhaustible reality, since its boundaries are contingent and not set by any meaning, explicit or implicit – against the grey rock above the graveyard on the outskirts of Ornans. Courbet's painting is thus not an 'irreligious' treatment of a religious subject, but rather an affirmation of quite different values which it established as worthy of large-scale, serious pictorial treatment.

The question of whether it was possible to create religious paintings in the traditional sense at all in the mid nineteenth century, when the very conception of reality upon which such art had been premised had been so radically altered, was an important one for the period.

Could an age in which 'hard-headed people' to use the words of Matthew Arnold, viewed the Bible as a 'set of asserted facts which it is impossible to verify' and hence to be rejected as either imposture or fairy-tale, continue to paint miracles, visions, transfigurations and apotheoses, angels bearing crowns of martyrdom on clouds of light? For Courbet the answer was an unqualified negative. 'I cannot paint an angel because I have never seen one', he frankly declared; and when a young art student brought him a study of the head of Christ, Courbet, having asked him whether he had been personally acquainted with the subject in question, and having received a negative answer, advised him to do 'the portrait of your papa' instead. For Manet, it was possible at least once or twice in his life to paint a religious subject, but only by firmly referring to the art, rather than to the quality of belief, of the past as an essential element, along with a stylistically advanced formal treatment of the subject. Whether or not Manet was a practising Catholic – the orthodox inscription on his *Dead Christ with Angels* [23] may well have been suggested to him by the abbé Hurel, an old family friend and an enlightened cleric, who gave Manet the absolution at his funeral – his painting, intentionally or not, is lacking in the devotional appeal of traditional treatments of this sacred theme. Years earlier, Hegel had predicted that, despite the withering of religion as a central force in life, painters would certainly continue to paint religious pictures. 'But', added the philosopher, 'however nobly and perfectly we may find God the Father, Christ or Mary represented, it is no use: they will not force us to our knees'. It is doubtful that Manet intended to force the spectators of his *Dead Christ* or his *Christ Scourged* to their knees. More likely, in these religious works, as in so many other paintings of the middle sixties, he was, in the words of Alain de Leiris, simply attempting to reconcile the 'iconographic and compositional conventions of the past with an objective portrayal of contemporary facts empirically grasped.'

Manet's admirers specifically praised the non-religious qualities of his treatment of a traditional religious theme: 'They say that the Christ is not a Christ, and I admit that may be the case', declared Zola; 'for me it is a corpse painted in full daylight with freedom and vigour.' George Moore stated: 'His Christ is merely a rather fat model sitting with his back against a wall, and two women with wings on either side of him. There is no attempt to suggest a Divine death or to express the Kingdom of Heaven on the Angels' faces. But the legs of the man are as fine a piece of painting as has ever been accomplished.' For Manet's supporters, the question as to whether this is a successful religious painting or a moving evocation of death is simply dismissed as irrelevant; the real question for them was whether or not it was a

good painting, which his admirers felt sure they could answer in the affirmative. Courbet, by declaring that he could not paint an angel because he had never seen one, flatly denied the possibility of a realist treatment of traditional religious themes at all; he resolves the dilemma of this-worldly fact versus other-worldly fiction by removing one of its terms.

Yet at times an other-worldly fiction may be retained by the Realist, but in the rather novel role of a more efficient cutting-edge against the factitiousness of the experience in which it is involved. For Flaubert, that unparalleled destroyer of poetic myth and comforting illusion, the religious imagery of the past serves as a potent weapon in setting in relief the multiple self-deceptions involved in Emma Bovary's ecstatic 'death' halfway through the novel. Here, the imagery of the traditional visionary experience is used to bring out not only the factitiousness of the 'death' itself (Madame Bovary is not really dying, she only imagines that she is, since that would make her more interesting to herself and to others), but also the falsehood of the religious rituals and delusions accompanying the imaginary death scene, and the complete inauthenticity of the heroine herself, her whole mode of life and, by implication, of all those who, like her, accept second-rate fiction for poor but honest fact. If we consider Flaubert's description of Emma Bovary's pseudo-death-bed scene in detail, we see how resolutely he struggles to afflict us with a sense of life – or, in this case, of death – simply as fact and nothing but fact; how patiently he tears down the traditional edifice of significance stone by stone, using every literary weapon he can, because the inherited world of consoling, traditional meaningfulness stubbornly resists attempts to destroy it.

One day, at the crisis of her illness, believing herself at death's door, she had asked for the sacrament. While they got her room ready, setting out the chest of drawers, with its array of medicine bottles, as an altar, and while Félicité strewed dahlia petals over the floor, Emma felt a powerful influence sweep over her, relieving her of all pain, all perception, all feeling. Her flesh found rest from thought; a new life had begun; it was as if her soul, ascending to God, were about to be swallowed up in His love like burning incense vanishing in smoke. The sheets were sprinkled with holy water, the priest took the white wafer from the sacred pyx, and as she parted her lips to receive the Body of the Saviour, she swooned with a celestial bliss. The curtains swelled softly around the bed like clouds; the beams of the two tapers on the chest of drawers appeared as dazzling aureoles of light. Then she let her head drop back on to the pillow, seeming to hear through space the harps of the seraphs playing, and to see, seated upon a throne of gold in an azure Heaven with His Saints around Him bearing branches of green palm, God the Father, resplendent in majesty, at whose command angels with wings of flame descended to Earth to carry her up in their arms.

Every means is used by Flaubert to bring out the hollowness of Madame Bovary's 'religious' experience. Not just the trappings but the very aura of a Baroque ecstasy or martyrdom – as if by Bernini or Guercino – now become a foil to set off the complete inauthenticity of the heroine's subjective experience (although, one suspects, Madame Bovary's imagination had probably been fired by the third-rate 'azure-bordered religious drawings' of her convent girlhood rather than by any more notable works of art). What more natural than to ask for the sacrament at the approach of death? Yet impending falsehood is already suggested in the next sentence, when it is revealed that not only is a homely domestic article, a chest of drawers, to make do as an altar, but that this makeshift altar is covered, not with appropriate holy objects, but with a utilitarian 'array of medicine bottles' – irony compounding irony. The account of the vision that follows, which would have been given 'straight' in earlier, more believing times, is rendered suspect by such crucial qualifications as 'as if', 'appeared' and 'seeming', which insist precisely on the reality of the commonplace world in which these visionary experiences take place by implying the delusory quality of the visionary experiences themselves. Similes are used to increase this sense of an actuality–delusion dichotomy: the curtains swell 'like' clouds; those customary accompaniments of the Baroque ecstasy, the tapers, 'appear as' dazzling aureoles of light. In the final sentence, the 'dying' woman gives in to her overheated imagination completely and envisions a full-scale Baroque Apotheosis, with herself, needless to say, at the centre of the stage, or canvas, except that this delicious consummation is both denied the heroine and succinctly distanced from the reader by Flaubert's insertion of 'seeming to hear . . . and see'. Far from having been a religious experience, this can readily be diagnosed as a psychophysical one: a classical case of hysteria, in fact, as Baudelaire implied in his review of *Madame Bovary* in 1857. Nothing could better serve to illustrate Ezra Pound's assertion that 'most good prose arises . . . from an instinct of negation; is the detailed and convincing analysis of something detestable: of something one wants to eliminate'.

Far from being considered a reality above and beyond what one might experience in ordinary life, the visionary or ecstatic experience associated with death must be surgically detached from reality by the Realist writer or artist. If, due to special circumstances, such as the demands of funerary memorials, it must be included within the monument, a tactful sculptor might discreetly insert the 'vision' into the context of sculptural Realism itself by transforming it into an 'art work', as did Bartolini in his *Monument to Princess Czartoryski* [42], where the transcendental implications of the presence of the Virgin

42. *Monument to Princess Czartoryski of Warsaw*, 1837–44. Lorenzo Bartolini

and Child above the effigy are completely nullified by isolating them from the corpse on a dark marble wall behind her and transforming them into a *quattrocento tondo* (similar to that in Desiderio da Settignano's Marsuppini monument in the same church) and hence to be construed simply as a material object on the wall – as real in the same literal sense as the naturalistically carved corpse dozing in her convincingly wrinkled nightgown beneath it.

In other cases, the symbolic meaningfulness appropriate to death imagery may be included in the world of everyday actuality by presenting it as a mere coincidence, as in La Thangue's *Man with the Scythe* [43]. Here, within the setting of a contemporary lower-class garden a mother, clutching the vegetables she has been gathering, leans over the chair of her little girl who has just stopped breathing, the very instant of awful realization, while, at the same moment,

43. *The Man with the Scythe*, 1896. H. H. La Thangue

viewed in the background of the picture, an old man comes by, returning from haying with a scythe over his shoulder – a coincidence which presumably made the theme all the more poignant because of its down-to-earth plausibility. In still another late nineteenth-century representation of death, Hubert Herkomer's *Sunday at Chelsea Hospital* [44], it is simply one old man's realization that his companion is dead

44. *Sunday at Chelsea Hospital*, 1875. H. von Herkomer

rather than dozing on the bench next to him that constitutes the entire 'meaning' of the painting: no added references or symbolic accoutrements are deemed necessary or appropriate.

By excluding references to the supernatural or the transcendental from subjects in which they had previously been an essential element, Realist artists had in fact invented a new category of painting, what

might be termed 'religious genre' or even perhaps 'religious sociology' or 'religious anthropology' – that is to say, meticulously objective descriptions of religious customs in the provinces. This was primarily a manifestation of that general interest in the rural, the provincial and the *folklorique* which constituted an important element of the Realist movement itself. Such 'religious genre', with its connotation of rural virtue and simplicity, softened in its early and sometimes in its later stages by an admixture of patronizing sentimentality, can be found as early as the eighteenth century in works like Greuze's *Père de Famille lisant le Bible* of 1755. In the early nineteenth century it was heightened with a liberal dose of Romantic pathos, in such works as A. Roger's *Un Enterrement de village* of 1822, and was finally raised to the level of self-conscious, simplistic rustic grandeur by Millet in his *Angelus* [45]. This development is closely related to such picturesque regional genre painting as that of Flers, who made Normandy famous, of Loubon who specialized in Provence, of Roqueplan who concentrated on the Pyrenees and, above all, of the Leleux brothers who fastened on that most popular and primitive of all picturesque regions, Brittany. Courbet's *Burial* is really the first of these secular paintings of what had

45. *The Angelus*, *c.* 1858-9. J.-F. Millet

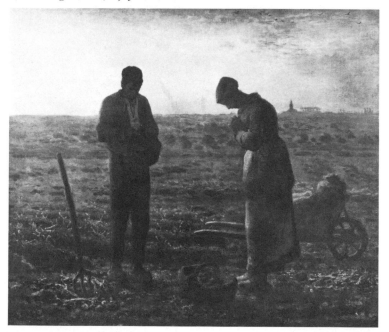

traditionally been considered a religious theme, and it raised this type of regional genre painting to the more serious realm of history painting. In so doing it provided a point of departure for a sociological approach to regional religious subjects. Courbet had, in fact, at one time considered another crypto-religious theme, a franc-comtois *Repas de Funerailles*, the wake of a young girl, which he described in detail: the body of the young girl lying in the centre, with the hubbub of festivities, eating and drinking, going on around the already greenish corpse. 'A very *realist* subject', Courbet proclaimed it. 'I am in the process of doing the underpainting.' No such work by Courbet has ever come to light, but the subject was taken up by one of his disciples, his pupil in the late fifties and early sixties, the Puerto-Rican painter, Francisco Oller, whose *The Wake* represents on a more than twelve-foot-wide canvas the funeral celebration of a new-born girl among the hill-people of Puerto Rico.

In France, such painters as Alphonse Legros and Jules Breton were to specialize in this type of regional religious genre painting. Baudelaire praised Legros's *Angelus* [46] under the heading of 'religious art' in his *Salon* of 1859, but the *Angelus* is not really a work of

46. *The Angelus*, 1859. A. Legros

religious art at all, in any accepted meaning of the term: it neither embodies any doctrines of the church, nor any miraculous or historical events in ecclesiastical history. Nor does it bear witness to the personal faith of the artist. If it recalls 'the burning *naïveté* of the primitives', as Baudelaire remarked of Legros's *Ex-Voto* the following year, it does so inadvertently. For its primitivism was employed solely to express the awkward simplicity of the peasant worshippers and is certainly not symptomatic of a similar simple faith on the part of the artist himself. Indeed, Legros's *Angelus*, *Ex-Voto* and *Le Calvaire* all recall Courbet in their bold and yet detailed brushwork, their craggy, unidealized figure-style and the rather objective attitude, not devoid of sympathy, towards the subject. In the case of the earliest, the *Angelus*, Baudelaire pointed out its Courbet-like characteristics: its 'rustic aspect . . . the little community clothed in corduroy, cotton and home-spun . . . simple people with their sabots and their umbrellas, all bowed by work . . .' and, noting the incorrect perspective and the way the figures seem to be stuck somewhat flatly to the background, he mentioned similar criticisms of Courbet's compositions.

The ambitious, painstakingly detailed *Three Women in Church* [47] by Courbet's German follower, Wilhelm Leibl, which took the artist almost four years of persistent labour, belongs to this same category. No reference is made in this incredibly veristic canvas to the objects of worship at all, but simply to the three worshippers, their costumes and appearance and their fervid concentration; and everything is executed with the same materially obsessive accuracy and the same microscopic detail as the jug or the carved wooden church furniture. They are indeed reminiscent of figures from some Holbeinesque altarpiece, like the *Altarpiece of the Burgomaster Meyer*, except that the religious focus of such earlier works has been resolutely excised from the nineteenth-century Realist painting, leaving only the donor portraits behind.

These and many similar, though slicker and often more sentimental, works by Jules Breton and Dagnan-Bouveret depicting the religious and folk customs of that perennial stronghold of the pious and the primitive, Brittany – notably of the picturesque *'pardons'* – all belong to the same category of religious sociology. And all of them, in their implications and pictorial motivations, are as different from traditional religious painting as is Renan's *Vie de Jésus* from the Gospel according to St John. They betray no direct religious feeling at all but rather, within the context of more or less objective description, a yearning sympathy with the archaic faith of these touchingly simple beings, producing equally touching pictorial records of a dying if exemplary pattern of rural life, expressed in appropriately rustic, and

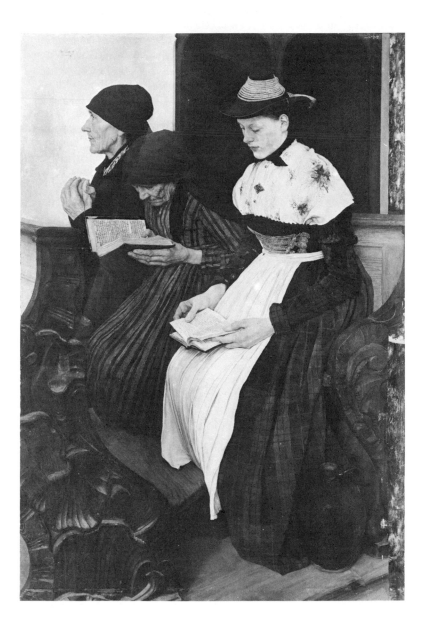

sometimes primitivizing, pictorial language. Significantly, Gauguin, Émile Bernard and their circle were working in Brittany at the same time as Breton and Dagnan-Bouveret. Gauguin too, steeped himself in native lore and made notes of local customs and resorted, even more wholeheartedly, to a 'burning *naïveté*, in order to create a pictorial equivalent for the archaic simplicity of belief characteristic of his Breton peasants. Of course, in works like *The Vision after the Sermon: Jacob Wrestling with the Angel*, Gauguin manages to fuse the visionary experience with the social reality, but within a context radically different from that of the Realists' insistence on truth as fidelity to empirical facts. Nevertheless, one is confronted with much the same sense of the artist distancing himself from the religious experience by assimilating it to the primitive fervour of the pious native participants – a characteristic of Realist religious genre painting and of an age when this sort of traditional piety had already become an historical relic.

Yet if painters like Breton and Legros deprived religion of its supernatural and miraculous qualities, and if Courbet denied death its transcendent implications, then Manet, in his *Funeral* [48] went still further, creating an image of death which is even more radically devoid of traditional significance. Courbet's *Burial* conveyed a sense of communal participation in a meaningful celebration, embodied in

concrete human identities: Manet's sense of the occasion is defined simply by locality and time of year. The place: Paris – probably viewed from the specific vantage point of the foot of the Montagne Sainte-Geneviève in the neighbourhood of the rue Monge, further localized by the cupola of the Observatory and the church of the Val-de-Grâce to the left, the Panthéon, the belfry of Saint-Étienne-du-Mont and the Tower of Clovis, to the right. The time: a gusty day of overcast sky and scudding clouds – probably shortly before the fall of the Second Empire, to judge by the style and the presence of the grenadier of the Imperial Guard in the modest funeral cortège. While the imagery, like Courbet's, is ultimately controlled by an insistence on truth to ordinary perceived fact, Manet, like Courbet, was obviously much more interested in the appearance of the landscape panorama as a whole than in the funeral.

Yet precisely the same comment might be made of Poussin's *Funeral of Phocion* [49], to which Manet's painting offers such a striking contrast and, at the same time, produces such a spectral effect of parody-reminiscence. Indeed, knowing Manet's methods of work in the sixties, one might well suspect that the composition of *Phocion* was in his mind when he began painting his unfinished *Funeral*, substituting observed, contemporary Paris for imaginatively reconstructed

48 *(opposite)*. *The Funeral*, c. 1870. Édouard Manet

49. *The Funeral of Phocion*, 1648. Poussin

Athens and a shabby, shambling nineteenth-century procession for that of the stoical hero of antiquity. Though both paintings are primarily landscapes, they nevertheless convey a coherent and extraordinarily apposite, and hence a different, sense of both the meaning of death and the imaginative order with which art constructs this meaning.

In Poussin's *Funeral of Phocion*, despite the small scale of the figures, the importance of man and his human significance looms large. Poussin's basic aim in a painting like the *Phocion* was to express a human idea through landscape – whether it be, in this particular instance, the didactic–political–moral one of Plutarch and Valerius Maximus, or simply the more general one of an orderly, finite, rationally comprehensible nature in which the specific story of Phocion exists as a single element, is unimportant in this connection. Poussin, without ever renouncing the essential qualities of pictorial vision, has masterfully integrated the notions of heroic death, stoical sacrifice, and an orderly, meaningfully organized universe into a unified visual image: the death of Phocion is the central issue of the canvas, both literally and figuratively, even if it does not dominate the composition. This centrality is convincingly conveyed by the placing of the body of Phocion himself, but this primary focus is reinforced by the antique sarcophagus directly above the body, a sarcophagus which occupies the exact centre of the painting itself. Both natural and human forms act, within their own realms, to reinforce this significance. The large tree at the right bends down to arch protectively over the significant area, though still bending in the manner of observed trees, while the shepherd bends in his human way, towards his flocks above the body of Phocion, leading us towards the still smaller, yet erect human figure behind him, which in turn is directly on axis both with the body of Phocion and the meaningful, stonily upright sarcophagus itself. Latent significance controls the entire painting through the organization of space and time, leading us from the cortège and landscape through the antique Athens which had condemned Phocion to death, then into the distance where we are transported to the metaphorical apotheosis of the dead hero: the erect, isolated tower at the right, in its triumphantly soaring verticality the very redemption of the passive, shapeless horizontality of the dead martyr himself; and then, finally, upward to the sky and the clouds, white, horizontal and relatively formless, like the body of Phocion, and, like Phocion, mutable – but, unlike him, freed from all physical weight and density, free-floating, beyond the bounds of earthly necessity. This complex interrelation of natural, architectural and human orders, existing within a clearly articulated, finite, three-

dimensional space, is all determined by the over-reaching view of the significance of Phocion's death, and of death in general within an ordered and meaningful universe.

It is precisely this over-reaching significance that Manet has cancelled out in his *Funeral*. If a willed meaning controls the pictorial structure in Poussin's work, then an equally determined sense of casual non-significance controls that of Manet, composed as it is of lightly-brushed, discrete entities – formless figures, shapeless clouds, scrubby trees – scattered across the surface of the canvas. Coherence arises from the conjunction of immediate perception and swift notation: at no point in the canvas does one element give pictorial or conceptual reinforcement to another. On the contrary: the dome of the Panthéon falls off axis with the hearse, and the most striking figure, the red-and-blue clad grenadier of the Imperial Guard at the very end of the procession, is on axis with nothing and has no particular reason for being so prominent, apart from the fact that he is there and is wearing a colourful uniform. The space in which the scene takes place is neither finite and measured nor infinite and boundless: it is a contingent space, both extensive and flat at the same time, a result of certain structural conjunctions on the picture surface. It is above all a shallow space, if not a flat one: one cannot progress through it or measure it off, or see it as an ample, coherent stage for the presentation of significant action and meaning, as one could in Poussin's painting. To be so resolute in destroying traditional order – and so successful in doing so – implies a consistent if not a totally conscious viewpoint on the part of the artist. Manet's painting is, of course, not a mere translation of a specific epistemological position, any more than is Poussin's: its overt, direct, conceptual implications are, in any case, minimal; it may simply, on one level, be interpreted as an expression of a more universal contemporary attitude towards death and the relation of man and nature.

Death, traditionally, has been not merely an end but a beginning, the gateway to the afterlife, an existential threshold to the heavenly or hellish consequences of moral choices made by men during their brief but ethically-charged sojourn on earth. It is, of course, both satisfying to one's sense of poetic metaphor, on the one hand, and to the historian's desire for a kind of structural neatness – a conservation of historical energies, as it were – on the other, to consider that the nineteenth century merely secularized the existing imagery of heaven and hell, by simply re-interpreting this time-honoured dichotomy in contemporary terms. Thus Manet's and Monet's picnics and Renoir's *bals*, the brief rural idylls of the lovers in *L'Éducation sentimentale* and *L'Oeuvre*, the harmonious communal beatitude of the Fourierist

phalanstère or the Marxian dream of the ultimate perfection of a socialist state may all be interpreted as new manifestations of the Elysian Fields, of the Garden of Paradise or the City of God, while the telluric imagery of mine and forge and factory, the dark Satanic mills, the horrors of city slums and low drink shops, might well be assimilated to traditional representations of Hell.

Such analogies were made – from Blake's contrast of the dark Satanic mills with the Jerusalem of England's green and pleasant land down to Marx and Engels's juxtaposition of the lot of the English factory hand with the ultimate perfection of the classless paradise on earth. On the level of literary metaphor and pictorial analogy Satan had been explicitly identified with the new powers of industry by Blake in his epic poem *Milton*, while the British Romantic painter, John Martin, had substituted the imagery of mine and industry – gained by first-hand experience during his youth near the Newcastle coalfields – for the traditional iconography of Hell in his illustrations for *Paradise Lost* in 1827. Martin transformed Milton's description of a bridge built by Satan, Sin and Death from earth down to Hell, into a causeway within a tunnel, and he illuminated the Palace of Pandemonium by gaslight – a then novel improvement which he doubtless appropriated to his pictorial vocabulary of Infernal imagery after visiting the fetid interior of the Thames Tunnel, or from some cotton mill, where its introduction had made possible the imposition of unlimited overtime, far into the night. Martin's greatest Romantic painting of apocalyptic vision, *The Great Day of His Wrath*, was created under the inspiration of a journey through the Black Country at night, where the glow of the furnaces, the red blaze of light, together with the liquid fire, 'seemed to his mind truly sublime and and awful', his son later recorded. 'He could not imagine anything more terrible even in the regions of everlasting punishment.'

Conversely, infernal imagery of the past could be, and was, used by nineteenth-century writers and illustrators for their representations and descriptions of their own industrial environment. Dickens's emotion-charged account of Wolverhampton in *The Old Curiosity Shop*, for instance, though rich in objective detail, is hallucinatingly Dantesque:

A long, flat straggling suburb passed, they came by slow degrees upon a cheerless region, where not a blade of grass was seen to grow; where not a bud put forth its promises in the spring; where nothing green could live but on the surface of the stagnant pools, which here and there lay idly sweltering by the black roadside.

... On every side, and for as far as the eye could see into the heavy distance, tall chimneys, crowding on each other, and presenting that endless repetition of the same dull, ugly form, which is the horror of oppressive dreams, poured out their plague of smoke, obscured the light, and made foul the melancholy air. On mounds of ashes by the wayside, sheltered only by a few rough boards, or rotten penthouse roofs, strange engines spun and writhed like tortured creatures; clanking their iron chains, shrieking in their rapid whirl from time to time as though in torment unendurable, and making the ground tremble with their agonies. Dismantled houses here and there appeared, tottering to the earth, propped up by fragments of others that had fallen down, unroofed, windowless, blackened, desolate but yet inhabited. Men, women, children, wan in looks and ragged in attire, tended the engines, fed their tributory fires, begged upon the road, or scowled half-naked from the doorless houses. Then came more of the wrathful monsters, whose like they almost seemed to be in their wildness and untamed air, screeching and turning round and round again; and still, before, behind, and to the right and left, was the same interminable perspective of brick towers, never ceasing in their black vomit, blasting all things living or inanimate, shutting out the fact of day, and closing in on all these horrors with a dense dark cloud.

But night-time in this dreadful spot! – night, when the smoke changed to fire, when every chimney spurted up its flame; and places, that had been dark vaults all day, now shone red-hot, with figures moving to and fro within their blazing jaws, and calling to one another with hoarse cries ...

Many illustrations of contemporary industrial scenes used the same sort of infernal imagery: George Robertson's 'tormented vision' of industrial Coalbrookdale or of the ironworks at Nant-y-glo, for instance, or James Sands's engraving after Thomas Allom of the Lymington Ironworks on the Tyne in 1832, or Francis Nicholson's lithograph of the *Explosion and Fire at Shiffnal*, or Thomas Hornor's *Rolling Mills, Merthyr Tydfil*, to name only a few. One might even go so far as to equate Zola's description, in *L'Assommoir* of the rumbling distilling-machine with the Cauldron of Hell and Gervaise Coupeau's hideous decline and fall into subhuman death in the anonymous waste-land of the slums, as a modern equivalent of damnation to the lowest circle of Inferno. And yet to do so would be to fall into the trap of accepting poetic analogies and Romantic metaphors for the concrete actualities of the situation. Mid nineteenth-century descriptions and depictions of social misery or individual despair were by no means mere up-to-date analogs for the old Last Judgment or Harrowing of Hell, re-clothed in secular form. A deep chasm separates the two world views no matter how apt the old view often was to body forth the new reality. In fact, one might say that the new interest in the

immanent suffering and injustice visited upon a particular social class on earth was posited upon the rejection of a theological scheme of transcendental, eternal rewards and punishments.

The religious view of Hell is essentially an asocial one, innocent, in any conscious sense at least, of class-distinctions. For the sculptors of Autun, the damned are essentially classless as well as clothesless, and their fate the result of their own free choice. Prelates, kings and princes, as well as burghers and peasants turn up amid figures writhing in eternal torment in the vivid frescoes of Traini or Signorelli, and the mighty of the earth are prominent among the Fallen in the tympana of the great French Gothic cathedrals: the kingdom of the damned was in its very essence a classless society. For the great reformers, investigators, novelists and artists of the mid nineteenth century, on the other hand, the question was a very different one indeed. For them, the immanent damnation, the hell-on-earth of slums and factories, mills and mines, of personal degradation and spiritual isolation, had been forced upon the members of a specific class or social group – the working class – not through any particular individual fault or as a judgement (although some factory owners and their apologists might try to make out that this was indeed the case), but simply through their misfortune at having been born members of the lower class and as a result of the greed and indifference of those who controlled the means of production and the institutions of power, or, alternatively, because of the injustice of impersonal social forces which could not be ameliorated by individual moral effort but only by objective understanding and ultimate mass action and revolution. While the poor had always been with us, it was not until the nineteenth century that imaginative attention, liberated from the ultimate vision of demons and pincers, turned to a sordid, everyday reality, visible in any large city or industrial town, which made the worst visions of Bosch or Breughel seem like mere fairy-tales in comparison. At the same time attention was turned to the collection of statistical, objective information about the lot of the poor, as well as to equally precise and objective accounts of their earthly fate in literature and art. Such works as the famous *Report on the Sanitary Condition of the Labouring Population of Great Britain* (1842), Buret's *De La Misère des classes laborieuses en Angleterre et en France* (1840), Engels's *The Condition of the Working Class in England* (1844), Mayhew's *London Labour and the London Poor* (1851–62), Audiganne's *Populations ouvrières* (1854) or l'Abbé Mullois's *La Charité et la Misère à Paris* (1854–7), novels like Dickens's *Hard Times* or Zola's *L'Assommoir* or *Germinal*, pictures like Doré's illustrations of London [50], Daumier's laundresses [51] or uprooted

50. *Houndsditch*, 1872. Gustave Doré

strolling players or refugees, Fildes's *Casual Ward* [89] or, less directly, Degas's sordid denizens of the world of low cafés [132] or Millet's toil-worn peasants [21], were all both symptoms and emblems of the prevailing secularization of vision and imagery of the period, sweeping away the entire age-old foundation of transcendental reality, in which death was the very pivot between ethics and eternity.

In this way, the representation of death as the factual experience of dying, within a concrete social situation, has as its corollary the con-

51. *The Burden, c.* 1855. Honoré Daumier

ception of Hell as the undeserved but actual lot of the vast majority
of mankind, here and now, on earth – Hell as a function of the
modern social system. Traditional imagery and structures of belief
no longer had the force to sustain their old power over imagination
or action. When one of Mayhew's London poor, a fourteen-year-old
boy, admits, upon questioning that while he had 'sartenly . . . heer'd
of God who made the world', but 'couldn't exactly recollec' when
he'd heer'd on him', that he 'knew there was a book called the Bible'

but didn't know what it was about and 'didn't mind to know', had never been in a church, but 'had heer'd they worshipped God there; didn't know how it was done', then one is hardly surprised to discover that he 'didn't know what happened to people after death, only that they was buried. Had seen a dead body laid out; was a little afeared at first; poor Dick looked so different, and when you touched his face, he was so cold! oh, so cold! Had heer'd on another world; wouldn't mind if he was there hisself, if he could do better, for things was often queer here . . .' Such confinement to the factual here and now is both an exaggerated product of and an expression of the withering of the forces of religion on the minds of men, which, on a vastly higher level, found its prophetic utterance in Ludwig Feuerbach's battle-cry of the new secularism and his impassioned plea for the substitution of the image of man, in his social context, for the image of God as the guiding light of Western civilization:

It is a question today, you say, no longer of the existence or non-existence of God, but of the existence or non-existence of man; not whether God is a creature whose nature is the same as ours, but whether we human beings are to be equal among ourselves; not whether and how we can partake of the body of the Lord by eating bread, but whether we have enough bread for our own bodies; not whether we render unto God what is God's and unto Caesar what is Caesar's, but whether we finally render unto man what is man's; not whether we are Christians or heathens, theists or atheists, but whether we are or can become men, healthy in soul and body, free, active and full of vitality. *Concedo*, gentlemen! That is what I want, too. He who says no more of me than that I am an atheist, says and knows nothing of me. The question as to the existence or non-existence of God, the opposition between theism and atheism, belongs to the sixteenth and seventeenth centuries, but not to the nineteenth. I deny God. But that means for me that I deny the negation of man. In place of the illusory, fantastic, heavenly position of man which in actual life necessarily leads to the degradation of man, I substitute the tangible, actual, and consequently also the political and social position of mankind. The question concerning the existence or non-existence of God is for me nothing but the question concerning the existence or non-existence of man.

3

'Il faut être de son temps' :
Realism and
the Demand for Contemporaneity

The demand for contemporaneity was one of the central issues, if not
the very crux, of nineteenth-century Realism. One of the few authen-
ticated pronouncements of Daumier, reiterated by the young Manet,
'il faut être de son temps' became the rallying cry of the militant Realist
movement centering around Courbet, an underlying assumption of
the innovating current around Manet and the Batignolles group in the
sixties and seventies, a challenge to some of the Pre-Raphaelites, and
to various supporters of the Realist cause in Germany, Italy, the
United States and elsewhere, as well as the basis of approach of such
advanced novelists as the Goncourts, Zola, Flaubert and De Mau-
passant in France itself.

The admonition that the artist 'be of his time' was not, of course, an
invention of the Realists. Anticipations of this position can be found
as early as the seventeenth century when, in the *Querelle des anciens et
des modernes*, the French writer Charles Perrault dared to suggest that
the century of Louis le Grand might be not only equal but actually
superior, in its literary, philosophical and artistic achievements, to the
century of Augustus. In the field of the fine arts, Perrault – a *littérateur*
celebrated mainly as the author of Mother Goose – maintained not
only that the art of the moderns was superior to that of Zeuxis,
Timanthes or Apelles, but that seventeenth-century painting, in its
more sophisticated handling of light and colour, had progressed even
beyond the achievements of Raphael, Titian or the other giants of the
preceding century. The same progressivist, or at least anti-*ancien* view
was implied by Roger de Piles's praise of Rembrandt, his championing
of truth to nature over servile obedience to antiquity, and generally
formed the substance of the French *Modernes'* position which ulti-
mately triumphed, putting into question the validity of permanent,
universal standards in much the same way that the Cartesian method
had given rise to scepticism about time-honoured philosophical

beliefs. The value of contemporaneity, though never stated in so many words, underlay the artistic judgements of Diderot, in his mid eighteenth-century *Salons*, where, despite his ostensible demands for elevation of subject and emotional tone, the philosopher-critic exhibited a marked preference for the works of Chardin and Greuze who dealt almost exclusively with contemporary, and not very elevated, subjects.

Yet it was not until the advent of the Romantic theorists of the early nineteenth century that being of one's time was viewed not merely as a possible good but as a positive advantage, and, putting it even more strongly, some Romantics affirmed that *not* being of one's time automatically guaranteed literary or artistic failure. In the words of the spokesman of the French Romantics, Emile Deschamps, it was the duty of writers to be of their own time *avant tout et en tout*. For Romantics, 'being of one's time' implied a broad spectrum of far-from-consistent values – revolt against established rules, conscious departure from 'correctness', a return to common speech and ordinary language, direct contact with nature, or, more broadly, simply an insistence on not repeating that which had already been done, not approving that which had already won approval, a relativist position which, as George Boas has pointed out, found its ultimate ideological sanction in the periodicity of history itself, as affirmed in Michelet's translation of Vico's *Scienza Nuova* in 1827, Comte's law of the three historical stages of intellectual evolution, and its definitive literary expression in Deschamps's *Préface des études françaises et étrangères* of 1828. Echoes of the Romantic demand for contemporaneity in the arts can be found throughout Europe during the first third of the century, in a wide variety of formulations: Shelley, despite the Platonic vision central to the argument of his *Defence of Poetry* (1821) nevertheless, as René Wellek points out, insisted upon his own contemporaneity and glorified his own age; Hazlitt maintained that 'the poet can do no more than stamp the mind of his age upon his works'; Stendhal, in his famous *Racine et Shakespeare*, maintained, half seriously, that Romanticism was simply that which was modern and contemporaneous, thereby destroying any stylistic validity for the term 'Romantic' by being forced to admit that even Racine and Dante were romantic in their day; Delacroix, while never supporting the notion of contemporaneity *per se* did, however, imply the possibility of it in his relativistic view of beauty: 'The Beautiful is everywhere ... and each man not only sees it, but absolutely must render it in his own way.'

Thus *'il faut être de son temps'* was essentially a Romantic rather than a Realist formulation. Yet the demand for the most part remained a

mere demand in Romantic critical theory and a vague aspiration or half-conscious articulation in the Romantic movement, assuming a meaning at once narrower and more concrete in Realist theory and practice and excluding, for the strict Realist, the exoticism, historicism, insistence on the supremacy of the imagination and acceptance of the irrational, which had constituted the basis of much Romantic literary and artistic practice.

Yet even for the Realists, to demand that the artist or writer be of his time is not to say how or in what ways he is to achieve his goal: the very concept of contemporaneity is a complex one. On the one hand, one might, as the great mid nineteenth-century historian, Hippolyte Taine, implied, be perfectly justified in saying that the admonition to be of one's times was unnecessary, since artists and writers, whether they would or not, were inevitably condemned to being contemporary, unable to escape those dominating determinants which Taine had divided into milieu, race and moment. Thus the works of such strivers after eternal verity as Ingres, Bouguereau or Baudry seem inevitably nineteenth century, far more attached to the era of the photograph and the Can-Can than to the realm of eternal Platonic beauty or to the aesthetic values of the High Renaissance. In this sense, it is much more difficult for an artist to escape from his own times than to be of them, as many a forger, or honest restorer, has found to his grief. On the other hand, it is apparent that the statement 'one must be of one's times' is much more than a mere truism phrased as an imperative – in other words, the artist has some choice in the matter. In the nineteenth century, the multiplicity of conscious attempts to be of one's time, to embody the ideals, aspirations, attitudes or events of the age in an appropriate artistic or literary form, bear witness both to the idiosyncratic self-consciousness of the age about its own particular qualities and needs *qua* historical epoch, and to the lack of unanimity on the part of artists and writers as to what constituted either an adequate understanding of these particular historical qualities or the modalities of expressing them.

Generally speaking, there are three ways of being contemporary open to artists and writers. In the first place, one may attempt to express the ideals, achievements and aspirations of one's own times in the symbolic or allegorical rhetoric of traditional art or literature. In the second place, one might insist that contemporaneity implied an actual confrontation with and serious, unidealized embodiment of, the concrete experiences, events, customs and appearances characteristic of one's own epoch, whether this be with a spirit of moral urgency or of phenomenological indifference to the social and human values involved. Finally, one can conceive of being artistically of one's times

as actually implying being in advance of them, an outlook which has conditioned the hermetic conception of contemporaneity prevailing within our *avant-gardes* at least since the beginning of this century.

Now it is obvious that the mere treatment of a contemporary theme or problem in and of itself hardly constitutes 'being of one's time' in the Realist sense of the term. The Republican Couture's *Romans of the Decadence* [52], for example, was intended as a monumental metaphor

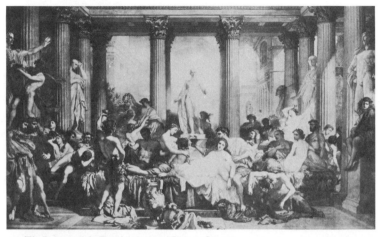

52. *The Romans of the Decadence*, 1847. Thomas Couture

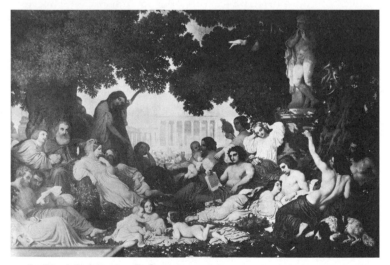

53. *Le Rêve de Bonheur*, 1843. D. Papety

for the vices of contemporary society and indeed contains overt references to the failure of Louis Philippe's régime; Papety's *Rêve de Bonheur* [53] is replete with the timely message of Fourierist felicity; Carpeaux's *Holy Alliance of the People* [54] embodies the ideals of the 1848 Revolution; Daumier's allegorical figure of The Republic was submitted to that government's contest for a suitable image of its aspirations; and Paul Chenavard's vast scheme of decoration for the

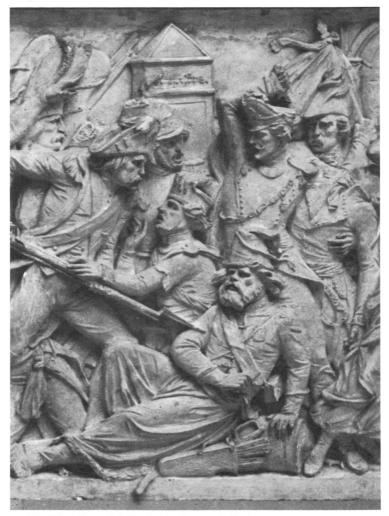

54. *The Holy Alliance of the People*, (detail) 1849. J.-B. Carpeaux

Panthéon is a pictorial compendium of the latest social and meta-physical outlooks. Yet none of these works meets the demand for contemporaneity as it was understood by the Realists.

Being 'advanced' or 'of one's times' in ideas or politics by no means implied a similarly progressive outlook when it came to picture-making. So the actual reality of the 1848 Revolution is better

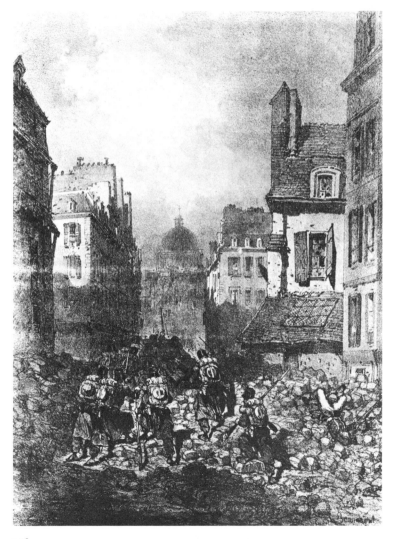

preserved for us in the unassuming illustrations of action on the barricades produced by an anonymous lithographer [55], or in an occasional unpretentious painting like that of Meissonier [56] or those of Champin, than in the grandiose symbolic embodiments of revolutionary afflatus provided by high art. As Manet later observed: 'it is odd how republicans become reactionaries when they talk about art.'

55 (opposite). *Storming a Barricade, Rue Perdue*, 1848. Anonymous

56. *The Barricade, rue de la Mortellerie (June 1848)*, 1848. E. Meissonier

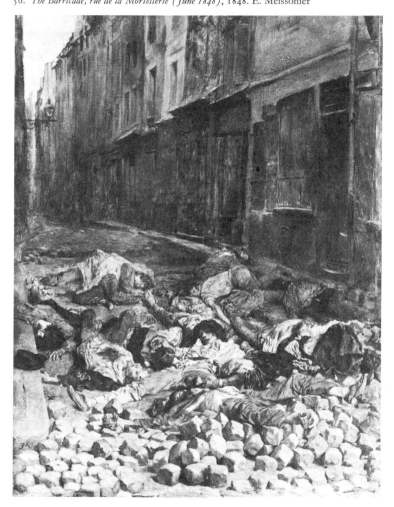

The same failure to grasp contemporary actuality characterizes most of the attempts to commemorate the industrial and scientific achievements that were the crowning distinction of the nineteenth century. Pietro Magni's *Monument to Commemorate the Cutting of the Suez Canal* [57] provides no clue to the technical feats involved in this great enterprise but, instead, clothes the subject in symbolic garb, displaying Commercial Enterprise as Hermes and forcing classical

57. *Monument to Commemorate the Cutting of the Suez Canal*, 1858-63. Pietro Magni

nymphs and deities to bear the unaccustomed and uncomfortable weight of the message of modern progress. Lord Leighton's monumental fresco of *Industrial Art as Applied to Peace* of 1873-86, reveals as little as Magni's monument about the specific nature of industrial progress, nor is there anything particularly contemporary about its artistic language, any more than there is in a literary work of would-be modernity like Maxim du Camp's *Les Chants modernes* of 1855. Here, despite a stirring preface praising the splendours of modern science and industry and exhorting poets to seek inspiration in these unprecedented wonders, Du Camp falls into all the old rhetorical clichés in the verse itself. Both Steam and the Locomotive apostrophize the reader in the first person, and the imagery is drawn almost entirely from classical antiquity.

It is clear, then, that for the Realists, the second mode of contemporaneity – that is to say, confronting the concrete experiences and appearances of their own times with an earnest and serious attitude and a fresh, appropriate imagery – was the only valid approach to creating an art of and for their own epoch. They therefore rejected both the pompous rhetoric and the grandiose subjects of the past, neither of which, they felt, had any relevance to modern life, and turned to such novel or hitherto neglected areas of modern experience as the lot of the labouring poor, both rural and urban, the daily life of the middle classes, modern woman and especially the fallen woman, the railroad and industry, and the modern city itself, with its cafés, its theatres, its workers and strollers, its parks and boulevards, and the life that was led in them. Of all these themes of contemporary life, none was felt to be so much the very epitome of modern experience, or was treated with such concreteness and urgency by mid century artists, not only in France but in England and throughout the Continent, as the theme of labour.

HAIL THE HERO WORKER

The working peasant had of course appeared in art, albeit in a subordinate position ever since the Middle Ages, adorning cathedrals in the works of the months, gracing the calendar pages of manuscripts and even being permitted, occasionally, to adore the Christ Child. In the sixteenth and seventeenth centuries, he had been raised to the level of a major theme in the work of such atypical artists as Breughel or the Le Nains. In the nineteenth century, the artistic status of the working classes in France had been somewhat advanced in the 1830s by George Sand, with her Berrichon novels and her stable of worker-poets, and, in the 1840s, by popular *chansonniers* like Pierre Dupont who dedicated

songs to the locomotive driver, the weaver and the peasants, as well as celebrating the trials and tribulations of the proletariat in '*Le Chant des Ouvriers*'. And as we have already seen, painters of picturesque genre, specializing in the various local customs of the French provinces – painters such as Flers, Roqueplan and the Leleux brothers – had celebrated the quaint mores of the regions of France. Yet it was not until the 1848 Revolution which raised the dignity of labour to official status and the grandeur of *le peuple* to an article of faith, that artists turned to a serious and consistent confrontation of the life of the poor and humble: to the depiction of work and its concrete setting as a major subject for art – as a possible subject even for an artistic masterpiece on a monumental scale.

For the 1848 Revolution had raised the issue of labour as a *major* issue for the first time. The right to work became a crucial question. The working man played a prominent role in the revolutionary festivals of the new régime, the popular revolutionary form of address becoming 'labourer' rather than 'citizen'. Thus for the French Realists of the fifties the artistic implications of the 1848 Revolution lay not in the creation of allegories based upon its ideals, but rather in turning to a more humane, authentic and popular subject matter, in extolling unvarnished nature and the dignity of the men and women who laboured within it. It is Courbet's *Stone-breakers* [58] or Millet's *Winnower* that are the real fulfillment of the ideals of 1848, rather than

58. *The Stone-breakers*, 1849. Gustave Courbet

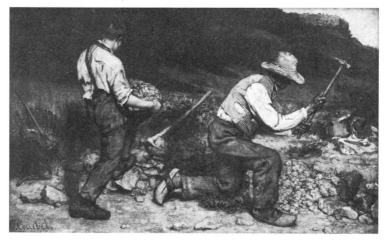

the grandiose frescoes of Chenavard, though it is significant that even so aesthetically conservative an artist as Couture now recommended workmen as a suitable subject for contemporary painters. In the words of the popular painter of peasant life, Jules Breton:

The causes and consequences of that revolution . . . had a strong influence on our spirits. . . . There was a great upsurge of new efforts. We studied what Gambetta was later to call the new social stratum and the natural setting which surrounded it. We studied the streets and the fields more deeply; we associated ourselves with the passions and feelings of the humble, and art was to do them the honour formerly reserved exclusively for the gods and for the mighty.

For those who sympathized with that enlargement of the '*sillon populaire*' consequent upon the 1848 Revolution, the dignified and accurate treatment of proletarian life was indeed a contemporary, compellingly timely theme. But what is crucial in the work of Courbet, Millet and their emulators, is that by painting peasants *au sérieux*, without any idealization, on the scale and with the earnestness and seriousness formerly reserved for history painting, they were making an assertion of value that at once assumed contemporary relevance, in the context of mid century social history – whether or not the artist intended to raise a social issue. After the 1848 Revolution, the worker becomes the dominant image in Realist art, partaking of both the grandeur of myth and the concreteness of reality.

It may seem odd, or even paradoxical, that the demands for contemporaneity in art and literature in the years around the middle of the nineteenth century were answered by artists who themselves so frequently chose to escape from the harsh realities of urban industrialism to the peace and eternal verities of the countryside, or that the time-honoured labour of the peasant should be more frequently treated than the mechanical activities of the factory hand. Yet, once again, the truth of the situation lies somewhere between Realist myth and social reality. It is important to remember that the contemporary reality of France – its social reality, that is – was primarily a rural one in the middle of the nineteenth century. Two thirds of the population was still rural as late as 1871: the vast majority of the poor and of the labouring force itself was still peasant rather than urban proletariat; rural home industry – that is to say, the labour of artisans such as knife-grinders, shoe-makers, blacksmiths, tinkers [59] – accounted for three quarters of the non-agricultural working force, factory labour but a quarter. Indeed the very distinction between peasant and urban proletariat was still not entirely clear-cut. There were a great many part-time factory workers who toiled on the land for part of the

59. *The Tinker*, n.d. A. Legros

year and worked in industry for the remainder, while factories them-
selves were usually small, by modern standards, often nothing more
than expanded craft workshops, and were still scattered in rural areas,
rather than concentrated in urban centres. Thus, while Werner
Hofmann may label as anachronistic the fact that 'from Courbet right
up to Van Gogh the picture of the worker as a human type was condi-
tioned by the earnest mood and simplicity of what was essentially an
agricultural or peasant background', the nineteenth-century worker
was in reality, at any rate in France, still apt to be either a country
dweller or, if a member of the urban proletariat, one who had only
recently arrived from the country. Nor was the distinction between
rural and urban labour absolutely clear-cut in the imagery of art and
literature: '*le peuple*', the present-day working class, could be embodied
equally well in the figure of Daumier's urban press-man or in that of
Millet's rural sheep-shearer, and some writers and artists, like Jeanron,

Champfleury, Zola or Courbet himself, could shift without any sense of contradiction from one milieu to the other in their depictions of modern life.

Yet, on the other hand, the choice of the image of the peasant to embody contemporary labour was also a function of Realist myth. For while it is true that the peasant still accounted for the largest proportion of the working force in Europe, nevertheless, he and his life, his habits and customs, were already beginning to be recognized as part of a vanishing reality. It is noteworthy that collectors of popular art and literature like Buchon and Champfleury, felt some urgency about amassing their material, and that the French government itself encouraged school teachers throughout France to note down local folk songs. The elaborate wedding rituals described by George Sand in *La Mare au Diable* or alluded to by Courbet in his *Toilet of the Bride* were already beginning to die out when their respective authors recorded them.

The image of the toiler on the land as the very embodiment of that near-metaphysical entity 'le peuple', that prototypical figure of *quarante-huitard* virtue, a figure of unchanging, unassailable value in the midst of an all-too-swiftly changing industrial, urban and commercial world, had evolved slowly and gradually. The mythic image of the toiling peasant or farmer had been propagated since the very beginning of the Industrial Revolution, in the writings of Rousseau, of Thomas Jefferson, later in those of Kropotkin, of the Barbizon artists, of Ruskin and Morris in England, and of Michelet in France in the years preceding the 1848 Revolution. 'The peasant is not only the most numerous part of the nation, he is the strongest, the healthiest, and, carefully weighing both the physical and the moral factors, the best as a totality', declared Michelet in *Le Peuple* first published in 1846. Michelet pointed out that the peasant seemed to be made of the very soil he coveted and cultivated so arduously – an image, incidentally, later used by Gautier to praise Millet's *Sower* [60], which seemed to the critic to be 'painted with the very earth that the sower is planting', and which was later taken up by Van Gogh to describe his *Potato Eaters* to his brother, to stress the connection between his peasants and their labour in the soil. And the peasant's primitive attachment to his land served later as the theme of that brutal, and at times, horrifying novel of contemporary rural life, Zola's *La Terre* (1887), where the grasping bestiality and narrow but ferocious emotional range of the peasantry are graphically depicted. But in general the relation of the peasant to the soil provided Realist art with a positive and sympathetic, if not an idyllic, image of rural life.

60. *The Sower*, 1850. J.-F. Millet

While attitudes towards rural labour might range from simpering sentimentality to no-nonsense objectivity, a sense of its contemporary importance is attested to by the sheer outpouring of paintings of the working peasant in the midst of, about to embark upon, or resting from, his habitual toil. Such peasant painters as Jules Breton [61], Jules Bastien-Lepage or Léon l'Hermitte and François Millet – despite Millet's veristic depictions of rocky soil and unlovely physiognomies – endowed the farm labourer with a pathos and nobility beyond sheer descriptive actuality. But it was the leader of the self-

61. *The Return of the Gleaners*, 1859. Jules Breton

styled Realist movement, Gustave Courbet, who provided the most graphically direct and startlingly unvarnished image of contemporary work of the entire century or, indeed, in the entire history of art, in his *Stone-breakers* [58].

Courbet's strict interpretation of Realism and the startling concreteness and contemporaneity of his image of rural labour is apparent if one compares the *Stone-breakers* with a Millet work-scene. Both artists were obviously concerned to create a valid image of hard times in the country, yet if one compares Courbet's painting with a similar theme by Millet, for instance the *Gleaners* [62], it immediately becomes apparent why Millet's work was much more widely and quickly accepted than Courbet's. Millet's composition implies something beyond the fact of specific nineteenth-century peasants performing a routine task – an extremely low one even by farm-labour standards – and conveys a comforting suggestion of the timeless, quasi-religious validity and moral beauty of labour in general. These implications and

62. *The Gleaners*, 1857. J.-F. Millet

63 *(opposite)*. *The Stone-breaker*, 1857. Henry Wallis

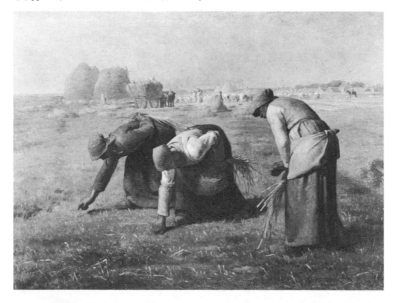

suggestions are conveyed by the formal configuration of the painting: the grandeur of the panorama which stretches out in the background, the reiteration of the bent forms of the three women – themselves emblems of human effort and backbreaking labour – the hazy indications of productive human activity near the horizon – all these carry the spectator beyond the realm of immediate experience to that of transcendent value. The figures themselves are idealized, generalized, and, in comparison to Courbet's, traditional in their poses, articulation and dress. It is obvious that Millet had steeped himself in Virgil and the Bible: there are intimations, in the *Gleaners*, of classical antiquity as well as suggestions of Ruth and Naomi in the fields of Boas.

Courbet's *Stone-breakers*, on the other hand, despite its monumental scale, implies nothing, in formal terms, beyond the mere fact of the physical existence of the two workers and their existence as painted elements on the canvas. There are no reassuring reiterations of meaning in the richly-detailed landscape, which, because of its very substantiality and its lack of aerial perspective, seems to rise up ponderously behind the figures rather than fade away poetically into some infinite distance behind them. No consoling analogies are proposed by the nature of their work for stone-breaking has always been

the lot of the lowest in society, from the time of the Pharaohs or the *corvée* down to that of the penal colony or the Southern chain-gang – an activity impervious to redemption by references to the nobility of labour or the cycle of the seasons. The stone-breaker was the very epitome of gratuitous, meaningless labour, the bottom of the manual heap. One can scarcely think of a traditional representation of this human zero. Courbet has simply depicted two members of the local franc-comtois sub-proletariat whom he encountered on the road one day. This sense of the concrete matter-of-fact contemporaneity of each of the figures is increased by their stiffness, awkwardness and lack of articulation, which has to do with Courbet's meticulous notation of the specific details of their dress, and, at the same time, with the artist's rejection of traditional ways of generalizing and idealizing the human body. Just as his compositions are not organized according to traditional principles, so Courbet's figures (often pilloried by contemporary caricaturists as stuffed dolls, scarecrows or toys on wheels), are not articulated according to conventional precepts. Unlike Millet's, they lack the time-honoured poses, the generalized contours, the suave transitions from part to part of traditional figure styles. It is no longer a question, in Courbet's *Stone-breakers*, of figures expressing

some idea or emotion about manual labour, but of figures which are themselves formal equivalents of certain qualities inherent in manual labourers: awkwardness, stiffness, taciturnity, for example. Much the same can be sensed in the early, realist style of Van Gogh, who, though more directly influenced by the humanitarian impulse of Millet, exhibits a like concern to embody the pathos and hardship of manual labour in what Meyer Schapiro termed an earnest, crude, effortful drawing style.

The stone-breaker became a popular subject for artists concerned to create an image of the rural toiler, but none is quite so stark or so down-to-earth in simply confronting us with the detailed facts of the situation as is Courbet's. Millet's *Quarryman* of c. 1847–9 verges on the romantic–heroic; Wallis's *Stone-breaker* [63] is subtitled 'thou wert our Conscript', embellished with a rhetorical tag from Carlyle, and is as poetically beautiful in colour as it is pathetically socially-conscious in its implications, for the stone-breaker has dropped dead on the job; John Brett's painting of 1858, apart from being brighter and more ingratiating in colour than Courbet's and much smaller in scale, is considerably lightened by the youthful charm of the stone-breaker himself, as pretty and almost as delicate as the flowers in the serenely

64. *The Man with the Hoe*, 1859–62. J.-F. Millet

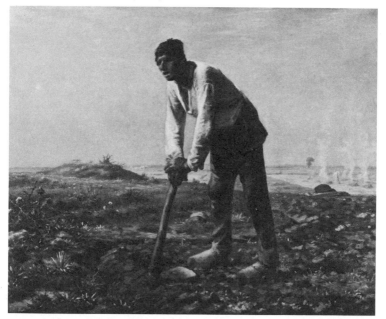

limpid landscape around him; Landseer's version includes the stone-breaker's daughter – not to mention a break for lunch. It is really only Courbet who faces the issue squarely and presents it squarely, who calls a stone-breaker a stone-breaker. He was, in fact, criticized at the time for making his stone-breakers no more important than his stones.

Yet despite Courbet's more stringently Realist conception of his theme, his *Stone-breakers* can be seen as the basis of a whole movement which encompassed Europe from the middle of the nineteenth century on, attempting to create a dignified, accurate, serious and sympathetic image of rural labour. In Germany artists such as Leibl and Thoma depicted scenes of rural life; in Austria the rural milieu was depicted by Ferdinand Waldmüller or by Michael Neder in unpretentious works like *Sunday in the Country* (1851). Albert Anker in Switzerland and Jan Stobbaerts in Belgium, as well as Banti, Filippo Palizzi and many members of the Italian Macchiaioli Group concerned themselves with the working life and relaxation of peasants and the rural petty bourgeoisie in authentic landscape settings.

Van Gogh, in his early Neunen works, Gauguin at Pont Aven and Le Poldu, formed part of this whole current of sensibility, participating in the same quest for contemporary authenticity in the simple, hum-

65. *Proximus Tuus*, 1880. Achille d'Orsi

drum life of the rural poor and humble. Van Gogh's later flight to Arles and Gauguin's to Tahiti really constitute attempts to pursue the dream of an untouched, natural paradise, even after it had ceased to exist as a local reality in France.

Both Millet in his *Man with the Hoe* [64] and the Italian, d'Orsi, in his *Proximus tuus* [65] created a memorable type of contemporary hero, envisioning the rural labourer as being both brutalized and yet ennobled by virtue of sheer endurance; the terrible consequences of the Irish famine were depicted by Watts in his monumental eponymous painting of 1849-50 and by Walter Deverell in his *Irish Beggars* [66]; while Herkomer created an equally graphic and socially-conscious image of urban working-class deprivation in his *Hard Times* and his monumental *On Strike* [67].

At the same time, the traditional classical and Christian theme of charity – which had already been transformed and renovated by being given political relevance in the eighteenth and early nineteenth century – was now re-interpreted in a more concrete and class-conscious vein appropriate to current social preoccupations. Courbet's

66. *The Irish Beggars, c.* 1850. W. H. Deverell

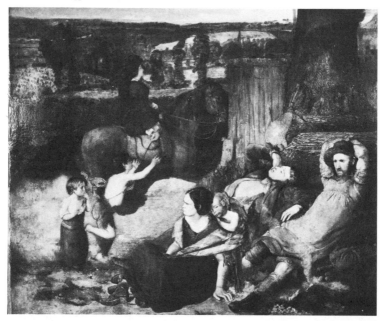

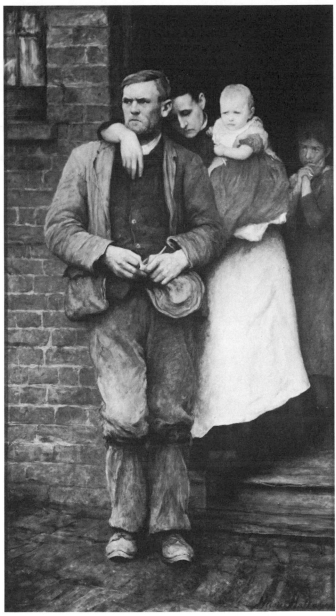

67. *On Strike*, 1891.
H. von Herkomer

large-scale landscape with figures, *The Village Maidens Giving Alms to a Guardian of Cattle* [68] which created such a scandal in the 1852 Salon, is actually an extremely forthright, unsentimental, contemporary rendering of the age-old charity theme, with Courbet's three sisters, Zöe, Juliette and Zélie, playing Ladies Bountiful on an upland pasture near their native Ornans. Critics at the time would seem to have objected most strongly to the rather obvious discrepancies in scale and perspective (the results of Courbet's transformation of the whole scene into a close-up view) and to the supposed ugliness and awkwardness of the village girls. Yet behind these and other quite justifiable and rational criticisms of the structural logic of the vast canvas, and behind the rather monotonous stream of venom directed against the charmless features of the Courbet sisters, lurks another issue, a contemporary and social one. For *The Village Maidens* was not merely another harmless representation of colourfully costumed natives in their natural habitat, such as William Dyce's miniature *Welsh Landscape with Two Women Knitting* of 1860, but, in the eyes of all right-thinking Salon visitors in 1852 (the year following Louis Napoleon's *coup d'état*), an unvarnished, enormous and most unwelcome reminder of class distinctions in the provinces – a reminder that all was not smiling peasantry and reassuring folklore in Franche-Comté, but that there too, the petty bourgeoisie was setting itself apart from the, now threatening, proletariat – and furthermore, with the artist's own sisters, clad in contemporary bonnets and dresses, rather than regional folk costume, playing the role of moneyed beneficence. Courbet's sisters might not be particularly fashionable or elegant, but they could not be dismissed or distanced in terms of quaintness or exoticism by the bourgeois Salon visitor of 1852. In a sense, this representation of provincial young ladies aiding the worthy poor held up a mirror to their middle-class, newly-arrived urban counterparts in Paris, and the reflection was not a flattering one. In short, while peasants might have been permissible, on a small scale, the petty bourgeoisie was not considered an appropriate subject for a monumental work of art.

Courbet had not been alone in choosing the theme of alms-giving in the 1852 Salon. His friend and early mentor, Bonvin, showed a small canvas entitled *La Charité*, representing a sister of charity at the door of a church, giving alms to a group of poor women and children, and Pils exhibited a *Soldier Distributing Bread to the Needy*. So it was certainly not the subject of alms-giving *per se*, but rather who was giving the alms, the grandeur of scale, the insistence on the unprepossessing contemporaneity of the costume, and the total lack of any customary rhetoric, sentimentality or anecdote, as well as the visual

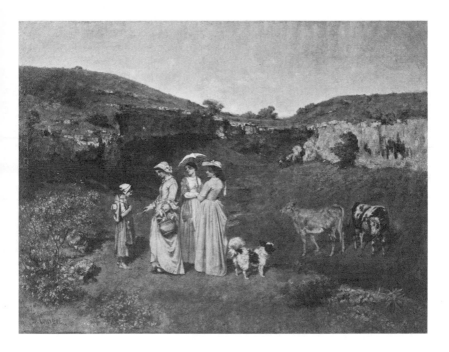

68. *The Village Maidens*, 1852. Gustave Courbet

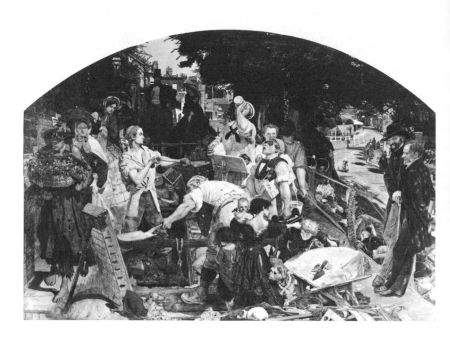

69. *Work*, 1852-65, F. Madox Brown

immediacy of the setting, which marked Courbet's painting off from its counterparts.

An interesting subvariant of the charity theme, particularly apposite to the mid nineteenth century in its insistence on the active, rather than the merely receptive, role of the lower classes, is that of charity offered by the poor to the poor – a variant which seems to have made its first appearance in the *quarante-huitard* Jeanron's *La Charité du peuple ou les forgerons de la Corrèze* of 1836. In this painting the generosity of the proletariat is substituted for the patronizing largesse of their betters in a work which, according to Thoré, was novel both in form and in content: representing two blacksmiths offering some bread to a needy woman. The Scottish painter Thomas Faed's *The Poor, the Poor Man's Friend* of 1867, in which a blind beggar appeals to a modest fisherman's family for alms, is a pictorial illustration of the opinion recorded later by Charles Booth: 'It is only the poor that really give. . . . They know exactly the wants of one another and give when needed.' Courbet himself, in his *Beggar's Alms* of 1868, was to depict the same theme of the charity of the dispossessed to those with even less, in the form of a beggar, perhaps another variant of the Wandering Jew, bestowing a coin from his meagre purse upon a barefooted gipsy boy.

Yet at the same time that the Realists were creating a visual compendium of social injustices, they were also finding ways for declaring the heroism, dignity and probity of manual labour, without resorting to traditional symbolism or other hallowed pictorial devices. Ford Madox Brown's *Work* [69] epitomizes this attempt to create a new and relevant iconography with which to manifest the heroism of labour – a concept which was itself fairly novel at the time. Before the middle of the nineteenth century, and indeed well past it in certain circles, to work with one's hands was considered degrading. Twenty years after Brown's painting, Ruskin could still appear radical rather than merely quixotic (or just plain silly) when, as part of his back-to-the-land campaign, he organized a party of Oxford undergraduates in a road-mending expedition, armed with navvies' tools, in order to accustom them to working with their hands. Ruskin himself took a turn at wielding the pick, although the total effect was somewhat dimmed by the undergraduates arriving, with their navvies' tools, in cabs. Thus Brown's *Work* was extremely of the moment in the issue it raised, even if, ironically, somewhat nostalgic in extolling physical prowess at just the time when, as Michelet had sadly pointed out as early as 1846, the machine was making manly strength an anachronism. Still, the central subject, the British navvy, was a timely one in the mid nineteenth century. Excavation for roads and railway tracks was then

at its height in Britain, as were Carlyle's inflammatory doctrines upon which Brown based his iconography. *Work*, like Courbet's rather similar *Painter's Studio* [70] might indeed have been subtitled like the latter, 'a Real Allegory', or rather, an allegory in terms of contemporary reality, although it is more narrowly and precisely formulated

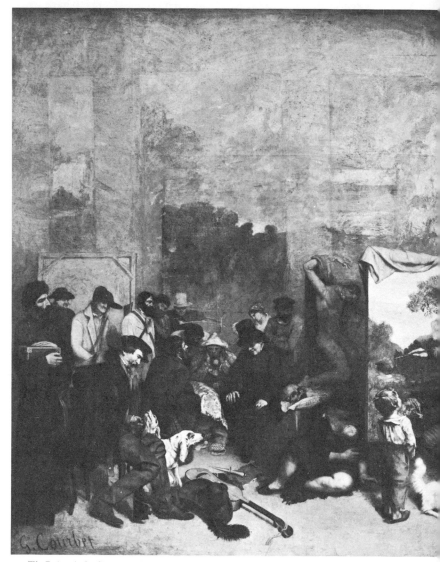

70. *The Painter's Studio*, 1855. Gustave Courbet

around a central theme than is Courbet's painting. Yet the same distinctions and, implicitly, social criticisms, are drawn between those who labour in the sweat of their brows – in Brown's case, the central group, which embodied the 'outward and visible sign of "Work"' – the ragged unemployed who cannot perform or find valid work,

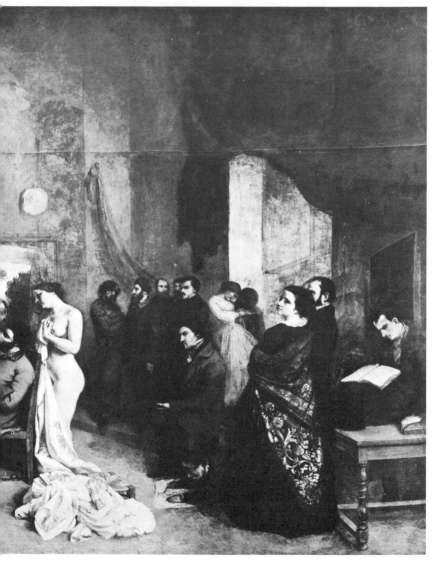

the idle rich who do not need to work, and the so-called 'brain-workers', who play the same role as Courbet's friends and colleagues to the right of the artist in *The Painter's Studio* and whose place is filled, in Brown's picture, by the significant figures of Carlyle and the Rev. F. D. Maurice, father of the Working Men's College and leader of the Christian Socialist Movement, in Brown's conception, 'actually . . . the *cause* of well-ordained work in others'.

It is the artist, Courbet, of course, who plays the central role in the monumental *Painter's Studio* [71], yet he envisions his role as one both socially more humble and ideologically more grandiose than the usual conception of the term. Courbet sees himself at once as the earthy, matter-of-fact master-painter, a popular craftsman working with the tools of brush and canvas and, at the same time, in the iconographic context of the *Studio*, as the Harmonian Leader, the immovable, active, generating centre from which the Fourierist implications of the whole work radiate. For the generating impulse behind Courbet's modern allegory is most probably Fourierist. The *Studio* may be interpreted as a pictorial statement, in contemporary, concrete, personal terms, of Fourierist ideals and doctrine – the Association of Capital, Labour and Talent, for example – partially based on a pictorially conventional sketch with a similar Harmonian theme by Papety and inspired by Courbet's close association with Proudhon [115], who himself had been deeply influenced by Fourier in his youth, by the Fourierist missionary, Jean Journet, whose portrait Courbet had recently painted, and, above all, by his intimacy with two Montpellieran Fourierists, Alfred Bruyas [1] and François Sabatier.

Both Courbet's *Studio* and Brown's *Work*, then, are not merely pictorial statements of problematic themes of their era, but, at the same time, are given greater force and coherence in the midst of apparent diversity, by a deeply-felt adherence to one of the many social religions or quasi-religions of the day: in Courbet's case, Fourierism, in that of Brown, the social doctrines of Maurice and Carlyle. Brown's *Work*, like Courbet's *Studio*, is one of those mid nineteenth-century attempts to create a complex, personal iconography relevant to contemporary life and its major areas of experience. In *Work*, the pictorial structure of the ambitious painting is as original and quirky as its iconography: its strange perspective, its almost surrealist disregard for incongruous juxtapositions combined with an obsessive insistence upon detailed descriptive accuracy, its monumental scale and *plein-air* brilliance of colour, which, as Brown explained, he introduced because 'the effect of hot July sunlight . . . seems peculiarly fitted to display *work* and all its severity'.

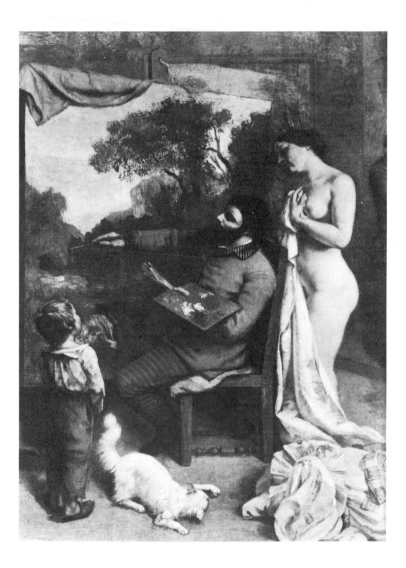

72. Sketch for *Monument to Labour*, 1889-91. Jules Dalou

None of the sculptural projects for monuments honouring the dignity of labour, most of them from later in the century and most of them, significantly, left unfinished, seem to have been able to rival either Brown's sense of contemporary relevance or his sense of moral urgency. Jules Dalou's projected *Monument to Labour* (1889-1900) survives only in the form of some hundred sketches, many of them, it is true, providing an authentic and immediate insight into working-class existence and activity [72]. Yet the only one ever brought to completion – a large *Statue of a Peasant* – completely lacks the verve and freshness of the rougher, small maquettes of city workers and industrial labourers as well as peasants, and offers, like Dalou's *Monument to the Republic*, a sorry hint as to what the finished *Workers' Monument* might have looked like. The individual figures and reliefs by the Belgian sculptor of the proletariat, Constantin Meunier, are both impressive and convincing, even if somewhat diluted by *fin de siècle* self-consciousness, heroic afflatus and, at times, a taste for easy pathos. But they are still vastly more authentic than his completed *Monument to Labour*, which reduces the individual elements to platitude rather than raising them, as the artist intended, to a higher level of symbolic grandeur. The very difficulties Meunier had in *conceiving* his monument as a whole, the ease with which he substituted one element from his *œuvre* for another in his various revisions, testify to the problems involved in constructing a traditionally heroic sculptural complex. Once more, the dilemma of supporting an abstract or general theme with elements of realist specificity and concreteness becomes apparent, and the difficulty is obviously greatest where the demands of the programme are the most grandiose, as in monumental sculpture.

The problem confronting Dalou or Meunier was just the opposite of that confronting an artist, such as Couture, who tried to embody contemporary ideas in traditional form. Couture's attempted synthesis was reversed in Dalou or Meunier's monuments to labour, but a precisely similar conflict between substance and structure is inevitably sensed in their brave attempts to create a grandiosely monumental and eternally valid image of specifically contemporary, even topical, realistic elements. When the intentions of the Realist sculptor were less ambitious and the theme more limited, to one particular event or action, as in Vela's extraordinarily circumstantial and, for this very reason, extremely moving *Victims of Labour* [73], the effect is more successful: the heroism is inseparable from the circumstantiality of a contemporary mining disaster, not some essence to be distilled from the juxtaposition of a bevy of puddlers and factory workers, or the superposition of sowers and winnowers.

73. *Victims of Labour*, c. 1882. Vincenzo Vela

74 *(opposite)*. *Chez le Fondeur*, 1886. J.-F. Raffaëlli

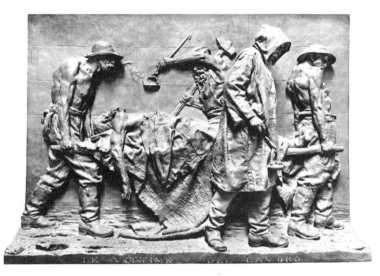

Rodin's incredibly ambitious project for a one-hundred foot *Tower of Labour* (1893–9), a column of reliefs spiralling upward from a base formed by representations of the trades originating beneath the earth, up to the noblest callings of artist, poet and philosopher, and crowned by the genii of love and joy – was to be, rather than realistic and concrete, universal and symbolic in its very inception – a mighty hymn in stone to the depths and summits of human aspiration and accomplishment, where physical direction and spiritual evolution were equivalences. Not unnaturally, it remained a magnificently hubristic dream but later found fulfilment of sorts in Tatlin's abstract *Design for a Monument to the Third International* of 1920, as well as echoes in Hermann Obrist's 1902 *Design for a Monument* or Frederick Kiesler's equally chimeric project for a kind of upward spiralling universal

museum of biological evolution, with man as its crowning exhibit at
the very top. In all these cases, a grand incarnation, rather than a
simple representation, is really the generating impulse, and the subject
itself, purportedly labour in the case of Rodin, is simply a pretext for
quite different explorations.

At the opposite pole from such ambitious treatments of the theme
of labour – and perhaps more convincing in its unassuming recording
of the actual function of a specific artisan as an image of the dignity of
work – is a portrait such as Raffaëlli's of the bronze-caster Gonon
[74], unique in its apparently unconscious assertion of the co-existence
of heroism and everyday activity in the working life of the highly-
skilled craftsmen. The metal-worker is represented supervising his
assistants in the casting of one of Dalou's bas-reliefs, so that this is at

once an interesting fragment of contemporary history and, at the same time, like Degas's studies of the ballet or of ironers, a revelation of professional gesture, in an action-portrait of an artisan and his helpers.

Another way for the Realist to create an appropriate amalgamation of the heroic and the quotidian was simply to select a contemporary occupation which was heroic *sui generis*. What more so than the gallant fireman – *'le soldat pacifique'* in the words of the popular *chansonnier*

75. *The Rescue*, 1855. J. E. Millais

Pierre Dupont – who translated the traditional military virtues of courage, self-sacrifice and obedience into higher terms by working for the good of humanity, by saving lives rather than taking them – and, in sprightly, paintable costume, to boot! The fireman going to the fire was the subject of one of Courbet's rare ventures into an urban theme – an enormous, unfinished canvas of 1851, reminiscent in composition and in its general theme of civic responsibility, of Rembrandt's *Night Watch*. The heroism of the individual fireman, depicted in the very act of saving children from a holocaust, is the subject of Millais's large-scale *The Rescue* [75], which, if Ruskin considered it replete with 'the immortal element', might with more justice be considered, like Courbet's mammoth canvas, a fulfilment of Proudhon's demand that contemporary art 'depict men in the sincerity of their nature and their habits, in their work, in the accomplishment of their civic and domestic duties, with their present day appearance.'

BETWEEN THE COUNTRY AND THE CITY:
THE PLEIN-AIR PROBLEM

While it was in the world of the agricultural labourer or the urban proletariat that the Realist movement found its inspiration in the years immediately following the 1848 Revolution, it was in the very different milieu of the park and the picnic, of the suburban pleasure-ground, the seaside resort or racetrack – junctures of eternal nature and transitory worldly fashion – that the modernism of the 1860s and 70s in France evolved. This development of Realism (in the work of Manet, the young Batignolles painters and, later, the Impressionists) came about by the convergence of *plein-air* painting and contemporary themes – themes neither wholly urban nor wholly rural, and which were as far from raising any awkward issues of industrial poverty and exploitation as they were from extolling the solid virtues of those who are bound to the soil and to work with their hands. The theme of the picnic displaced sophisticated urbanity to the fields, meadows and waterways of France, preferably near the metropolis; the park scene introduced a patch of verdure and outdoor relaxation into the city itself; while the beaches depicted by Boudin, Monet, Manet, Degas and their English counterparts, were inhabited by the middle-classes and their superiors enjoying themselves.

The whole question of the nature and significance of out-of-doors painting in the middle of the nineteenth century is a complex and generally misunderstood one. *Plein-air* is usually considered to have been a 'technique' which was 'discovered' by the Impressionists and which accounts for their bright colours and broken brushwork. But it

was in fact the product of a gradual evolution. Indeed the very notion of what constitutes *plein-air* painting deserves some investigation, for artists had been painting out-of-doors long before the issue *as* an issue was ever raised. Topographically accurate views had been painted on the spot, or from notes made on the spot, from as far back as Dürer and doubtless earlier. And landscape painters generally had long been in the habit of making sketches out-of-doors, from nature, as the basis of the finished, carefully composed paintings which they would later work up in their studios – in fact, such studies from nature were considered obligatory for any competent landscape painter (e.g. the drawings of Claude or Poussin, done out-of-doors, for their paintings; or Salvator Rosa's landscape sketches in oils done in the open air, according to his contemporary, G. B. Passeri). But equally obligatory was the proviso, even with such adventurous out-of-doors painters as Constable or Corot, that such studies, however fresh, spontaneous and accurate, were not to be considered as serious, permanent and final works of art, but merely as the basis, the first step towards them. Turner, Constable and Corot, for instance, often felt compelled not merely to polish, correct, enlarge and clarify their original observations for their large-scale exhibition paintings, but even to add some sort of narrative element – a story or 'theme' – which would endow mere nature with a more elevated, permanent value.

The sketch had sometimes been admired, and even preferred to the finished painting, by eighteenth-century connoisseurs who appreciated its freedom and spontaneity – a question discussed at some length by Diderot in his Salon of 1767 – but it was the artists of Barbizon in the early nineteenth century, as Robert Herbert has pointed out, who were the 'first to narrow the gap that had traditionally existed between the direct sketch and the finished studio picture.' By the early twenties, *plein-air* painting was so popular that there were summer colonies of artists established in Fontainebleau Forest, along the Channel coast and in the region of Sèvres and St Cloud. The paintings of the Barbizon School in the thirties and forties, despite their obvious dependence upon the Anglo-Dutch tradition, as well as upon certain elements of the landscape practice of Poussin, Claude and eighteenth-century painters, and despite the fact that major works were painted in the studio, were still far more concerned with the momentary effects of nature – the play of light, the effect of changing seasons, the instantaneously observed and the haphazardly recorded phenomena – conveyed in freer, sketchier and more open and responsive brushwork than that of any landscape painters hitherto.

Indeed, the whole question of what constituted a sketch and what a finished painting was raised by both the Barbizon group, and by their near contemporaries, the Macchiaioli in Italy. Baudelaire, in his discussion of Corot's landscapes in the Salon of 1845, formulated the question very succinctly and clearly as being the difference between a painting which is *finished* (i.e. worked up in detail, smoothed out, *léché*) and a painting which is *completed* – although the latter may be left rough, spontaneous and open-textured. 'There is a great difference between a work that is *complete* and a work that is *finished*; . . . in general what is *complete* is not *finished*, and . . . a thing that is highly *finished* need not be *complete* at all.'

In France, in the middle of the nineteenth century, *pleinairisme* was not merely a question of personal choice about whether to paint freely and spontaneously or whether to paint indoors or outdoors, but, far more importantly, it began to challenge the very notion of what constituted a work of art itself. When *plein-air* painters modestly exhibited the fruits of their outdoor activity (small-scale, unpresumptuous sketches) in the Salons, they were more or less acceptable as such. But when these 'sketches' – often with contemporary human figures, bright in colour, vivid in brushwork, open and random in composition, provocative in their general air of casualness, and often, in the sixties, as large as the most worked-over, carefully contemplated and slowly built-up *machine de salon* - were exhibited and demanded to be judged by the same standards as the traditional studio composition, they posed a very different question indeed. The sketchy, out-of-doors painting – proclaimed as a valuable, completed work of art in its own right – constituted a serious challenge to traditional values both by being a statement of contemporary reality and by embodying a forceful, innovating viewpoint towards it.

It is important to see and understand the ideological significance of what Manet and the young Batignolles painters were doing in the sixties, rather than merely to ascertain who painted the first large-scale canvas out of doors. In the latter case, one would certainly grant priority to the English, to the Pre-Raphaelites or their associates. But the important question at stake is not merely whether or not a certain canvas was actually painted out of doors and on the spot, but whether, like Monet's enormous and unfinished *Déjeuner* [76, 77], it established a radical new approach, technique, attitude and compositional type in the creation of large-scale, finished (or rather 'completed' as defined by Baudelaire) and important pictures (in the sense of 'major works of art') and, in so doing, rejected centuries of tradition, even if, as in the case of Monet's picture, it was in fact painted in a studio. Monet's

76. Sketch for *Le Déjeuner sur l'herbe*, 1865-6. Claude Monet

77 *(opposite)*. Fragment from *Le Déjeuner sur l'herbe*, 1865-6. Claude Monet

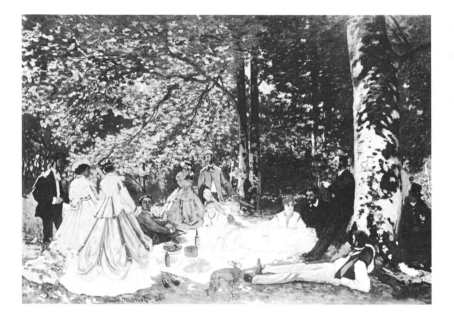

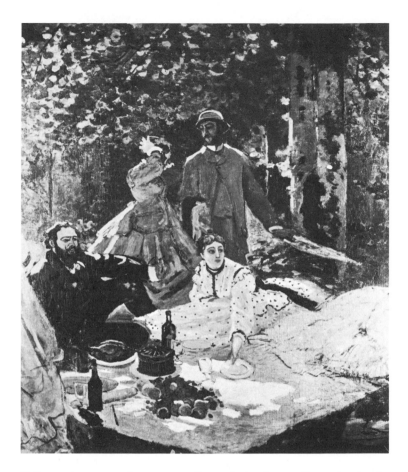

Déjeuner, known today as a totality only in the small version in the Pushkin Museum in Moscow [76], is at once highly original and, at the same time, in its innovations, points to the future. The actual painting of such a work entirely out-of-doors was carried out by Monet several months later in his *Women in the Garden* [22], for which he devised a special easel, with an elaborate system of pulleys, and had a trench dug in the garden so that the enormous canvas could be lowered and raised. In later years *pleinairisme* was to have further, remarkable effects on Monet's paintings, but already by the mid sixties his works look more radically affected by light, air, immediacy of pose and spontaneity of attitude than anything that had been painted before.

It is interesting to contrast what Monet was doing in the mid sixties in France with what some of the Pre-Raphaelites in England had been doing as early as the fifties. Once more, the issue is that of the relation of the artist to contemporary reality, rather than a mere choice of techniques: to use the words of Sartre, *'une technique implique toujours une métaphysique'*. For the Pre-Raphaelites, Realism – *plein-air* or otherwise – implied an earnest, painstaking accuracy, a commitment to hard work shared in common with the aspiring middle classes of their country, and an insistence on the recording of minute details which tended both to congeal or embalm the subject for posterity and, concomitantly, to project a meaningfulness upon it beyond its mere presence on the canvas here and now. Ford Madox Brown may have protested that there was 'no meaning beyond the obvious one' in his *Pretty Baa Lambs* [78] – though the title itself would cast some doubt upon this assertion! – and that 'pictures must be judged first as pictures' and that his was 'painted in the sunlight, the only intention being to record that effect as well as my powers in a first attempt of this kind would allow': in other words, *Pretty Baa Lambs* was intended merely as a representation of his wife and daughter and a group of sheep out-of-doors. Nevertheless, the

78. *The Pretty Baa Lambs*, 1851-9. F. Madox Brown

tightness of the surfaces, the rigidity of the poses, the historical costume, the whole sense of painstaking, time-consuming effort, insistently point beyond the visual facts to some hidden meaning, whether or not the artist consciously intended to convey one. There may be a lot of sunlight, but there is little sense of contemporary immediacy in *Pretty Baa Lambs*. In effect, while he certainly painted it out-of-doors – the sunlight twice gave him a fever whilst doing it, he said – Brown had merely transformed the out-of-doors into a studio, importing the lambs every day from Clapham Common in a truck, making his wife stand stock-still in eighteenth-century costume, taking a lay-figure out every morning and bringing it in at night or if it rained, slowly building up the work part by part. Monet, on the other hand, although he painted his *Déjeuner* in the studio, created a far greater sense of *pleinairisme* and of all the contemporary immediacy which the term implies, by means of the sophisticated, modern costumes, the casualness of the poses, the informality of the composition and the seeming rapidity of the pictorial notation, with its synoptic, open brushwork. In other words, the important point here is not so much who first painted out-of-doors, or even whether or not a particular work was painted in the open air, but rather, what the

79. *Strayed Sheep*, 1852. W. Holman Hunt

total outlook of the artists in question was towards art and the reality towards which it was directed.

For some of the Pre-Raphaelites, like Holman Hunt, armed with unshakeable moral earnestness, for whom achievement was the product of effort and effort implied detailed rendering, 'looseness of touch seems almost to have been equated with moral laxity', to use the words of Keith Roberts. Indeed, Hunt's diatribes against the Impressionists recall those of another English artist who equated a specific technique with morality – wiry outline with sanctity – William Blake, and his pungent invective against the immoral sketchiness of Rubens, Rembrandt, Reynolds and their 'filth'. Hunt's *Strayed Sheep* [79] may simply, as Ruskin later claimed, show 'for the first time in the history of art, the absolutely faithful balance of colour and shade by which actual sunshine might be transported into a key in which the harmonies possible with material pigments should yet produce the same impressions upon the mind which were caused by the light itself . . .' Yet overtones of the strayed pastoral flock (overt in Hunt's own *Hireling Shepherd* of the previous year) still linger, while any impression of the momentariness of contemporary outdoor vision is laboriously contradicted by the painful minuteness of the brushwork. It hardly seems accidental that the Pre-Raphaelites' enthusiasm for the accurate rendering of out-of-doors light and natural colour was accompanied by an equally intense admiration for similar qualities in the art of the past, notably in that of the fifteenth century. The English artists' paintings are generally craftsmen's hard-worked *tours-de-force*, leaning heavily on tradition, rather than brisk, accurate recordings of present-day motifs, *plein air* though they may sometimes be.

It was precisely the capturing of the immediate present with brush strokes as fleeting and nonchalant as their motifs that constituted the Impressionists' radical step. It was also, of course, their way of stressing the contemporaneity, the here and nowness of both their subjects and their way of recording them – and nothing *but* their visual immediacy here and now. And while for the Pre-Raphaelites, the identical formal approach which served for out-of-doors, contemporary subjects could serve just as well for invented literary and historical themes, for the Impressionists there was no question of turning their mode of vision to anything *but* the representation of the present day: their 'technique' and their sense of what was real – and pictorially possible – were inseparable.

Monet's huge *Déjeuner*, of which only fragments now survive, while not actually painted out-of-doors, might just as well have been. Light, flickering through forest leaves, is a tangible pictorial presence here, flattening forms, lightening the weightiness and solidity of objects,

80. *An English Autumn Afternoon*, 1852–4. F. Madox Brown

used much like traditional shadow at the edges of figures, and thereby acting as a de-solidifier rather than as a sculptural force. Compared with Brown's *Pretty Baa Lambs* or even his relatively subject-less *An English Autumn Afternoon* [80] the Monet is infinitely more daring, more advanced, more contemporary in its casualness of mood, its up-to-date costumes, the momentary *désinvolture* of the poses, or rather the very *unposed* quality of the sprawling figures captured with such laconic immediacy. At this stage in Monet's career, it was not yet a question of dissolving form, but simply of synopsizing it, of achieving a sense of form as it exists in light with minimal pictorial means. As a total image, the *Déjeuner* was a paradigm of presentness, of immediate experience, executed on the vast scale usually associated with the Salon painting, yet offering the very opposite to the pretentiousness suggested by such a large scale – indeed Monet used this large scale simply as a means to make the 'picnic' more immediately assimilable, more open in expressive and pictorial texture.

The theme of the picnic was an ideally contemporary one for Realists in the fifties and sixties, offering as it did a natural way of combining contemporary figures, still-life and landscape in out-of-doors light, a scene of great casualness, involving friends and familiars in unbuttoned intimacy, caught as if unawares in easy, nonchalant postures, lacking all overtones of *poncif* or rhetoric, and reminiscent, if of anything, of the light-hearted *fêtes galantes* of the eighteenth century. While Manet's *Déjeuner sur l'herbe* [19] was certainly the most notorious of mid nineteenth-century picnics, it is something of an anomaly, with its nudes and its recognizable references to traditional art, and it was, of course, by no means the earliest of such

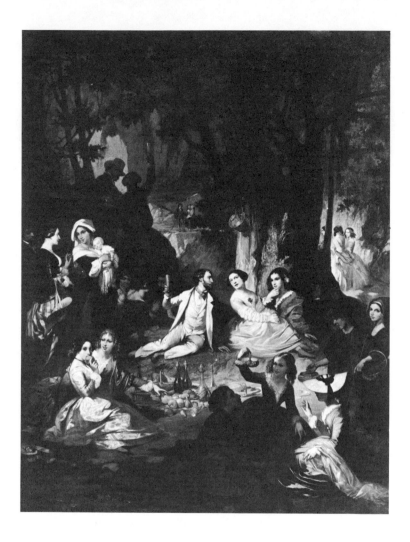

81. *The Picnic*, *c.* 1850. Auguste-Barthelemy Glaize

picnic paintings. Courbet had painted *The Hunt Picnic (or The Death of the Deer)* on a trip to Frankfurt in 1858 and while the composition may be somewhat reminiscent of an eighteenth-century counterpart such as Carle van Loo's *Hunt Breakfast*, the picnickers are obviously contemporary, probably German friends or acquaintances of the artist. Even more circumstantial and specific in its recording of an actual (or hypothetically actual) picnic *en plein air* is a painting by Barthelemy Glaize, a Montpellier artist much favoured by Courbet's patron, Alfred Bruyas, who appears in the centre of the lively composition [81]. Still later, the Hungarian admirer of Courbet, Paul von Szinyei Merse, in his *Picnic in May*, a work marked by freshness of colour, contemporary dress and casualness of pose, still refers to Watteau's idylls in the flirtatious relationships of his couples – the internal communication within the pictorial world making the work more traditional than French treatments of similar themes, despite the fact that it too is treating a subject from contemporary life.

The beach, like the country picnic, offered the Realist a milieu neither urban nor rural – of nature tamed, made both approachable and elegant, even *mondain*, by the presence of urban pleasure-seekers. The very idea of the sea-coast as a resort, a place for the pursuit of pleasure rather than of the hazardous occupations of sailors and fishermen, the very existence of the beach *as* a beach, with its casinos, boardwalks and bathing machines, was still a relatively recent one in the mid nineteenth century, and one which appealed to artists of realist inclination because of its very contemporaneity. Once again it is the English who have chronological precedence in the painting of the theme, but it was the French who succeeded in embodying its contemporaneousness in truly inventive, contemporary terms. Frith's *Life at the Seaside (Ramsgate Sands)* [82] has priority in date and superiority in ambition over Boudin's *Beach at Trouville* [83], one of his very many similar seaside paintings. Frith's work is in every way a lively, amusing, richly anecdotal representation of the contemporary resort, based on studies made in 1851 after a holiday spent at Ramsgate. But it is essentially a narrative painting, worked up part by part, so crammed with incident that it must be read rather than viewed, and ultimately looks back to the example of Hogarth or Wilkie, rather than being a realistic visual totality based on the artist's own immediate experience of the situation. Boudin, on the other hand, while including contemporary resort-goers in his scene, makes them part of a total out-of-doors motif, grasped on the spot in an atmosphere at once particularized and evanescent. An even greater sense of random immediacy and openness of context marks Manet's *On the Beach at*

Boulogne [84] composed of various deliberately disconnected elements rather than, as in the case of the more traditional Frith, linked by narrative and compositional relationships. It is this separation of the parts which creates a new kind of pictorial reality in Manet's work, typical of his œuvre of the sixties as a whole, a sense positively anti-narrative and anti-monumental in its contemporaneity, of how things were when and where the artist recorded them, the parts linked only

82. *Life at the Seaside (Ramsgate Sands)*, 1852–4. W. P. Frith

83. *The Beach at Trouville*, 1865. E. Boudin

by their happening to belong to the same segment of visual experience. Degas in his *At the Seaside*, despite his greater emphasis on a single group of figures, maintains a similar indifference to narrative significance in the casualness of the poses, the apparent fortuitousness of the angle of vision: a still greater sense of visual immediacy is generated by Monet's *On the Beach, Trouville* [85], by the concise and elliptical composition, as undeliberate as an enlarged close-up snap-

84. *On the Beach at Boulogne*, 1869. Édouard Manet

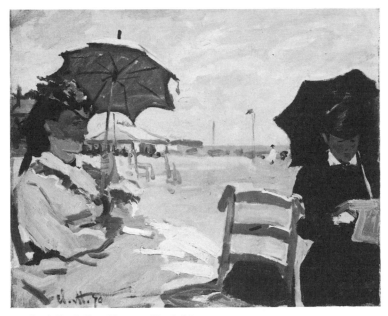

85. *On the Beach, Trouville*, 1870. Claude Monet

shot, yet utterly concrete in its momentary explicitness. Everything is there that tells us when, how and where the figures are, like good *reportage*: costume, poses, quality of atmosphere, everything down to the little beach shoes drying on the back of the chair, tokens of the presence of an invisible child. Clearly Frith, like his countrymen Hunt and Brown, or even the more inventive Arthur Boyd Houghton in his *Ramsgate Sands* of 1861, still belongs to an older tradition in his painstaking meticulousness of the construction of the finished work, in the sense of the posed in the *ersatz* spontaneity of his calculatedly 'casual' groups, and the artist's efforts to *possess* and pin down the subject through diligence and craftsmanship, an effort to make the subject available through plenitude of incident and charm of detail rather than through concise notation. Once again, it is not merely a question of who painted out-of-doors, but rather that for a painter like Monet, leaving out detail, summing up a segment of visual reality in a few synoptic strokes constitutes an ingredient of modernity itself.

Like the beach, the racetrack, with its exciting amalgam of colourful, fashionable crowds, highly-bred horseflesh, and dynamism in an out-of-doors atmosphere literally charged with tension, provided a theme *par excellence* to Realist artists and writers, while the actual speed of the racing thoroughbreds offered a challenge to painters who wanted to create an equivalent for movement, with paint on canvas, as well as to an adventurous and scientifically minded photographer like Edward Muybridge, who took the first photographs of race horses in motion. Contemporaneity grasped on the wing as instantaneity – this was the goal of both brush and lens at the great race meetings of France and England. While Muybridge did not begin experimenting with horses in motion until 1872, did not obtain his first satisfactory results until 1877 and only succeeded in establishing a world-wide reputation as an action photographer in 1879, painters of contemporary life like Frith, Doré, Degas and Manet, as early as the fifties and sixties had depicted the colourful and dynamic spectacle of the racetrack [33], while realist writers – Tolstoy in *Anna Karenina* and Zola in *Nana* – had set some of their tensest and most dramatic scenes in the pressure-filled setting of the track and the galloping horses.

THE URBAN MILIEU: THE CITY AS ATTITUDE AND VIEWPOINT

The city and the country have always functioned as terms of a mythic dichotomy, reaching at least as far back in history as the Alexandrian poets of the third century B.C. With the advent of the Industrial Revolution and the evolution of the modern urban-industrial com-

plex, the clash of values embodied in City versus Country became stronger. The city was seen imaginatively as the heart of contemporary darkness, a secular Hell – temptation, trap and punishment all in one – exciting, rich in potentiality for the ambitious, threatening to the weak, destructive of traditional mores, creator of novelties, of anonymity, breeder of the pervasive modern diseases of *anomie*, alienation and *ennui*, a jungle of brick, stone and smoke, with its greedy predators and apathetic victims, its brutal indifference to either communal value or individual feeling.

The imagery of the modern city played a major role in the work of most of the important literary figures of the nineteenth century, and in that of the less important ones also. Balzac, Dickens, Baudelaire, Zola, Eugène Süe and the Goncourt brothers, Charles Kingsley and Mrs Gaskell, all found it the natural setting, or even the generating impulse, behind many of their creations. Flaubert, in his *L'Éducation sentimentale* and Zola in *L'Oeuvre*, found the brief idylls in bucolic settings enjoyed by their protagonists an effective device for setting in greater relief the sordid pathos of their customary urban environment. In the visual arts, it is perhaps Daumier who most fully investigated the human dimensions of urban life, creating a *comédie humaine* as rich, variegated and insightful into the new realities of individual and class existence in the contemporary metropolis as did Balzac in his *Comédie Humaine* or Zola in his Rougon-Macquart cycle. Daumier, like so many Realists, equating truth with exhaustiveness and universality, touched on all aspects of urban existence – on all categories of class, occupation and type – yet at the same time, envisioned all of them as fragments of the more inclusive category of Parisian life itself, whether it be the strolling players, the wretched proletariat or the venal lawyers and politicians. But above all he concentrated his incisive observation on the great, amorphous, urban middle class, in all its variations, from the small shopkeeper or threadbare *rentier* to the pompous lawyer or refined art-lover: on the world of the theatre, of the boulevard, of the art-dealer and the Salon visitor as well as that of the butcher or the laundress. Daumier even confronted the human reactions to the sudden vast physical changes wrought on the city of Paris by Baron Haussmann under Napoleon III, in works like *Behold our Nuptial Chamber* [86]. '. . . Le vieux Paris n'est plus', as Baudelaire remarked in one of his *Tableaux parisiens*, adding, with sad truth, 'the form of a city changes more quickly than the heart of a human being.' Daumier naturally investigated that quintessentially mid nineteenth-century industrial phenomenon, the railway, with its restless crowds, its sharp class stratifications, its masses of urban travellers shuttled

86. *Behold our Nuptial Chamber*, 1853. Honoré Daumier

hither and yon, pressed together in meaningless intimacy [87]. 'Multitude, solitude . . . the terms are equal and interchangeable for the
active, productive poet', declared Baudelaire appositely in his discussion of Parisian crowds. Daumier was of course not alone in
choosing the theme of railway travel: in England, artists like Frith
[88], Egg and Solomon had dealt with its more sentimental and anec-

87. *The Third Class Carriage, c.* 1856. Honoré Daumier

88. *The Railway Station,* 1862. W. P. Frith

dotal aspects, as did the German, Adolph Menzel, in his satirically naturalistic *The Trip through the Beauties of Nature* of 1892, while in Italy, Adolfo Tommasi documented the effects of modern technology – the telegraph as well as the train-whistle – in his *Locomotive Whistle.* Monet, aside from his famous series of the Gare Saint-Lazare, often, like Pissarro, made the suburban vista or the countryside contem-

porary with the presence of a puffing locomotive; even the conservative Couture suggests the locomotive as a subject for a great painting. Tolstoy set the fateful beginning and tragic dénouement of *Anna Karenina* in a railway station; De Vigny gave the locomotive portentous symbolic significance in *La Maison du Berger* and Zola in *La Bête humaine* had established railway life as one of the categories of social existence in his all-inclusive panorama of Second Empire reality, *Les Rougon-Macquart*; and in a lighter vein, Offenbach opened his bubbling celebration of Parisian high-life and high jinks, *La Vie Parisienne*, at the railway station, with a first chorus of railway employees and a second one intoned by the lucky arriving passengers, thereby emphasizing the role of Paris as the hub of the universe of civilized sensuality.

While writers on both sides of the Channel – Zola in *L'Assommoir*, Dickens in *Hard Times* and *Oliver Twist* – created graphic and memorably realistic images of the lowest depths of urban society, French painters, on the whole, tended to avoid representations of the lower depths. It was, nevertheless, the Frenchman, Doré, who, in an enterprise more journalistic than artistic, it is true, created the most unforgettable representations of the limits of poverty in London's East End [50], while English artists (many of them newspaper illustrators also, for the *Illustrated London News* and the *Graphic*), turned to large-scale representations of the suffering and misery of the London poor, as in Sir Luke Fildes' *Applicants for Admission to a Casual Ward* [89], a canvas which raises its subject from the level of melodramatic genre to solemn social statement by its sheer breadth of scale and

89. *Applications for Admission to a Casual Ward*, 1874. Sir Luke Fildes

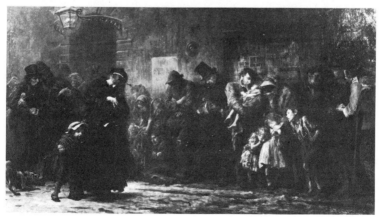

seriousness of intention. It was, incidentally, works like this by Fildes and his fellow illustrator-painters, Frank Holl and Hubert von Herkomer, which so impressed the young Van Gogh during and after his English sojourn. In Italy, too, a painting like Zandomeneghi's *Poor People on the Steps of the Ara Coeli in Rome* of 1872 pointed to the widespread awareness on the part of Realists of one of the major urban facts of their times. Even while avoiding direct reference to the human wreckage spawned by the urban environment, artists like Cals, in his *Cabanes de Chiffoniers*, Raffaëlli in *En Banlieu* or *Le Terrain Vague*, Meunier in his drawings of factory landscapes or Doré in his *Devil's Acre*, could create a sense of contemporary urban misery merely by depicting its physical setting.

Yet the city was far from being an unmitigated social evil in the eyes of the advanced artists of the mid century. For Manet and the young Batignolles artists in the sixties (the Impressionists in the seventies) the Parisian milieu offered an inexhaustible supply of contemporary pictorial motifs. But while Degas may have created an *ersatz* image of urban 'viciousness' in *L'Absinthe*, or Manet have sketched his equivalent of Daumier's *Rue Transnonain* during the

90. *Unloading Coal*, 1872. Claude Monet

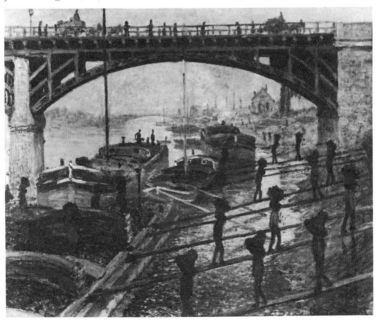

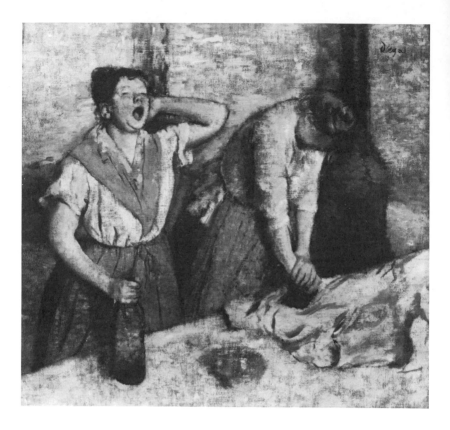

91. *The Ironers, c.* 1884. Edgar Degas

bloody days after the fall of the Commune [36], on the whole the Impressionists' views of bars, balls, laundresses, boulevards, café-concerts, theatres and cityscapes were remarkably free of any sort of social or political *parti pris*. It was their very choice of and involvement with such subjects and their novel grasp of them which constituted a radical gesture at the time. Monet's *Unloading Coal* [90] and Degas's *Ironers* [91] as well as Caillebotte's *Floor-Scrapers* [92], are themes

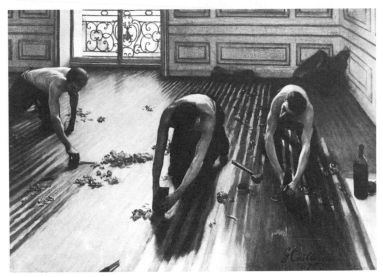

92. *The Floor-Scrapers*, 1875. G. Caillebotte

taken from the labour of the urban proletariat and, in all cases, the subject is a vital part of the painting, but it is not insisted on as the *point* of the painting, as it might have been by a contemporary English graphic artist. Nevertheless, the works of the young Impressionists bear witness to their ultimate commitment to their own times and their own place; even in the relatively 'neutral' realm of landscapes a locomotive may puff in the background or a factory chimney obtrude through the foliage. The difference between a view of a bridge like Caillebotte's *Pont de l'Europe* or Monet's *Railway Bridge at Argenteuil* [93] and Corot's almost contemporary *Bridge at Mantes* [94], is very significant. Both Monet and Caillebotte were representing, with a kind of Japanese or photographic obliquity, a daily experience of

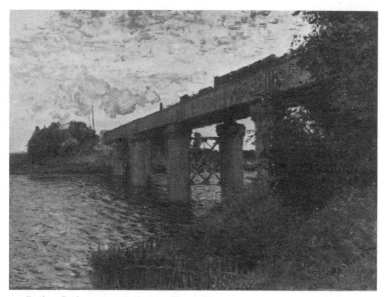

93. *Railway Bridge at Argenteuil*, 1873. Claude Monet

modern life, whereas for Corot modern life simply did not exist as an occasion for the making of art. His bridge is essentially timeless. Their attitudes towards living in the modern world – Monet and Caillebotte so insistently of their time, Corot so resolutely oblivious to it – have everything to do with their respective styles, the sheer pictorial differences between their conceptions of the motif of a bridge.

Baudelaire, as early as his 1846 Salon, had already asserted that Parisian life was 'rich in poetic and marvellous subjects' and, by the sixties, both Manet and Degas had set out, more or less systematically, to capture this new urban reality in their paintings. Yet at the same time, they rejected any implication that this reality was 'poetic' or 'marvellous' in the old romantic sense of these terms. Degas jotted down his radical programme of city themes informally in his notebook and in innumerable sketches and drawings. 'On smoke, smoke of smokers, pipes, cigarettes, cigars, smoke of locomotives, of high chimneys, factories, steamboats, etc. Destruction of smoke under the bridges. Steam. In the evening. Infinite subjects. In the cafés, different values of the glass-shades reflected in the mirrors.' His series of café-concerts, his representations of the urban theatre milieu – above

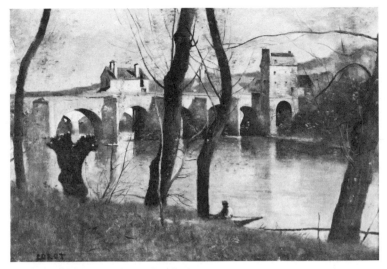

94. *Bridge at Mantes, c.* 1868–70. Camille Corot

all, of the ballet – as well as his canvases and pastels of milliners and laundresses, are at least partial fulfilments of these aspirations, contemporary in theme and novel in viewpoint.

But it is perhaps Manet who was the city-dweller *par excellence*. 'To enjoy the crowd is an art' declared Baudelaire, and Manet seems to have developed the art to an extraordinary degree. It is with him that the city ceases to be picturesque or pathetic and becomes instead the fecund source of a pictorial viewpoint, a viewpoint towards contemporary reality itself. In Manet's case, this has nothing to do with capturing the bitterness of lower-class existence, nor yet with a specific and systematic depiction of the *haute monde*, nor is it related to the minute topographical accuracy which informed the urban scenes of eighteenth-century *vedutisti*. Manet had been drawn to contemporary reality from the start, even when he was still working in Couture's studio, where he demanded that the model pose naturally or, even more daring, in contemporary dress, and was firmly put in his place by his teacher who, according to Antonin Proust, declared scathingly, that he 'would never be anything but the Daumier of his time'. Even during, and concomitantly with, his close involvement

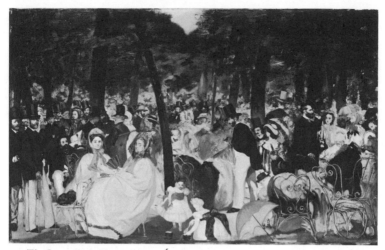

95. *The Concert in the Tuileries*, 1862. Édouard Manet

with the old masters, he was turning towards themes of his own day:
as he himself proudly asserted, he was 'painting modern Paris when
Degas was painting Semiramis'.

How many of his paintings of the sixties and seventies are essentially,
if uninsistently, urban! In the *Concert in the Tuileries* [95], the contrast
between the stark black accents of the top-hatted artists and writers
and the random awkwardness of the roughly-brushed green trees that
rise from their midst, relieved by the flower-like accents of chairs,
women and children, creates new and modern urban imagery of
concrete and distinct contemporaneity in a specifically Parisian,
immediately identified setting, free of the anecdotal trivia, the
'meaningful' incident that usually marks such representations. In the
Street Singer [96], a different segment of the urban milieu is captured
in a single figure, caught, as though by the clicking of the lens of a
camera, between the to and fro of the barroom door, hand raised to
mouth, her previous surroundings dimly adumbrated through the
fleetingly perceived opening. Time is simply suspended here, in the
momentary but fully-grasped image of a single atom of urban reality.
There is indeed, as Sandblad points out, something Japanese about
the form and feeling of this work, its deliberateness as a cool, pictorial
statement, yet it was also, according to Antonin Proust, the product
of a chance encounter on the streets in the Monceau quarter of Paris.

96. *The Street Singer*, 1862. Édouard Manet

In *The Railroad* [97], the urban setting, while not stressed, is an essential ingredient of the painting, the iron bars, the steam, and the fragmentary glimpse of industrial actuality endowing woman and child with an explicitly contemporary vividness, a momentary incandescence which is held firm by the knowing articulation of the composition and the substantial density of the paint surfaces them-

97. *The Railroad*, 1873. Édouard Manet

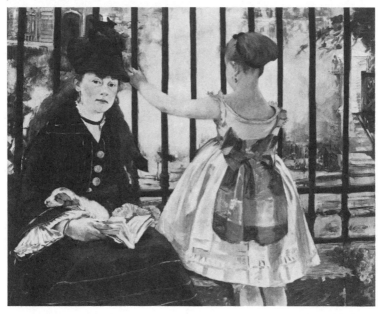

selves. *Chez Père Lathuille* might seem to serve up a quintessentially romantic anecdote in an 'intimate' scene of meeting glances, but the imagery is squeezed dry of all overtly psychological implications, an urban incident being so firmly arrested mid-stream (without ever, in the usual sense, being raised above the level of ordinariness) that questions and answers must die out before they are ever raised. Both the *Ball at the Opera* of 1873 and *Nana* [98] are drawn from the Parisian demi-monde, but once more, it is Manet's discretion, his laconic refusal either to poeticize or to vulgarize his piquant themes that accounts for their vivid contemporaneity.

These works are immediate without being momentary. Manet's compositions generally bear a simple, parallel or perpendicular (rather

than oblique) relation to the picture plane. The sense of immediacy in both the *Ball at the Opera* and *Nana* [98] has to do with their being pictorial slices of life, or, more literally of 'sliced off' life: in both cases Manet asserted his choice of viewpoint as the controlling element, not by stressing an unusual angle of vision, as Degas tended to do, but rather by cutting off the scene arbitrarily, even if, or especially if, this

98. *Nana*, 1877. Édouard Manet

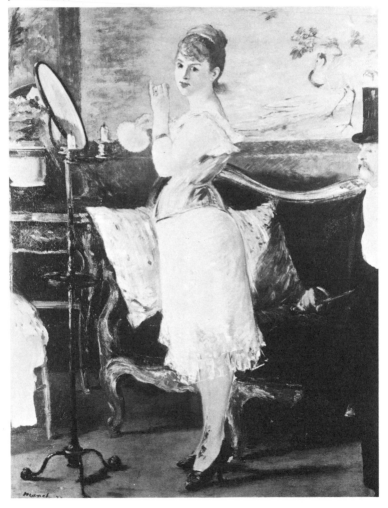

meant the amputation of a tantalizingly important human figure – in the *Bal*, the polichinelle to the left and, upper right, the charming pair of detached legs (later to appear, still detached, dangling from a trapeze in the *Bar at the Folies Bergère*); in *Nana*, the *soigné* figure of the admirer to the right who is permitted only quarter presence, his physical incompleteness emphasizing the more central importance of the mirror in the imagery of provocative narcissism. One is reminded, in these works, of photography where cropping is used to emphasize the seeming fortuitousness of the image, or, at times, to pique our imaginations about the amputated element; and, at the same time, of Roman Jakobson's assertion that the rhetorical device of *synedoche*, the

99. *The Tavern*, 1878. Édouard Manet

100 *(opposite)*. *At the Café*, 1878. Édouard Manet

representation of the whole by the part, is fundamental to Realist imagery.

Perhaps nowhere does Manet's firm but fragmentary compositional vision create a more authentic image of contemporary urban existence than in his many paintings and drawings of Parisian bars and cafés. There is no sense of historical reminiscence in these (*Le Bon Bock* excepted), only a sense of complete and synoptic presentness, as in drawings like *At the Café* or *The Tavern* [99] or a painting like *At the Café* [100] where contrasts of focus and direction within the painting – singer in the background, barmaid raising her glass to her lips in the middleground, relaxed, inward-looking woman versus

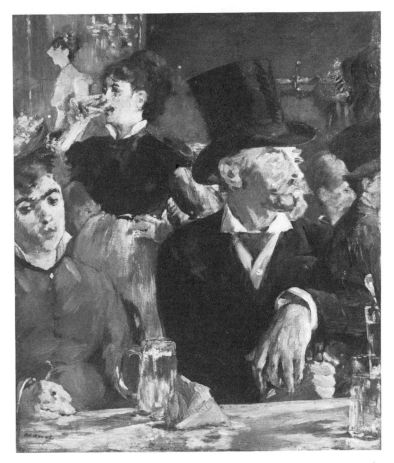

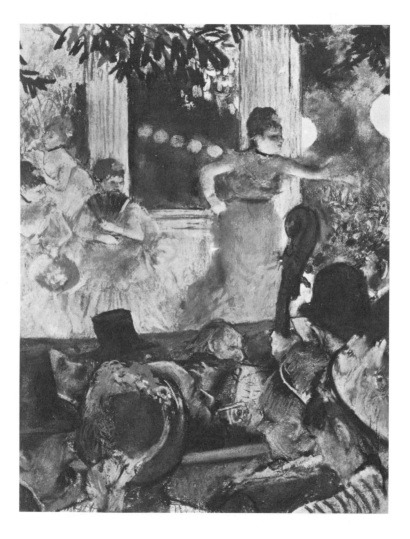

tensely outward-focused man to the right and the slight, very slight, tilt of the plane of the marble bar in the foreground – create a confrontation of urban actuality unmediated by anecdote or explanation. This same sense of actuality characterizes Degas's representation of Parisian night life, like the *Café-Concert* [101], where the effects of artificial light in the nocturnal setting add to the sense of vivid immediacy created by the slightly tilted angle of vision and the divergent directions established by heads, foliage and instruments.

This sort of pictorial structure, which emphasizes the random and fortuitous and denies any literary meaning to the occasion of the work of art, this new way of presenting the phenomena of the times have led critics in the past to assert that Manet, Degas and the Impressionists generally were (unlike Daumier) quite uninterested in the human, emotive qualities of urban existence – were in fact not interested in subject matter at all but only in the purely formal, visual elements of art. The mere phrasing of such an assertion is of course entirely misleading – as though art must be, or can be, divided into the 'subjective' and the 'objective', the 'expressive' and the 'visual', into 'form' and 'content'. What is happening with Manet, the Impressionists and later French Realism generally, is that a new and different set of phenomena, viewed in a new and different way, demanding novel modes of composition and notation, has become the occasion for picture making. The old categories of reality and the old ways of embodying them in art were rejected simultaneously by Realist artists, and in so doing they were obliged to create an entirely new structure for art as a whole. In this way, they were fulfilling the implications of the statement made by Théophile Thoré in 1865 that 'the mission of art . . . is precisely to create plastic forms adequate to the ideas and mores of each era', although they went further than Thoré, who hastily qualified his statement by adding that it must achieve this without deserting the permanent, typical character of universal life.

It was in an urban milieu that this new structure of art was made manifest, and nowhere more vividly than in representations of the very essence of the urban experience, the metropolitan panorama: the streets and boulevards. The imagery of the hurried, the haphazard and disjunctive, so characteristic of the modern urban milieu and, in Paris, increased by the extensive perspectives and large, open *places* recently created by Haussmann, was also indigenous to photography, or at any rate admirably suited to it, with its random, significance-destroying cut-offs, blurring of moving figures and oblique composi-

tions [102]. Sudden diminution of scale and radical cropping are equally characteristic of photography and of advanced pictorial representations of city streets, such as Caillebotte's *Place de l'Europe* [103] where the sudden diminution of scale, as in a close-up photograph, adds to the sense of completely literal confrontation of contemporary reality, as does the brutal cropping of the figure at the right; or Degas's *Vicomte Lepic and his Daughters* 'snapped' in the midst of the Place de la Concorde, with a similarly cut-off figure to the left; and, perhaps more factitiously, de Nittis's *Place des Pyramides* of 1883 with its accurate and circumstantial portrayal of a specific spot in Paris, in the very process of transformation, under clearly specified circumstances.

Yet the most typical and novel Realist city view is the *distant* view, more properly the 'cityscape' or 'urban vista', in which the very

102 *(opposite)*. *Boulevard de Strasbourg*, 1860–5. From a stereoscopic photograph.

103. *Place de l'Europe on a Rainy Day*, 1877. G. Caillebotte

height and range of the artist's vantage point tends to distance the spectator from either involvement in dramatic anecdote or absorption in minute descriptive detail. This more remote viewpoint may, but does not necessarily, include a reference to the position of the spectator-artist: hints of his presence may be included, as in Monet's *Boulevard des Capucines* [104] where the top-hatted spectators on the right side imply the position of the artist. In Caillebotte's *Man at a Window* [105], the dark silhouette of the observer, hands in pockets, serves the same function even more directly. Such Realist views are rather analogous to those of the camera lens in their combination of concreteness, specificity of vantage point, and coolness, eschewing the focus on human or humanitarian problems characteristic of Daumier and other socially-conscious depictors of the city scene, and at the same time, avoiding that dramatic or psychologically meaning-

ful contrast between interior and exterior by which Lorenz Eitner has
characterized Romantic paintings of the 'open window' theme.

That this shift in focus and attitude towards the urban milieu,
embodied in Impressionist city vistas, was connected with a charac-
teristic increase in psychic, as well as physical, distance, is clearly
revealed by a comparison of two city views which fall within Realist
territory: Charles de Groux's *The Coffee Mill* [106] and Manet's *Road
Menders* [107]. In the De Groux work, we are pressed close to the

104 *(opposite)*. *Boulevard des Capucines*, 1873. Claude Monet

105. *Man at a Window*, 1875. G. Caillebotte

106. *The Coffee Mill*, pre-1870. Charles de Groux

107. *Road Menders in the rue de Berne*, 1877-8. Édouard Manet

108. *Quai du Louvre, c.* 1866. Claude Monet

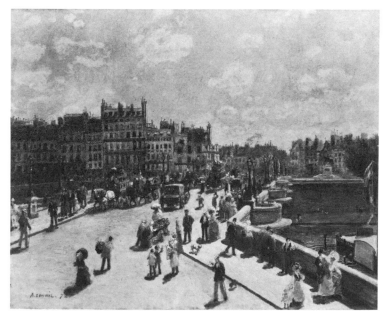

109. *The Pont Neuf,* 1872. Auguste Renoir

110. *Nadar Elevating Photography to the Height of Art*, 1862. Honoré Daumier

image of urban misery, the peeling billboards, snowy cobbles and shadowy background vista adding, through descriptive means, to the sense of precarious, make-shift, inadequate shelter sought out by the urban poor. In Manet's *Road Menders*, no point is made of the social significance or even the physical effort demanded of the labourers: it is the street view *as a totality*, with all its visual incident, of which the road-menders are simply an element among many, that is the true theme of the painting. Similarly in Monet's *Quai du Louvre* [108] or Renoir's *Pont Neuf* [109], there is no piquant incident or anecdotal *divertissement* to distract our attention from the view as an active totality. The figures, in Monet's work especially, are summarized in a few telling dots and streaks of pigment, marvels of pictorial short-hand, no more detailed than a child's stick figures. Yet these cityscapes, despite their lack of overt commentary or incident are certainly neither inexpressive, chilly or remote: they are as far from being mere exercises in pure form or demonstrations of a theory of colour or light as possible: all the variety, movement and defining specificity of contemporary Parisian street life is presented in them, is, in fact, the *point* of them. In all these French city vistas, a loose, open, synoptic, all-over manner of brushwork – the type of pictorial notation formerly reserved for the background or the far distance – is now used in fore-grounds, both as an equivalent for the impermanence of the 'subjects' (now considered to be *motifs*), with their perpetual mobility and, at the same time, as a token of the distance established between the artist and what he is painting.

The view of the city from above had actually been captured in photography by Nadar in his balloon trip over Paris in 1856 and had been parodied by Daumier [110] and by popular illustrators like Grandville in the *Magasin pittoresque*, or in *Le Diable à Paris*. While the Realist cityscapes of the sixties and seventies are never as vertical as these balloon's-eye or devil's-eye views, they are emphatically seen from the second storey or above. The intense confrontation of human situations characteristic of the close-up is sacrificed to the panoramic diversity of sheer extensiveness or distance characteristic of the wide-angle or telescopic lens, paradigmatic of the vastness and diversity of the modern metropolis itself. It is this and not the quest for 'pure formal values' that determined the particular expressive qualities of the Impressionist city vista: a necessary indifference to the traditional human values, an excited response to what is now seen and ex-perienced. As Gerald Brennan once remarked apropos of landing at an airport: 'the view of the observer up above is necessarily one of indifference. One sees a man bicycling, one sees a little farm with its stream and bridge, and they have nothing human about them. One

does not wish to help the man on his road or to drop a blessing on the little house. To feel well- or ill-disposed towards them one must see them horizontally, on the human level. Man can only be man to those who walk on the earth beside him.'

While Monet, Pissarro or Caillebotte may be looking from the second or third storey of a Parisian apartment house rather than from an airplane, this sense of indifference to the specifically human element does, quite necessarily, increase with a more vertical vantage point. In Pissarro's remarkable series of cityscapes, painted from various Parisian hotel and apartment windows from 1897 to 1903, for example *Avenue de l'Opéra* [111] the figures are reduced to little blot-like nota-

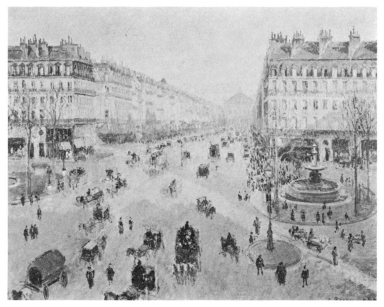

111. *Avenue de l'Opéra*, 1898. Camille Pissarro

tions. In Caillebotte's *Boulevard, vu d'en haut* [112] the view is insistently from above and remarkably similar, in fact probably based on, contemporary photographic experiments. Monet chose to record the Fête Nationale after the Franco-Prussian war, not by mingling with the crowd on the street, but by mounting a balcony. From this vantage point, as recorded in his *Rue Montorgueil Decked out with Flags* [113] he captured the excitement not of men and women, but rather of the pulsating, chromatic drama of the flags themselves. While Monet may

have been indifferent to the human element, in the conventional sense of the term, as he is to conventional factual detail, one can hardly, for that reason, call such a painting cold or unemotional. It is simply that feeling and its expression are committed to new and different segments of experience – urban experience in this case. It is also true that in a painting like the *Rue Montorgueil*, the limits of Realism have been reached. In this work, as in the later series of haystacks, cathedrals, poplars and water-lilies which occupied Monet from the 1880s on, as is the case also in the later works of Degas or of Renoir, the elements of contemporaneity and concreteness, so central to the Realist outlook, have been abandoned for values at once more timeless

112. *Boulevard, vu d'en haut*, 1880. G. Caillebotte

and more evanescent. For the former members of the Impressionist group, 'il faut être de son temps' no longer implied the necessity of capturing the actual appearance and quality of one's epoch on the canvas, as it had in the fifties, sixties and seventies, when artists throughout the world, with France in the vanguard, tried to create a pictorial equivalent for the new and relevant experiences of their own age.

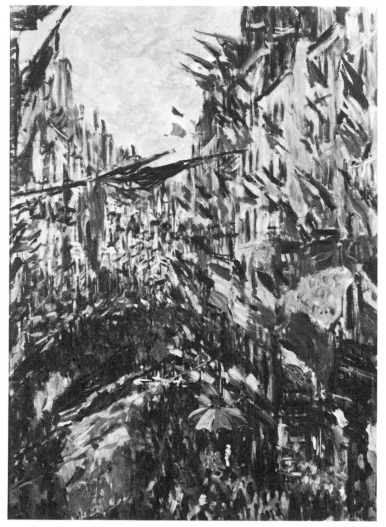

113. *Rue Montorgueil Decked out with Flags*, 1878. Claude Monet

4

The Heroism of Modern Life

It was Baudelaire who used this term, not without irony, one suspects, in his Salon of 1846. And it is quite true that, hovering in the background of the Realist intention to portray ordinary, contemporary life in all its prosaicness, was the idea that there was in fact an epic side to modern life itself, a grandeur as innate to modern times as the heroism of antiquity had been to its own epoch. Indeed, from Claude Lantier to Claes Oldenburg, artists have dreamed, without any apparent sense of contradiction, of an epic art of the ordinary, works like Zola's fictional hero's monumental *Paris*, summarizing the sensuous vitality of the whole city in a grand canvas of the Seine with three splendid female bathers in a boat in its midst, or Oldenburg's vision of a gigantic Toilet-Tank Float rising and falling with the tides of the Thames. Like the artists and writers who had preceded them, the Realists tried to find some equivalent for their sense of the heroic; yet, unlike artists of the past, they had to embody it in an imagery which would at once be convincingly truthful and unembellished, yet at the same time, create when appropriate, a sense of long-range value and importance. In certain instances, of course, the mere recording of modern reality would, in the eyes of some Realists, almost automatically result in the creation of an entirely new and appropriately modern type of literary or pictorial heroic mode. It is often the sense of immanent self-contradiction which enhances the effect of the more ambitious attempts to create pictorial equivalents for the heroic side of modern life, adding, in paintings like Brown's *Work*, Courbet's *Painter's Studio*, or William Bell Scott's *Iron and Coal* [114] (part of a series of eight murals describing the history of Northumberland), vibrations of meaning or expression which neither the straight allegories of the past nor the straight recording of direct experience of Realism in general could achieve. Yet on the whole, and for obvious reasons, Realist artists avoided any subjects or treatments of subjects that might implicate them in that rhetoric of grandeur which they automatically considered suspect, opposed to the Realist values of truth and sincerity. Significantly, most of the more ambitious Realist schemes for commemorating the heroism of modern life remained in the realm of speculation, like Courbet's proposal to transform the waiting-rooms of railway stations, vast

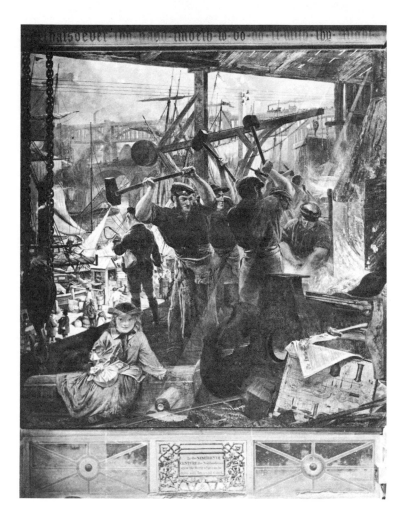

114. *Iron and Coal*, 1861. W. Bell Scott

natural museums with ready-made audiences, into 'temples of art' by depicting on their walls the accomplishments of the various *départements* of France; or Manet's fascinating project, proposed to the Prefect of the Seine in 1879, for the decoration of the new Hôtel de Ville of Paris – a series of compositions representing the 'belly of Paris', with murals depicting the various milieux of Parisian life – les Halles, the railroads, the bridges, the sewers, the racetracks, and the parks – and, on the ceiling, a gallery around which would circulate portraits of all the living men who had contributed to the grandeur and richness of Paris; or Manet's logical suggestion that it was Degas, rather than Baudry, who would have been the appropriate master to create the decorations for the foyer of the new opera.

REALIST HEROES

Yet if Realists generally avoided the rhetoric of heroism, they nevertheless could scarcely avoid having their heroes. And even if, in some cases, these heroes might simply turn out to be modern man in general, or a generic class, like 'the worker', 'the peasant', or 'the ordinary middle-class citizen', and in others to be representations of groups traditionally considered to be quite opposite or even antithetical to the notion of heroism itself – the criminal or the prostitute, for example – yet in still other instances, Realist heroes might turn out to be more narrowly and traditionally defined as those individuals who most seemed to embody the major values of their time and culture: politicians and philosophers, artists and writers, scientists and musicians. The Realists' approach to these heroes of their time, was, however, completely consistent with their general attitude. If they raised the labourer and the lower classes to the serious and important level formerly reserved for gods, kings and the mighty, at the same time, in their representations of the great men of their own time, they tended to play down the exceptional and to depict their heroes casually, in an everyday setting, often in the milieu of, or actually engaged in, their work, as though the sitters themselves were unwilling to bother with the histrionic, posed gestures or conventional postures of grandeur. In effect, they claimed that greatness was neither a matter of external accessories nor the traditional appurtenances of glory, but rather, that it lay in certain talents, qualities and abilities, which, instead of setting the great apart in some timeless realm of dignity, bound them firmly, by posture, pose and action, to their own times, to their concrete place in history. This insistence upon a specific context, pose and texture as essential

simply to being – much less to being *great* – at a concrete historical moment, is central to the impact of a nineteenth-century Realist work like Courbet's *Portrait of P.-J. Proudhon* [115], where the philosopher, Courbet's close friend and mentor, is represented sitting on the back steps of his house, in proletarian blouse, like any other worker, his sleeve rolled up to reveal the wrinkled sweater beneath, books and papers, the materials of his work, scattered around him, his two daughters playing at his feet, the absent Madame Proudhon indicated by the work basket and mending on a nearby chair.

While the portrait is rich in information, not messages, about Proudhon's appearance, character and ideas – his humble, artisan origins, his approval of universal literacy, his emphasis on the family, even his almost obsessive insistence on the purely domestic role of women – all these details are related not in terms of some super-imposed meaning, but rather in terms of metonymy, that linking of elements by sheer contiguity, which Roman Jakobson has postulated as the fundamental imagery of Realist art, opposing it to the pre-dominance of metaphor in Romantic and Symbolist works. One is, for example, drawn to examine Proudhon's shoes, not because they are particularly handsome or particularly affecting – certainly, they have none of the pathos or metaphysical implications of Van Gogh's various pairs of empty boots – but simply because they are there as a separately rendered but relevant factor in the total situation of Proudhon in his garden. It is exactly this sort of accuracy of 'meaning-less' detail which is essential to Realism, for this is what nails its productions down so firmly to a specific time and a specific place, and anchors Realist works to a concrete rather than an ideal or poetic reality. Although the chin-in-hand pose may take one back to the traditional classical philosopher portrait and forward to Rodin's *Thinker*, it seems, in its concrete, everyday context, completely natural, fortuitous and simply the way Proudhon might sit to think through an idea. It is the material presence of the image here and now rather than any abstract, traditional notion of grandeur that makes this such a memorable portrait, a phenomenological transcription, more accurate and richer in characteristic detail than any photograph could be (although the portrait was, in fact, based upon photo-graphs), overwhelming in the sheer richness and profusion of its large-scale exactitude. Yet the contemporaneity of the Proudhon portrait, as is the case for so many of the great Realist works of the nineteenth century, is not merely a matter of accurate transcription of the costumes and accoutrements of the times, but rather, is the result of the establishment of a new and appropriately modern way of look-ing at them: a new pictorial structure of reality, in short. For example,

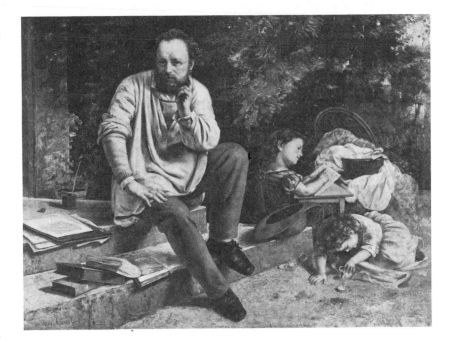

115. *Pierre-Joseph Proudhon and his Family*, 1865–7. Gustave Courbet

could Courbet have conceived of the reality of Proudhon in exactly that way before the invention of photography?

In a similar way, Manet avoids the traditional rhetoric of heroism in his representation of a major political figure of the day in his large-scale *Escape of Rochefort* [116]. Resolutely avoiding the opportunity to emphasize heroic derring-do, implicit in the incident itself – the escape of this equivocal radical leader from the French penal colony on the island of New Caledonia – Manet at the same time refuses to endow it with the pathos of its great sea-going predecessors, Géri-

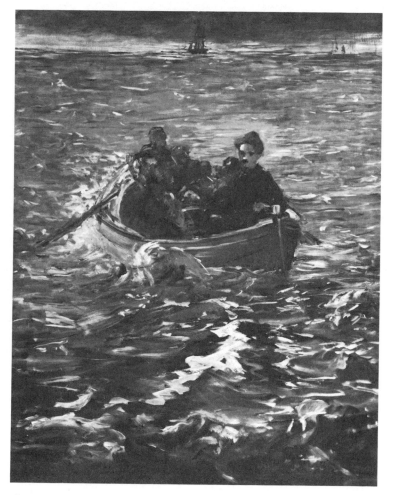

cault's *Raft of the Medusa* or Delacroix's *Christ on the Lake of Genasareth*, which he no doubt had had in mind when he created his composition: there is none of the mounting tension and dramatic, baroque conflict of the first, nor the moving contrast between natural passion and supernatural serenity of the second. The protagonist, Rochefort, far from being the romantic hero in the storm-tossed boat is merely, at most, a patch of diffuse brushstrokes, an invisible protagonist, part of a total pictorial and political situation. While Manet's dream of painting a politician, preferably Gambetta *in situ*, on the tribunal

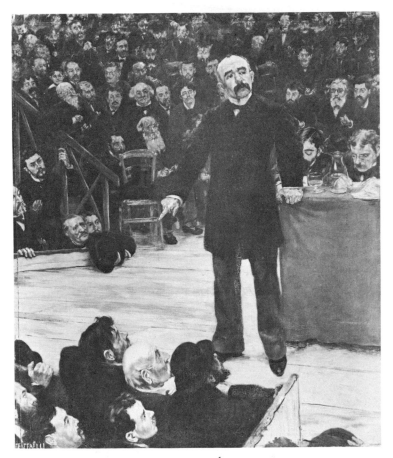

116 *(opposite). The Escape of Rochefort*, 1880–1. Édouard Manet

117. *Clemenceau Addressing his Montmartre Constituents*, 1885. J.-F. Raffaëlli

during a meeting of the Assembly (itself an echo of Baudelaire's suggestion that the depiction of a Minister in the Chamber might be a theme suitable for the imagery of modern heroism) was never fulfilled, it was realized by Raffaëlli in his scrupulously accurate, large-scale representation, *Clemenceau Addressing his Montmartre Constituents* [117], a work in which one feels, once more, the impact which photography has made upon contemporary vision, and which again, stresses the down-to-earth actuality of poses, costumes, gestures and setting.

While by the mid nineteenth century, the artist, hero *par excellence* of modern times, enshrined *qua* Realist in literature by both the Goncourts and Zola, had already begun to assume that messianic and apocalyptic function formerly reserved to the religious way of life – a role which was to blossom in the exemplary *viæ crucis* of Rimbaud, Verlaine, Van Gogh and Gauguin – Realist artists nevertheless tended to represent themselves, their friends, and their literary and artistic colleagues in the most informal poses, the most convincingly ordinary working milieux possible. Not for the Realists was Gauguin's pictorial self-identification with Christ, or Van Gogh's suggestive

118. *Pissarro on his Way to Work*, c. 1874. Paul Cézanne

halo of brush strokes around the tortured mask of his late self-portraits. In *The Meeting* [1], Courbet represents himself in informal working attire, his painting equipment strapped to his back, a staff in his hand; the same situation is chosen by Cézanne for his representation of Pissarro [118] and by Roll for his portrait of the painter Damoye. Manet's *Mallarmé* reclines on one arm, the great poet's pose and pictorial substance as evanescent as the smoke from his cigarette. The omnipresence of cigars, pipes and cigarettes in Realist portraiture is itself significant of the deflationary attitude of Realist painters towards their heroes: it is difficult to be formal or grandiose while puffing. Portraits of the artist as a smoker are numerous: Courbet's of himself (*L'Homme à la Pipe*), his early portrait of Baudelaire working and pipe-smoking, Renoir's extremely casual portrait of Monet, Manet's of Desboutin filling his pipe while his dog drinks out of a glass behind him, and, perhaps most daring of all, given the generally more permanent and pompous nature of the medium, Carpeaux's bronze bust, the so-called *Breton Poet*, with a cigar jammed into his mouth [119].

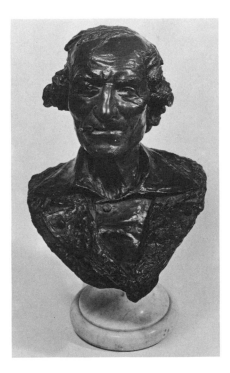

119. *The Breton Poet, c.* 1873-4.
J.-B. Carpeaux

Poses are often informal, casual, candid, or even awkward, at times to suggest the momentary or fortuitous nature of the image, at others, or coincidentally, to suggest the free and easy manners, the informal way of life within the milieu of advanced artists. Degas represents Manet in a far from elegant position, one hand thrust into his pocket, his foot drawn up on the couch, in his (now amputated) portrait of the artist listening to his wife playing the piano [120]; in his portrait

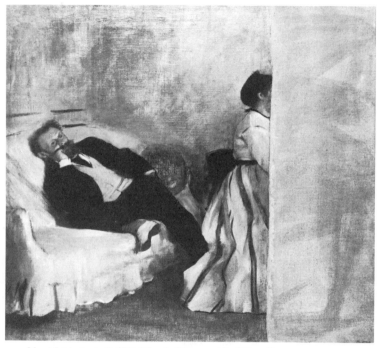

120. *Manet Listening to his Wife Play the Piano, c.* 1865. Edgar Degas

of another artist, formerly thought to be Cézanne but recently identified by Theodore Reff as the minor Impressionist Michel-Lévy, the artist is caught at a deliberately 'casual' off-centre angle, slouching, hands in pockets, shirt-tails tied in front, in the midst of his own paintings; Boldini, in a dazzling *tour de force* adumbrates the painter Cabianca with a few synoptic brushstrokes, lying down on his bed, reading, his feet dangling ignominiously, like a child's, off the floor; Bazille represents Renoir with both feed drawn up on a chair, like an illustration of bad manners in a current book on deportment [121];

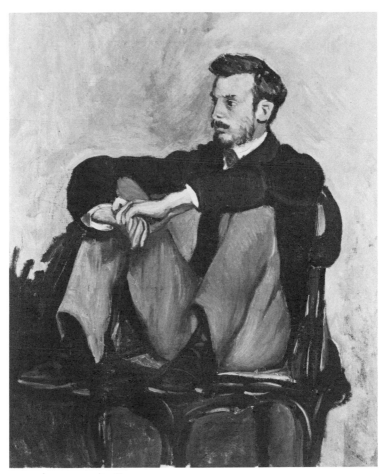

121. *Renoir*, 1867. F. Bazille

and Monet in bed with an injured leg. Mary Cassatt is viewed at a piquant angle, from the rear, by her friend Degas, who, eschewing the rather formal, stiff pose, if not the relevant setting of Manet's earlier *portrait à l'apparat* of his friend, Émile Zola, chooses an un-expected view from above for his portrait of the Italian engraver and critic, Diego Martelli [122]. The rotund figure, in working dress, is represented in an off-centre, casual view, amidst the clutter of his tools, with his slippers carelessly flung off on the ground to the left, his body silhouetted against an extensive expanse of blue to the right,

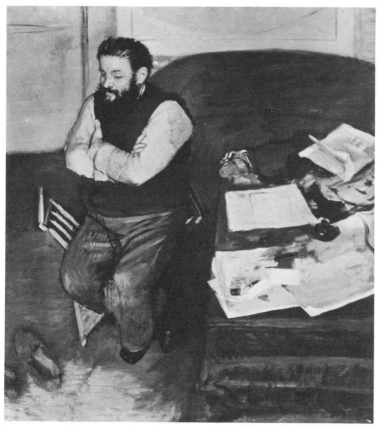

122. *Diego Martelli*, 1879. Edgar Degas

which creates a sense of asymmetrical deliberateness at the same time that it stresses the subject in a way that might well have been impossible before the arrival of the Japanese woodcut and photography.

In the case of group portraits of artists and their friends, if Courbet has lined up his intellectuals rather formally on the right hand side of the *Painter's Studio*, one must remember that this is - atypically for the arch-Realist - an allegory, albeit an *allégorie réelle*, and that the formal structure of the painting depends on Courbet's pre-ordained conception of his, and his friends' roles, rather than upon immediate observation; Fantin-Latour, on the other hand, while out to pay homage to Manet and the Batignolles group, and scarcely erring in the direction of casualness, found a more factual pretext for assembling

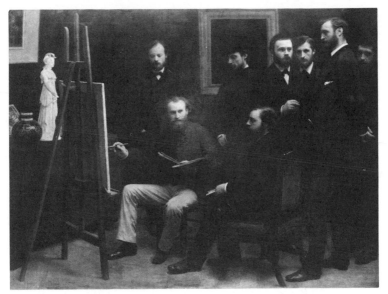

123. *Studio in the Batignolles Quarter*, 1870. H. Fantin-Latour

124. *Studio in the rue de la Condamine*, 1870. F. Bazille

his group of artists, writers and critics (including Renoir, Zola, Bazille, and Monet), all depicted with near photographic intensity, by dispersing them in a more plausible way around the working artist [123]. Yet it is Bazille, who, eschewing all sense of the posed and pre-ordained, has endeavoured to convey a convincing sense of the informality of the atmosphere itself in his group portrait of his friends, *The Studio in the rue de la Condamine* [124], with Maître, Zola, Renoir, Manet, Monet, and the artist himself, distributed casually about the airy atelier, in seemingly haphazard poses and a deliberately asymmetrical composition engaged in their own activities or in conversation in the midst of a great deal of empty floor space and walls crowded with canvases. Renoir represented his friends in the humble surroundings of a country inn, with a waitress clearing the dirty cups from the table and crude caricatures on the wall behind.

Scientists and doctors, nineteenth-century heroes in the service of humanity, are, like artists and poets, portrayed in their working milieu, in the midst of their feats of discovery or missions of mercy. Perhaps the best known of these medical panegyrics, familiar to all who visited the doctor's surgery before physicians turned to Picasso prints for their interior decor, is Luke Fildes's moving, and certainly extremely accurate *The Doctor*, a vivid representation of an all too frequent occurrence at a time when, in Liverpool, only forty-five per cent of all babies lived to reach the age of twenty. The great physiologist, Claude Bernard, friend and inspirer of Zola, is represented by Léon L'Hermitte in the midst of an experiment, surrounded by his pupils, displaying what Edmond de Goncourt had described as 'a fine head, that of a good man, a scientific apostle'. Gervex's Dr Péan is conducting an operation for breast cancer before spectators, and the American realist, Thomas Eakins's canvases of doctors, his *Gross Clinic* of 1875 [125] and *Agnew Clinic* of 1889, both represent their protagonists in the midst of their customary professional activities, in actual settings, no matter how strongly reminiscent any such representation must be, by its very nature, of Rembrandt's *Anatomy Lessons*. Zola's Dr Pascal becomes the archetype of the selfless man of science, later apotheosized in Sinclair Lewis's *Arrowsmith*, and Paul de Kruif's biographical *Microbe Hunters*, where, in heroicized brief accounts of the actual achievements of real scientists, life seems to be imitating Realist art, to say nothing of the same phenomenon in films like *Dr Erlich's Magic Bullet* or *Madame Curie*, where the scientist-hero, depicted with circumstantial accuracy, wins through in the end against overwhelming odds.

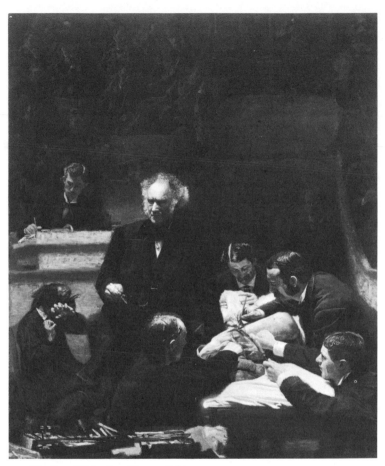

125. *The Gross Clinic*, 1875. Thomas Eakins

THE FAMILY

By the middle of the nineteenth century, the virtues of family life had become an article of faith to the rising middle classes, replacing the many outmoded social relationships which had been eradicated or vastly altered by the revolutionary political and social changes of the times. While Fourier and Engels may have decried the basically exploitative, purely economic basis of family life in capitalist society, the anarchist Proudhon, coiner of the phrase 'property is theft', saw

marriage as a social necessity and the family as the nucleus of social regeneration.

In art, the image of the family provided a locus of intimacy and cohesiveness, an island of natural feeling and, no less important, an inexhaustible source of natural models in relaxed, everyday poses, set off from the harshness and anonymity of life in the larger world. While domesticity itself was primarily a middle-class value, the family could serve as a focus for artists from the realm of the peasantry to that of royalty itself. Courbet had made his initial Realist statement in the form of a family picture, the *After-Dinner at Ornans* of 1849, representing himself, his father and two of his most intimate friends gathered around the familial table, a circumstance neither picturesque nor anecdotal, accurately reproducing his provincial, petty-bourgeois background on the scale and with the seriousness usually reserved for history painting. At the same time, in Austria, Michael Neder, in his *Sunday in the Country* of 1851, represented the same sort of personally-experienced milieu, in a work, which, if far more naïve and less ambitious than Courbet's, is still remarkably lacking in romantic coyness or petty picturesqueness – in short, is a Realist treatment of the subject. Equally personal, familial and undeniably contemporary in its setting and in its visual intimacy, is Adolph von Menzel's *Evening Party* [126] of 1848, so different in its unpretentious contemporaneity from the same artist's historical and ambitious *Round Table of Frederick the Great at Sans Souci* of 1850-51. At the very lowest level of the

126. *The Evening Party, c.* 1848. Adolph von Menzel

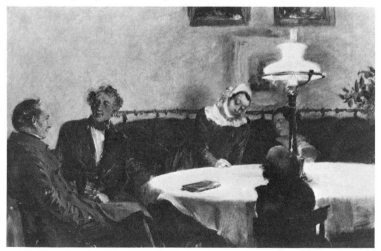

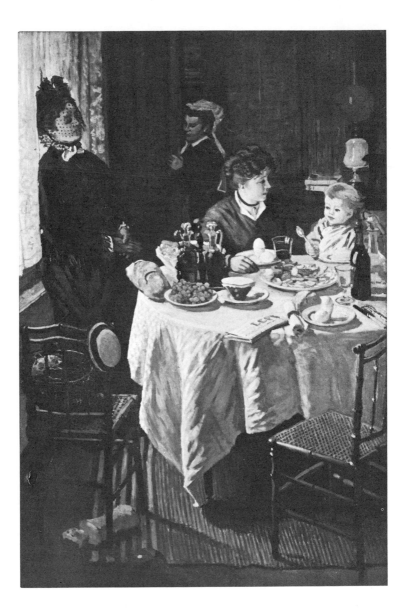

127. *Le Déjeuner*, 1868. Claude Monet

128. *The Artist's Family on a Terrace near Montpellier*, 1867. F. Bazille

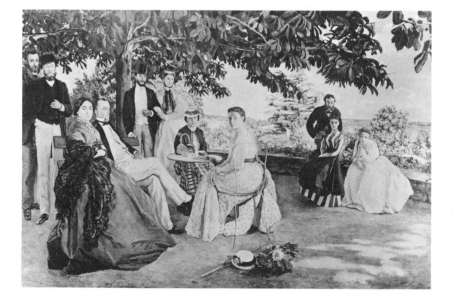

social scale, the Dutch painter, Josef Israels, like Daumier in his *La Soupe*, recreated the meaningful sharing of food and spiritual value formerly associated with religious themes like the Last Supper or the Supper at Emmaus, in modern, proletarian terms in his *Frugal Meal* of 1876, providing, in a seemingly objective depiction of the humble facts of mealtime in a peasant family, the basis for Van Gogh's far more overtly expressive embodiment of the sacred at the basic level of existence, of the religious value immanent in the most mundane acts of life, *The Potato Eaters*. Here the artist, in his anxiety to embody the crudeness, the poverty and, at the same time, the innate, secular sacredness of these poor people and their meagre nourishment, has actually overstepped the very boundaries of realism itself.

Yet the same social reality, the family meal, could provide a very different sort of contemporary theme for the young Monet, whose painting of his own family, *Le Déjeuner* [127], is, as Seitz has pointed out, a high point of 'both social and optical naturalism', presenting with complete veracity and richness of specific detail the material and visual facts: the toys and hat of the child, the boiled eggs, the folded copy of *Le Figaro* at the place of the missing Monet himself (realistically 'out of the picture' because he is, in fact, in the process of creating it). While echoes of the Dutch Little Masters and, in the French tradition, of Le Nain and Chardin necessarily accrue to all these family-table paintings, it is all the more remarkable how truly contemporary and underivative, how freshly drawn from the material of daily experience and personal feeling these representations of humble or ordinary middle-class scenes actually are, how they present a truly immediate, rather than mediated, sense of intimacy in their fidelity to the concreteness of pose, of setting, of costume, of the very atmosphere, of their own times – indeed, how little they recall the art and attitudes of the past, despite their almost inevitable thematic relation to it. In Monet's painting, it is the material detail itself that convinces us: the light-revealed textures of cloth, cruets, wicker chairs, bread crusts, the sensuous actuality of lettuce, eggs and oysters, the unsentimental yet convincing charm of mother and child represented as a perceived fact in the visual-domestic context.

Not all family paintings centred about the dining-room or the shared meal, of course. Perhaps no other painting so successfully captures the life-style of a specific class at a given moment within its native milieu – the provincial *haute bourgeoisie* in the 1860s – Frédéric Bazille's monumental *Artist's Family on a Terrace near Montpellier* [128], a work which is the very epitome of phenomenological rectitude, a model of visual authenticity. The discreteness of the various human and landscape elements, the cool dignity yet self-assured

relaxation of the poses, the painstaking exactitude of the *reportage*, sharing in the objective inclusiveness of the contemporary photograph (upon which the artist may have indeed depended for some of his documentation), even the subtle yet completely natural differentiation – in pose, compactness of relationship and location – of the more dominating mother and father from the rest of the less assertive groups and couples – all of this creates an absolutely authentic social and visual document of the reality of family life of the times, as characteristic and coherent in its way as the family portraits of Hals and his seventeenth-century cohorts. There is absolutely no historical reminiscence here: nothing but the concrete actuality of modern times, presented on the grandest possible scale.

While Bazille, in his representation of the upper middle class has firmly rejected the aura of sentimentality or nostalgia that sometimes seems inherent in the theme of the family, transforming his subject into a motif modern in both emotional tone and pictorial structure, Degas has gone one step further, making his family portrait, *The Bellelli Family* of 1858–62 an occasion for the dispassionate and objective recording of subtle psychological tensions and internal divisions in the representation of a refined group from the Italian minor aristocracy. Once again, the implications are built into the pictorial structure: there is no meaningful anecdote to serve as the 'purpose' of the picture as there is in an almost contemporary English work representing a family of a similar class in a situation of overt external and internal disruption, Martineau's *Last Day in the Old Home* of 1862, where the artist has placed his truly remarkable powers of concentrated observation in the service of a trite sermon on the evils of drink and gambling and the long suffering forbearance of women, as opposed to the thoughtlessness of men.

So strong was the pull of middle-class domestic values in the mid nineteenth century that even a reigning monarch, Queen Victoria of England, herself the very epitome of domestic virtue, might be shown in what is essentially a bourgeois home setting in Landseer's well-known painting of her [129], stripped of all regalia, with husband and child, surrounded by frolicking dogs and dead game, in the cosy parlour of Windsor Castle. Life again seems to be imitating art: for had not Ingres, in his *Henri IV Playing with his Children, While the Spanish Ambassador is Being Admitted*, provided the prototype for the instructive combination of the royal, the domestic and the canine in the representation of domestic bliss in high places, showing the great monarch on his hands and knees playing horsie with his sons, while his doting wife, a lap dog at her feet, fondles still another royal infant, and Raphael's *Madonna della Sedia* on the wall emphasizes the edifying

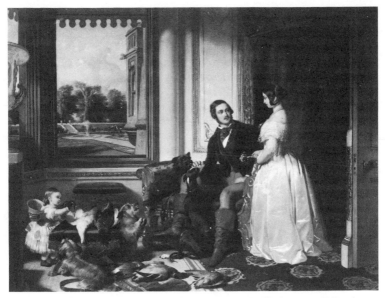

129. *Queen Victoria, the Prince Consort and the Princess Royal at Windsor*, 1843. E. Landseer

moral of the scene. Incidentally, the sheer number of paintings representing mighty rulers 'lowering' themselves, in the wake of the French Revolution and its aftermath, deserves further study: most of them demand stooping, crouching or bending on the part of the monarch concerned, whether it be Henri IV on his hands and knees playing with his children, François I tenderly bending over to take the dying Leonardo da Vinci in his arms, or the Emperor Charles V stooping to pick up Titian's paint brush in the eponymous painting by Robert-Fleury.

THE GREAT ANTI-HEROINE: THE FALLEN WOMAN

Perhaps more consistent with the Realist concern to get at the truth – generally equated with the seamier side – of contemporary mores, was the overwhelming attention accorded by both writers and artists to a social category previously neglected or treated with less than seriousness or objectivity, but raised by the Realists to the status of a major issue: that of the prostitute or demi-mondaine. As Steven Marcus has demonstrated most admirably in *The Other Victorians*, Victorian adulation of the family and its associated virtues seems to have been

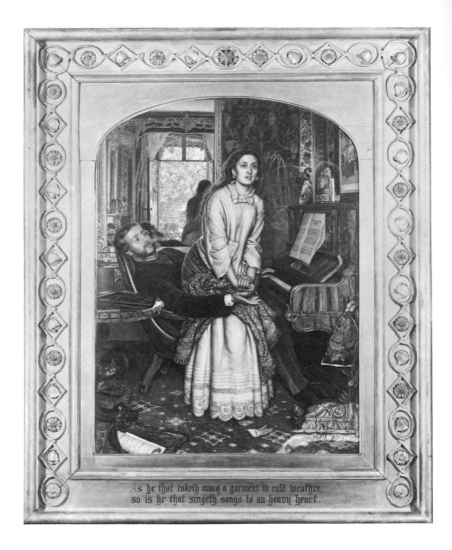

As he that taketh away a garment in cold weather,
so is he that singeth songs to an heavy heart.

130. *The Awakened Conscience*, 1853. W. H. Hunt

matched only by the Victorian preoccupation with vice: ostensibly, of course, with its detection, punishment or reform. If English Realists when confronted with the touchy issue of sex seem to have been unable to refrain from prudish recoil or moralistic judgement, yet their very reactions, like Hunt's *The Awakened Conscience* [130] or Augustus Egg's tripartite narrative, *Past and Present*, seem to provide an accurate record of contemporary Victorian social values, just as does the sheer prolixity of material objects in the arena where conscience awakens or moral failure is judged. For the English painters of the middle of the century, moral truth and material fact, relentlessly pursued down to the last stitch in the last antimacassar, seem to be absolutely equated. If the situation depicted in *The Awakened Conscience* – showing 'how the still small voice speaks to a human soul in the turmoil of life' – seems a rather unlikely one, we must realize that the Realism involved is actually one of obsessively detailed accuracy of setting rather than of accurate psychological analysis. The bower of bliss in St John's Wood in which the moral epiphany takes place is extraordinarily convincing, as a piece of social observation and as a contemporary artefact – down to what Ruskin called the 'fatal newness' of the furniture – even if the expression on the young woman's face is not. Yet even here, where sexual liberation today leads us to view the painting as a parody, one must remember, as Marcus has indicated, that for the Victorian lower-class woman, strict morality could be a liberating assertion of personhood, as opposed to objecthood, degradation and passing enjoyment in the hands of 'gentlemen' exploiters, and thus, the young woman who casts off the material fruits of her sinful existence is, in a sense, affirming her humanity by an act of decision, indicating her essential difference from the 'fatally new' things which she at once rejects, and, at the same time, in a single epiphanic gesture, differentiates herself from. Still another moral, or more accurately, pseudo-moral decision, this time before the fact, is presented in Alfred Elmore's *On the Brink* of 1865, with its forced contrast between hope (the gamblers) and despair (the young woman on the brink of ruin); Rossetti's only depiction of a contemporary theme is the unfinished *Found*, where a young country man, bringing a captive calf into the sinful city, recognizes his lost love in a miserable street walker. All in all, one can say that if the English middle-class moral code placed woman on a pedestal, this implied that she had all the farther to fall when she fell, and that the art dealing with this issue truly mirrors the false consciousness of an age.

In France, the sheer plethora of Realist literary works concerned with the prostitute – Edmond de Goncourt's *La Fille Elisa*, Guy de

Maupassant's *La Maison Tellier*, Joris Huysman's *Marthe, histoire d'une fille*, and of course, Zola's *Nana* – all bear witness to the importance of the theme in Realist iconography as well as to the central position of the demi-mondaine in the social life of the times. There is a certain charm, an ironic matter-of-factness, in the notion, expressed in Zola's *La Terre* and de Maupassant's *La Maison Tellier*, that running a brothel is simply a good business like any other, in which the owners take pride in the excellence of their products and service, and in which their business acumen is highly regarded by the rest of the community. Nevertheless, even in France, a certain amount of moral indignation was felt, not so much against the fallen woman herself, as against the social hypocrisy surrounding her. Thomas Couture's allegorical drawing, *La Courtisane moderne* of 1864, representing a lightly draped nude seated in a carriage, holding a whip over a team of warrior, artist, youth and old man, simply elevated a contemporary reality to the level of allegory: the famous courtesans of the Second Empire, according to the Goncourts and others in a position to know, certainly exerted a lively influence over the manners and morals of the times, exercised their power in occasional political decisions, appeared at the theatre and opera with famous political and intellectual figures, ran the most sophisticated Salons in Paris (if, of course, one excepts that of the Princesse Mathilde), and set standards of elegance in interior décor and dress.

131. *Olympia*, 1863. Édouard Manet

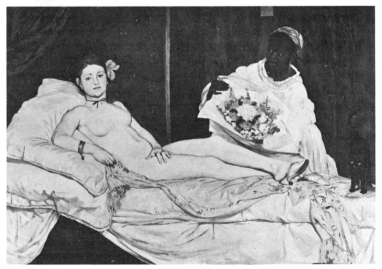

Manet's *Olympia* [131] and Zola's *Nana* are both, in their ways, statements of this truth, although Zola, to be sure, yields to the temptation to endow his super-sexual heroine with symbolic significance, when, after a career of whirlwind destruction and self-destruction, she succumbs dramatically to smallpox, her internal and external corruption thereby paralleling that of the French nation itself on the brink of the Franco-Prussian war. Manet, like the Goncourts in their *Journal*, Courbet, Guys and Degas, is far more casual and direct in dealing with a theme which was such an important facet of contemporary Parisian life. His *Olympia*, far from being an essay in pure form is – as Theodore Reff has astutely pointed out – the very image of the contemporary courtesan, part of Manet's project to represent the wide variety of Parisian types of his times. Thin, tense and chilly, she embodies a timely ideal of elegant artificiality and, with her mules, her velvet ribbon, her black cat and Negro servant carrying a token of admiration up to her boudoir, is very different, in her present-day actuality, from the romanticized or idealized nudes of the distant or recent past; in every way, the *Olympia* seems like the fulfilment of Baudelaire's demand that modern artists find contemporary situations for representing the nude, which, he pointed out, was as much a factor in modern life as it had been in antiquity, different though the appropriate situations and the ideal of beauty might be. Manet's close-up view and his immediacy of handling the theme transform the orchid, flower of lasciviousness, and the black cat, promiscuous beast, from hidden symbols into natural accessories of the mid nineteenth-century demi-mondaine, although the chilly aura of luxurious perversity may, in fact, take us back to the beginning of the century to a work like Girodet's crystalline *Danae*, or forward to the *femmes fatales* of the *fin de siècle*, so brilliantly analysed by Mario Praz in his *Romantic Agony*. Without being a transient 'slice of life', like his later *Nana* [98], transfigured by iconic remoteness and a flatness both physical and psychological, Manet's *Olympia*, at the same time, as Reff indicates, shares a sense of realistic actuality and an objectivity towards its inflammatory subject with the social drama of its times: indeed, the very name 'Olympia' had been used by Dumas *fils* for one of the courtesans in *La Dame aux Camélias*.

Other French artists, like Constantin Guys, made a speciality of the theme of the courtesan, depicting the various stratifications of the profession and its places of work and recreation with a great deal of sophisticated verve and a penetrating sense of sinister atmosphere; Courbet represented the fashionable theme of lesbian love, which had been treated, with considerably more breast-beating and a great deal less sensual enjoyment, by Baudelaire, in his long poem *Les*

Femmes Damnées; and obviously, in his *Girls by the Banks of the Seine*, Courbet was dealing with young women who were no better than they should have been, as any contemporary spectator could tell, simply because they were lying down on the grass, in full public view, in all their tawdry finery. Degas, in his *Women on the Terrace* [132], incorporated the prostitute into the visual ambience of contemporary Paris by night, in a momentary vision, caught, as it were, on the run, a vicious gesture obliquely glimpsed out of the corner of the stroller's eye. Degas actually treated the prostitute in monotype at least fifty

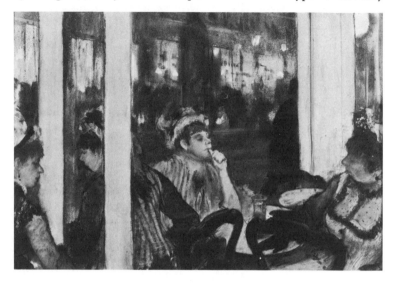

132. *Women on the Terrace*, c. 1877. Edgar Degas

133 *(opposite)*. *L'Attente*, c. 1879. Edgar Degas

times, in 1879-80, and in a series of related drawings of 1876-7, taking the theme rather humorously, not glossing over the natural obscenity of poses and gestures, yet, at the same time, viewing the prostitutes within their native habitat with the same cool attention to the characteristic poses and gestures of their profession as he had brought to his treatment of other feminine occupations like that of the milliner, the ballet dancer or the laundress, as Eugenia Parry Janis has pointed out [133]. Glimpsed as though through a keyhole, totally lacking in any imposed sense of self-conscious moral or

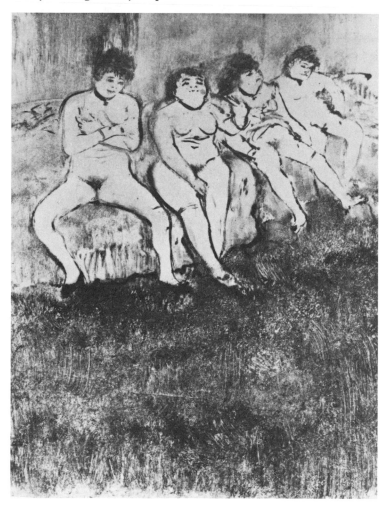

moralizing, these monotypes lie at the opposite extreme from Victorian moral hyperbole, both in the freedom of their range and the openness of their formal means, both of which, incidentally, may owe something to similar qualities in the Japanese woodcuts which Degas admired and collected. Yet perhaps the most vivid of all of Degas's works in the novelty of its realism and its sense of sheer immediacy, is his statue of a female who is neither quite yet a woman nor quite fallen: *The Little Dancer of Fourteen* [134]. Certainly the most convincing representations of adolescence in sculpture since Donatello's *David*, the *Dancer* is significant in that Degas has not represented either a famous personage or some allegorical quality, the usual pretexts for sculpture-making at the time, yet, at the same time, although technically anonymous, the little dancer is in actuality absolutely concrete and immediate as an entity, the sub-heroic heroine personified, accurate in pose, gesture and even, in the tulle skirt and coloured surfaces, in the very material of which she is made. In the artificial pose of her profession, angular by reason of age and arrogant by nature, this is a tantalizing simulacrum, softened neither by the generalization of classical idealism nor by that of romantic pathos. The *Dancer* is, as a Realist work must be, in the present tense, singular.

134. *The Little Dancer of Fourteen, c.* 1880–1. Edgar Degas

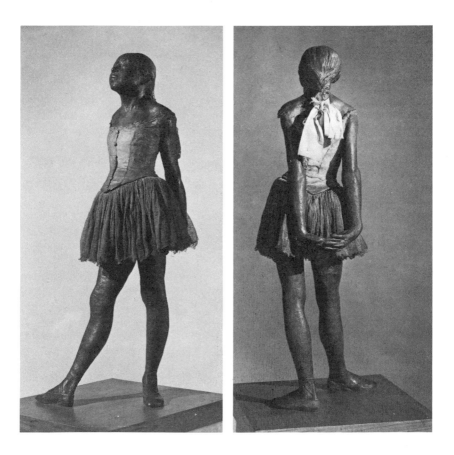

Epilogue

REALISM IN ARCHITECTURE AND THE DECORATIVE ARTS

A good case can be made out for extending the term 'Realism', or the concept of the Realist movement to other fields of art: to architecture and the decorative arts particularly. Certain difficulties in interpretation do arise, however, once we leave the 'representational' arts of painting, sculpture and literature – i.e., arts which tend to stress their relation to some sort of pre-existing objective reality of which their work functions as a simulacrum or embodiment, however naïve we may think such a view. Moreover, in the non-representational arts, we find no self-styled or self-conscious Realist Movement to provide us with any orientation towards the nature of a potential Realist style. In other words, when it comes to architecture or decoration we must use the term 'Realist' figuratively, analogically or metaphorically rather than descriptively. Pierre Francastel, for example, points out that Viollet-le-Duc's conception of the active equilibrium of medieval edifices, and his promulgation of its principles was 'coloured by a mechanistic rationalism by means of which that attitude is connected to contemporary positivism in philosophy and realism in aesthetics'. Sir John Summerson has also made out a good case for Viollet-le-Duc as a Realist, by comparing him in certain respects with the Impressionists:

> The history of modern painting is usually held to begin with the impressionists, and it may be said that they and Viollet-le-Duc had at least this much in common – they were determined realists. Viollet wanted architecture to conform with the conditions imposed by modern scientific discovery; he was ready to use cast-iron and to use it in forms appropriate to industrial production, with precision and economy. The impressionists were equally anxious to be hard-boiled – to meet the challenge of Science. Pissarro got hold of the spectroscopic theories of Helmholtz and Drude [sic] and, with Monet, applied them to the business of painting – at least to the extent of being determined *plein-airistes* and arranging their palettes in conformity with the doctrines of vision which Science had placed at their disposal.

But here, quite wisely, Sir John Summerson feels forced to bring his comparison to an end with a distinction: 'But there all similarity ends. Viollet's designs were intellectual solutions overshadowed all

the time by the analogy with Gothic. Pissarro and Monet were intuitive artists of a younger generation, and if dabbling in optics gave them a stimulus and a bent that is all it did.'

Despite the necessity for all sorts of qualifications, architectural and cultural historians have tended to imply, if not assert, that there was indeed a clearly defined clash between 'Realist' and 'non-Realist' modes of architecture and theory during our period of the nineteenth century, and tend to view the 'Realist' outlook as the forerunner of a twentieth-century Modernist architectural ethos. Such a vision of the situation was of course at times expressed by nineteenth-century writers themselves. *'Ceci tuera cela, le fer tuera la pierre'* : when Claude Lantier in Zola's *Le Ventre de Paris* (1873) uses these words to oppose the glittering iron and glass of Les Halles to the crumbling Gothic stonemasonry of the adjacent Saint-Eustache, he is speaking not in tones of Ruskinian despair, but with a vigorous, materialist optimism; and he quite naturally equates this innovative, utilitarian architecture, the architecture of the future, with the combative anti-traditionalism of the Realist movement – 'Come now, there's a ready-made manifesto: modern art, realism, naturalism, whatever you want to call it, grown up in opposition to the old art' – seeing the new iron and glass market-hall as the vital force of a new social reality, akin to the great heaps of produce, part of the surge of men, food, buying and selling, the vigorous structures supporting and sheltering the burgeoning energies of a new urban pantheism, and as such, opposed to the crumbling, time-eroded architectural remnants of the old order, no longer socially integrated, although still playing their role in an even more expansive framework of universal catabolism.

Françoise Choay has described Baron Haussmann's attempt, and those of nineteenth-century city planners in general, to replace the outmoded and obstructive 'syntagmatic' urban patterns whose natural order was determined by relationship to other concurrent systems within the social order as a whole, with a more 'realistic' kind of city plan, a conscious and considered attempt, on the basis of objective analysis of contemporary need and function, to 'regularize' – Haussmann's own word – the city disordered by the onslaughts of the industrial revolution and its concomitants and at the same time 'to disclose' what Mlle Choay has termed 'its new order by means of a pure, schematic layout which [would] disentangle it from it dross'. This 'real' Paris which Haussmann sought to articulate was a 'huge consumer market', an 'immense workshop', which his plan would unify and transform, through rational systems of circulation, into an operative whole. Haussmann's conception of the city parallels to a remarkable degree that of Manet in his unfulfilled project for decorat-

ing the Hôtel de Ville with scenes from the *ventre de Paris*, as well as Zola's vast, imaginative projection of the 'consumer market' in his novel, *Le Ventre de Paris*. In the sense that Haussmann shared this outlook, he, like Manet and Zola, may be considered a Realist; but in the sense that he considered his analysis of the 'reality' of the contemporary situation only as a beginning, a mere starting point for a complex problem requiring a practical solution, the Realist metaphor begins to break down. For as soon as we approach architecture or city-planning, we confront problems which are at once more strictly utilitarian – did or did not Haussmann's plan work, adequately resolve the dilemmas posed by the contemporary situation in Paris? – and at the same time more abstract – i.e. how can we decide whether a given architectural language or conception is 'Realist' or 'non-Realist' – than those projected by a style or attitude in the visual or narrative arts.

Now of course, one can greatly simplify the problem of deciding about what might constitute a Realist architecture by constructing a simple binary system, rather like Gombrich's 'ping and pong', to which one might 'instinctively' consign various architectural characteristics or dimensions. Let us attempt to set up such an 'instinctive' Realist versus non-Realist opposition:

Realist	*Non-Realist*
Simplicity	Complexity
Functional vocabulary	Decorative vocabulary
Scientific	Artistic
Revelation of purpose	Concealment of purpose
Revelation of structure	Concealment of structure
Engineer's architecture	Beaux-arts architecture
Iron and glass	Stone and timber
Pure form	Symbolic form
Austere	Ornate
Contemporary	Historicizing
Modern style	Eclectic style
etc.	

Obviously, this sort of dichotomy raises a great many difficulties. In the first place, we seem to be ending up with a conception of 'Realist' architecture which sounds a great deal more like twentieth-century Modernism than nineteenth-century Realism, and in the second place, a great deal of the most original architecture of the nineteenth century – an architecture peculiarly rooted in its own times and their novel requirements – would automatically be relegated to the non-Realist category: indeed, this is precisely what the prophets and

architectural messiahs of the First Machine Age did, mainly on the basis of *their* own peculiar needs as forgers of a new, twentieth-century architectural style.

But even within our oversimplified system, certain difficulties immediately emerge. For example, our ping-pong reflexes would immediately force us to consign Les Halles to the Realist category and the Paris Opéra to its opposite: Les Halles uses modern materials, is relatively undecorated, does not employ an historical vocabulary, reveals both its structure and its function or purpose; as opposed to the pretentious neo-Baroque, ornately decorated, complex forms and symbolic pomposity of the Paris Opéra. Yet of course one must be wary of equating 'realism' with a reductivist conception of 'function' characteristic of Le Corbusier or Sigfried Giedion but quite foreign to many of the most innovating architectural minds of the nineteenth century. One must always ask 'functional for what?'. In which case, the Paris Opéra, in its effulgence of neo-Baroque ostentation, its purposely small *salle* (its anti-democratic selectivity and poor stage but excellent audience visibility were explicitly demanded by the specifications), its enormous audience-displaying staircase, were all supremely 'functional' in playing the role of providing an appropriate shrine for *nouveau-riche* conspicuous consumption and display during the French Second Empire; even the provision of many little private rooms in which ballerinas or divas could entertain their admirers was certainly functional enough in the particular situation. Thus, the Paris Opéra is a fine example of 'realistic' functionalism, if we take into account the symbolic and iconographic dimensions of 'function' as well as the strictly utilitarian ones: but in this case, the parallels between Realist art and literature and a would-be Realist architecture no longer seem either workable or fruitful: any 'good' architecture would be 'realistic', and 'realism' becomes an empty category. Or, let us take the notion of Realism in architecture being in some way connected with a building's revelation of its purpose – for example, a bank should look like a bank and not like a Greek temple; a railway station should look like a railway station and not like a Roman bath. Certainly, the demand that a building reveal its function and not 'pretend' to be something which it is not comes very close to the demands for honesty and sincerity on the part of Realist writers and artists, and which we will discuss in relation to architecture and the decorative arts in greater detail below. But in what sense can a building be said to 'look like what it really is'? In the case of a church, one might, like Pugin, argue with a great deal of justice for the Gothic style as being more 'honest' or appropriate than a Neo-classical or Georgian one; designers of synagogues, with the same sort of his-

torical or geographic, rather than essentialist, interpretation of 'honest' revelation of the nature of the building, have often opted for some sort of middle-Eastern reference: bulbous domes, horseshoe arches or exterior tile-work, perhaps some twisted columns and a vaguely Islamic decorative scheme. Yet aside from making a Christian Church in the shape of a cross, a Synagogue in the shape of a Torah – an actual fact in the author's own neighbourhood! – or a hamburger stand in the shape of a hamburger – most kinds of 'honest' revelation of purpose or social function in architecture rest heavily on associative rather than 'realistic' criteria. In the case of relatively new architectural types, a kind of hidden associationalism is generally allied with a *manifest* or ostensible essentialism in this cry for revelation of purpose or function. In what sense, for example, may a bank be said to look like a bank? Is there some essence of 'bankness' that Realist architecture would presumably embody in its formal qualities? Are there certain activities carried out in a bank, or a certain Platonic Idea of Banking, which actually demand certain specific kinds of formal-expressive structures rather than others? In the nineteenth century, a bank might well look like a Greek or Roman temple or a Renaissance palazzo, in the twentieth century, like a factory, a supermarket or a drive-in theatre: any or all of these could carry out their functions and inspire the necessary confidence – or give rise to the notion of 'bankness' – in their clients. Obviously, the whole notion of 'realistic' architectural expression of function, or *'architecture parlante'* depends on when and to whom one is doing the speaking. Is it more 'realistic' for a house to look like a factory or a cube than like a Cosy Cottage, a Palladian villa, or a railroad car? Only to the apologists for the architectural principles of the First Machine Age, with their doctrines of purity, 'functionalism', simple form in space and disdain for decoration or symbolism.

It is obvious that the binary system of 'realist' architecture is formulated around stipulations that are neither descriptive nor strictly aesthetic, but, like all mythologies, hide decidedly moral and ethical biases beneath a stylistic façade, and are in no sense necessarily connected with the complex situation which existed in architecture around the middle of the nineteenth century, when questions both of new needs and new vocabulary to express these needs – structural, social and expressive – were a burning issue in architectural circles. Certainly, as Summerson has pointed out, this was an age of doubt and burgeoning self-criticism beneath the optimistic veneer of progress.

It is, perhaps, both more fruitful and less presumptuous in attempting to work out an equivalent for Realism in architecture, to abandon the simplistic 'binary' system and simply try to examine architecture

along one of the dimensions of Realism which we considered in the first chapter and examined in greater detail in chapter 3: the demand for modernity, for an architecture suitable to and bodying forth contemporary life, in other words '*il faut être de son temps*', architecturally speaking. The demand for contemporaneity was certainly as strong in architecture as in art or literature: here too, the historical outlook, with its emphasis on objective consideration of the past, led to a sense of the present as a 'period' defined by special needs and by relative, rather than absolute qualities, set off from those which had preceded it. Yet here again, there is considerable latitude, not to speak of sharp contradiction, about what constituted a contemporary architecture as such. A new style? (The King of Bavaria actually organized a contest for the invention of one.) New constructional methods or materials? New building types? A new formal language? A new emphasis on the primacy of structure? Peter Collins has suggested and documented the complexity of this issue in his excellent account of 'The Demand for a New Architecture', a chapter in *Changing Ideals of Modern Architecture*, so the present discussion will be restricted to major issues.

On the one hand, the emphasis might be placed on the rational planning of new building types to meet new social needs or to ameliorate existing social conditions, building types often involving the use of iron or other new materials, and clearly based on functional and utilitarian considerations – in France César Daly and his *Revue générale de l'architecture* from 1841 onward offers a perfect example of this interpretation of contemporaneity – such modern building needs and accessories as railroads, electric telegraphs, heating, scientific plumbing, ventilation, detailed instructions for the use of iron and cast-iron, etc. Among the projects set forth in great detail and copiously illustrated in the pages of Daly's journal, are those for Primary Schools based on Mutual Instruction – there is a Fourierist cast to much of the social planning of these *actualiste* French architects – taking into account all the practical needs of this particular educational situation; a lengthy consideration of communal crêches, prefaced by an article by D. Laverdant on crêches in relation to the social problems of the day (1851) and followed by an essay on furniture for a crêche, emphasizing simplicity and suitability to purpose. Daly constantly maintains that architecture must fulfill contemporary requirements, and conceives of this need as determined by social consideration; traditional Beaux-Arts training he feels, is irrelevant to 'the needs and tendencies of the times in which we live'.

Looking backwards in 1860, Daly points out that the government, after the coup d'état of 1851, called for many projects of a social and public nature – baths and laundries, workers' housing (a major issue

in England as well, documented in Pevsner's classic article of 1943, 'Early Working Class Housing'), nurseries, shelters, public gardens, sewage systems, city planning and such; and the pages of the *Revue* during this ten-year period offer ample evidence of this sort of project. It is interesting how close many of the projects published by Daly, as well as his theoretical outlook, come to today's demand for closer contact between sociologists and architects, or for an architecture predicated upon social need and the decision of those who are to use it, rather than dictated by the stylistic *a prioris* of the artist-architect. Gilbert's Charenton Insane Asylum, a relatively new field of endeavour for architects in 1852, was based upon detailed programmes emanating from twenty years of study of the specific needs for the treatment of the mad by eminent physicians; the various projects for the Halles Centrales were examined in minute detail in relation to the governing needs of a central market place for modern Paris; new needs created new forms, in the case of the Asile of Vincennes for convalescent workers, planned by Laval, who attempted to make the shelter as pleasant as possible, by linking it with the surrounding countryside. 'In an establishment with a new destination, without any precedent, prudence advises us to leave the field open to experimentation', comments Daly in 1858. Of course, Daly admits that while utilitarian, rather than stylistic, questions must predominate in his own time in the question of contemporary architecture, this does not mean that the ideal is to be indefinitely neglected. In 1860, he writes: 'From today's great practical work will come greater knowledge of the resources of modern science and industry.' It was not to *'faire de l'art* that Paxton, the English gardener, proposed to construct the Crystal Palace for the Great Exhibition of 1851 in glass and iron', he maintains. Yet far from decrying this triumphant utilitarianism, he feels that architecture is in a transitional era, and that 'our architects may be instruments of a great renewal without being aware of it'.

Now the whole question of the Crystal Palace brings into focus the complexity of what constituted the very nature of contemporaneity or modernity or of being of one's times in the mid nineteenth century in architecture. While a Modernist critic like Sigfried Giedion may see the Crystal Palace as the very model of contemporaneity in mid nineteenth-century architecture – the first expression of the possibilities dormant in modern industrial civilization in architectural form – and view this brilliant solution to a tremendous practical problem, combining wood, glass and iron as evocative of a 'new kind of imagination which sprang directly from the spirit of the age'; if the popular press and the public went wild about Paxton's marvellous construction, one critic referring to it as 'a precept inspiring as the

Parthenon, an exemplar vital as the Pont du Gard . . . as important as Stonehenge or Ely Cathedral', and even the sober *Times* praised its 'glittering arch far more lofty and spacious than the vaults of even our noblest cathedrals' (2 May 1851); if Thackeray, in his 'Ode on the Opening' termed it 'A palace as for a fairy prince'; and if a foreign visitor went so far as to maintain that 'the Crystal Palace is a revolution in architecture from which a new style will date' (Lothar Bucher, 1851), still, England's most respected architectural critic at the time refused to consider it – or indeed, any structure made of glass and/or iron – as architecture at all. For John Ruskin the Crystal Palace was ineligible to be even judged as architecture because, first of all, it was made of glass, and 'perfect and refined form' could only be expressed in opaque matter. Since all noble architecture depended for its majesty upon its form, asserted Ruskin, 'therefore you can never have any noble architecture in transparent or lustrous glass . . .' As for the amount of human thought which entered into its making, a crucial factor in the value of the work of art, or, in this case, architecture, in Ruskin's view: 'The quantity of thought it expresses is, I suppose, a single and very admirable thought of Sir Joseph Paxton's, probably not a bit brighter than thousands of thoughts which pass through his active and intelligent brain every hour – that it might be possible to build a green house larger than ever green house was built before. This thought, and some very ordinary algebra, are as much as all that glass can represent to human intellect.' One man's triumph of contemporaneity is simply another architectural critic's overgrown greenhouse, not even worthy to qualify as architecture at all. Style in architecture, for Ruskin, was not something that could simply be invented to 'go with' or express a modern civilization; '. . . the very essence of a Style, properly so called, is that it should be practised *for ages*, and applied to all purposes; and that so long as any given style is in practice, all that is left for individual imagination to accomplish must be within the scope of that style, not in the invention of a new one.' (*The Two Paths* delivered 1858–9, published 1859.)

Here, certainly, we have the rationale for what to Modernists – or many of today's students of nineteenth-century architecture – is a paradoxical equation of modern style and contemporary expression with medieval mystique and gothic vocabulary. Yet within one faction of those demanding an architectural rebirth in the nineteenth century, there was no necessary contradiction in this linking of the modern to the medieval. The nexus between the two might well be social as much as formal – indeed, Gothic architectural style and medieval life style might be viewed as aspects of a unitary, much-needed reorientation of the mode of contemporary life itself: for Ruskin, the triumph and

eternal viability of the Gothic style, even its so-called 'grotesquerie' were 'signs of the life and liberty of every workman who struck the stone; a freedom of thought, and rank in scale of being, such as no laws, no charters, no charities can secure; but which it must be the first aim of all Europe at this day to regain for her children' (*Stones of Venice*, II, 1853); Pugin seems to have anticipated Ruskin in even more insistently basing the claims for a return to the principles of a Gothic or 'Christian' architecture on the exemplary life-styles or religious attitudes of its creators, '. . . men who were thoroughly imbued with devotion for, and faith in, the religions for whose worship they were erected. . . . They felt they were engaged in one of the most glorious occupations that can fall to the lot of man – that of raising a temple to the worship of the true and living God. It was this feeling that operated alike on the master-mind that planned the edifice, and on the patient sculptor whose chisel wrought each varied and beautiful detail . . .' Even Viollet-le-Duc, whose revolutionary demand for contemporaneity based on modern need and function seems much more rooted in rational analysis of Gothic principles than emotional attachment to their social context, declared, as a natural sympathizer with 'le peuple' in his own day, that he placed his trust in the Gothic working man. The connection of William Morris's aesthetico-socialist solution to contemporary problems is inextricably bound up with his admiration for the democratic-cooperative mode of life of the Middle Ages: the force of his vision is remarkably prophetic of the demands of today's revolutionaries for a return to natural life, handicraft modes of production, the small face-to-face group or commune as the social unit, and trust in the instincts of the people to determine the nature of their own destinies. 'What business have we with art at all, unless all can share it?' asks Morris. Art, in Morris's view, must be for the people, not for the connoisseur; it must be by the people and not by 'unassisted individual genius', as Pevsner has pointed out. 'And this is how it was with art in the Middle Ages, and unless such conditions can be restored in our own times, there is no hope of a decent art or a decent life.' Morris was most interested in architecture as the result of a 'work of co-operation', and his credo for the present was the outcome of his veneration for the Middle Ages, when buildings were 'the work of associated labour and thought of the people'. Morris believed that as far as building for his own times was concerned: 'There is only one style of architecture on which it is possible to found a true living art . . . and that style is Gothic architecture.'

Morris's particular association of Gothic stylistic and social virtues with contemporary need is strikingly analogous to an important new direction in architectural thinking of the present day: the looking

back to group tradition and anonymous local structure for the inspiration for new urban planning, a granting to groups of local people the right to work out their architectural destinies for themselves in terms of their own experience instead of entrusting them to some knowledgeable, objective authority or superior 'great architect' ('carefully guarded from the common troubles of the common man', to use the words of Morris). A recent publication like Paul Oliver's (ed.) *Shelter and Society* (1969), finds models and prototypes for contemporary architectural problems in primitive and vernacular architecture, architecture created by anonymous groups, based upon a traditional social-symbolic – rather than an objective-scientific – conception of function. Today, in the wake of the Technological Revolution, many urban planners base their ideas on that same sort of nostalgia for the anonymous art and 'intuitive' wisdom of the people, characteristic of mid nineteenth-century artists and architectural theorists caught in the toils of the Industrial Revolution. Courbet's admiration for the Imagerie d'Épinal and Morris's adulation of the art and life of the cooperative communities of modest medieval craftsmen and their upholding of both as the models of a contemporary art and life style are not really so different from the motives and ideas which inspire the contributors to Paul Oliver's volume. It is precisely this attitude towards contemporaneity in architecture that was so stringently rejected, until very recently by this century's Modernist architects who felt, in the words of Oliver, 'that the many years of struggle for an attitude to architecture appropriate to an industrialized society was incompatible with any sympathy for vernacular forms'. Even in the instances when vernacular architecture was appreciated in the twentieth century by architectural Modernists, it was generally in order to support the dictum 'Form follows Function', for supposed virtues of simplicity and revelation of structure: formal virtues, on the whole. But today, architects, structural anthropologists, sociologists, urban-planners, community workers and so on are going much further in this derivation of contemporary planning from the vernacular or the local traditional, in some cases trying to recapture, in modern terms, that total cohesiveness characteristic of the traditional community in which buildings and aggregations of buildings were expressions of the societies which built them. In other words, they, like their nineteenth-century predecessors, are trying to restore to contemporary life that intimate relation between culture, shelter and individual, which Pugin, Ruskin or Morris sought out in the Middle Ages.

For the present-day champions of anonymous, traditional or vernacular architecture – like medieval architecture in the eyes of

nineteenth-century champions, an 'architecture without architects' – the previously rejected, 'outmoded', traditional open courtyard houses of Iraq have now been rediscovered as functionally and socially superior to their modernized 'Western' replacements; the formerly 'congested, filthy, formless' Walled City of Old Delhi is now re-evaluated as uniquely suited both physically and psychologically to the life style of the poor of urban India, and indeed, a vital element of its communal institutions – a marginal environment is now considered to be a rich one; the South American Barriadas, formerly rejected out of hand as cancerous suburban slums have been revealed through painstaking and sympathetic investigation to be, in many cases, the vital and organic outgrowth of local community self-help movements, bestowing not only shelter, but a new sense of worth and dignity upon their uprooted creators and inhabitants; the unauthorized peripheral *banlieue* mushrooming on the outskirts of Athens are held up as heroic examples of 'dynamism and creativity' in the face of almost insuperable bureaucratic opposition. Going even further in the current trans-valuation of architectural values, architects and planners in the United States are attempting to give local 'slum' communities a chance to preserve what they consider to be the valuable features of their environment against the inroads of faceless, authoritarian and paternalistic 'slum clearance' and unsatisfactory public planning imposed upon its victims from above, by instituting the system of 'architectural advocacy', where the architect simply speaks for the local people and their ideas of what they would like to hold on to or to improve; sometimes, architects and urban planners try to forge a new kind of contemporary architecture or city planning out of the materials of urban or technological reality itself, so to speak: but those segments of it most despised or ignored by Modernist theorists and critics. Robert Venturi and Denise Scott-Brown, for example, have looked for inspiration to Levittown, the Sunset Strip, or Las Vegas – what might be called the reality of the contemporary American building scene, adapting elements from it into their more sophisticated plans in much the same way as Pop artists, also realists of a sort, incorporated previously-despised elements of commercial and mass-art into their productions. Is it they or Le Corbusier in the Unité d'Habitation at Marseilles who is creating a realistically 'contemporary' architecture? Or is it, once more, that the nature of modern reality itself has radically altered since the Second World War, and along with it, our interpretation of the nature of the humanly good and viable ultimately underlying the notion of architectural reality itself?

Even that mid nineteenth-century architectural sub-style which might seem to be the least concerned with contemporaneity – Eclec-

ticism – a term proposed almost simultaneously in 1858 by both César Daly in France and G. G. Scott in England – made a good case out for itself as both 'realistic' and 'contemporary', above all, to those who were neither out-and-out Gothic revivalists, nor, on the other hand, able to accept 'mere engineering' or the functional use of new materials for new needs as all there was to architectural creation. Indeed, some of those whom we have already referred to as *actualistes* in another context could also, without any felt sense of contradiction, call for an eclectic basis for the new modern style: a group of architects in Daly's *Revue générale*, four months after the 1848 Revolution, proclaimed their liberty to use 'the whole architectural vocabulary', and, as S. Lang has recently pointed out in an interesting article, 'Richard Payne Knight and the Idea of Modernity', the very notion of 'modernity in architecture' was originally conceived as a 'mixed style'. Says Lang of the eighteenth-century architect: '. . . he wanted to be modern, but the idea of throwing overboard all these styles of the past and creating one of the present never occurred to him. . . . For Knight there was only one way to "create" a new style – by mixing the existing ones . . .' While the desire for 'modernity' in architecture increased as the nineteenth century progressed, it was still formulated, for example by T. L. Donaldson, as some sort of mixed style; even the often-despised G. G. Scott was apparently not merely trying to veil the distasteful facts of modern life with a mishmash of traditional leftovers, but, at least early in his career (1858), trying to evolve some sort of modern style based upon a judicious use of the elements of the past: '. . . We aim not at a dead antiquarian revival, but at developing upon the basis of the indigenous architecture of our own country, a style which will be pre-eminently that of our own age, and will naturally, readily, and with right good will and heartiness, meet all its requirements, and embrace all its arts, improvements, and inventions.' However stilted the language, the programme set forth is not so different from that of a domestic architecture of disposable standard-of-living-packages (phrase and concept courtesy of Buckminster Fuller) or portable airdome units proposed by Reyner Banham for the United States, based on the technological 'improvements and inventions' as well as the natural predispositions for novelty, out-of-doors living and travel of its inhabitants, nor Vincent Scully's contention that an indigenously American, rather than an International Style, traceable to the dwellings of nomadic Indian tribes, the makeshift shacks of pioneers and prospectors, the relatively flimsy stick and shingle styles, apotheosized in Frank Lloyd Wright's early Prairie Houses, furnishes an architectural model appropriate to his fellow countrymen in the second half of the twentieth century.

The very idea that one could create a new or modern style at will, starting with a *tabula rasa*, seemed monstrous to many nineteenth-century architectural thinkers, even relatively 'advanced' ones, who, because of the very richness of their own historical backgrounds in this most historically-aware of periods, realized how profoundly style must be related not merely to abstract desire for novelty, but to stern demands of race, milieu and moment – i.e. to national-historical character and environmental conditions, and who were making it clear that architecture, like all other cultural artefacts, and the *Weltanschauung* itself, were not absolute rational choices, but products of evolutionary forces. How then could one, in this historically deterministic frame of reference, hope to create a new architectural style *ex nihilo*? Whether or not he was actually responding to the King of Bavaria's remarkable proclamation of an architectural competition for the invention of a new style (as recently suggested by L. D. Ettlinger), the erudite German architect Gottfried Semper, aware of the crucial role of architectural evolution and tradition in the creation of *any* style, was properly indignant when he pronounced, while staying in London at the time of the Exhibition: 'First provide some new notion, afterwards we shall find out how to express it in terms of architecture. For the present we must be content with the old.' In 1858 even G. G. Scott – hardly a radical modernist – was aware that buildings 'whose uses and origins belong . . . to our own day have . . . a claim to be treated in a manner at once new and characteristic of the age which they represent,' yet felt that 'no age of the world has ever deliberately invented a new style, nor yet made use of a style for one class of buildings different from what it applies to others.' Ruskin was equally scornful of the pretentions of young architects to 'invent' a new style. 'Perhaps the first idea which a young architect is apt to be allured by, as a head-problem in these experimental days, is its being incumbent upon him to invent a 'new style' worthy of modern civilization in general, and of England in particular; a style worthy of our engines and telegraphs; as expansive as steam, and as sparkling as electricity. When our desired style is invented, will not the best we can all do be simply – to build in it? – and cannot you now do that in styles that are known? . . . If you will think over this quietly by yourselves and can get the noise out of your ears of the perpetual empty, idle, incomparably idiotic talk about the necessity of some novelty in architecture, you will soon see that the very essence of a Style, properly so called, is that it should be practised *for ages*, and applied to all purposes . . .' Yet, despite his seemingly outright rejection of 'contemporaneity', as Summerson has recently pointed out, Ruskin might stand for a certain rather important branch of contemporaneity-as-an-ideal, which we

today might tend to lump together with eclecticism, but which English architectural theorists of the time, like Robert Kerr, certainly distinguished from it: what was known as 'Latitudinarianism' – a sort of 'free trade' style, or rather 'a flux of styles', to use Summerson's words, sometimes with an Italian, sometimes with a modern French base. 'Whichever base was taken there was liberty, liberty, liberty – liberty to introduce polychromy in brick and tile, naturalistic ornament, and caps and bases not at all unlike the illustrations in *Stones of Venice*.' Indeed, as Summerson points out, it is to this 'latitudinarian' sector that most of the architecture of about the sixties and seventies that we think of as most typically 'Victorian' actually belongs – in other words, it is the most outstanding, widespread and typical 'contemporary' style of mid century England: the architecture of hotels, apartment houses, railway buildings, offices and warehouses.

TRUTH AND HONESTY
IN ARCHITECTURE AND THE DECORATIVE ARTS

Architecture

The call for truth, honesty and sincerity, so often associated with nineteenth-century Realism in art and literature, was also heard in the realms of architecture and the decorative arts. As early as the 1840s Pugin was inveighing against the dishonest concealment of architectural members, declaring that 'architectural skill consists in embodying and expressing the structure required, and not in disguising it by borrowed features'; the same moral overtones are characteristic of his remarks about the 'modern deception' of plaster used for any other purpose than coating walls, the 'deceptive' use of cast-iron, when painted to look like something else, or wooden groining decked out to look like stone. Peter Collins points out that as early as 1805, the architect John Robinson had 'drawn attention to the truthfulness of Romanesque timber roofs' where the structural parts were 'exhibited as things understood and therefore relished'. One of Ruskin's *Seven Lamps* is the Lamp of Truth, and, demanding honesty both in the use of materials and in structure, he inveighs against architectural deceits considered under three headings: 1) Structural deceits – 'the suggestion of a mode of structure or support, other than the true one'; 2) Surface deceits – 'the painting of surfaces to represent some other material than that of which they actually consist . . . ; 3) Operative deceits – 'The use of cast or machine-made ornaments of any kind.'

The language of some of these architectural theorists sounds suspiciously close to advice to young ladies in contemporary handbooks

of deportment: a moral building, like a proper young woman, should not try to 'paint' herself into a deceitful beauty by hiding her real looks, she should not try to appear above her station in life through assumed airs and graces; she should be modest and not gaudy, she should not try to model her actions and appearances upon a modish, passing style. Indeed, one may well agree with Peter Collins, when he states: 'Perhaps the most influential aspect of Gothic Rationalism was its ethical message expressed in its emphasis on "truth".'

The assimilation of the aesthetic or formal, to the moral imperative – truth, honesty, lack of deceitfulness or 'cheating' – is perhaps carried to an extreme, though in a somewhat different way, in the work of the mid century architect, William Butterfield. For the creator of All Saints, Margaret Street, as for Courbet or for Dickens, truthfulness to the facts demanded coming to grips with unpleasant realities, be they social, literary, perceptual or in this case structural, exacting the sacrifice of judicious taste for the sake of that forceful, ruthless but unrelentingly honest 'ugliness' of expression, which John Summerson has pointed out is characteristic of the Camden architect.

In America, these ethical-architectural demands, perhaps traceable to the influence of Pugin himself, were directing principles in the domestic architectural programme of Andrew Jackson Downing, who, in his influential *Cottage Residences* of 1842, in the course of developing three major architectural principles – Fitness or Usefulness, Expression of Purpose and Expression of Style – equates expression of purpose with 'truthfulness', that is, a building's revelation of exactly what it is: a house should look like a house, a bank like a bank and a barn a barn, and the same style should not be used for all of them. Downing was naïvely convinced that he knew precisely what features to emphasize in order to express the 'purpose' of domestic architecture honestly: 'the most prominent features conveying expression of purpose in dwelling houses are the chimneys, the windows, and the porch, veranda, or piazza . . .' As Vincent Scully has pointed out, Downing, by emphasizing 'truth' – which he identifies with the picturesque at this moment in architectural history – places himself 'in the main stream of the new moral, and at the same time basically rational and socially conscious phase of the Gothic Revival'. In *Country Houses* of 1850, the American architect subdivides truth in three different ways: general truth – 'that the building is intended for a dwelling house'; local truth – 'that it is intended for a town or country house'; and specific truth – 'that it is intended for a certain kind of country house – as a cottage, farm-house or villa.' Both iconographic-moral and formal-structural elements may be assimilated to the concept of 'honesty' or 'truthfulness': for example, the wooden

cottage should not attempt to imitate its betters and pretend to be a villa; and, at the same time, it should assert the 'nature of its material' through vertical rather than horizontal boarding: 'The main timbers which enter into the frame of a wooden house and support the structure, are vertical, and hence, the vertical boarding properly signifies to the eye a wooden house; It is as incorrect, so far as regards truthfulness of construction, to show horizontal lines on the weather-boarding of a wooden house, as it would be to mark vertical lines on the outside of a brick or stuccoed wall.'

It seems no accident that the word 'real', if not the term 'realism' itself, should be associated with this standard of architectural morality. The word 'real' is used by the architect Gervase Wheeler to describe the design for a Plain Timber Cottage Villa in Maine, in reference to its simplicity, fitness of construction and the revelation of that construction on the exterior; as Scully points out, the word 'real' in architecture stems directly from the first issue of the *Ecclesiologist*, the organ of the Camden Society, in 1841, in which architectural reality was equated with morality in no uncertain terms, in religious edifices: '. . . in God's House everything should be real.' Thus 'reality' – i.e. truth, honesty, bluntness – set itself up as a new kind of architectural *desideratum*, often, as in the case of Realism in the arts and literature, and as we have seen in the brutally powerful style of Butterfield, in opposition to established 'good taste'. As Scully points out, this sort of 'reality' was central to American architecture, indeed, to American creative endeavour as such. Downing 'was attempting to do for architecture what Whitman was soon to attempt to do for the experience of life in America, and it was in this double, rather poignant, meaning that "reality" was later to become the central word of Sullivan's and Wright's architectural philosophy.' The association of this simple, truthful, unpretentious wooden style with a quiet, unpretentious, honest, and hence 'real' *agrarian* way of life, as distinct from an urban one, the vision of an America composed of farms and villages, full of space, air, fields and trees – the Jeffersonian Utopian nineteenth-century dream of America, in short – is of course, rich in analogies with certain attitudes and presuppositions of the Realist movement in Europe which we have discussed in chapter 3, in which the values of the land, the country, and the peasant are contrasted with their opposite numbers in the sinister urban-industrial environment.

The Decorative Arts

It is in the unlikely soil of the decorative arts – furniture, carving, crafts, pottery, book illustration, textiles, weaving and wallpaper –

that the seeds of the avant-garde mystique were sown in the second half of the nineteenth century. It is here that the Realist virtues of honesty, contemporaneity, truth, directness and authenticity begin most discernibly to take on the Modernist implications which they have retained to this very day, for it is here that the independence of the *means* of art – the determining role of language, or formal structure *qua* language – begins to become a part of aesthetic theory: the nature of the material determines 'truth' and the properties of the flat surface to be decorated determine 'honesty'. It is also in the realm of the decorative arts, mainly in England, that the conflicts and ambiguities inherent in the Realist position begin to reveal themselves synchronically, just as they do, historically, in the split between Impressionist and Post-Impressionist attitudes in the 1890s.

The decorative arts are the ideal arena in which to examine the nature of these 'inherent' theoretical conflicts, because the so-called minor arts themselves, almost by definition, involve a yoking together of both representation, traditionally associated with the visual arts, and abstraction, generally considered inherent to the architectural ones. Both naturalism and stylization have almost always played their role in decoration, though of course, to what degree which side of the equation will dominate may vary radically from period to period, context to context, style to style. The decorative arts, and any consideration of them, must also involve that slippery concept 'taste', which certainly has a role to play in the shift from a Realist to a non-Realist – or Post-Impressionist or Symbolist, or later, Modernist, abstract – outlook. It is in the realm of the decorative arts that the anti-narrative, anti-anecdotal, anti-naturalist, anti-illusionistic, anti-historical bases of Modernist High Art are first and most clearly articulated, and first accepted; and it is in this area that the Realist virtues of probity, honesty, sincerity, straightforwardness and directness are 'transvaluated' so that they now have their present 'avant-garde' meanings. This is not, of course, to say that abstract art, symbolism, formalism and avant-gardism generally did not have a great many other roots and sources: the genesis of avant-garde values is one of the most complex problems confronting anyone who deals with the late nineteenth and early twentieth centuries; it is merely to say that the decorative arts are perhaps more important in considering the evolution of a self-conscious Modernism than has generally been thought, and they are especially interesting in a study of Realism, or rather, even more interesting when we begin to wonder whatever happened to Realism.

Realism, as a vital and progressive movement in art, begins to lose steam in the eighties, although it may linger on as a progressive force

in certain special circumstances, places, or in the work of specific artists and writers for much longer. But generally speaking, in the visual arts, it had given way to new directions and new aesthetic outlooks by this time; by the twentieth century, either its values have been transvaluated to yield quite other implications in the work and theory of the avant-garde, or have shifted over into other media – like photography or the film – where the honest representation of modern life in an accurate and detailed social setting may still have progressive implications. Otherwise, Realism of the mid nineteenth-century variety is either a symptom of a retardataire sentimentalism, or the official, and generally highly idealized, art style of authoritarian regimes, such as so-called 'Social Realism' which is not Realism at all but a very idealized sort of naturalized Neo-classicism, or else a type of latter-day regional or provincial flowering of impulses similar or analogous to those embodied in nineteenth-century Realism, in movements like those of the American Ash-Can School, or German *Neue Sachlichkeit*. We shall examine the fate of Realism, tracing it to its initial inner 'contradictions' – characteristic of course of *any* style of sufficient complexity to be interesting – in greater detail below. Now we shall turn to an examination of the decorative arts, and the problems they offer about deciding in what ways, and in terms of what qualities or principles, they may be considered 'realist', as well as the way in which they played a crucial role in determining the character of Modernism.

 While the conflict between sensitive artist and unappreciative public, between poet and philistine, between aristocratic dandy or proletarian Bohemian and *juste milieu* bourgeois can be traced back to the genesis of the Romantic movement, which created a whole mythology of the misunderstood artist, and certainly was solidified in the overtly combative stance of Realists like Courbet or Zola, and given concrete expression in the *Refusés* or the rebellious *Société anonyme des artistes peintres* . . . dubbed 'Impressionists', or in little groups like the Pre-Raphaelites, one may say that at least one aspect of the opposition between the formal, social and ethical values of the artist – or man of taste – and those of the predominant society was crystallized in England, in the middle of the century, and perhaps, even more exactly, around the nexus of the Great Exhibition of 1851. The conflict centres around the issue of 'taste', yet of course, it implies far more than taste, or rather, one may say that by the middle of the nineteenth century, taste itself begins to have vastly expanded significance, becoming a tremendously important means of social distinction-making. Now it is quite true that almost from the beginning, as Pevsner and Alf Bøe have pointed out, there were those, who like, perhaps,

Wedgwood, and certainly and even more deliberately Henry Cole, Digby Wyatt, Owen Jones and the whole *Journal of Design* group, and, unlike Ruskin and Morris, felt, perhaps with undue optimism, that good design and machine production – i.e., taste and mechanization – were not mutually exclusive; indeed, with the democratic optimism characteristic of the socially-conscious branch of Realism, they could even see the mass-produced object, if well and tastefully designed, as aiding in the spread and dissemination of good taste throughout a wider segment of the population than had ever been permitted to have taste at all – 'taste' which of course implies that one has the education and leisure to make such refined aesthetic choices. Yet although this democratic-technological branch of taste-reformation continued throughout the nineteenth-century, and finally crystallized in the theory and practice of the Bauhaus and the Machine Aesthetic, it basically conflicted with the Romantic-Symbolist notion, not by any means foreign to Realism itself, in a harsher sort of way – of those with taste, or more broadly, those who appreciated Art, as Outsiders, a beleaguered little band attacked on all sides by entrenched bourgeois interest and Philistine misunderstanding.

In its most exaggerated form, the artist saw himself as a Saint or Martyr in the cause of Higher Values and the Philistine masses as the party of the Devil. 'I believe in a last judgement where all those who in this world have dared to traffic in sublime and chaste art, all those who have dirtied it and degraded it by the lowness of their feelings, by their vile covetousness, by material pleasures, will be condemned to terrible punishment . . .' So begins Richard Wagner's credo, transcribed on the whitewashed wall of the room at Le Pouldu which Paul Sérusier shared with Paul Gauguin during the summer of 1889. While Courbet might have laughed coarsely at the high-flown sentiments expressed, he might also have sympathized with the underlying aggressive antipathy towards Establishment values, not too different from his own. One could almost adopt the terms Gombrich has used to distinguish Alberti's refined and advanced taste in the Renaissance from the less sophisticated admiration of sheer richness and glitter – i.e. more direct sensual appeal – of the Middle Ages, to describe the new canons of 'good' or avant-garde as opposed to 'philistine' or 'middle-class' taste in the decorative, and later the fine arts, during the latter half of the nineteenth century. Alberti, like the mid nineteenth-century dandy or aesthete, 'rejects the gratification of outward splendour [i.e. an Academic *machine* or a Great Exhibition machine-carved bog-oak chair] in favour of something more "dignified".' Alberti values the white wall not only for what it is, just as Morris values the flat-patterned wallpaper, or Émile Bernard the stylized,

unmodelled, heavily outlined painting – but for what it is *not*. (The first is *not* an imitation of three-dimensional flowers insensitively done by machine for Birmingham tradesmen, the second is *not* an illusionistic bit of salacious anecdotalism straight from the Salon for tired stockbrokers.) As Gombrich says, referring to Alberti's concept of Renaissance values, but equally applicable to avant-garde canons of good taste, truth, or pure art of the end of the nineteenth century: 'Art now stands in a cultural context in which an expectation aroused and denied can by itself become expressive of values.' And of course, the renunciation must, as Gombrich points out, be made in the name of 'higher values', and 'higher values' within the realm of art.

It is this sort of attempt at social differentiation through refinement, subtlety, renunciation and in-groupness of taste, when taste is no longer simply the inherited, bone-bred prerogative of a small, hereditary aristocracy, that led to the creation in the nineteenth century of the notion of Dandyism and the Dandy, that very epitome of the human-being-as-*objet d'art*, self-created by his own choice of image and costume. The dandy's costume, contrary to popular belief, was distinguished by its restraint. Colour and textures were subdued, greys or blacks and small, tasteful patterns were favoured, restraint was exercised in richness of material, flamboyance was generally avoided, distinction provided by subtle little niceties of detail or refinements noticeable mainly to other 'insiders'. In his mixing together of the aristocratic and bohemian versions of outsiderness, distinction and rejection, in his antagonism to philistine *juste-mileu* bourgeois values, in his loathing of modern science and industry and all that it implied, the dandy, both the Baudelairian and the English variety, was prophetic of avant-gardism: anyone, after all, can appreciate the 'feats' of an over-ripe naturalism, or richness, elaborateness, abundance and 'scientific' skill, that is, any old nouveau-riche industrialist or nouveau-middle-class greengrocer. It is only a deprived and self-denying 'avant-garde', highly self-conscious and aware of the intimate connection between aesthetic choices and moral-ethical ones – in other words, existentially sophisticated people – who can feel that as far as art and taste are concerned, less is *truly* more. Only a highly sophisticated male, for example, can appreciate thinness rather than opulent curves as sexually provocative, or a Morris chair over a bog-oak bit of cushioned symbolism cum 'hand' machine carving. In that complex coordination of 'peasanty' honesty and directness or revelation of function and structure, characteristic of Realism, meeting with aristocratic 'good taste', restraint and elegance in the burgeoning avant-gardes of the 1880s – somewhat before, in the realm of the decorative arts in England – we have the beginning of Modernism, in

both modern design and art, so characteristic of the taste and aesthetic values of the first half of our own century. It is no accident that the Nabis - an 'in-group' par excellence - were one of the first groups to articulate the new ethos of flatness and the triumph of the means of art over its former ends - an occult fraternity, half joking, half deadly serious about Art, in some ways like the Pre-Raphaelites but with a good deal more hocus pocus and none of the talk about contemporary subjects or honesty as real, painstaking faith to nature. Realist values have been transvaluated in the Nabi's credo.

Taste, advanced taste, by the eighties was, by definition to be the blessing of the chosen few, even though individual members of this coterie might be fiercely radical or indeed anarchist, in their social and political outlook, as Eugenia Herbert has suggested in *Artists and Social Reform*. The notion of an avant-garde of taste and art-creation cannot, by definition, be a mass movement, and the enemy was clearly defined. It was indeed by transferring the meaning of 'truth' and 'honesty' - first associated with the Realists' attempt to record their perceptions of contemporary reality - then used to connote the purity and distillation of the distinctively 'art' quality inherent in 'good taste' in the decorative arts, back into the area of the representational or High ones, that a sufficient degree of difficulty and arcaneness was created to separate the aesthetic sheep from the goats after the middle of the nineteenth century. Thus, the issues of taste, brought to a head by the Great Exhibition of 1851, were crucial ones, both in raising analogies to Realism in the decorative arts and, at the same time, in revealing the transvaluation of Realist values, like truth and honesty, generally.

Yet in looking over both objects and issues associated with the Great Exhibition we must ask ourselves in exactly what sense we may use the term 'realist', or the Realist analogy, in talking about the decorative arts: is it more appropriate to the naturalism and scientific accuracy-to-facts characteristic of so many of the more objectionably 'Victorian' artefacts or to that 'truth' to the nature of the material, the function of the object, or the literal surface to be decorated, associated with 'fact' by most advanced theoreticians of the applied arts at the time?

One can, on the one hand, relate the demands of the decorative reformers for honesty - i.e. flatness in design of wallpaper or carpets - to similar demands for truthfulness in Realism; on the other hand, a perfectly good case might be made out for simply accepting the 'scientifically' accurate naturalism of Victorian objects and textiles as the equivalent of a similar thirst for the transcription of natural facts in Realism. In this case, who can we say was more analogous to the

Realists in the representational arts: the decorative reformers or those they were revolting against?

Now of course, there were critics, artists and craftsmen who were certainly able to discern, if at times only dimly, that there was no necessary paradox involved in demanding scientific naturalism in the representational arts and schematized abstraction in the decorative ones as part of the same moral–aesthetic impulse towards truth and reality. The same person who demanded scrupulous, objective fidelity to the facts of perception in the natural world as a requirement of Realism in painting, might interpret 'truth to nature' in the case of a wallpaper or a carpet, to mean truth to the nature of wall or floors, 'fidelity' to mean faithfulness to the 'fact' of the flatness of the surface to be decorated, with no reason for inner conflict. It is perhaps no accident that William Dyce, one of the most minutely accurate of naturalists in his *Pegwell Bay* or *Welsh Landscape with Two Women Knitting*, could have demanded, only a little earlier, in his connection with the Schools of Design – in which he proved his competence, like a Bauhaus *Formeister*, with the Jacquard Loom and potters' wheel as well as with brush or pencil – an ornamental art, 'rather *abstractive* and *reproductive* than imitative' of nature, and stressed the need of the designer to 'anatomise' the works of nature, and, in drawing from it, to eliminate 'all their effects of light and shade, of surface or of material, *as an artist does*'. I have italicized the last phrase to emphasize how clearly Dyce, who was both an artist and designer, distinguishes between the artist's realism, or truth to nature, and that of the designer, or truth to the nature of the material, even if only in an embryonic sense.

Certainly, there was a distinct tendency within the decorative arts, starting in the 1840s in England, expanded in the *Journal of Design and Manufactures*, and brought to a climax in the writings and activities of William Morris, to demand stringent reform, if not radical revolution, and to conceive of this decorative reform or revolution in terms of a more abstract, decorative, and, in the case of flat surfaces, flatter style, which was supported by theoretical claims for greater truthfulness, honesty and lack of deceit, similar to that of contemporary architectural reformers. In their writings, if at times briefly and only in hints, we find the beginnings of that transvaluation of Realist truth and honesty to mean truth to the nature of the material, the beginnings of the moral and ethical establishment of the claims of the 'rights' of objects, surfaces or materials, to their own 'organic' kinds of expression, which is indeed one of the, if not the chief, foundation stones of Modernism.

Pugin, for example, as early as 1836 and 1841, had maintained that 'construction should vary with the material employed', and it is thus absurd in wallpapers to repeat 'a perspective over a large surface' and in carpets to use 'highly relieved foliage'; in 1849, the pages of Henry Cole's *Journal of Design and Manufactures*, reformist rather than revolutionary in outlook, declared that 'wallpapers must give the proper impression of flatness' and that 'carpets should not have Louis Quatorze scrolls, gigantic tropical plants, shown in high relief and suggestive of anything but a level or plane'. Matthew Digby Wyatt, in the same journal in the same year, in the context of a discussion of the principles of design, maintained that for an object to give pleasure, it should be fit for its purpose and true in its construction. Ornament should be related to the process by which the object is executed and to the position from which it will be seen. Thus a wallpaper made to cover a wall must 'give an impression of flatness'. R. Redgrave, in the same journal the following year, stated: 'A carpet, whilst it covers the floor, is also the ground from which all the furniture . . . [is], as it were, to rise; it should therefore be treated as a flat surface and have none of those imitations of raised forms and solid architectural ornaments so often seen'; Charles Eastlake, in his influential *Hints on Household Taste* of 1868, recommended unvarnished exposure of the natural grain of wood and strict flatness in wallpaper design. William Morris, of course, stated the requirements for flatness quite bluntly, as though by now there were no further need for explanation: 'As for a carpet design, it seems clear that it should be quite flat, that it should give no more . . . than the merest hint of one plane behind another.'

Yet at the same time, we must be wary of making out too strong a case for 'truth to the nature of the material' and the demand for flat or abstract ornamentation as a correlative of Realist truth or factuality on the part of the Victorian reformers. In the first place, too great a stress upon the opposition between a 'functionalist' view of honesty or truth to the facts and an imitative or naturalist one is much more likely to be a result of twentieth-century Bauhaus-Modernist critical prejudices than a dispassionate appraisal of the actual situation obtaining in the middle of the nineteenth century. Certainly, both the 'naturalism' of the horrid examples of Great Exhibition Victoriana – dessert dishes modelled directly upon water plants in Kew Gardens, curtain hooks made out of brass fuchsias and anemones, stork-supported tables or corn-handled bread-knives, not to speak of such dubious innovations in the field of bibeloterie as that taxidermist's tour de force, 'An Ermine Tea-Party', where the stuffed company goes through all the gestures of human bonhomie with a kitschy

verisimilitude that might well be the envy of Walt Disney – both this naturalism and the abstraction or stylization demanded of the decorative reformers, can be likened to what Pevsner (who is really decrying the thirst for naturalism in the decorative arts which reached its apogee in the Great Exhibition), calls 'the Victorian faith in facts': 'The generation of the exhibition was prouder of nothing more, and considered nothing more an original achievement all their own, than this scientific naturalism of foliage carving and modelling.' Yet this 'faith in facts' could just as well be embodied in the decorative reformers' attitude as in the excesses of the vulgar naturalists: Dickens aptly caricatures such a humourless insistence on 'the nature of the material' at the expense of the thirst for naturalism in his *Hard Times*, where 'fact, fact, fact' is the refrain of the Superintendent – modelled unflatteringly after Henry Cole – of the government School of Design, rebuking the innocent desire of little Sissy Jupe to carpet a room with illusionistic representations of flowers. That drive towards naturalism – characteristic of the capitals of a Gilbert Scott church; of Semper's praise of designs which borrow their forms from nature; of Ruskin's contention that 'whatever is in architecture fair or beautiful is imitated from natural forms'; inherent in F. M. Brown's plea for meticulously correct historical costume in the *Germ*; or W. H. Hunt's trek to Palestine in search of an authentic setting for his *Scapegoat* – is one aspect of Victorian 'faith in facts': 'truth to the nature of the materials' is perhaps another. While the latter interpretation of truth may be more sympathetic to modern sensibilities, it is not necessarily more 'truthful' or 'honest' in the Realist sense, or indeed in any absolute one, either.

Naturalism or its opposite are choices in the decorative arts as much as in any other, not moral imperatives or mysterious 'decrees' established by the nature of the objects themselves. The demand for a certain kind of decorative style in the middle of the nineteenth century is not a necessary sign of reform or progress over a benighted naturalistically inclined Victorian mass taste, but rather the expression of strong moral and ethical principles, with profound social implications: it made the simpler, subtler, more refined, less technically skilful or obviously virtuistic objects unavailable to people without the education, training or leisure to appreciate them. As Pevsner rightly says, 'anyone could tell whether a certain motif was an accurate copy of nature'; one learns from the Museum of Modern Art, slowly and painfully, in the course of being an 'educated person', what 'good design' is.

Certainly, simplicity and anti-naturalism have not always been considered the epitome of decorative excellence, even in aristocratic eras.

It is we who see naturalism and good design as mutually exclusive, by picking and choosing our models: Victorian 'naturalist' decorative artists after all had equally good prototypes for a naturalistic decorative style: for example, the foliage carving from the *Ara Pacis* in antiquity; the triforium moulding of Amiens in the Gothic period; Ghiberti's marvellous leaves, flowers and squirrels on the Florentine Baptistry Doors in the Renaissance. When Pevsner states that even Ruskin takes 'no end of trouble to reconcile his moralist theory of art with constant emphasis on natural laws and a close study of nature,' we may well ask ourselves why he chose to use the term 'reconcile'. Why, indeed, should naturalism have to be 'reconciled' with a moralist theory of art, as though there were some necessary opposition between them? Surely, in the representational arts, naturalism was seen to function as a kind of cleansing, honest moral purgative, at the very heart of Realist endeavour: truth and accuracy were seen as companions, not as enemies. It is rather the advocates of the new decorative style who transvaluated the meaning of truth to mean truth to the nature of the materials or the flatness of the surface, not those who created a naturalist style of decoration. One can only agree with Alf Bøe, when he suggests that 'the starting-point for any consideration of Ruskinian philosophy is to be found in his own passionate love of natural beauty, so strong that in reality it amounted to nothing less than a cult'. Indeed, far from having to 'reconcile' emphasis on a close study of nature with a moralist theory of art, a good case might be made for Ruskin's believing that the moral impact of art *depended* upon its adherence to natural form, as Bøe suggests.

One must also keep clearly in mind that the decorative innovations or reforms of the English reformers – be they Henry Cole's, Owen Jones's, William Morris's or Christopher Dresser's – were by no means completely 'abstract' or non-naturalistic by our standards. Their textile and wall patterns, for example, were almost always based on the stylization of natural forms, adapted to the demands of the flat surface. Nor was mere simplicity of form considered to be all that was needed for furniture or utensils; and certainly, they were hardly devoid of the 'derivativeness' of which Victorian design in general is so often accused. Morris, for example, depended heavily on medieval Sicilian, Near Eastern, Elizabethan and seventeenth-century English proto-types for his woven patterns, and certainly the more 'Establishment' reformers, like Redgrave, Wyatt and Jones, in their attempt to adapt inspiration from natural forms to decorative purposes through conventionalization and the study of the past, regarded ornament, generally naturalistic ornament, as an essential part of design, rather than, to borrow Pevsner's terms, as a 'dainty costume to cover and

embellish function'. Indeed, their demand for 'fitness' and for 'appropriateness' of design, as Bøe indicates, 'more often than not signifies that the decoration should correspond in meaning to the use for which the decorative object was designed'.

Nevertheless, it is quite true, that the reformers in the decorative arts – both the more conservative government-sponsored ones, and the more radical 'independents' like Ruskin and Morris – were demanding, in the name of Realist truthfulness and honesty, something quite different in its actuality from the standard Victorian style, which had reached hyperbolic proportions in the objects revealed in the Great Exhibition. As against imitativeness, historicism, coarseness and bulginess, emphasis on narrative or sentimental elements, imitative, minute naturalism, imitation of natural materials by new, artificial ones, pride in mere technical virtuosity and ingenuity rather than craftsmanship and genuine functionalism – Pevsner's Victorian style – the reformers, be they conservative or radical, set up an opposition which could well be likened to the representational Realists' cry for truth, honesty and contemporaneity – but now conceived in terms of the creation of new forms for new needs and attitudes.

The paradox is, of course, not that many of these reformers could 'reconcile' the thirst for scientific naturalism with demands for more 'honest' or 'moral' truth to form and function, but that those who were in effect most radical and sweeping in their notions of what reform in the arts implied – that is to say, Ruskin and Morris – saw that it was not merely aesthetic principles, but the whole basic social organization that was at fault. They realized that the roots of the evils of Victorian design lay not in the designers and their training, but in the division of labour and the Capitalist system which so brutally severed head from hands, thought from feeling, work from pleasure. It was they, precisely in their, and especially in Morris's, passionate humanitarian concern, who in effect, by their emphasis upon handicraft, flatness, abstraction and patterning – insistence on the nature of the material or surface as a virtue, and 'good design as something dependent upon some sort of mystical relationship between inner feeling and external materials' – laid the basis for the avant-garde elitism and avant-garde exclusivism of the Modernist art of the twentieth century. As industrial civilization went right on producing 'Victorian' artefacts, in the form of mass-produced kitsch, in ever increasing variety and numbers, simple, tasteful, functional (what we might choose to call 'realist'), decorative objects have really been made available, or seem to be attractive, to only a chosen few. And it is no accident that those who are capable of responding to avant-garde art are, for the most part, those who furnish their houses with Good

Design furniture. It is thus difficult to decide in what way to consider the Realist analogy in the decorative arts: we are left with paradoxes, but no real solutions. In any case, I believe that a look into the average middle-class home in Europe or America would usually reveal no less a taste for 'naturalistic imitation'-as-realism than would its mid nineteenth-century counterpart; nor any more willingness to accept simplicity, abstraction and functionalism-as-realism, either. Whether this is a judgement upon our society, or the canons of Modernist good taste themselves, which have always functioned to separate the 'tasteful' sheep from the 'philistine' goats, thereby creating an avant-garde aristocracy even when the intentions are most democratic or egalitarian, it is difficult to decide.

WHATEVER HAPPENED TO REALISM?

Breakdowns and Changes

By the last quarter of the nineteenth century the amalgam of qualities, structures and attitudes which we have been examining – the Realist style or the Realist movement – had begun to come apart at the seams as an integral unity. Some of its qualities were transvalued – i.e. they begin to acquire different or opposite meanings or implications to those they had in the Realist context. For example, truth and honesty, which have already assumed radically different implications in the theory and practice of the reformers of the decorative arts and architecture; or qualities, such as the social concern or radical thrust of a certain branch of the Realist movement became the dominating force behind art, as in the case of Soviet Socialist Realism, or, to a lesser degree, the Mexican mural painters' movement of the thirties. In addition, certain qualities implicit in a manifestation of Realism, like Impressionism, in which the latent subjectivity implied by 'nature viewed through a temperament', with its emphasis on individual perception rather than conventional, learnable rules for art, contained the seeds of a rampant subjectivism, developed into an art style in which the 'temperament', so to speak, the creative will of the individual, outshone the role of nature almost completely – as was the case in the various Symbolisms of the turn of the century. Yet despite the split up of, and even the opposition to Realism, it is interesting to see that even its antagonists, or those whose own originality depended upon opposing it later in the century, hark back to some of its defining qualities in their own contexts of rebellion. Signac, for example, though committed to the relative abstraction of the neo-Impressionist

system, kept the radical Utopian political fervour so often associated with the Realist movement in France, despite his insistence on a very different pictorial style: 'Justice in sociology, harmony in art: the same thing . . .' or 'The anarchist painter is not the one who will create anarchist pictures, but he who, without concern for wealth, without desire for recompense, will fight with all his individuality against official bourgeois conventions by means of a personal contribution.'

Probably the most interesting, and significant, of all these split-offs or transformations of Realist values, as far as the painting of the future was concerned, was the transformation of the Realist concept of truth or honesty, meaning truth or honesty to one's perception of the external physical or social world, to mean truth or honesty either to the nature of the material – i.e. to the nature of the flat surface – and/or to the demands of one's inner 'subjective' feelings or imagination rather than to some external reality. We have already seen that a certain kind of subjectivism was inherent in the whole Impressionist notion of 'nature seen through a temperament' with its possible emphasis on the vagaries of individual, rather than scientific–objective perception – vagaries which 'scientific' neo-Impressionism strove to overcome – and that the transvaluation of truth and honesty to imply truth to the nature of the materials was achieved at least theoretically first in England, in the realm of the decorative arts, where the role of subject and imitation of nature could more easily be played down than in the traditionally representational 'high' arts of painting and sculpture. The connection existing between the advanced art of France at the turn of the century and the achievements and theoretical statements of the English Decorative radicals, most especially William Morris, has often been underestimated, but it seems to me that it is precisely here that the French Symbolist artists find truth ready-made to mean truth to the surface to be 'decorated' – i.e. a moral and metaphysical rationale ready-made for their own imaginative High Art constructed on the basis of the Arts and Crafts insistence on truth in decoration as a function of the so-called demands of the object itself. It is surely no accident that *art nouveau* started out by being called 'Yachting Style' and then 'Modern Style' by the French, in order to give notice of its British origins. It is no accident that the emphasis on the links between fine arts and craftsmaking, characteristic of the Pre-Raphaelites and the whole point of 'Morris, Marshall, Faulkner & Co., Fine Art Workmen . . .', founded in 1861, should have provided inspiration for the Belgian *La Libre Esthétique* in 1894, or that the French Symbolist composer Débussy should have played his *La Demoiselle élue*, based on one of Rossetti's poems, at the opening of its first exhibition. The French poster-maker, Jules Chéret, doubtless

owes a great deal of his flatness to the British examples of Walter Crane and William Morris, as Robert Goldwater has suggested; but no matter how much one wishes to argue about the primacy of British versus French sources for the anti-naturalist movements at the end of the nineteenth century – ultimately a futile task in a movement whose character is International in scope – it is nevertheless true that many members of the French *fin-de-siècle* avant-garde in the pictorial arts, not to speak of decorative artists and architects from the rest of the continent, consciously refer to British sources for their work. When Henri de Toulouse-Lautrec was questioned about a new style, he declared: 'I believe one has only to look to William Morris to find an answer to all your questions. That man has produced readable books and useable objects.' While certainly, one can find many other sources for Gauguin's interest in both the minor arts and the flatness and abstraction of his style – as well as for his emphasis and that of the Pont Aven group and the Nabis on the union of the arts and crafts – besides the purely English one of the Pre-Raphaelites, Morris, or the other British Decorative Reformers – it is significant nevertheless that Gauguin's earliest ceramics, in the conception of their motifs, were very probably influenced by the style of English children's books, which appeared in Paris early in the eighties – works by Walter Crane, Kate Greenaway, Caldecott – and which were, as Denys Sutton has pointed out, discussed enthusiastically by Huysmans in 1881. (Before Gauguin's departure for Brittanny in the summer of 1886, the *Gazette des Beaux-Arts* published an article on Caldecott mentioning, among others, his illustrations for Henry Blackburn's *Breton Folks*.) While Gauguin himself seems never to have acknowledged any influence from British sources, Morris's decorative work and theories were widely known in France by the eighties and the Pre-Raphaelite painters, revealed to the French public as early as the Exposition Universelle of 1855, had reached an apex of popularity – Burne-Jones above all – by 1884. Gauguin himself sounds remarkably Morrisian when he annunciates the primary role played by the decorative arts, in his own estimation of his work to Daniel de Monfried in 1892: 'Say that I was born to be a craftsman and that I couldn't make it. Stained glass, furniture, pottery, etc. – those are my talents, much more than painting itself.' But what is most important, in the context of our discussion of the metamorphosis of Realist 'truth' to mean 'truth to the nature of the materials' rather than 'truth to nature', and, in the case of painting, of course, the corollary that this truth implied an abstract, decorative, contour- and colour-based flatness and emphasis on the 'true' qualities of the surface rather than 'truthful' representation of the social and natural world, is the fact that, as Merete Bodelsen

has definitively demonstrated, that it was indeed the discoveries that Gauguin made in his ceramic work that led him to emphasize flatness in his painting. '. . . Gauguin's ceramic work as early as the winter of 1886-7 caused him to adopt a simplified handling of line, which was to lead him on to cloisonnism and synthetism. As was the case with Bernard and Anquetin, his activities in the field of the decorative and applied arts came to influence his painting style. . . .' And it was Gauguin (and the members of his circle), who both in his paintings and in his writings most forcefully emphasized the virtues of flatness-as-honesty – and the only form of honesty – in the two-dimensional arts.

The Transvaluation of Realist Values : Truth as Flatness

If it was in the English decorative arts that flatness was first made a correlative of Realist truth and honesty, it was in Symbolist painting that truth and honesty were definitively severed from the context of Realism. All paintings are, of course, literally flat as objects, aside from the occasional projections of *impasto* characteristic of certain techniques of applying pigment, projections which generally have nothing to do with the figurative or illusory depth of the elements depicted (i.e. the white lump of pigment denoting the highlight on a pearl earring in a Rembrandt portrait may be much higher in relief than the thin glazes of shadow of the illusionistically 'closer-to' eye-sockets). Yet in terms of style or pictorial structure, flatness in art is, of course, relative – relative in terms of 'how flat' and to a total context of form and meaning. Still, whatever the qualifications we may make, flatness in painting generally implies an emphasis on the reality of the pictorial *means* at the expense of the reality of the external world depicted by, or, in extreme cases 'reflected' by these means. No matter how much we may insist that illusionism demands conventions and schemata just as much as abstract art, there is nevertheless a tendency in illusionist art – art that stresses the existence of credible three-dimensional forms in a believable space – to minimize the pictorial means, to make them 'disappear' : hence the image of the painter as a kind of magician and, in the nineteenth century, the accusations of 'deception' and 'dishonesty' hurled at those who, through foreshortening, over-subtle modelling or minute description of surfaces, would tend to make mock of the recalcitrant imper-meability of the pictorial surface. Against the 'simplistic' view – i.e. that of the new, untutored mass Salon or Academy art-audience, yet not *completely* foreign to such fine spirits as Ruskin – of painting as a gradual gaining of grasp on the reality of the material world – in theory, perfectly achieved at last by the technical miracles of photo-

graphy in the nineteenth century, but still of course, not endowed with the truly transmogrifying power of real-life colour – arose a more austere, sophisticated, purified, elitist view of painting as a *rejection* of dishonest, extra-artistic illusion along with the notion of external, material reality as what was to be depicted, and the substitution of the so-called demands or necessities of the realities of the art-world itself as an imperative for 'honest' Art, in painting: such 'realities' as flatness, contour, and colour. Far from implying loss of meaning, in the beginning at least, these 'purified' art-means were held to have innate emotional-communicative properties in and of themselves, often being compared to the 'pure' spiritual communicability of music. To adopt the Saussurean model of language, with its three-part division of all communication systems into signifier (or vehicle), signified (or what is conveyed) and sign (what comes into being through the association of the other two), we may say that the Symbolists of the nineties had by no means done away with the signified: they had simply made it relatively and deliberately private, ambiguous, and 'unavailable to translation', by emphasizing the self-determination of the signifiers and the independence of the resulting signs from material, external reality.

One might, of course, point out that the association of flatness with honesty and truth had occurred much earlier than in the theories and practice of Morris or the *Journal of Design* group, and surely earlier than the Symbolist aesthetics of the *fin de siècle*: one can find a prelude to it in the proponents of the International Linear style of about 1800. As Robert Rosenblum has pointed out: 'The years around 1800, in their fervor for an artistic *tabula rasa*, witnessed a dissolution of post-medieval perspective traditions as radical as anything instigated by Impressionist color patches or by that later nineteenth-century equivalent of Greek vase painting, the Japanese print. . . . Once set in motion, this pursuit of an utter purity was to lead to the abstract white spaces of Flaxman's outlines as well as to even more extraordinary negations of Renaissance and Baroque illusionism.' Rosenblum indeed compares an Ingres outline drawing of 1807 with Matisse's *Red Studio* of more than a hundred years later in terms of the quest for purity, in that both share the 'same goal of a continuous, pristine flatness', and he finds that Ingres has in fact deviated radically from one point perspective in order ultimately to 'accommodate the absolute flatness of the white paper'. Certainly this is true, and certainly artists like Blake, Flaxman or Cumberland, who based Truth on wiry, simplified outlines and Falsehood and Deception on illusionistic foreshortening or Baroque colourism, share many of the moralistic-aesthetic viewpoints of their later nineteenth-century followers. But

all of these are drawings, engravings, or water-colours. In painting itself, none of these earlier nineteenth-century artists – with the exception perhaps of the fabulous Maurice Quaï and his band of *Barbus* – ever came close to the abstraction, the personal symbolism, the flatness, or the stylization of Gauguin or the Nabis, much less of Matisse. Their art was rooted in classical tradition and precept, no matter how they might flirt with medievalism, and in many ways is closer, in its insistence on a certain austere moral probity and classical heroic subject matter, to the viewpoint of the seventeenth-century *Poussinistes* in their battle with the sensuous, colourful, painterly *Rubenistes*, though relying on Kant instead of Descartes for metaphysical and moral support, than to the daring of Japanese-print or medieval cloisonné-inspired Post-Impressionist painters. When Maurice Denis made his famous remark about a picture being essentially a plane surface covered with colours assembled in a certain order, he was really the spokesman for a radically new, and certainly, a radically anti-realist viewpoint, yet one which was anti-classical and anti-traditional at the same time.

The pithiest statement of what one might call the 'traditional' position in art – the position that provided the theory, if not the actual practice of artists since the Renaissance, or at least, since the founding of the Academy in France in the seventeenth century – is that of Charles Blanc in 1867, in his *Grammaire des arts du dessin*. Contrary to H. Chipp's assertion, this is by no means the forerunner of Denis's formalist position. Blanc, unlike either Realists or Modernists, sees flatness *and* nature *and* imagination as integrated factors in the inseparable unity of the artwork : 'Painting is the art of expressing all the conceptions of the soul by means of all the realities of nature, represented on a single surface in their forms and in their colours.' Charles Le Brun or Sir Joshua Reynolds might have used different terminology, but it is doubtful whether either of them, or David with slight variations, would have found anything unacceptable about this mid nineteenth-century definition of art, which holds, in suspension as it were, all the separate elements which will, or have already, given rise to the divergent and, by definition, more limited, stylistic 'isms' of the nineteenth and twentieth centuries : Romanticism by emphasizing the 'conceptions of the soul', Realism, the 'realities of nature', and Modernism, or even more properly, Abstract Art, the forms and colours on a single surface.

This sense of the mutual exclusiveness of the various dimensions of art – an issue raised by Lessing in *Laocoon* as early as 1766 – indeed, the rejection of those dimensions which seem to interfere with the 'pure' artness of art and a compensatory stress on the formal means or

language of art, increases as we approach our own era: Courbet and Manet, as well as the Impressionists, had of course thrown out imagination, the Symbolists the reality of nature. This exclusiveness is not by any means a purely aesthetic matter. While this purifying, limiting operation can in one sense be interpreted as a continuation of Realist 'honesty' and 'truthfulness', it is also a predictably successful way of limiting the *audience* of art to those whose taste is guaranteed by *its* purity of motivation at the very moment when mass communication, kitsch and academicism were beginning to make art attainable to, and the business of, an ever increasing, ever less-educated public. One can scarcely conceive of Michelangelo replying to Julius II about his ceiling as Gauguin did to the critic André Fontainas about his complex allegory, *Where Do We Come From? What Are We? Where Are We Going?*: 'It is a musical poem, it needs no libretto.' Until the later part of the nineteenth century, pictorial iconography might be difficult, but it could be made available to reason and reasoned explication. The idea that only an elect – an anti-Philistine elect known as the avant-garde – self-chosen and self-perpetuating – could respond to the work of art on the basis of its *art* qualities alone, is a *social* response, not merely an aesthetic one, to the tremendous social and institutional pressures on the production and consumption of art that went along with the more general upheavals of the nineteenth and twentieth centuries. In other words, the creation of the avant-garde was the mirror image, the precise response *to* the emergence of the mass Philistine audience. Kitsch and formalism are mirror images of the same impulse to keep the ever culture-hungry bourgeoisie at bay; the rapid succession of movements, each a response to, or reaction against, the previous one in the restricted world of avant-garde production, focused upon purely 'art' problems – i.e. the relation of the means to reality, the art-means to each other, the reduction of these means, the torturing self-consciousness about these means – all were in some way related to the fact that after the middle of the nineteenth century there is no single, unequivocal external reality outside to be captured by the artist, whether social or perceptual, and the artist's feeling that this equivocal reality either must be demonstrated by the formal character of the work itself or must demand the creation of a reality absolutely independent of that of the experienced world, a counter-world, self-reflexive and absolute, uncorrupted by perceptual, social or emotional references, and, by definition, unavailable to those who are not *au courant*.

Yet the rejection of Realism – the movement towards perfect purity, flatness, art about art, reductivism – has never been as absolute or unilinear as its spokesmen, or its critics, have made out. It is certainly

true that Gauguin and his followers were resolute about condemning Realism and the 'scientific' literalism and superficiality of Impressionism: 'The Impressionists study colour exclusively as a decorative effect, but without freedom, retaining the shackles of verisimilitude. . . . They heed only the eye and neglect the mysterious centres of thought, thereby falling into merely scientific reasoning. . . . When they speak of their art, what do they mean? A purely superficial art, full of affectation and completely material. . . .' Gauguin really sets the scene for future avant-gardism, stressing decoration, warning against modelling, calling for a musical kind of colour and composition which would be expressive in its own right rather than 'in translation', demanding condensation rather than reduplication of sensations, in short, as he maintained to Schuffenecker, 'art is an abstraction', although of course, by this he meant something very different than a Malevich, a Mondrian, or even a more spiritually analogous Kandinsky in the twentieth century. The demonstration of the artness of art – or even the inherent conflict between the representation of contemporary reality and the reality of the formal means of art themselves – which Manet had to accomplish tongue in cheek, through *blague* and irony in the context of a self-conscious Realism in the sixties and seventies, could now be achieved straightforwardly: indeed, the demonstration that art is art and nothing more, an independent system of signs having no 'signified' (to borrow the terms of modern linguistics), becomes the business of art – its 'subject', as it were. 'Composition,' says Matisse, 'is the art of arranging in a decorative fashion the various elements at the painter's disposal for the expression of his feelings', or later, almost fifty years later, speaking of his *découpages*: 'each work is a combination of symbols invented during execution as they are needed in the particular spot. . . . The symbol is determined at the very moment I use it – and use it for the object in which it will appear.' 'The secret aim of the young painters of the extremist schools is to produce pure painting. . . . It is still in its beginnings, and is not yet as abstract as it would like to be', said Guillaume Apollinaire of the Cubist Painters in 1912. 'The goal is not to be concerned with the *reconstitution* of an anecdotal fact, but with the *constitution* of a pictoral fact', maintains Braque; Mondrian carries the implications of the Cubist attitude still further: 'The new plastic idea will ignore the particulars of appearance, that is to say, natural form and colour. On the contrary, it should find its expression in the abstraction of form and colour, that is to say, in the straight line and clearly defined primary colour.' The very meaning of 'real' is transvaluated by Mondrian: Art, in his neo-Platonic terms, 'is *not the expression of the appearances of reality such as we see it . . .* but *. . . the expression of true reality*

and true life . . . indefinable but realizable in plastics'. For Klee, 'art does not reproduce the visible; rather, it makes visible': a line may go for a walk, a formal cosmos be created out of abstract elements; for Mark Rothko, pictorial shapes 'are organisms with volition and a passion for self-assertion'. Reality is no longer felt to be tied to a certain moment in history: on the contrary, to the purist, reductivist Modernist view, the opposite is the case. Less is admitted to be less, by the New York painters of the forties and fifties: 'We are creating images whose reality is self-evident and which are devoid of the props and crutches that evoke associations with out-moded images. . . . We are freeing ourselves of the impediments of memory, association, nostalgia, legend, myth, or what have you. . . . The image we produce is the self-evident one of revelation, real and concrete, that can be understood by anyone who will look at it without the nostalgic glasses of history,' says Barnett Newman; truth as reduction is succinctly defined as such by Robert Motherwell in a 1951 symposium: 'One might truthfully say that abstract art is stripped bare of other things in order to intensify it, its rhythms, spatial intervals, and colour structure.' By 1962, the current prophet of the modernist *Kunstwollen*, Clement Greenberg, found it more or less self-evident that 'the irreducible essence of pictorial art consists in but two constitutive conventions or norms: flatness and the delimitation of flatness; and that the observance of merely these two norms is enough to create an object which can be experienced as a picture . . .' By now, so purified has abstraction become that the dilemma lies between what the critic Philip Leider has defined as a conflict between 'literalism' and 'abstraction', the former stressing the 'objectness' of the painting, its literal material reality as an object, the second viewpoint stressing two dimensional surface through colour, and, as much as possible, through colour alone. In essence, the modernist *telos* seems to have been fulfilled; all that is left is the (literal) smile of the (vanished, two-dimensional) Cheshire cat. Art itself has left to join action, concepts or information theory, leaving behind such latter day apostles of the flat surface as Frank Stella or Kenneth Noland.

Yet all through this historical unfolding of avant-garde Modernism, to its 'ultimate' reduction, other major innovations like those of Dada, or Surrealism, have been entering in and complicating the issue of flatness and purity; in the very beginning of the rebellion against Realism in the eighties in France, and among the very people who were creating the new, more expressive, abstract, stylized and flattened pictorial style themselves, the older Realist insistence on truth as paying attention to nature and perception, honesty as depicting contemporary life as known and experienced by the artist, a

certain kind of sympathy and empathy for the poor, the ordinary and the humble as somehow more 'real' than other realms or strata – all this, so much part of Realist ideology, rings out in the writing of Van Gogh, himself such a staunch admirer of Millet and the English Realist illustrators, who indeed provided him with inspiration for his own pictorial adventures. How severely Van Gogh criticizes Émile Bernard in 1888 for too great a concentration on formal problems in isolation; while he himself may talk about the expressive qualities of line or colour, he almost never talks about them in isolation from the larger context of emotion, feeling, imagination or reality in which they occur. For Van Gogh, reality and truth mean what they meant to the Realists; they have not been transvaluated. In 1888, he writes to Bernard: 'In the matter of form, I am too afraid of departing from the possible and the true. . . . My attention is so fixed on what is possible and really exists that I hardly have the desire or the courage to strive for the ideal as it might result from . . . abstract studies.' In letters of 1889, he continues to warn Gauguin and Bernard against leaving nature for abstraction, deserting contemporary subjects for Biblical ones: 'Modern reality has got such a hold on us . . .' he insists. He feels that abstraction might 'make me soft'. Cézanne, the most revered predecessor of Modernism and abstraction, as late as 1904 warned the ever-present Émile Bernard that 'the artist must "beware" of the literary spirit which so often causes painting to deviate from its true path – the concrete study of nature – to lose itself all too long in intangible speculations.' The imagery of contemporaneity – the city, the machine, industry, speed – as well as a revolutionary political outlook, is inherent in the Futurist and Constructivist movements of Italy and Russia; the attempt to unite abstract, modernist form and revolutionary politics, or at least reformist ones, is proclaimed by Moholy-Nagy in his 'Constructivism and the Proletariat' in 1922; later, the Bauhaus, following the example of William Morris to a large extent, but unlike him, accepting the machine and the machine aesthetic as the basis of their programme, attempted to bridge the gap between avant-garde and mass public, to 'reintegrate the artist into a technological society', to use the words of Peter Selz; both in Mexico and in the United States during the 1930s, artists tried to incorporate elements of social reality into a new, public mural art, understandable and available to large masses of people: the union of Communism and Surrealism under Breton at about the same time was another such attempt to ally progressive and practical revolutionary politics with avant-garde freedom in art – a short-lived union, but one that still lives on in the life and work of Pablo Picasso.

Yet by far the most closely allied to the goals, the subjects, the attitude and the tone of nineteenth-century Realism in the art world of twentieth-century Modernism is Fernand Léger. This relationship is, of course, only homologous, in no sense a revival of outmoded stylistic elements. Yet one cannot resist thinking back to Courbet in looking at Léger's work or reading his statements. Like Courbet, Léger was born in the country, of simple people – poorer than Courbet's family – and retained a genuine rapport with and sympathy for popular culture throughout his life; he was known by his students as 'le Patron' – the Boss – encouraged independence, spoke informally. Like Courbet, he pooh-poohed refinement, taste and pretentions to Beauty: '. . . There is no catalogued, hierarchized Beauty; . . . this is the worst error possible. Beauty is everywhere, in the arrangement of your pots on the white wall of your kitchen . . .' This Realist dislike of hierarchy comes out clearly in a 1930 painting where, in modern Realist–Surrealist fashion, he 'demotes' the Mona Lisa by inserting a postcard of her in a still life, subordinated to his key-ring and a tin of sardines. '. . . The Gioconda for me is an object like the others.' Shades of Courbet, with his 'M'ssieu Raphael' and 'O! O! O! Le Beau Idéal'! Like Courbet, he took pride in his own lack of discrimination. 'I have no taste. . . . I only feel contrasts, strength,' and, unlike snobbish Europeans who, during sojourns in the United States, decried the barbarism and lack of culture of America, found this her greatest asset: 'Bad taste is . . . one of the valuable raw materials for this country. Bad taste, strong colour.' He loved its scrap metal, its popular music and musicians, the tawdry bravado of Broadway billboards. In abandoning taste, he felt he could appeal to large masses of ordinary people: 'I wanted . . . to return to simplicity through a direct art, an art comprehensible to all, without subtlety.' But above all, Léger is allied to the Realist tradition and attitude by his profound concern for contemporaneity and the contemporary. He alone of the vanguard modernists was concerned to create a painting strictly related in imagery, content and structure to the objective reality of modern times, and not merely 'by accident', as it were – in the sense that all the cubists, for example, felt that they were in some ways 'reflections' of their epoch, or even prophets of its underlying spirit. 'A work of art,' says Léger, 'should be representative of its times, like every other intellectual manifestation, no matter what. Painting, because it is visual, is necessarily the reflection of external conditions and not psychological. . . . If pictorial expression has changed, it is because modern life made it necessary. The existence of modern creative people is much more condensed and complicated than that of the

people of preceeding centuries.' He spoke about the new Realism of modern times, a Realism based on the 'liberation of the object'. Painting, he felt, had never been 'as realistic and attached to its epoch as today. A Realist painting in its highest sense is beginning to be born. . . .' It was his search for new means to express contemporary reality that led him to the film – *Ballet Mécanique* in 1924 – an attempt to find a substitute for rejected 'subjectivity' in the objective representation of the object – or the fragment of the object – in motion: 'There is a whole new realism,' Léger declared, 'in the way of envisaging an object or its part. . . .' Above all, his subjects, his imagery and his formal vocabulary are functions of his own times: subjects like the city, steam, machinery, pistons, mechanical elements, scrap iron, factories, tugboats; contemporary people, generally working class, in 'popular' milieux: construction workers, the mechanic, musicians in *chapeau melon* playing the accordion, the monumental group scenes of his later style, like *La Belle Équipe* with its bicycle, where the figure style and the composition owe more to Rousseau and the frontality of popular art or the group photograph than they do to Jacques-Louis David, in homage to whom it was painted; the *Partie de Campagne*, grand in scale, modern and popular in its flavour, with the explicitly contemporary *bricoleur* and his car to the left of the landscape; above all the massive series of *Construction Workers*. These latter he saw on the road to his home in the Chevreuse, building a factory – again, an echo of Courbet, who, almost exactly a hundred years earlier, had seen his monumental labour-subject, *The Stone-breakers*, on the road near his home.

At the same time, in his tastes, his prototypes and his attitudes, Léger really prefigured the New Realists of the sixties – Pop Artists and others – who, although very different in tone and attitude – cool, deadpan, outrageous – from many of their nineteenth-century predecessors, do, like them, look to contemporary life for their inspiration, stylistic as well as iconographic. Claes Oldenburg can find a model for monumentality in a hamburger, a New Obelisk in a lipstick tube, banality of today blown up to become High Art through sheer presumptuousness of scale and intention. Like Courbet, who turned to crude, anonymous popular imagery, considered unsuitable as inspiration for High Art, pop artists like Warhol, Rosenquist and Lichtenstein have turned to commercial art, advertising or comic strips for a ready-made imagery of their own times. '*Il faut être de son temps*' may be said tongue-in-cheek by a Campbell's Soup Can; the impulse and the impact are still related to Realism, though it is the artificial, commercial, bill-board reality of the twentieth-century mass-communications industry that is now the primary 'given' for the artist. We have

indeed come full circle when snobbish, 'with-it' connoisseurs will pay hundreds of dollars for a 'tasteless' tea-cup stippled with Ben Day dots from the kiln of Lichtenstein, or when the most *raffiné* sensibilities seek out their mother's discarded art-deco *objets d'art*, feeling that the austerities of Modernist Good Design are by now déclassé, effortful, and somehow Philistine.

Yet at its very apogee, the firmest prophets of the modern movement had mixed feelings about the moribund, unequivocal Realism they so scorned and rejected at the beginning of the twentieth century. For Gleizes and Metzinger, championing the new style in *Du Cubisme* in 1912, it was indeed Courbet who 'inaugurated a realist impulse which runs through all modern efforts', despite the fact that he still remained enslaved to 'the worst visual conventions' and 'accepted without the slightest intellectual control, all that his retina presented to him'. Of course, they are talking about a transvaluated Realism, as becomes apparent when they continue their pre-history of Cubism with a discussion of Manet: 'In spite of many failings we call Manet a Realist less because he represented everyday episodes than because he knew how to endow the many potential qualities concealed in the most commonplace objects with a radiant reality,' and then go on to subdivide realism into the 'superficial' realism of the Impressionists, which they condemn, and the 'profound' realism of Cézanne. Yet Guillaume Apollinaire feels called upon to make no qualifications when he declares, in the same year, in his poetic, inspired meditation on the cubist painters: 'Courbet is the father of the new painters.' Indeed, we in the second half of the twentieth century still feel the impact of his paternity and the radical change in vision and values wrought by the Realist movement of the middle of the nineteenth century.

Catalogue of Illustrations

ABBREVIATIONS:

Art Bull.: *The Art Bulletin*

Burl. Mag.: *The Burlington Magazine*

G.B.A.: *Gazette des Beaux Arts*

J.W.C.I.: *Journal of the Warburg and Courtauld Institutes*

1. THE MEETING. By Gustave Courbet, 1854. Oil on canvas, 129 × 149 cm. Montpellier: Musée Fabre. (Photograph: Archives.)

 The painting, nick-named *Bonjour, M. Courbet*, represents the encounter of the artist, his patron, Alfred Bruyas and the latter's servant and dog on the road to Sète, outside Montpellier.

 Lit: L. Nochlin in *Art Bull.*, 1967, 209-22.

2. LE VRAI PORTRAIT DU JUIF ERRANT. Detail. Popular image from Le Mans, *chez* Leloup. (Photograph: Lancelot Lengyel.)

 For a complete discussion of Courbet's relation to popular imagery, and its social and aesthetic implications, see M. Schapiro in *J.W.C.I.*, 1941, 164-91.

3. STUDY OF CLOUDS. By John Constable, *c.* 1822. Oil on paper, 48 × 59 cm. Oxford: Ashmolean Museum. (Photograph: Museum.)

 The painting is probably one of a group of about fifty 'careful studies of skies' painted in 1822 at Hampstead. It is inscribed, with great precision, '31st Sept. 10-11 o'clock morning looking Eastward a gentle wind to East'. For Gombrich's views on Constable's cloud studies, see *Art and Illusion*, 1960; also see K. Badt, *Constable's Clouds*, 1950.

4. BUILDING SEEN FROM BELOW. By Edgar Degas, *c.* 1874-83. Drawing in Carnet 9 (Dc. 327d réserve), p. 96. Paris: Cabinet des Estampes, Bibliothèque Nationale. (Photograph: Bibliothèque Nationale.)

 Lit: J. Boggs in *Burl. Mag.*, 1958, 245-6; T. Reff in *Burl. Mag.*, 1965, 614.

5. LE TUB. By Edgar Degas, *c.* 1886. Bronze, 47 × 42·0 cm. New York: Metropolitan Museum. Bequest of Mrs H. O. Havemeyer, 1929. The H. O. Havemeyer Coll. (Photograph: Museum.)

 Degas's wax sculptures were mainly in the nature of private experiments, a way of getting at problems of mass in motion that drawing alone could not handle. Rewald's date *c.* 1886 is based on contemporaneous pastels of women bathing.

 Lit: J. Rewald, *Degas Sculpture*, 1956, 146, cat. no. 27.

6. LE PONT DES ARTS, PARIS. By Pierre Auguste Renoir, *c.* 1868. Oil on canvas, 62·2 × 102·8 cm. Los Angeles, Norton Simon Foundation. (Photograph: Courtesy of The Norton Simon Foundation.)

 This was the first painting the dealer Durand-Ruel purchased from Renoir.

 Lit: J. Rewald, *The History of Impressionism*, 1961, 272, 354.

7. VIEW OF DELFT. By Johannes Vermeer, *c.* 1660. Oil on canvas, 98 × 117 cm. The Hague, Mauritshuis. (Photograph: A. Dingjan.)

8. DEATH OF CAESAR. By Jean-Léon Gérôme, 1865(?). Oil on canvas, 85·4 × 45·5 cm. Baltimore: Walters Art Gallery. (Photograph: Museum.)

Although the painting is dated in the lower left corner, the lettering is very difficult to decipher. W. R. Johnston, the Assistant Director of the Walters Art Gallery, reads the date as MDCCCLXX rather than MDCCCLXV, and suggests that the 1865 date might apply to the larger version of the painting (10 ft 5 in. × 7 ft 2 in.) formerly in the Astor Collection, then in the Corcoran, and subsequently sold to an unknown dealer.

Lit: G. Ackerman in *G.B.A.*, 1967, 163-76; G. Ackerman in *The Academy (Art News Annual*, 1967), 107.

9. RETURN FROM A BEAR HUNT DURING THE STONE AGE. By Fernand Cormon, 1882. Oil on canvas. Carcasonne: Musée des Beaux-Arts. (Photograph: Bulloz.)

This painting is no doubt the sketch for the painting acquired by the state for the Museum of National Antiquities at Saint-Germain-en-Laye. The pre-historic subject of the *Return from a Bear Hunt* was of course perfectly suited to the Museum of Saint-Germain-en-Laye, with its extensive collection of Paleolithic materials - skeletons, tools, cave-paintings - published in an illustrated catalogue by Salomon Reinach in 1889. Fernand Cormon might well be termed a specialist in pre-historic genre painting. His best known work, *Caïn* (Salon of 1880), represented Cain and his tribe as pre-historic beings, clad in shaggy skins, and won him the Legion of Honour. Suitably enough, Cormon was chosen to decorate the walls and ceiling of the Paris Museum of Natural History with scenes of pre-historic animals and men, and the evolution of the human race (1898).

10. AN APODYTERIUM. By Sir Lawrence Alma-Tadema, 1886. Oil on panel, 44·5 × 59 cm. Toronto: Mr and Mrs Joseph M. Tanenbaum.

The painting, which was exhibited at the Royal Academy in 1886, was inscribed: *L Alma Tadema Op CCLXXIV*. It is one of a number of subjects painted by the artist of Roman baths. The apodyterium is the undressing room at the entrance to the baths.

Lit: M. Amaya in *Apollo*, 1962, 771-8. G. Reynolds, *Victorian Painting*, 1966, 123, 140.

11. LOUIS XIV AND MOLIÈRE AT DINNER: engraving after painting by Jean-Léon Gérôme, 1863.

The painting is obviously based on Ingres's *Molière at the Table of Louis XIV at Versailles* of 1857, and is one of many such scenes showing the democratic or home-loving proclivities of the reigning monarchs of the past in historically accurate décors. Many of these were specifically aimed at raising the status of artists by showing them on intimate terms with royalty, as is the case here.

12. LE MOULIN DE LA GALETTE. By Pierre Auguste Renoir, 1876. Oil on canvas, 131 × 175 cm. Paris: Louvre. (Photograph: Giraudon.)

The *bal* of the Moulin de la Galette was an unpretentious, almost rustic outdoor dancing place in Montmartre, frequented for the most part by working-class families of the neighbourhood, artists of the locality, and a few students: everyone knew everyone else. In order to be on the spot, Renoir rented a room near the Moulin on the rue Cortot. For his large painting, Renoir was determined to use the usual clientèle of the dancing-spot, rather than professional models: it is his friends who are seated at the tables and dancing with the young women of the locality.

Lit: G. Rivière, *Renoir et ses amis*, 1921, 121-40.

13. THE STAR, or DANCER ON THE STAGE. By Edgar Degas, 1878. Pastel, 60 × 44 cm. Paris: Louvre. (Photograph: Agraci.)

Lit: P. A. Lemoisne, *Degas et son œuvre*, II, no. 491, 270.

14. THE EXECUTION OF THE EMPEROR MAXIMILIAN. By Édouard Manet, 1867. Oil on canvas, 252 × 305 cm. Mannheim: Kunsthalle. (Photograph: Museum.)

Manet undertook this subject in at least five versions: a large painting in the Boston Museum of Fine Arts; an even larger one, now in fragments, in the London National Gallery; an oil sketch in the Ny Carlsberg Glyptotek, Copenhagen (probably made in preparation for the largest version, the one in Mannheim); a lithograph.

A certain amount of controversy exists about the chronological order of the various versions, the relation of the works to photographic documentation and news reports, and their expressive qualities. For a general summary of facts and scholarly opinions, see A. C. Hanson, *Édouard Manet*, exh. cat., 1966-7, 102-5.

Lit: K. Martin, *Édouard Manet: Die Erschiessung Kaiser Maximilians von Mexico*, 1948; N. G. Sandblad, *Manet: Three Studies in Artistic Conception*, 1954, 109-61; A. Scharf, *Art and Photography*, 1968, 42-9.

15. THE THIRD OF MAY: SHOOTING OF THE SPANIARDS BY THE FRENCH ON MAY 3, 1808. By Francisco de Goya, 1814. Oil on canvas, 264·3 × 345·3 cm. Madrid: Prado. (Photograph: Anderson-Giraudon.)

16. MENELAUS VICTORIOUS. By Honoré Daumier, 1841. Lithograph, 23·8 × 19·0 cm. D. 925. Delteil, XXII, publishes the 2nd State.

This is the first of a series of fifty lithographs by Daumier comprising *L'Histoire Ancienne*, published in *Charivari* from December, 1841, to January, 1843. It was published with a satirical introduction, praising Daumier for revealing the intimate, lively, down-to-earth side of antiquity and for the freshness of his interpretation of the time-honoured classical subjects: 'Perhaps some uncultured persons will reproach Helen for her gesture, which in our corrupt civilization means something quite different from chaste remorse. Actually, the gesture is full of local colour, and Daumier has seen the descendants of the Hellenes execute it with winning grace before the Bavarian monarch . . .'

Lit: L. Delteil, *Daumier*, 1969, XXII, n.p.

17. THE BATHERS. (detail) By Gustave Courbet, 1853. Oil on canvas, 227 × 193 cm. Montpellier: Musée Fabre. (Photograph: Giraudon.)

A photograph by Villeneuve would seem to have furnished Courbet with the pose for his left-hand figure. The painting was considered shockingly naturalistic, lacking in idealization or classical refinement of proportion at the time it appeared in the 1853 Salon. Scharf, however, quite correctly suggests that what actually shocked the public – the Emperor supposedly thumped the *Bather*'s rump with his riding crop – was the coupling of photographic reality with a classically ideal subject – nymphs in a forest – which makes it, in a certain sense, a predecessor of Manet's *Déjeuner* in its disturbing juxtaposition of the traditional and the contemporary.

18. NUDE STUDY. By J. V. de Villeneuve, c. 1853. Photograph. Paris: Bibliothèque Nationale.

The photograph bears the acquisition date of 1853. Villeneuve specialized in series of nude or lightly-clad women. It is quite likely, according to Aaron Scharf, that Courbet knew and used his photographs in the fifties.

Lit: A. Scharf, *Art and Photography*, 1968, 98f. and n. 36, 270-71.

19. LE DÉJEUNER SUR L'HERBE. By Édouard Manet, 1863. Oil on canvas, 208 × 264·5 cm. Paris: Louvre. (Photograph: Giraudon.)

Le Déjeuner sur l'herbe created a storm of critical abuse when it was exhibited, as *Le Bain*, in the Salon des Refusés in 1863. Critical reactions are examined in G. H. Hamilton's *Manet and His Critics*, 1954, 43-50. According to the reminiscences

of his friend Antonin Proust, Manet conceived of the idea for the painting while watching two women bathing at Argenteuil, at which point he remarked that he would like to re-do Giorgione's *Fête champêtre* in the Louvre in a more transparent atmosphere with contemporary figures. A detailed study of the genesis and formal qualities of the painting is to be found in N. G. Sandblad, *Manet*, 1954, 87–97, in which the author, following Tabarant, points out that the connection between the composition of the *Déjeuner* and that of a Marcantonio Raimondi engraving after Raphael's *Judgment of Paris* had been discovered as early as 1863 by Ernest Chesneau. A related water-colour of the subject is now in the M. S. Walzer Collection, Oxford (A. de Leiris, *The Drawings of Édouard Manet*, 1969, Cat. No. 197), and there is a smaller and less finished oil version of the Louvre painting in the Courtauld Collection in London, where, however, the face of the naked woman is not that of Manet's favourite model, Victorine Meurend, as it is in the larger painting.

More recent interpretations or discussions of the painting are those of Michael Fried, who maintains that 'Watteau's art presides over the conception of the *Déjeuner* as a whole,' and who specifically relates the figure of the woman in the background to Watteau's *La Villageoise* (*Artforum*, March, 1969, 40–43), a suggestion severely contested by T. Reff in his reply to Fried's long article, in *Artforum*, September, 1969, 46. L. Nochlin, in *The Avant-Garde* (*Art News Annual*, XXXIV, 1968, 16), sees the painting as, among other things, a 'monumental and ironic put-on', a deliberate example of the popular and destructive *blagues* of the period, and asserts that a hostile critic of the time was making no mistake in seeing it as 'a young man's practical joke'.

20. THE FORCED HALT. By Alexandre Antigna, 1855. Oil on canvas, 140 × 204 cm. Toulouse: Musée des Augustins. (Photograph: Archives.)
Antigna turned to genre painting in 1846. He exhibited a heart-rending *Fire* in the 1850–51 Salon, involving a mother and her children, and generally devoted himself to sentimental canvases of the poor and humble.

21. TWO PEASANTS TILLING THE SOIL. By Jean-François Millet, c. 1844–8. Ink, 22·7 × 30 cm. Oxford: Ashmolean. (Photograph: Museum.)
While Millet does not, in this relatively early drawing, stress the physical brutality of agricultural labour, he is nevertheless working with a peasant motif drawn from his own observation and experience, rather than with an idyllic, literary subject.
Lit: R. L. Herbert in *Burl. Mag.*, 1962, 298.

22. WOMEN IN THE GARDEN. By Claude Monet, 1866–67. Oil on canvas, 255 × 205 cm. Paris: Louvre. (Photograph: Archives.)
In order to paint his vast canvas out-of-doors, Monet had to dig a trench in his garden, so that he could lower it on a pulley to reach the top. Camille seems to have been the only model; several authorities, among them Mark Roskill in *Burl. Mag.* 1970, 391–5, have pointed out the relation of the painting both to photographs and to contemporary fashion illustrations. Bazille bought the painting in 1867; it was rejected by the Salon jury of that year.
Lit: W. C. Seitz, *Claude Monet*, 1960, 70; J. Rewald, *The History of Impressionism*, 1961, 150, 152.

23. THE DEAD CHRIST WITH ANGELS. By Édouard Manet, 1864. Oil on canvas, 179·4 × 149·9 cm. New York: Metropolitan Museum. (Photograph: Museum.)
The painting was originally called 'The Angels at Christ's Tomb' in the 1864 Salon. The critics reproached Manet for putting Christ's wound on the left side, rather than the more customary right. The composition is related to those of several Italian Renaissance artists, especially Veronese. The orthodox biblical

inscription may well have been suggested to Manet by his friend, the abbé Hurel.

Lit: C. Sterling and M. Salinger, *French Paintings, III* (Metropolitan Museum Catalogue), 36–40; E. Wind in *Art News*, May 1953, 19–20.

24. IN THE SUN (formerly called AT THE TOMB OF PHILIPPE POT). By Charles Édouard de Beaumont, 1875. Oil on canvas 59·7 × 95·9 cm. New York: Metropolitan Museum. (Photograph: Museum.)

In the Wallraf-Richartz Collection in Cologne there is a smaller, more loosely-painted version of exactly the same scene, ascribed to the Belgian, Alfred Stevens. Erwin Panofsky (*Wallraf-Richartz-Jahrbuch*, XX, 1968, 287–304) saw the paintings as light-hearted statements of the 'et in Arcadia' theme. In both works, a fashionable young lady and gentleman are represented drowsing against one of the *pleurants* of the forbidding medieval tomb of Philippe Pot, a seneschal of Burgundy.

A similar sort of trivialization of the theme of death – or murder – is found in a work like Paul Delaroche's *Murder of the Duc de Guise*, (1834), where, despite the artist's attempt to inject some sort of emotional authenticity into his subject by means of a slinking dog, a wrinkled rug, an overturned chair and a portentously unbalanced composition, there is little to redeem the work but detailed historical accuracy.

25. THE DEAD CHRIST. By Wilhelm Trübner, 1874. Oil on canvas, 95 × 109·5 cm. Hamburg: Kunsthalle. (Photograph: Museum.)

Trübner, a pupil of the realist Leibl, worked in Munich most of his life but his *Dead Christ* was painted in Brussels in the summer of 1874 when sharing a studio with K. Schuch and K. Hagemeister. This is the first of three versions of the same subject, all painted in 1874: the others are in Munich, Neue Staatsgalerie and Stuttgart, Staatsgalerie. Trübner, like Liebermann, Menzel and Slevogt, the major German nineteenth-century realists, tried to create a new, fresh, more honest and, if necessary, even brutal pictorial imagery, often re-vitalizing traditional subjects such as this one, with a novel approach. While reminiscent of Mantegna, Rubens and Ribera, this painting is unmistakably of its epoch.

Lit: J. A. Beringer: *Trübner* (Klassiker der Kunst, vol. 26), 1917.

26. TINTORETTO PAINTING HIS DEAD DAUGHTER. By Léon Cogniet, c. 1846. Oil on canvas, 143 × 163 cm. Bordeaux: Musée des Beaux-Arts. (Photograph: Museum.)

The painting was exhibited in the Salon of 1846, where Baudelaire commented on it briefly.

Lit: *Baudelaire*, exh. cat., 1968–9, no. 154.

27. CAMILLE ON HER DEATH BED. By Claude Monet, 1879. Oil on canvas. Paris: Louvre. (Photograph: Réunion des Musées Nationaux.)

Lit: G. Clemenceau, *Claude Monet: cinquante ans d'amitié*, 1965, 22.

28. THE DEAD TOREADOR (LE TORERO MORT) (L'HOMME MORT). By Édouard Manet, 1864. Oil on canvas, 76 × 153·3 cm. Washington: National Gallery of Art, Widener Coll. (Photograph: Museum.)

The original composition from which *The Dead Toreador* was removed was felt by critics to be spatially distorted. Another fragment, the *Bullfight*, is in the Frick Collection in New York. The figure of the dead toreador has been related to the *Orlando Muerto*, now in the National Gallery in London, which was then in the Pourtalès Collection and considered to be by Velasquez. Bates Lowry has pointed out the relation of the figure to Gérôme's dead Caesar, from the Salon of 1859.

Lit: A. C. Hanson, *Édouard Manet* exh. cat., 1966–7, 78–81.

29. TOMB OF GODEFROI DE CAVAIGNAC. By François Rude, 1845–7. Bronze, 200 cm. Paris: Cimitière de Montmartre. (Photograph: Archives.)

Lit: F. Licht, *Sculpture: 19th and 20th Centuries*, 1967, no. 61 and p. 313.

30. THE DEATH CHAMBER OF LÉON GAMBETTA. By Jean-Charles Cazin, *c.* 1882. Oil on canvas, 38 × 47 cm. Versailles, Musée National. (Photograph: Archives.)

Gambetta, a moderate Republican and a leading force in the Third French Republic, died from an accidental gun-shot wound on 31 December 1882.

The motif of the domestic interior without figures, as an independent motif, seems to have been a romantic invention, as L. Eitner has pointed out in the context of his discussion of the theme of the open window (*Art Bull.*, 37, 1955, 285). Among the earliest examples I know are Turner's various interiors of his patron's splendid home at Petworth (*c.* 1830). German artists are, however, the major contributors to this genre: Adolph von Menzel's *Room with Balcony*, 1845, being a notable example, as is C. D. Friedrich's watercolour *Studio Window* of *c.* 1818.

The bedroom, specific locus of personal, everyday intimacy, is represented with charming informality by Turner in a gouache of *c.* 1830, *Bedroom at Petworth* and with Biedermeier concreteness – and a young girl's back – in M. von Schwind's *Morning* (1858) in the Schackgalerie, Munich. While Van Gogh's *Bedroom at Arles* (1889) may constitute the apotheosis of the bedroom painting in its transformation of the factual, domestic interior into a highly-charged pictorial paradigm of inner tensions, yet an important prototype for both Van Gogh's foreshortened composition and his highly personal interpretation of the theme exists in an earlier, realist work, which may well have been familiar to Van Gogh, Adolph von Menzel's *The Artist's Bedroom in the Zimmerstrasse* in the National Gallery in Berlin. The motif of the bedroom is further abstracted and intensified by the addition of figures and a meaningful theme in Edvard Munch's various *Death Chambers* at the end of the century, and provides a setting of metonymic verisimilitude for Degas's subtle investigation of physical and psychological estrangement between a couple – perhaps the heroine of Zola's *Madeleine Férat* and her husband – in *The Interior* (sometimes called *Le Viol*) *c.* 1869, in the Henry P. McIlhenny Collection, Philadelphia.

Lit: Cat. Raisonné, Musée du Luxembourg, no. 54, 17.

31. TOMB OF CONTESSA D'ADDA. By Vincenzo Vela, 1849. Plaster, 371 cm. (base 225 × 130 cm.) Ligornetto (Switzerland): Museo Vela. (Photograph: Christian Senn.)

Lit: F. Licht, *Sculpture: 19th and 20th Centuries*, no. 113 and p. 319.

32. TOMB OF VINCENZO DRAGO. By Augusto Rivalta, *c.* 1880. Detail. Genoa: Staglieno Cemetery. (Photograph: Alinari.)

33. STEEPLECHASE – THE FALLEN JOCKEY. By Edgar Degas, 1866. Oil on canvas, 180 × 152 cm. Washington: Mr and Mrs Paul Mellon. (Photograph: National Gallery of Art, Washington.)

There is a group of drawings as well as a large oil sketch related to this painting, which is no. 140 in Lemoisne's catalogue of Degas's œuvre. Both J. Boggs and R. Pickvance stress the timeliness of the theme of steeplechasing (the *Société des Steeplechases de France* had been founded in 1863), the relation of the painting to English sporting prints and Degas's peculiarly remote, laconic attitude towards his subject.

Lit: J. Boggs, *Drawings by Degas*, 1966, nos. 44 and 45 and p. 76; R. Pickvance, *Degas' Racing World*, exh. cat., 1968, n.p.

34. THE TROUT. By Gustave Courbet, *c.* 1872. Oil on canvas, 52·5 Y 9) cm. Zurich: Kunsthaus. (Photograph: Museum.)

Although the painting is signed at the lower left: '. . . 71 G. Courbet. In vinculis faciebat', it is generally, on the basis of a letter written by Courbet to M. Pasteur, dated 1873. There is a replica, dated 1873 and painted in reverse.

Lit: *Gustave Courbet*, exh. cat., 1959–60, no. 81.

35. THE SUICIDE. By Édouard Manet, *c*. 1877–81. Oil on canvas, 38 × 46 cm. Zurich: Kunsthaus, Bührle Collection. (Photograph: Courtesy of Bührle Coll.)

Very little is known about the specific subject of the painting. It seems to have been painted for the sale organized by F. Lamy for the musician Cabaner. Another extraordinarily circumstantial painting of this theme is that by the Italian Francesco Netti – *The Suicides* – in the Gallery of Modern Art, Venice. (See E. Lavagnino, *L'Arte Moderna*, 1961, II, 849 and fig. 735.)

36. CIVIL WAR. By Édouard Manet, 1771. Lithograph, 40·0 × 50·8 cm. (Photograph: Art Institute, Chicago.)

This lithograph is strikingly similar to Daumier's *Rue Transnonain* in its composition. Manet joined the National Guard and stayed in Paris during the seige of 1870–71, and was present during the bloody days after the fall of the Commune. The similarity in attitude with Goya's *Disasters of War,* in both this and *The Barricade*, another lithograph of the same sort of subject, have been noted in the literature.

Lit: A. Hanson, *Édouard Manet*, exh. cat., 1966, 130–31.

37. RUE TRANSNONAIN LE 15 AVRIL, 1834. By Honoré Daumier, 1834. Lithograph, 44·5 × 29·0 cm. (Photograph: Bulloz.)

The lithograph was inspired by one of the major outrages of Louis Philippe's government, when, during an insurrection in the workers' quarters of Paris, a soldier was killed by a sniper from a window in the rue Transnonain, whereupon his associates massacred everyone in the house. Details of the massacre based on the depositions of survivors were published by the republican leader, Ledru-Rollin, which reveal that Daumier's lithograph is strikingly accurate.

Lit: O. Larkin, *Daumier, Man of his Time*, 1966, 26–8.

38. PUBLIC FUNERAL OF THE VICTIMS OF THE MARCH REVOLUTION. By Adolph von Menzel, 1848. Oil on canvas, 45 × 63 cm. Hamburg: Kunsthalle. (Photograph: Museum.)

Later in life, probably about 1885, Menzel turned to the subject of the funeral again in a watercolour now in the Georg Schäfer Collection in Schweinfurt.

Lit: A. Lichtwark, *Menzels Aufbahrung . . .*, 1902; W. Hofmann, *The Earthly Paradise*, 1961, 430.

39. A BURIAL AT ORNANS. By Gustave Courbet, 1849. Oil on canvas, 314 × 663 cm. Paris: Louvre. (Photograph: Giraudon.)

The *Burial* created a scandal when it was first shown in the 1850–51 Salon. For a collection of outraged opinion, see G. Riat, *Gustave Courbet, peintre*, 1906, 86–8.

Lit: M. Schapiro, *Art Bull.*, 1954, 164 f.; L. Nochlin in *Essays in Honor of Walter Friedlaender*, 1965, 119–26.

40. THE BURIAL OF COUNT ORGAZ. By El Greco (Domenikos Theotokopoulos), 1586–8. Oil on canvas, 480 × 360 cm. Toledo: Church of Santo Tomé. (Photograph: Alinari.)

41. JOAN OF ARC. By Jules Bastien-Lepage, 1879. Oil on canvas, 254 × 279·4 cm. New York: Metropolitan Museum. (Photograph: Museum.)

The same sort of attempt to distinguish the 'real' saint from 'visionary' angels in a convincingly naturalistic manner is attempted by Jacques-Clément Wagrez in his *Ecstasy of St Clare* of 1884, in the opposition between the photographic verisimilitude of the kneeling saint and the 'artistic' romanesquoid elongation of the angels hovering above the ground.

Bastien-Lepage, a native of Lorraine, painted this work during an upsurge of interest in Joan of Arc following the loss of Lorraine to Germany in 1871. The analogies between past and present were obvious. He at first intended to show Joan kneeling at the altar of the village church at Domrémy, but later decided on a more workaday, outdoor setting.

Lit: C. Sterling and M. Salinger, *French Paintings, Metropolitan Museum*, 1966, II, 207–10.

42. MONUMENT TO PRINCESS CZARTORYSKI OF WARSAW. By Lorenzo Bartolini, 1837–44. Marble: 187 cm. Florence: Santa Croce. (Photograph: Alinari.)

Lit: F. Licht, *Sculpture: 19th and 20th Centuries*, 1967, figs. 48 and 49 and pp. 311–12.

43. THE MAN WITH THE SCYTHE. By Henry Herbert La Thangue, 1896. Oil on canvas, 167·5 × 166·5 cm. London: Tate Gallery. (Photograph: Museum.)

La Thangue who was trained in the Royal Academy Schools and the Paris École des Beaux-Arts, was strongly influenced by Jules Bastien-Lepage in his treatment of simple, rural subjects.

Lit: R. Lister, *Victorian Narrative Paintings*, 1966, 146.

44. SUNDAY AT CHELSEA HOSPITAL (THE LAST MUSTER). By Sir Hubert von Herkomer, 1875. Oil on canvas, 214 × 157·5 cm. Port Sunlight: The Lady Lever Art Gallery. (Photograph: Museum. Reproduced by courtesy of the Trustees of the Lady Lever Art Gallery.)

Lit: *Art Journal*, 1880, 109. *Magazine of Art*, 1890, 16: 1896–7, 127. J. Saxon Mills: *Life & Letters of Sir Hubert Herkomer*, 1923 *passim*.

45. THE ANGELUS. By Jean-François Millet, c. 1858–9. Oil on canvas, 55·5 × 66 cm. Paris: Louvre. (Photograph: Giraudon.)

46. THE ANGELUS. By Alphonse Legros, 1859. Formerly Cheltenham: Mr Asa Lingard. (Photograph: by courtesy Phaidon Press.)

The Angelus was bought by Whistler's brother-in-law, Seymour Haden, shortly after Legros's arrival in London. (He was to settle permanently in England.) Unfortunately, Haden was an artist, and he undertook to 'correct' the faulty perspective of *The Angelus* by repainting the floor, much to the chagrin of Whistler and Legros, who made off with the work and restored it to its original condition.

Legros's *L'Ex-Voto*, 1860, is now in the Musée des Beaux-Arts of Dijon; his *Calvaire*, 1874, in the Louvre. The same sort of 'regional sociology' or 'anthropology' is offered by Jules Breton's *Plantation du Calvaire*, 1858, in the Musée de Lille; the latter's *Religious Procession in Brittany*, 1869, formerly in the collection of the Metropolitan Museum in New York; or his *Pardon de Kergoat* of 1891.

Lit: Baudelaire, *The Mirror of Art*, ed. J. Mayne, 1955, 241–3, 344; *Alphonse Legros*, exh. cat., Dijon, 1957.

47. THREE WOMEN IN CHURCH. By Wilhelm Leibl, 1878–82. Oil on panel, 113 × 77 cm. Hamburg: Kunsthalle. (Photograph: Museum.)

Leibl reports on the slow progress of his masterpiece in a series of letters to his mother from Berbling. In one of 1879 he states: 'Several peasants came to look at it just lately, and they instinctively folded their hands in front of it. One man said "that is the work of a master." I have always set greater store by the opinion of simple peasants than by that of so-called painters, so I take that peasant's remark as a good omen.'

48. THE FUNERAL. By Édouard Manet, c. 1870. Oil on canvas, 72·7 × 90·4 cm. New York: Metropolitan Museum. (Photograph: Museum.)

The painting is unfinished, but 'complete', in Baudelairian terms.

Lit: C. Sterling and M. Salinger, *French Painting, Metropolitan Museum*, 1966, III, 44-5.

49. THE FUNERAL OF PHOCION. By Nicholas Poussin, 1648. Oil on canvas, 114 × 175 cm. Ludlow, Earl of Plymouth Collection. (Photograph: Giraudon.)
This painting is now known to be the original version. There is a seventeenth-century copy in the Louvre.
Lit: Sir A. Blunt, *Nicolas Poussin*, 1967, Cat. No. 173; text 165 ff. for discussion and further bibliography.

50. HOUNDSDITCH. By Gustave Doré, 1872. Illustration, wood engraving, 24·2 × 19 cm. In *London*, opp. p. 126. (Photograph: Djirdjirian.)
This is one of many similar illustrations to the remarkable literary and pictorial investigation of the city, published by Blanchard Jerrold and Doré. In neighbourhoods such as this, Jerrold remarks, 'The West-End Londoner is as completely in a strange land as any traveller from the Continent.'
Lit: B. Jerrold and G. Doré, *London*, 1872.

51. THE BURDEN. By Honoré Daumier, *c.* 1855. Terra cotta, height 35 cm. Baltimore: Walters Art Gallery. (Photograph: Museum.)
The sculpture was formerly in the Paul Rosenberg Collection.
Lit: J. Wasserman, *Daumier Sculpture*, 1969, no. 40a and pp. 184-5.

52. THE ROMANS OF THE DECADENCE. By Thomas Couture, 1847. Oil on canvas, 466 × 775 cm. Paris: Louvre. (Photograph: Archives.)
The painting was viewed by such left-wing critics as Théophile Thoré as an attack on the corrupt government and mores of the time.
Lit: J. Seznec in *G.B.A.*, 1943, 221-32; A. Boime in *Art Bull.*, 1969, 48-56; *Thomas Couture, Paintings and Drawings in American Collections*, exh. cat., 1970; M. Fried, *Artforum*, June 1970, 36-46.

53. LE RÊVE DE BONHEUR. By Dominique Papety, 1843. Compiègne; Museum. (Photograph: Archives.)
Dominique Papety was a Fourierist and belonged to the circle around Alfred Bruyas and François Sabatier in Montpellier. Drawings for this painting, as well as a sketch for an elaborate but uncompleted Fourierist allegory, *The Last Night of Slavery*, are in the Musée Fabre at Montpellier. Although Baudelaire was sarcastic about *Le Rêve de Bonheur*, another contemporary critic saw 'a club, a popular bank, a phalanstery in "this dream of the gardens of Academos".' For a later interpretation of this Fourierist Utopian theme, see Paul Signac's *Temps d'Harmonie*, 1896, in E. Herbert, *The Artist and Social Reform*, 1961, fig. 13.
Lit: L. Nochlin in *The Avant-Garde* (*Art News Annual*), 1968, 13-14.

54. THE HOLY ALLIANCE OF THE PEOPLE, (detail). By Jean-Baptiste Carpeaux, 1849. Plaster, 105 × 353 cm. Valenciennes: Musée des Beaux-Arts. (Photograph: Archives.)

55. STORMING A BARRICADE, RUE PERDUE (PANTHÉON DISTRICT). From *Souvenirs des journées de juin 1848*, series of lithographs, *chez* Aubert, 1848. Paris, Bibliothèque Nationale. (Photograph: B.N.)
For a more dramatic and circumstantial illustration of revolutionary activity on the barricades, anti-Delacroix in its insistence on 'real life' concreteness, see the English illustrator A. Boyd Houghton's depiction of a barricade under the Commune (1871), with its marvellous foreground close-up of a *femme du peuple* and some children dragging an over-turned grand piano up the mound of paving stones. The only other such vivid musical synecdoche of wartime chaos is the brief glimpse of somebody dragging *a harp* through the hysterical crowds of Atlanta in the movie *Gone With the Wind*!

56. THE BARRICADE, RUE DE LA MORTELLERIE (JUNE 1848). By Ernest

Meissonier, 1848. Oil on canvas, 29 × 22 cm. Paris: Louvre. (Photograph: Giraudon.)

This painting, by the enormously popular Meissonier, was exhibited in the 1850–51 Salon as 'Souvenir of the Civil War'.

57. MONUMENT TO COMMEMORATE THE CUTTING OF THE SUEZ CANAL. By Pietro Magni, 1858–63. Marble; base: 103 × 162 × 162 cm. Group: 190 × 143 × 143 cm. Trieste: Civico Museo Revoltella. (Photograph: Museum.)
 Lit: F. Licht, *Sculpture: 19th and 20th Centuries*, 1967, no. 97 and p. 318.

58. THE STONE-BREAKERS. By Gustave Courbet, 1849. Oil on canvas, 165 × 238 cm. Formerly, Dresden: Museum. (Photograph: Archives.)
 The painting was destroyed during the Second World War. A painted sketch for it still exists in the Reinhart Collection in Winterthur, Switzerland. *The Stone-breakers* served as the basis of a sermon by P.-J. Proudhon, the anarchist, against the iniquities of modern industrial civilization, in his *Du principe de l'art*, 1865.
 Lit: T. J. Clark in *Burl. Mag.*, *CXI*, 1969, 208–11.

59. THE TINKER. By Alphonse Legros, n.d. Oil on canvas, 170 × 140 cm. London: Victoria and Albert. (Photograph: Museum.)
 Courbet also did a painting of a tinker, and the blacksmith was certainly a favourite subject of painters of the rural scene: both Jules Breton and François Bonvin painted village smithies, as opposed to the more industrialized, large-scale subjects depicted by Menzel in his *Rolling Mill* or Cormon in his *Forge*.

60. THE SOWER. By Jean-François Millet, 1850. Oil on canvas, 101 × 82·5 cm. Boston: Museum of Fine Arts. (Photograph: Museum.)
 Two other versions of this painting exist: one in the Provident Trust in Philadelphia, the other in the Julius H. Weitzner Collection.
 A good brief discussion is in R. Herbert, *Barbizon Revisited*, 1962, 41f, 148ff.
 Lit: J. Cartwright, *Jean-François Millet*, 1896, 110ff.

61. THE RETURN OF THE GLEANERS (ARTOIS). By Jules Breton, 1859. Oil on canvas, 90·5 × 176 cm. Arras: Musée. (Photograph: Alinari.)
 Breton was one of the earliest painters to specialize in the activities of field-workers, generally those of his native Artois. A contemporary critic called these gleaners 'beautiful rustic caryatids'.
 Lit: *Baudelaire*, exh. cat., 1968–9, no. 471.

62. THE GLEANERS. By Jean-François Millet, 1857. Oil on canvas, 835 × 111 cm. Paris, Louvre. (Photograph: Archives.)
 Earlier versions of the subject are mentioned in R. L. Herbert, *Barbizon Revisited*, 1962, 151, and there is a brief general discussion, 41ff.
 Lit: J. Cartwright, *Jean-François Millet*, 1896, 175ff.; R. L. Herbert, 'Millet Revisited', *Burl. Mag.*, 104, 1962, 294ff.

63. THE STONE-BREAKER (THOU WERT OUR CONSCRIPT). By Henry Wallis, 1857. Oil on panel, 65·3 × 79 cm. Birmingham: City Museum and Art Gallery. (Photograph: Museum.)
 The painting was exhibited at the Royal Academy in 1858 with the following quotation from Carlyle's *Sartor Resartus*: 'Hardly entreated, brother! For us was thy back so bent, for us were thy straight limbs and fingers so deformed; thou wert our conscript on whom the lot fell, and fighting our battles wert so marred. For in thee too lay a God-created form, but it was not to be unfolded . . .'
 The painting was much admired by Ruskin, who wrote of it, in his 1858 *Academy Notes*: 'On the whole, to my mind, the picture of the year . . . It is entirely pathetic and beautiful in purpose and colour.'
 Lit: *Romantic Art in Britain*, exh. cat., 1968, no. 232.

64. THE MAN WITH THE HOE. By Jean-François Millet, 1859–61. Oil on canvas,

81 × 100 cm. San Francisco: Private Collection, on loan to the California Palace of the Legion of Honour. (Photograph: California Palace of the Legion of Honour.)

The Man with the Hoe was bitterly attacked when it was shown in the Salon of 1863, and was jeeringly dubbed 'Dumoulard', the name of a labourer who had murdered his employer's family. It later became one of the best-known works in the history of art, immortalized by Edwin Markham's verses in 1899, and adored by many who were otherwise ignorant of artistic matters.

Lit: R. L. Herbert, *Barbizon Revisited*, exh. cat., 1962, no. 70.

65. PROXIMUS TUUS. By Achille d'Orsi, 1880. Bronze. Height 79 cm. Rome: Galleria Nazionale d'Arte Moderna. (Photograph: Alinari.)

D'Orsi, a Neapolitan sculptor, had created a stir with his brutally veristic bronze group, *The Parasites*, 1868, representing two drunken Romans whose poses and accoutrements were based on the archeological discoveries at Pompeii. *Proximus tuus* bears witness to his warm sympathy for the lowest level of the social order, and was probably inspired by a visit to the studio of the socially conscious Teofilo Patini. The pose of the labourer would, however, seem to be directly based on Millet's pastel, *Le Repos de Vigneron*, *c.* 1869, in the Musée Mesdag, the Hague.

66. THE IRISH BEGGARS (HARVESTERS BY THE ROADSIDE). By Walter Howell Deverell, *c.* 1850. Oil on canvas, 62·3 × 75·2 cm. Johannesburg: Art Gallery. (Photograph: Museum.)

This painting, like George Watts's *Irish Famine*, 1849–50, would seem to refer to the terrible conditions in Ireland resulting from the failure of the potato crop in the forties, and leading to mass emigration and decimation of the Irish population. The woman with her baby, who appears in both this painting and the Watts canvas, is also present in the left foreground of Courbet's *Studio* of 1855, and Courbet refers to her as an 'Irishwoman suckling a child', a souvenir of a trip to England. Since Courbet is not known to have visited England, one wonders whether he might have come across reproductions of this or the Watts painting.

Lit: R. Ironside and J. Gere, *Pre-Raphaelite Painters*, 1948, 27–8.

67. ON STRIKE. By Hubert von Herkomer, 1891. Oil on canvas, 227·5 × 126·5 cm. London: Royal Academy of Arts. (Photograph: Royal Academy of Arts.)

Herkomer had depicted distress among the rural labouring classes in his *Hard Times* of 1885 (now in the Manchester Art Galleries), in which he depicted an unemployed labourer standing in the road next to his despairing wife, who is seated next to him on the ground with a baby and an older child. In *Pressing Westward* of about 1882, he depicted a crowd of poor people emigrating to New York.

68. THE VILLAGE MAIDENS (LES DEMOISELLES DE VILLAGE). By Gustave Courbet, 1852. Oil on canvas, 195 × 261 cm. New York: Metropolitan Museum. (Photograph: Museum.)

The painting was listed in the Salon catalogue of 1852 as *The Village Maidens Giving Alms to a Guardian of Cattle*. Courbet believed that with this painting, he had put his critics off the track by doing 'something charming'; the work was, in fact, secretly purchased before the Salon opening, by the Duc de Morny. The painting was, however, savagely pilloried by the press and the public: a satiric review based on the painting, entitled *Le Feuilleton d'Aristophane* was played in the theatre. A painted sketch for the work is in the City Art Gallery of Leeds.

Lit: C. Sterling and M. Salinger, *French Paintings: Metropolitan Museum*, 1966, II, 106–9; T. J. Clark in *Burl. Mag., CXI,* 286–90.

69. WORK. By Ford Madox Brown, 1852-65. Oil on canvas, 113 × 196 cm., curved top. Manchester: City Art Gallery. (Photograph- Museum.)

The painting is inscribed on the frame (left): Neither did we eat any man's bread for naught, but wrought with labour & travail night and day; (centre): I must work while it is day for night cometh when no man can work; (right): Seest thou a man diligent in his business? He shall stand before kings. F. M. Hueffer (*Ford Madox Brown*, 1896, 189-97) relates the iconography to Carlyle's writing, most notably his *Past and Present*. Brown himself wrote a long, detailed description of the work and its meaning in a catalogue statement of 1865. He also wrote a sonnet to accompany the painting (published by R. Lister, *Victorian Narrative Paintings*, 1966, 74) beginning: 'Work, which beads the brow and tans the flesh/ Of lusty manhood, casting out its devils.' A smaller version of *Work*, commissioned by James Leathart in 1860, is in the Birmingham City Museum and Art Gallery. Brown specifically insists on the appropriateness of the light to the subject: 'The effect of hot July sunlight attempted in this picture, has been introduced because it seems peculiarly fitted to display *Work* in all its severity, and not from any predilection for this kind of light over any other.'

Lit: *Ford Madox Brown*, exh. cat., 1964, no. 25.

70. THE PAINTER'S STUDIO. By Gustave Courbet, 1855. Oil on canvas, 361 × 598. Paris: Louvre. (Photograph: Giraudon.)

The painting was entitled: 'Interior of my studio; a real allegory determining a phase of seven years of my artistic life', when it first appeared in Courbet's independent exhibition of 1855, in the 'Pavillion of Realism'. The basic source for the study of this important work is the publication by R. Huyghe, G. Bazin and H. Adhémar, *Courbet: L'Atelier* (*Monographies des Peintures du Musée du Louvre*, III), 1944. Recent interpretations of this complex and provocative work are those by: W. Hofmann in *The Earthly Paradise*, 1961, 11-21; M. Kozloff in *Art and Literature*, 1964, 162-83; L. Nochlin in *The Avant-Garde* (*Art News Annual*, XXIV), 11-16. The latter interprets it in terms of Fourierist doctrine.

71. THE PAINTER'S STUDIO (detail, centre). By Gustave Courbet.

72. SKETCH FOR THE MONUMENT TO LABOUR. By Aimé-Jules Dalou, 1889-91. Plaster. Paris: Petit Palais. (Photograph: Giraudon.)

A study for one of twelve figures in high relief to be placed in niches around a central column. This figure and a Sower are illustrated in H. Caillaux, *Aimé-Jules Dalou*, 1935, plate 9, and discussed, 64ff.

73. VICTIMS OF LABOUR: MONUMENT IN HONOUR OF THE WORKERS WHO DIED DURING THE BUILDING OF THE ST GOTTHARD TUNNEL. By Vincenzo Vela, c. 1882. Bronze, 224 × 327 cm. Rome: Galleria Nazionale d'Arte Moderna. (Photograph: Alinari.)

Lit: F. Licht, *Sculpture: 19th & 20th Centuries*, 1967, no. 112, p. 319.

74. CHEZ LE FONDEUR. By Jean-François Raffaëlli, 1886. Oil on canvas, 128 × 116 cm. Lyon: Musée. (Photograph: Museum.)

The bronze caster, Gonon, is represented working on Dalou's memorial bas-relief of Mirabeau and Dreux-Brézé, commissioned by Gambetta in 1883.

Lit: A. Alexandre, *Jean-François Rafaëlli*, 1909; M. Vincent, *La Peinture des XIX^e et XX^e siècles* (catalogue du Musée de Lyon), 1956, 214-15.

75. THE RESCUE. By John Everett Millais, 1855. Oil on canvas, 121·4 × 84 cm. Melbourne: National Gallery of Australia. (Photograph: Royal Academy of Arts.)

The model for the mother was Mrs Senior, the reformer of pauper schools. Millais went to great pains to create the illusion of an actual blaze, visiting several big fires in London to study the light effect, achieving the sense of glare

by placing a sheet of coloured glass between the window and the models, and painting the flaming timber from a burning brand in the studio. Like Courbet, he was a friend of the leader of his city's fire brigade.

Lit: *Romantic Art in Britain*, exh. cat., 1968, no. 227.

76. LE DÉJEUNER SUR L'HERBE. By Claude Monet, *c.* 1865–6. Oil on canvas, 123·8 × 180·4 cm. Moscow: Pushkin Museum. (Photograph: Museum.)

Critics are divided about whether this is a large preliminary sketch for the final painting, or a replica painted in 1866, when Monet presumably abandoned the final canvas. There is also some question about the identity of the figure seated to the left of the table-cloth, who is different in the Moscow version and Paris fragment. Nevertheless, despite the date 1866 inscribed on the Moscow version, the evidence would seem to favour its being viewed as a study, rather than as a replica, and the identification of the seated figure, originally the painter Lambron, in the Moscow version, with Gustave Courbet in the final painting.

77. LE DÉJEUNER SUR L'HERBE (Fragment). By Claude Monet, 1865–6. Oil on canvas, 247 × 216·7 cm. Paris: Private Collection. (Photograph: Roger Viollet.)

Both the history of the original, large painting, of which this fragment constituted the central portion (the left-hand section is now in the Louvre) and its relation to the smaller version, now in the Pushkin Museum in Moscow, are somewhat unclear. Monet embarked on the gigantic painting – originally about 15 × 19 feet! – in the spring of 1865 at Chailly, intending to prepare the work for the 1866 Salon: he was obviously inspired by, and competing with, Manet's *Déjeuner* of 1863, both in scale and in realist contemporaneity. Camille posed for all the female figures. Monet's friends posed for the male figures, most notably Bazille, who, after much urging, arrived at Chailly in August. It is uncertain just *when* the painting was abandoned, and for what reasons, and whether or not Monet continued to work on it during January and February, 1866, in his Paris studio, as some younger scholars, J. Isaacson and G. Needham (in unpublished doctoral dissertations) have suggested. In any case, they feel that the major part of the work on the *Déjeuner* occurred from October 1865, to February, 1866. It is generally assumed that Monet dismembered the painting after it had been seized for non-payment of debts, rolled up and attacked by damp, although some authorities assert that Monet abandoned the painting because he was dissatisfied with it – which seems unlikely.

Lit: W. Seitz, *Claude Monet*, 1960, 66.

78. THE PRETTY BAA LAMBS (SUMMER HEAT). By Ford Madox Brown, 1851–9. Oil on panel, 61 × 76·2 cm. Birmingham: City Museum and Art Gallery. (Photograph: Museum.)

This was the artist's first important landscape. The critic R. A. M. Stevenson later exclaimed of this work: 'By God! the whole history of modern art begins with that picture. Corot, Manet, the Marises, all the Fontainebleau School, all the Impressionists, never did anything but imitate that picture.' For the whole question of British *plein-air* painting see A. Staley, *Burl. Mag.*, 1963, 474 ff.

Lit: *Ford Madox Brown*, exh. cat., 1964, no. 21; *Romantic Art in Britain*, exh. cat., 1968, no. 212.

79. STRAYED SHEEP (OUR ENGLISH COASTS). By William Holman Hunt, 1852. Oil on canvas, 43·2 × 58·5 cm. London: Tate Gallery. (Photograph: Museum.)

The painting was commissioned by an admirer of Hunt's *Hireling Shepherd*. It was shown in the Paris Universal Exposition of 1855, where it received a great deal of attention. For the relation of the work to English religious currents, see L. Errington, *Burl. Mag.*, 1969, 521 f.

Lit: *Romantic Art in Britain*, exh. cat., 1968, no. 216.

80. AN ENGLISH AUTUMN AFTERNOON. By Ford Madox Brown, 1852–4. Oil on canvas, oval, 72 × 134·8 cm. Birmingham: City Art Gallery and Museum. (Photograph: Museum.)

When Ruskin, in an unfavourable comment, asked Brown why he had chosen such an ugly view, the artist retorted: 'Because it lay out of a back window.' In his 1865 catalogue, Brown wrote that it was a 'literal transcript of the scenery around London, as looked at from Hampstead' and even gives the exact hour – 3 p.m. – represented.

Lit: *Ford Madox Brown*, exh. cat., 1964, no. 28.

81. THE PICNIC. By Auguste-Barthelemy Glaize, *c.* 1850. Oil on canvas, 145 × 114 cm. Montpellier; Musée Fabre. (Photograph: Claude O'Sughrue.)

Glaize was a painter from Montpellier who also represented Alfred Bruyas in his *Studio*, a painting which may well have influenced Courbet when he visited Bruyas in Montpellier. Still other, less-known representations of picnics in the fifties and sixties are those by Degas's friend, James Tissot, of about 1865, now in the A. R. MacWilliams Collection in London, and Paul Cézanne's far more brooding and sombre *The Picnic, c.* 1869, in the René Lecomte Collection in Paris.

82. LIFE AT THE SEASIDE (RAMSGATE SANDS). By William Powell Frith, 1852–4. Oil on canvas, 76·3 × 52·4 cm. Collection: H.M. the Queen. (Photograph: Reproduced by gracious permission of H.M. the Queen.)

This was Frith's first large-scale painting representing a scene from everyday life. The first studies for it are dated 4 September 1851.

83. THE BEACH AT TROUVILLE. By Eugène Boudin, 1865. Oil on cardboard, 265 × 405 cm. Paris, Louvre. (Photograph: Museum.)

84. ON THE BEACH AT BOULOGNE. By Édouard Manet, 1869. Oil on canvas, 33 × 65 cm. Washington: Mr and Mrs Paul Mellon Collection. (Photograph: National Gallery, Washington.)

Lit: A. De Leiris in *G.B.A.*, 1961, 53–62.

85. ON THE BEACH, TROUVILLE. By Claude Monet, 1870. Oil on canvas, 38 × 45·8 cm. London: Tate Gallery. (Photograph: Museum.)

Lit: W. Seitz, *Claude Monet*, 1960, 86.

86. BEHOLD OUR NUPTIAL CHAMBER. By Honoré Daumier, 1853. Lithograph, 25·6 × 20·9 cm.

This lithograph, Delteil 2429, was published in *Charivari* on 13 December 1853. Daumier's lithographs dealing with the destruction and reconstruction of Paris under Baron Haussmann are discussed by F. D. Klingender in the *Architectural Review*, Aug. 1941, 55–60.

87. THE THIRD CLASS CARRIAGE. By Honoré Daumier, *c.* 1856. Oil on canvas, 65·4 × 90·2 cm. New York: Metropolitan Museum. (Photograph: Museum.)

This is one of three painted versions of the theme: a water-colour in the Walters Gallery in Baltimore is probably the earliest and a slightly larger, more finished version in the National Gallery of Ottawa is probably the final one. In addition, Daumier treated the subject of railway travel in at least four series of lithographs.

Lit: C. Sterling and M. Salinger, *French Paintings: Metropolitan Museum*, 1966, II, 37–9.

88. THE RAILWAY STATION. By William Powell Frith, 1862. Oil on canvas, 117 × 256·6 cm. Englefield Green, Surrey: Royal Holloway College (University of London). (Photograph: Royal Holloway College.)

There is a reduced replica of this painting from 1863 in the Museum and Art Gallery, Leicester. The scene is set in Paddington Station and crowded with incident. The artist explained in a letter of 1887 that the group of children in the foreground – boys going to school – were portraits of his own family, the father

being his own likeness, while the two police officers arresting the man who is about to enter the train are portraits of well-known detectives. A lengthy description of the entire cast of characters was published by *The Times* in April, 1862. The painting contains almost a hundred figures and, in the words of *The Times*, is a work of art 'natural, familiar and bourgeois' rather than ideal, epic, or heroic.

89. APPLICANTS FOR ADMISSION TO A CASUAL WARD. By Sir Luke Fildes, 1874. Oil on canvas, 142·5 × 247·8 cm. Englefield Green, Surrey: Royal Holloway College (University of London). (Photograph: Royal Academy.)

The composition first appeared as a drawing in *The Graphic*, Dec. 4, 1869. In the Royal Academy exhibition catalogue, its title was followed by an appropriate quotation from Dickens. Van Gogh remarked on the version in *The Graphic – Houseless and Hungry* – in a letter to his brother (169) of 1882. He also remarked on Fildes' drawing for Dickens's *Edwin Drood*, entitled *The Empty Chair*, which may well have inspired his own famous representations of his and Gauguin's chairs.

Lit: L. V. Fildes, *A Victorian Painter*, 1968, 24–7.

90. UNLOADING COAL. By Claude Monet, 1872. Oil on canvas, 54 × 64 cm. Paris, Durand-Ruel. (Photograph: Giraudon.)

The 'labour' theme is here completely subordinate to the design itself, which shows the strong influence of Japanese woodcuts in the bridge, the rhythmic diagonals of the gangplanks, the upright silhouetted figures and the rich, muted colours.

Lit: W. C. Seitz, *Claude Monet*, 1960, 94.

91. THE IRONERS. By Edgar Degas, *c.* 1884. Oil on canvas, 76 × 82 cm. Paris, Louvre. (Photograph: Agraci.)

Degas shows the ironers, like his dancers or race horses, in terms of their habitual gestures, the result of training and constantly repeated actions – in direct contrast to his presentation of more sophisticated, individuated *désinvolture* in his portrait of the Manets, for example.

Lit: P.-A. Lemoisne, *Degas et son œuvre*, 1946–9, no. 785; C. Sterling and H. Adhémar, *Peintures: Ecole Francais XIX Siècle, Musée du Louvre*, 1959, II, no. 642; J. Walker, 'Degas et les Maîtres anciens', *G.B.A.*, 1933, 175.

92. THE FLOOR-SCRAPERS. By Gustave Caillebotte, 1875. Oil on canvas, 102 × 146·5 cm. Paris: Louvre. (Photograph: Giraudon.)

Caillebotte, a generally underestimated artist, better-known as the donor of his magnificent collection of Impressionist paintings to the Louvre, painted a related subject, *The House-Painters*, showing building workers out of doors, in 1877.

Lit: M. Berhaut, *La Vie et l'œuvre de Gustave Caillebotte*, 1951.

93. RAILWAY BRIDGE AT ARGENTEUIL. By Claude Monet, 1873. Oil on canvas, 54·5 × 71·2 cm. Paris, Louvre. (Photograph: Museum.)

There is another version of this railway bridge, also with a train crossing, painted in 1875, at the Philadelphia Museum or Art.

Lit: J. Rewald, *History of Impressionism*, 1961, 353; D. Rouart, *Claude Monet*, 1958, 59.

94. BRIDGE AT MANTES. By Camille Corot, *c.* 1868–70. Oil on canvas, 38 × 56 cm. Paris, Louvre. (Photograph: Museum.)

Lit: A. Robaut, *Corot*, cat. rais., 1956, No. 1516.

95. THE CONCERT IN THE TUILERIES. By Édouard Manet, 1862. Oil on canvas, 76 × 119 cm. London: National Gallery. (Photograph: National Gallery.)

Lit: N. G. Sandblad, *Manet: Three Studies in Artistic Conception*, 1954, 17–68.

96. THE STREET SINGER. By Édouard Manet, 1862. Oil on canvas, 174 × 118 cm. Boston, Museum of Fine Arts. (Photograph: Museum.)

This was the first painting for which Manet's favourite model, Victorine Meurend, posed.

Lit: N. G. Sandblad, *Manet*, 1954, 82–7; J. Richardson, *Édouard Manet*, 1958, 18–19 and Cat. No. 15.

97. THE RAILROAD. By Édouard Manet, 1873. Oil on canvas, 92·9 × 112 cm. Washington, D.C.: National Gallery of Art. (Gift of Horace Havemeyer.) (Photograph: National Gallery, Washington.)

Manet was a great admirer of railroads, considering them the epitome of modern life. He thought of railroad drivers as 'modern heroes', and looked forward to painting them.

98. NANA. By Édouard Manet, 1877. Oil on canvas, 154 × 115 cm. Hamburg: Kunsthalle. (Photograph: Museum.)

Whether or not this painting is related to Zola's novel *Nana*, which did not begin to appear serially until 1879, and in which an incident similar to the one depicted by Manet occurs, is a matter of conjecture. The model for the painting was, presumably, a famous *cocotte* of the period, the musical-comedy star Henriette Hauser. Manet did several other works depicting women at their toilettes, such as the near-contemporary *Devant La Glace* in the Thannhauser Collection or the pastel *Woman with Garter* in the W. Hansen collection in Copenhagen. The theme of the woman at her toilet with or without a masculine admirer, had, of course, been a popular one in the eighteenth century, and there is more than a hint of the mood and manner of the rococo in this painting, although, as is so often the case in Manet's works with traditional references, the tone is resolutely modern.

Lit: I. Ebin in *G.B.A.*, 1945, 357–78; T. Reff in *G.B.A.*, 1964, 552–9.

99. THE TAVERN. (LEBOUCHON or LA GUINGUETTE.) By Édouard Manet, 1878. Drawing, pencil, 14·0 × 9·2 cm. New York: Miss Carole Anne Slatkin. (Photograph: reproduced by courtesy of Miss Slatkin.)

100. AT THE CAFÉ. By Édouard Manet, 1878. Oil on canvas, 47·3 × 39 cm. Baltimore: Walters Art Gallery. (Photograph: Museum.)

The locale is probably the Brasserie de Reichshoffen on the Boulevard Rochechouart. This is one of a group of four related paintings of café subjects, painted by Manet from 1878 to, possibly, 1879. This group includes: *Au Café*, now in the Oskar Reinhart Collection in Winterthur and *The Waitress (La Servante de Bocks)* now in the National Gallery in London. The two latter may at one time have formed a single large painting. There is also another version of *The Waitress* in the Louvre, formerly in the Matsukata Collection, Tokyo. For a discussion of the relationship among these works, see M. Davies, *National Gallery Catalogues: French School*, 1957, 149–52.

Lit: A. C. Hanson, *Édouard Manet*, exh. cat., 1966–7, No. 174.

101. CAFÉ-CONCERT. By Edgar Degas, *c.* 1877. Pastel over monotype on paper, 37 × 27 cm. Lyon: Musée des Beaux-Arts. (Photograph: Giraudon.)

This work was shown in the third Impressionist Exhibition, 1877.

Lit: E. P. Janis, *Degas Monotypes*, 1968, no. 23.

102. BOULEVARD DE STRASBOURG. By Hippolyte Jouvin, 1860–65. Stereoscopic photograph. Collection André Jammes.

This is an early instantaneous photograph.

Lit: A. Scharf, *Art and Photography*, 1968, 139.

103. PLACE DE L'EUROPE ON A RAINY DAY. By Gustave Caillebotte, 1877. Oil on canvas, 209 × 300 cm. Chicago: Art Institute. (Photograph: Art Institute, Chicago.)

Lit: *The Past Rediscovered: French Painting 1800–1900*, exh. cat., 1969, no. 7.

104. BOULEVARD DES CAPUCINES. By Claude Monet, 1873. Oil on canvas, 80 × 60 cm. New York: Mrs Marshall Field, III. (Photograph: Wildenstein, courtesy of Mrs Marshall Field, III.)

Monet painted this subject twice – one version was shown in the first Impressionist Exhibition of 1874 – from the photographer Nadar's studio.

Lit: J. Rewald, *History of Impressionism*, 1961, 320-6; W. C. Seitz, *Claude Monet*, 1960, frontispiece; J. Lethève, *Impressionistes et Symbolistes devant la presse*, 1959, 69-70.

105. MAN AT A WINDOW. By Gustave Caillebotte, 1875. Oil on canvas, 117·3 × 82·8 cm. Paris: Private Collection. (Photograph: Les Beaux-Arts.)

The painting was exhibited at the second Impressionist Exhibition, 1876, in which the artist showed eight paintings and was much noticed by the critics. It is one of a remarkable series of plunging, almost aerial, views undertaken by Caillebotte, such as his *Caserne de la Pépinière*, 1878, his *Refuge, Boulevard Haussmann*, 1880, or his *Le Balcon* of the same year. Of these views, his figures at windows form a sub-series, of which the earliest appeared in 1875. These works are of course, related to similar ones by Degas (*À la fenêtre, c.* 1872), Manet (*Mme Manet au balcon*), or, especially, Monet (*Boulevard des Capucines*, 1873).

Lit: J. Rewald, *History of Impressionism*, 1961, 372-3; M. Berhaut, *Caillebotte, L'Impressioniste*, 1951, 30-4.

106. THE COFFEE MILL. By Charles de Groux, before 1870. Oil on canvas, 117 × 150 cm. Antwerp: Royal Museum of Art. (Photograph: Museum.)

De Groux, a Belgian, turned from history painting to the depiction of social themes as early as 1847, and the latter gradually assumed primacy in his work.

107. ROAD MENDERS IN THE RUE DE BERNE. By Édouard Manet, 1877-8. Oil on canvas, 64 × 80 cm. Cambridge: Lord Butler. (Photograph: Courtauld Institute.)

In Manet's time the rue de Berne was called the rue Mosnier and was visible from the artist's studio window. In addition to this painting of the rue de Berne, he did two others, showing the street decorated with flags to celebrate the 1878 Universal Exposition. There are also a number of studies in pencil and wash.

Lit: A. C. Hanson, *Manet*, exh. cat., 1966-7, Nos. 142-3.

108. QUAI DU LOUVRE. By Claude Monet, *c.* 1866. Oil on canvas, 64·7 × 93·1 cm. The Hague: Gemeentemuseum. (Photograph: Museum.)

This is one of three views of Paris painted from the elevated vantage point of the Louvre. Two of these were painted from the east balcony – *Saint-Germain-l'Auxerrois* in the Berlin National Gallery and *The Garden of the Princess, Louvre* in the Allen Memorial Art Museum, Oberlin College, Ohio. The third of these urban vistas, the *Quai du Louvre*, was painted from the south side of the building. In the catalogue of the 1957 Monet Exhibition at the Tate Gallery, London, the work is dated 1866-7.

Lit: W. C. Seitz, *Claude Monet*, 1960, 21-2, 68; *Claude Monet*, exh. cat., London, Tate Gallery, 1957, no. 9; J. Isaacson in Oberlin College Bulletin, vol. 24 (1966), 4-22.

109. THE PONT NEUF. By Auguste Renoir, 1872. Oil on canvas, 74·4 × 92·7 cm. Washington, D.C.: National Gallery of Art, Ailsa Mellon Bruce Collection. (Photograph: Knoedlers.)

The painting is published by J. Rewald (*The History of Impressionism*, 1961, 280) with a similar photograph of the Pont Neuf, of about 1860. According to Rewald, the work was painted from the second floor of a café opposite the bridge, with Renoir's brother stopping the passers-by to ask some bit of information in order that Renoir might have time to sketch them. Monet painted a similar, but far sketchier, view of the Pont Neuf in 1873.

110. NADAR ELEVATING PHOTOGRAPHY TO THE HEIGHT OF ART. By Honoré Daumier, 1862. Lithograph, 27·2 × 22·2 cm. Boston: Museum of Fine Arts. (Photograph: Museum.)

Nadar, a friend of many artists of the time, was a flamboyant character – photographer, caricaturist and writer – famed for his balloon ascents.

Lit: H. Schwarz in *G.B.A.*, 1957, 100–104.

111. AVENUE DE L'OPÉRA. By Camille Pissarro, 1898. Oil on canvas, 73 × 92 cm. Reims: Musée. (Photograph: Giraudon.)

Lit: L. R. Pissarro and L. Venturi, *Camille Pissarro*, cat. rais., 1939, no. 1024. R. T. Coe in *G.B.A.*, 1954, 93–118.

112. BOULEVARD, VU D'EN HAUT. By Gustave Caillebotte, 1880. Oil on canvas, 63·7 × 53·5 cm. London, Private Collection. (Photograph: Les Beaux-Arts.)

The bird's-eye viewpoint of this remarkable painting was rare, even in photography, at the time it was painted, according to A. Scharf. While he finds a comparable viewpoint in a stereoscopic photograph by Hippolyte Jouvin for Caillebotte's *A Shelter, Boulevard Haussmann*, 1880, Scharf says the exaggerated bird's-eye view of the *Boulevard, Seen from Above* is hardly to be found in photography until 1913.

Lit: A. Scharf, *Art and Photography*, 1968, 133, and illus. 135.

113. RUE MONTORGUEIL DECKED OUT WITH FLAGS. By Claude Monet, 1878. Oil on canvas, 62 × 33 cm. Rouen: Musée des Beaux-Arts. (Photograph: Giraudon.)

Manet, on the same occasion, painted the flag-bedecked rue de Berne. Said Monet later, in 1920, reminiscing about this day: 'I like flags very much. At the first Fête Nationale, of June 30th [1878], I was walking along Rue Montorgueil with my painting equipment. The street was decked out with flags, but swarming with people. I spied a balcony, mounted the stairs and asked permission to paint. It was granted . . .' (Cited in W. Seitz, *Claude Monet*, 1960, 108.)

114. IRON AND COAL. By William Bell Scott, 1861. Mural on wall, 189·6 × 189·6 cm. Wallington Hall, Northumberland. (Photograph: National Trust.)

This was one of a series of eight murals by Scott, describing the history of Northumberland and culminating in this view of contemporary Newcastle. The scene is a view of Tyneside, shortly after the completion of R. Stephenson's High Level Bridge, which appears in the distance. Representations of all local industries are included, the three hammersmen being portraits of men from the locomotive works of Robert Stephenson & Co.

Lit: F. D. Klingender, *Art and the Industrial Revolution*, 1968, 178 and no. 112, p. 218.

115. PIERRE-JOSEPH PROUDHON AND HIS FAMILY. By Gustave Courbet, 1865–7. Oil on canvas, 147 × 198 cm. Paris: Petit Palais. (Photograph: Archives.)

The date 1853 inscribed on the second step refers to the time Courbet wished to represent, when he had seen the philosopher on the steps of his house in the rue d'Enfer. The painting was created after Proudhon's death, on the basis of photographs, a cast and another portrait of the subject; in the original version shown in the 1865 Salon, it included Madame Proudhon, seated in the chair to the right, but the figure was removed in the course of repainting in 1866–7.

Extensive bibliographical references may be found in *Gustave Courbet*, exhibition cat., Philadelphia, Boston, 1959–60, No. 54. The fullest discussion of the complex problems of the origins and dating of the painting is that of C. Léger in the *Bulletin* of the Amis de Gustave Courbet, no. 2, 1947 and no. 12, 1952.

116. THE ESCAPE OF ROCHEFORT. By Édouard Manet, 1880–1. Oil on canvas, 143 × 114 cm. Zurich: Kunsthaus. (Photograph: Museum.)

There is a smaller version of this painting in the collection of Mrs Frank Jay Gould.

117. CLEMENCEAU ADDRESSING HIS MONTMARTRE CONSTITUENTS (THE PUBLIC MEETING). By Jean-François Raffaëlli, 1885. Oil on canvas, 245 × 205 cm. Versailles: Musée. (Photograph: Giraudon.)

118. PISSARRO ON HIS WAY TO WORK. By Paul Cézanne, c. 1874. Pencil on paper. 18·5 × 11·4 cm. Paris: Louvre. (Photograph: Museum.)

For a more deliberately meaningful portrait of Pissarro by Cézanne from 1874, see T. Reff in *Burl. Mag.*, 1969, 627–33. Yet here, too, the subject retains 'vestiges of passionateness and Bohemian non-conformity', is dressed informally in cap and coarse out-door clothing, and is surrounded by unpretentious, popular, and rustic works on the wall behind, in keeping with his own character and predilections.

119. THE BRETON POET (THE SMOKER). By Jean-Baptiste Carpeaux, c. 1873–4. Bronze, 53·3 cm. London: Heim Gallery. (Photograph: Heim Gallery.)

This portrait dates from the artist's stay in Brittany in 1873–4, and is known in several bronze casts.

Lit: *Paintings by Paul Huet and some Contemporary French Sculpture*, exh. cat., 1969, no. 141, p. 35.

120. MANET LISTENING TO HIS WIFE PLAY THE PIANO. By Edgar Degas, c. 1865. Oil on canvas, 65 × 71 cm. Owner unknown, formerly Kojiro Matsukata, Tokyo. (Photograph: Archives.)

A double portrait – horizontal, unstressed, informal – of the Manets and their marriage relationship. The musician and listener appear as subjects of other Degas portraits, e.g. *Pagans playing the Guitar, c.* 1869, Louvre.

Lit: J. S. Boggs, *Portraits by Degas*, 1962, 23–5, no. 42; Lemoisne, *Degas et son œuvre*, II, no. 127.

121. PORTRAIT OF AUGUSTE RENOIR. By Frédéric Bazille, 1867. Oil on canvas, 62·5 × 51 cm. Algiers: Musée des Beaux-Arts. (Photograph: Giraudon.)

Lit: J. Rewald, *History of Impressionism*, 1961, 203.

122. DIEGO MARTELLI. By Edgar Degas, 1879. Oil on canvas, 107·7 × 100 cm. Edinburgh: National Galleries of Scotland. (Photograph: Museum.)

Martelli was one of the earliest and most convincing of the Italian apologists for contemporary art, and was particularly warm in his support of Degas's work. An excerpt from Martelli's 'Gli Impressionisti' of 1880, translated into English, may be found in L. Nochlin, *Impressionism and Post-Impressionism*, 1966, 21–5. For his relationship with Degas, see L. Vitali, *Burl. Mag.*, 105 (1963), 269–70. For a discussion of the painting see D. C. Rich, *Degas*, 1951, 86, and T. Reff in *Metropolitan Museum Journal*, I, 1968, 155–6.

123. STUDIO IN THE BATIGNOLLES QUARTER. By Henri Fantin-Latour, 1870. Oil on canvas, 204 × 273 cm. Paris: Louvre. (Photograph: Archives.)

The figures are seated, left to right: Manet and Zacharie Astruc; standing, left to right: Otto Schölderer, Renoir, Zola, Edmond Maître, Bazille, and Monet. The small statue of Athena on the table to the left, as well as the oriental vase, probably have overtones of significance. Fantin-Latour had even gone so far as to paint an *Homage to Truth – The Toast*, in 1865, a work in which Bracquemond, Duranty, Manet, Whistler, Astruc and himself were represented toasting a lightly-clad young lady labelled 'the Truth', a work which the artist himself later destroyed, realizing that an allegorical figure was out of place in a tribute to the guiding principle of Realism.

124. STUDIO IN THE RUE DE LA CONDAMINE. By Frédéric Bazille, 1870. Oil on canvas, 98 × 128·5 cm. Paris: Louvre. (Photograph: Giraudon.)

125. THE GROSS CLINIC. By Thomas Eakins, 1875. Oil on canvas, 244 × 198·3 cm. Philadelphia, Jefferson Medical College. (Photograph: Philadelphia Museum of Art, courtesy of the Jefferson Medical College of Philadelphia.)

Dr Samuel David Gross was one of the greatest surgeons in the United States and is shown in this painting operating on the thigh of a young man. All the figures working around Dr Gross are representations of medical men, while, to the left, a female, probably a relative, hides her eyes. There is a sketch for the painting in the Philadelphia Museum of Art. G. Hendricks has recently brought to light new information about this masterpiece of American Realism. It was entitled by Eakins himself *Portrait of Professor Gross* and, like his *Portrait of Max Schmitt in a Single Scull*, was intended as a portrait of the sitter in a characteristic mileau, a Realist portrait type *par excellence*, rather than as a genre painting.

Lit: L. Goodrich, *Thomas Eakins*, 1933, p. 167. G. Hendricks in *Art Bull.*, 51, March 1969, 37-64.

126. THE EVENING PARTY (THE MAERCKER FAMILY, MENZEL AND HIS SISTER). By Adolph von Menzel, *c.* 1848. Oil on paper, 25 × 40 cm. Berlin: National Gallery. (Photograph: Museum.)

127. LE DÉJEUNER. By Claude Monet, 1868. Oil on canvas, 191·6 × 125·2 cm. Frankfurt: Staedel Institute. (Photograph: Museum.)

This painting is related to two others of the Monet family at table of *c.* 1868-9, recently discussed by J. Rewald (in *G.B.A.*, 1967, 245-8): one, erroneously called *The Luncheon at the Sisley's*, Zurich, E. Bührle Collection, and the other, representing an *After Dinner*, formerly in a private collection in Norway, now in New York, showing Mme Monet with a friend and a neighbour.

128. THE ARTIST'S FAMILY ON A TERRACE NEAR MONTPELLIER. By Frédéric Bazille, 1867. Oil on canvas, 152 × 230 cm. Paris: Louvre. (Photograph: Giraudon.)

The painting was exhibited in the Salon of 1868, then retouched and dated 1869. The painter is the tall man at the extreme left. It would seem that the ambitious combinations of figures and landscape embodied in Manet's and Monet's *Déjeuners* must have offered the precedent to Bazille.

129. QUEEN VICTORIA, THE PRINCE CONSORT AND THE PRINCESS ROYAL AT WINDSOR CASTLE. By Sir Edwin Landseer, 1843. Collection: H.M. the Queen. (Photograph: reproduced by gracious permission of H.M. the Queen.)

Landseer was, to all intents and purposes, Queen Victoria's court painter, kept constantly busy with decorative commissions and portraits of the palace pets, as well as of the Royal Family. In addition, Landseer instructed the royal couple in the art of etching.

130. THE AWAKENED CONSCIENCE. By William Holman Hunt, 1853. Oil on canvas, 75·5 × 55·2 cm. (arched top). Trustees of Sir Colin and Lady Anderson. (Photograph: Cooper.)

The painting was exhibited as *The Awakening Conscience* in the 1854 Royal Academy Exhibition but Hunt later called it *The Awakened Conscience*. Hunt said of the picture that 'his desire was to show how the still small voice speaks to a human soul in the turmoil of life'. The catalyst in this case has been Moore's song, *Oft in the Stilly Night*, which reminded the fallen woman of her childhood home. The expression on the girl's face was evidently originally so harrowing that its first owner, Thomas Fairbairn, had Hunt repaint the face in 1864. The frame was designed by the artist with emblems of sorrow (marigolds) and warning (bells). Robert Rosenblum has pointed out the relation of the painting to Jan van Eyck's *Arnolfini Wedding Portrait*, then recently acquired by the National Gallery. Hunt originally thought of this painting as 'a material inter-

pretation of the idea in *The Light of the World*'. The theme may be related to W. B. Scott's poem about a prostitute, 'Rosabel'.

Lit: G. Reynolds, *Painters of the Victorian Scene*, 1953, 74; *Victorian Painting*, 1966, 62, 95, 109; W. H. Hunt, *Pre-Raphaelitism*, 1905, I, 347–8; *Royal Academy of Arts Bicentenary Exhibition*, exh. cat., 1968–9, no. 374; *William Holman Hunt*, exh. cat., 1969, no. 27.

131. OLYMPIA. By Édouard Manet, 1863. Oil on canvas, 130·5 × 190 cm. Paris: Louvre. (Photograph: Giraudon.)

Lit: N. G. Sandblad, *Manet: Three Studies in Artistic Conception*, 1954, 69–107; T. Reff in *G.B.A.*, 1964, 552–9.

132. WOMEN ON THE TERRACE (A CAFÉ ON THE BOULEVARD MONTMARTRE). By Edgar Degas, *c.* 1877. Pastel over monotype on paper, 41 × 60 cm. Paris: Louvre. (Photograph: Giraudon.)

133. L'ATTENTE (first version). By Edgar Degas, *c.* 1879. Monotype on paper, first of two impressions. Plate 21·0 × 15·9 cm.

Lit: E. P. Janis, *Degas Monotypes*, 1968, no. 64.

134. THE LITTLE DANCER OF FOURTEEN. By Edgar Degas, *c.* 1880–81. Bronze, muslin, satin, 99 cm. London: Tate Gallery. (Photographs: Tate Gallery).

This was the only sculpture by Degas to be exhibited during his lifetime, at the Impressionist Exhibition of 1881, where it created a sensation. The body is cast in bronze, the bodice and shoes made to order and then covered with a thin layer of wax, the hair tied back with a real silk ribbon. In addition, the wax was tinted to make it more realistic. The writer and critic J. K. Huysmans declared: 'The frightful realism of this statuette evidently makes people uncomfortable: all our ideas on sculpture, on those cold, inanimate white objects, on those memorable imitations, copied and recopied for centuries, are upset. The fact is that, with a single blow, M. Degas has overthrown the traditions of sculpture . . .'
Jack Burnham discusses its revolutionary significance, especially of its base, in *Beyond Modern Sculpture*, 1968, 21–2.

Lit: J. Rewald, *Degas, Sculpture: The Complete Works*, 1956, 16–20.

Books for Further Reading

There exist no recent, full-scale studies of Realism in art. Artistic Realism is discussed in J. C. SLOANE, *French Painting Between the Past and the Present: Artists, Critics and Traditions from 1848 to 1870*, 1951, and G. BOAS (ed.), *Courbet and the Naturalistic Movement*, 1938; F. BOUVIER's *La Bataille réaliste, 1844-1857* [1913], and L. ROSENTHAL's *Du romantisme au réalisme: Essai sur l'évolution de la peinture en France de 1830 à 1848*, 1914, deal with French Realism, Bouvier mainly with Courbet and Champfleury, Rosenthal with antecedents of the movement. B. GOLDMAN raises the question of Realist iconography in 'Realist Iconography: Intent and criticism', *Journal of Aesthetics and Art Criticism*, vol. 18, 1959. The extensive article on Realism by Dario Durbé in the MacGraw-Hill *Encyclopedia of World Art*, 1966, is helpful, as is the lengthy bibliography which follows it. Briefer discussions of the Realist movement and Realism are to be found in more general accounts of nineteenth-century art like P. FRANCASTEL, 'Les Grandes Tendences de l'Art Européen au XIXᵉ siècle,' *Cahiers d'Histoire mondiale*, III, 1956, F. NOVOTNY, *Painting and Sculpture in Europe 1780-1880*, 1960, A. HAUSER, *The Social History of Art*, vol. II, 1951, W. HOFMANN, *The Earthly Paradise: Art in the 19th Century*, 1961, P. POOL, *Impressionism*, 1967, and two volumes of the Propyläen-Kunstgeschichte series, E. WALDMANN, *Die Kunst des Realismus und des Impressionismus im 19. Jahrhunderts*, 1927, and R. ZEITLER, *Die Kunst des 19. Jahrhunderts*, 1966.

The best accounts of Realist critical theory are those formulated by literary historians and critics. These offer useful paradigms and models to the art historian: R. JAKOBSON's 'The Metaphoric and Metonymic Poles,' *Fundamentals of Language*, 1956 offers a great deal of food for thought, as does his 'Du Réalisme artistique,' in *Théorie de la litterature*, 1965. The 'Symposium on Realism,' ed. HARRY LEVIN in *Comparative Literature*, 3 (Summer), 1951, presents a variety of viewpoints; LEVIN's *The Gates of Horn: A Study of Five French Realists*, 1963 is essential to the study of literary Realism, as is GEORG LUKÁCS's *Studies in European Realism*, 1964, and, of course, ERIC AUERBACH's monumental, historical-evolutionary treatment of Realism, *Mimesis*, 1953. The novelist ALAIN ROBBE-GRILLET's article 'From Realism to Reality,' in *For a New Novel: Essays on Fiction*, 1965, 157-68, is a very different sort of account of the phenomenon. Most useful in providing guidelines to the formulation of realist theory is R. WELLEK's chapter, 'Realism in Literary Scholarship,' in *Concepts of Criticism*, 1963, while his volumes III and IV of *A History of Modern Criticism*, 1965, provide a more detailed, descriptive account of critical attitudes towards and within the movement. B. WEINBERG's *French Realism: The Critical Reaction*, 1937, traces the usage of the term 'realist' carefully and scrupulously, but without much sense of context, and P. MARTINO's *Le Naturalisme français 1870-1895*, 1923, and *Le Roman réaliste sous le second Empire*, 1913, are old standbys; R. DUMESNIL's *L'Époque réaliste et naturaliste*, 1945, is another thoroughgoing survey of the period as is, in a more lively though restricted way, A. TABARANT's *Le Vie artistique au temps de Baudelaire*, 1963.

C. E. GAUSS, *The Aesthetic Theories of French Artists: 1855 to the Present*, 1949, gives a brief account of Realist ideas in art; R. STROMBERG, *Realism, Naturalism, and Symbolism:*

Modes of Thought and Expression in Europe, 1848–1914, 1968, and L. NOCHLIN, *Realism and Tradition in Art 1848–1900,* 1966, have source material available in English translation; the essential companion to *any* investigation of our period in France is still C. H. C. WRIGHT's *The Background of Modern French Literature,* 1926; P. LABRACHERIE, *Napoleon III et son temps,* 1967, is also useful. In England, B. WILLEY's *Nineteenth Century Studies: Coleridge to Matthew Arnold,* 1966 (orig. 1949), and *More Nineteenth Century Studies: A Group of Honest Doubters,* 1966 (orig. 1956), are extremely helpful.

CHAPTER 2

F. JOST, 'Littérature et suicide: Du Werther à Madame Bovary,' *Revue de la Littérature Comparée,* vol. 42, 1968 is relevant to our subject; Flaubert studies abound: most notable in short compass and in English: A. THORLBY's *Gustave Flaubert and the Art of Realism,* 1957; in French, J.-P. SARTRE's recent discussion of Flaubert in *Question de méthode* in *Critique de la raison dialectique,* 1960, as well as recent articles in *Les Temps modernes;* in English, F. STEEGMULLER's *The Selected Letters of Gustave Flaubert,* 1953, and his biography *Flaubert and Madame Bovary, a Double Portrait,* 1939, are good. Two more recent studies are V. BROMBERT's *The Novels of Flaubert: A Study of Themes and Techniques,* 1966, and E. STARKIE's *Flaubert: The Making of the Master,* 1967.

For the Goncourts, see J.-P. RICHARD's chapter in *Littérature et Sensation,* 1954, and R. BALDICK's translations, *Pages from the Goncourt Journal,* 1962. Both SIDNEY HOOK's *From Hegel to Marx,* 1936 and EDMUND WILSON's *To the Finland Station: a Study in the Writing and Acting of History,* 1940 provide readable introductions to the philosophical, social and political currents of the period, as does S. TOULMIN and J. GOODFIELD's *The Discovery of Time,* 1965; E. WIND's 'Traditional Religion and Modern Art,' *Art News,* 1953, is one of the few investigations of the general implications of this subject. A. BRIGGS's *Victorian Cities,* 1964, gives the hellish setting a concrete historical basis.

CHAPTER 3

G. BOAS, 'Il faut être de son temps', in *Journal of Aesthetics,* vol. I, 1941, 52–65 naturally sets the stage for any discussion of the problem in the nineteenth century. Both H. J. HUNT, *Le socialisme et le romantisme en France,* 1953, and H. A. NEEDHAM, *Le Développement de L'Esthétique sociologique en France et en Angleterre au XIX* siècle, 1926, deal with the interaction of contemporary aesthetic and social attitudes. R. HERBERT's article, 'City vs. Country: The Rural Image in French Painting from Millet to Gauguin', *Artforum,* 8 (Feb.), 1970, 44–55, characterizes rural imagery; F. D. KLINGENDER, *Art and the Industrial Revolution,* 1947 and re-issued in 1968, does the same thing in the case of the urban and industrial context; the catalogue *Art et travail,* Geneva, 1957 is a good supplement.

G. DUVEAU's monumental study, *La Vie ouvrière en France sous le second Empire,* 1946, gives the context for workers' conditions in France of the period, as does H. MAYHEW's equally large-scale *London Labour and the London Poor,* 4 vols., 1967, for England. A. BRIGGS's *Victorian People: A Reassessment of Persons and Themes 1851–67,* 1965 casts light on the characters of some typical Victorians; E. M. GRANT's *French Poetry and Modern Industry, 1830–1870,* 1927 and P. J. WEXLER's *La Formation du vocabulaire des chemins de fer en France 1778–1842,* 1955 are far more specific studies of literary and linguistic contemporaneity respectively.

As far as heroism, or its reverse is concerned, M. PRAZ, *The Hero in Eclipse in Victorian Fiction*, 1956, is a key work. H. C. and C. A. WHITE's *Canvases and Careers: Institutional Change in the French Painting World*, 1965, is an excellent study of the changing institutional framework in which French artists were working at the time; J. LETHÈVE's *Impressionistes et Symbolistes devant la presse*, 1959, and *La Vie quotidienne des artistes français au XIX^e siècle*, 1968, give various views and insights on the life of, and attitudes towards, artists of the time.

SIDNEY BRAUN's *The 'Courtisane' in the French theatre from Hugo to Becque (1831-1885)*, 1947, deals competently with the subject, as do C. PEARL's *The Girl with the Swansdown Seat* (1955), P. THOMSON's, *The Victorian Heroine*, a study of women in English novels, 1956, and J. RICHARDSON's *The Courtesans*, 1967.

For reading about specific subjects, countries and problems relevant to our study: Photography: good general studies are those of A. SCHARF, *Art and Photography*, 1968; H. GERNSHEIM, *The History of Photography*, 1955; and B. NEWHALL, *Masters of Photography*, 1968. More specifically concerned with our period are G. FREUND, *La photographie en France au XIX^e siècle. Essai de sociologie et d'esthétique*, 1936; H. and A. GERNSHEIM, *Creative Photography and Aesthetic Trends 1839-1870*, 1962, and, most recently, M. BRAIVE, *The Era of the Photograph: A Social History*, 1966.

For studies of Realist art in specific countries:
In Italy, E. LAVAGNINO, *L'Arte Moderna: Dai Neoclassici ai Contemporanei*, 2 vols., 1961, and C. MALTESE, *Storia dell'arte in Italia, 1785-1943*, 1960, are both extremely thoroughgoing in presentation of the material.

For English art and literature W. FREDEMAN's *Pre-Raphaelitism: A Bibliocritical Study*, 1965, is an essential tool for this subject. M. PECKHAM's recent *Victorian Revolutionaries: Speculations on Some Heroes of a Culture Crisis*, 1970, is a stimulating revision of many attitudes towards Victorian gods, demigods and myths. As far as the visual arts are concerned, R. IRONSIDES and J. A. GERE's *Pre-Raphaelite Painters*, 1948, is still the major account of their works, to be supplemented by various exhibition catalogues like The National Gallery of Canada, 'An Exhibition of Paintings and Drawings by Victorian Artists in England', 1965 and the Philadelphia Museum of Art, 'Romantic art in Britain; paintings and drawings, 1760-1860', 1968. G. REYNOLDS, *Painters of the Victorian Scene*, 1953 and *Victorian Painting*, 1966 and R. LISTER's less ambitious *Victorian Narrative Paintings*, 1966 are useful accounts, as is Q. BELL's witty and illuminating *Victorian Artists*, 1967. J. MAAS's *Victorian Painters*, 1969 has excellent illustrations. For the United States: B. NOVAK, *American Painting of the Nineteenth Century: Realism, Idealism, and the American Experience*, 1969, is good; M. W. BROWN, *American Painting: from its Beginnings to the Armory Show*, 1955 deals with the nineteenth century. The recent Metropolitan Museum of Art catalogue, 'Nineteenth Century America: Paintings and Sculpture,' 1970, presents the work of some charming if lesser American Realist masters.

As far as I know, there is no recent major account of German Realist art available in English, although a recent exhibition catalogue of the Brooklyn Museum, 'Triumph of Realism: An Exhibition of European and American Realist Paintings, 1850-1910', 1967, deals with some German Realist artists, and two German catalogues, *'Der Frühe*

Realismus in Deutschland, 1800–1850: Gemälde und Zeichnungen aus der Sammlung Georg Schäfer, Schweinfurt,' 1967 and *'Romantik und Realismus in Österreich: Gemälde und Zeichnungen aus der Sammlungen Georg Schäfer, Schweinfurt,'* 1968 provide excellent texts and illustrations. M. BRION's *German Painting* (tr. W. J. Strachan), 1957 contains a brief section on Realism, and R. HAMANN's *Die deutsche Malerei im 19. Jahrhundert,* 1914 is an old standby.

EPILOGUE

Architecture and the Decorative Arts:

There are several classics essential to any investigation of the field of nineteenth-century architecture, among them: L. HAUTECOEUR's *Histoire de L'Architecture classique en France, VII, La fin de l'architecture classique, 1848–1900,* 1957, and for England, H. R. HITCHCOCK's *Early Victorian Architecture in Britain,* 1954; N. PEVSNER's various studies, conveniently gathered together as 'Victorian Themes,' in *Studies in Art, Architecture and Design,* vol. II, Victorian and After, 1968; the relevant chapters on Butterfield as well as on Viollet-le-Duc in J. SUMMERSON's *Heavenly Mansions and Other Essays on Architecture,* 1950, and his more recent *Victorian Architecture, Four Studies in Evaluation,* 1970. R. F. JORDAN's *Victorian Architecture,* 1966, is a handy guide to the field. As far as architectural theory is concerned, PETER COLLINS's *Changing Ideals in Modern Architecture: 1750–1950,* 1965, is rich in ideas and material, to be supplemented by a brief article, 'Aspects of Ornament,' *Architectural Review,* 139, 1961, dealing with the problems of historicism and eclecticism, R. ETTLINGER's article, 'On Science, Industry and Art: Some Theories of Gottfried Semper,' *Architectural Review,* 136, 1964, has an importance beyond its brief length. Both of S. GIEDION's books: *Mechanization takes Command, a Contribution to Anonymous History,* 1948, and *Space, Time and Architecture,* 1967, are masterful and still exciting accounts of the evolution of Modernism and its technological accompaniment; while dealing with a slightly later period than the one with which we are concerned, R. BANHAM's *Theory and Design in the First Machine Age* casts light in retrospect: a real transvaluation of values that makes one view the nineteenth as well as the twentieth century with new eyes. F. CHOAY's *The Modern City: Planning in the 19th Century,* 1969 is a key work for the study of this subject; V. SCULLY, JR's article, 'Romantic Rationalism and the Expression of Structure in Wood: Downing, Wheeler, Gardner, and the "Stick Style," 1840–1876,' *Art Bulletin,* 35, 1953, as well as his books *The Shingle Style; Architectural Theory and Design from Richardson to the Origins of Wright,* 1955 and *American Architecture and Urbanism,* 1969 are lively and relevant to our topic, as are the essays in P. OLIVER (ed.), *Shelter and Society,* 1969 and C. JENCKS and G. BAIRD (eds.), *Meaning in Architecture,* 1969, though neither of them is concerned with nineteenth-century material *per se.*

For the decorative arts, A. BØE's *From Gothic Revival to Functional Form,* 1957 provides an excellent general survey, especially of the ideas of Pugin, Cole and the British Schools of Design. The decorative arts are, of course, discussed by N. PEVSNER in 'High Victorian Design' and other essays in the collection already referred to, as well as in Q. Bell, *The Schools of Design,* 1963. H. Shaefer's *Nineteenth Century Modern: The Functional Tradition in Victorian Design,* 1970, examines a variety of simple, practical objects available during our period.

Index

Bold numbers refer to illustration number

Ackerman, Gerald, 25
Alberti, Leon Battista, 227-8
Alma-Tadema, Sir Lawrence, 25, 250, **10**
Anker, Albert, 121
Anquetin, Louis, 238
Antigna, Alexandre, 46, 252, **20**
Apollinaire, Guillaume, 242, 247
Architecture, truth as value in, 222-4
Arnold, Matthew, 82
Art Nouveau, 236-7
Artist, portraits of, 186-92, 267
Astruc, Zacharie, 267
Auerbach, Eric, 51
Autun, 98
Avant-garde (*also see:* Modernism and decorative arts), 225, 227-9, 241-4

Babou, Hippolyte, 44
Bagehot, Walter, 34, 48
Balzac, Honore, 151
Banham, Reyner, 220
Banti, Cristiano, 121
Bars, theme of, 165-7
Barthes, Roland, 67
Barbizon School, 115, 138-9
Bartolini, Lorenzo, 84-5, 256, **42**
Bastien-Lepage, Jules, 80, 117, 255, **41**
Batignolles group, 103, 137, 139, 155, 190
Baudelaire, Charles, 14, 28, 44, 48, 50, 53, 84, 89-90, 139, 151, 152, 158, 159, 179, 186, 203, 228, 253, 256, 257
Baudry, Paul Jacques Aimé, 105, 181
Bauhaus, 227, 244
Bazille, Jean Frédéric, 28, 188, 192, 197-8, 252, 261, 267, 268, **121, 124, 128**
Bazin, André, 15
Beach, theme of, 137, 147-50, 262
Beaumont, Charles François Édouard de, 58, 253, **24**
Bernard, Claude, 44, 192

Bernard, Émile, 92, 227, 238, 244
Bernini, Giovanni Lorenzo, 84
Blackburn, Henry, 237
Blake, William, 96, 144, 239
Blanc, Auguste Alexandre Philippe Charles, 240
Boas, George, 104
Bodelsen, Merete, 237-8
Bøe, Alf, 226, 233, 234
Boldini, Giovanni, 188
Bonvin, François, 124, 258
Booth, Charles, 127
Bosch, Hieronymus, 98
Bossuet, Jacques-Bénigne, 66
Boudin, Eugène-Louis, 40, 137, 147, 262, **83**
Bouguereau, Adolphe William, 105
Boulevards, theme of, *see* cityscape
Bowler, Henry Alexander, 58
Bracquemond, Félix, 267
Braque, Georges, 242
Brenan, Gerald, 175-6
Breton, André, 244
Breton, Jules-Adolphe-Aimé-Louis, 89, 90, 92, 113, 117, 256, 258, **61**
Brett, John, 120
Brouwer, Adriaen, 33
Brown, Ford Madox, 51, 133, 150, 232
 An English Autumn Afternoon, 145, 262, **80**
 Pretty Baa Lambs, 142-4, 261, **78**
 Work, 127-30, 179, 260, **69**
Breughel, Pieter (The Elder), 98, 111
Bruyas, Alfred, 17, 130, 147, 249, 257, 262
Bucher, Lothar, 216
Buchon, Max (Maximilien), 38, 52, 115
Burne-Jones, Sir Edward Coley, 237
Butterfield, William, 223, 224

Cabianca, Francesco, 188
Café, theme of, 264

Caillebotte, Gustave, 157, 158, 168, 169, 176, 263, 264, 265, 266, **92, 103, 105, 112**

Caldecott, Randolph, 237

Cals, Adolphe Félix, 155

Camus, Albert, 73

Caravaggio, Michelango Merisi, 20, 45

Carlyle, Thomas, 53, 120, 128, 130, 258, 260

Carpeaux, Jean-Baptiste, 107, 187, 257, 267, **54, 119**

Cassatt, Mary, 189

Castagnary, Jules Antoine, 28, 36, 42, 46, 47

Cazin, Jean-Charles, 68, 254, **30**

Cézanne, Paul, 187, 188, 244, 247, 262, 267, **118**

Champfleury (Jules-François-Félix Husson), 28, 35, 36, 38-9, 115

Champin, Jean-Jacques, 109

Chardin, Jean-Baptiste-Siméon, 33, 104, 197

Charity, theme of, 122, 124-5, 127

Chenavard, Paul-Marc-Joseph, 55, 107-8, 113

Chéret, Jules, 236-7

Chesneau, Ernest, 252

Chipp, Herschel Browning, 240

Choay, Françoise, 210

Cinema, 15

City, theme of, 111, 150-78, 244

Cityscape, theme of, 167-78, 264-6

Claude (*see* Gellée)

Clemenceau, Georges, 63, 186, 267

Close-up, *see* photography

Cogniet, Léon, 61, 253, **26**

Cole, Henry, 227, 231, 232, 233

Colet, Louise, 39

Collins, Peter, 214, 222-3

Commune, 157

Comte, Auguste, 23, 25, 41, 42, 43, 53, 104

Constable, John, 18, 19, 20, 51, 138, 249, **3**

Contemporaneity, 28, 157-60, 177-8
 in architecture, 214-17, 221-2
 and modern art, 244-6
 and Romantics, 104-5
 theoretical attitudes, 103-11

Cormon, Fernand-Anne (Piestre), 25, 250, 258, **9**

Corot, Jean-Baptiste-Camille, 19, 138, 139, 157-8, 263, **94**

Courbet, Gustave, 23, 25, 28, 34, 35, 36, 38, 39, 41, 46, 47-8, 49, 50, 54, 83, 90,

Courbet, Gustave *continued*
 103, 113, 114, 115, 137, 203, 218, 223, 226, 227, 241, 247, 258, 261
 and Buchon, 52
 Franche-Comté, subjects from, 78
 and Léger, 245
 and photography, 44
 and railways, 179-81
 After-Dinner at Ornans, 194
 The Bathers, 44, 46, 251, **17**
 Beggar's Alms, 127
 Burial at Ornans, 35, 48, 60, 78-81, 88-9, 92-3, 255, **39**
 Le Camp des bourgeois, illustrations, 44
 Girls by the Banks of the Seine, 204
 Grain Sifters, 78
 L'Homme à la pipe, 187
 Hunt Picnic, 147
 The Meeting, 17, 28, 187, 249, **1**
 The Painter's Studio, 44, 128-30, 179, 190, 259, 260, 262, **70**
 Portrait of Baudelaire, 187
 Portrait of P.-J. Proudhon, 44, 182-4, 266, **115**
 Return from the Fair, 78
 Stone-breakers, 46, 112, 117-21, 246, 258, **58**
 Toilet of the Bride, 78, 115
 The Trout, 72-3, 254-5, **34**
 The Village Maidens, 122, 124-5, 127, 259, **68**
 Wake, 78, 89

Couture, Thomas, 106-7, 113, 133, 154, 159, 202, 257, **52**

Cozens, Alexander, 18

Crane, Walter, 237

Crystal Palace, *see* London, Crystal Palace

Cumberland, George, 239

Dagnan-Bouveret, Pascal Adolphe Jean, 90, 92

Daguerre, Louis Jacques Mandé, 44

Dalou, Aimé-Jules, 133, 135, 260, **72**

Daly, César Denis, 214-15, 220

Damoye, Emmanuel, 187

Dandyism, 228

Dante Alighieri, 104

Daumier, Honoré, 50, 98-9, 103, 114, 159, 167, 169
 and city, 151-2
 and railroad, 151-2
 Behold our Nuptial Chamber, 151, 262, **86**

Daumier, Honoré *continued*
 The Burden, 257, **51**
 L'Histoire ancienne, 37, 251, **16**
 Menelaus Victorious, 251, **16**
 Nadar Elevating Photography, 266, **110**
 The Republic, 107
 Rue Transnonain, 76, 155, 255, **37**
 La Soupe, 197
 Third Class Carriage, 262, **87**
David, Jacques Louis, 76, 240, 246
Débussy, Claude, 236
Decorative arts
 and modernism, 224-5
 and naturalism, 231-5
Degas, Hilaire-Germain-Edgar (de Gas),
 29, 50, 99, 136, 137, 150, 160, 163,
 177, 181, 203, 254, 262, 265
 city themes in, 158-9
 and Japanese woodcuts, 206
 and photography, 44
 prostitute monotypes, 204-6
 themes in, 19-20
 L'Absinthe, 155
 At the Seaside, 149
 L'Attente, 269, **133**
 The Bellelli Family, 198
 Building Seen from Below, 249, **4**
 Café Concert, 167, 264, **101**
 Dancer on Stage, 30-31, **13**
 Diego Martelli, 267, **122**
 The Star, or *Dancer on the Stage*, 250, **13**
 Fallen Jockey, 71-2, 254, **33**
 The Interior, 254
 The Ironers, 157, 263, **91**
 Little Dancer of Fourteen, 206, 269, **134**
 *Manet Listening to his Wife Play the
 Piano*, 188, 267, **120**
 Portrait of Diego Martelli, 189-90
 Portrait of Mary Cassatt, 189
 Le Tub, 249, **5**
 Vicomte Lepic and his Daughters, 168
 Women on the Terrace, 204, 269, **132**
Delacroix, Ferdinand-Victor-Eugène, 24,
 44, 56, 104, 185, 257
Delaroche, Paul (Hippolyte), 253
Denis, Maurice, 240
Descartes, René, 103
Deschamps, Émile, 104
Deverell, Walter Howell, 122, 259, **66**
Dickens, Charles, 34, 54, 96-7, 98, 151,
 154, 223, 232, 263
Diderot, Denis, 76, 104, 138

Disney, Walt, 232
Doctor, theme of, 192, 268, **125**
Donaldson, Thomas Leverton, 220
Donatello (Donato di Nicolò di Betto
 Bardi), 206
Donne, John, 66
Doré, Paul-Gustave-Louis-Christophe,
 98, 150, 154, 155, 257, **50**
D'Orsi, Achille, 122, 259, **65**
Downing, Andrew Jackson, 223-4
Dresser, Christopher, 233
Dubois-Pillet, Albert, 61
DuCamp, Maxime, 111
Dumas, *fils*, Alexandre, 203
Dupont, Pierre, 111, 137
Duranty, Louis Émile Edmond, 33, 36,
 267
Dürer, Albrecht, 138
Dutch Little Masters, 20
Dyce, William, 124, 230

Eakins, Thomas, 192, 268, **125**
Eastlake, Charles, 231
Eclecticism, in architecture, 219-22
Egg, Augustus Leopold, 152, 201
1848 Revolution, 47, 48, 49, 77, 107, 108-9,
 112, 113, 115, 137, 220, 257-8, **55**
Eisen, Charles-Dominique-Joseph, 61
Eitner, Lorenz, 170
Eliot, George, 35
Elmore, Alfred, 201
Enault, Louis, 34
Engels, Frederick, 96, 98, 193
Ettlinger, Leopold David, 221

Faed, Thomas, 127
Fairbairn, Thomas, 268
Fantin-Latour, Ignace-Henri-Jean-
 Théodore, 190-92, 267, **123**
Feuerbach, Ludwig, 101
Fildes, Sir Samuel Luke, 99, 154-5, 192,
 263, **89**
Firemen, theme of, 136-7, 260-61
Flatness,
 in decorative arts, 229-35
 and truth, 238-43
Flaubert, Gustave, 23, 40, 49-50, 103
 and science, 42-3
 Un Cœur Simple, 50
 Éducation Sentimentale, 49-50, 61, 95, 151
 Madame Bovary, 38, 39, 43, 50, 54, 73,
 83-4

Flaxman, John, 239
Flers, Camille, 88, 112
Fontainas, André, 241
Fontainebleau Forest, *see* Barbizon
Fourier, Charles, 53, 107, 130, 193, 257, 260
Fourierism, 95-6, 214
Francastel, Pierre, 209
Franck, Sebastian, 13
Friedrich, Caspar David, 254
Frith, William Powell, 147, 148, 150, 152, 262, **82, 88**
Fuller, Buckminster, 220
Fustel de Coulanges, Numa Denis, 42

Gambetta, Léon, 185-6, 254, 260, **30**
Gaskell, Mrs Elizabeth Cleghorn (Stevenson), 151
Gauguin, Paul, 92, 121-2, 186, 227, 237, 238, 240, 241, 242, 244, 263
Gautier, Théophile, 115
Gellée or Gelée, Claude (Le Lorrain or Lorrain), 138
Geoffroy, Louis de, 35
Géricault, Jean-Louis-André-Théodore, 184-5
Gérôme, Jean-Léon, 24-5, 249-50, 253, **8, 11**
Gervex, Henri, 192
Ghiberti, Lorenzo, 233
Giedion, Sigfried, 212, 215
Gilbert, Jacques Émile, 215
Giorgione (Giorgio) (Zorgo da Castelfranco), 252
Girardet, Karl, 61
Girodet de Roucy Trioson, Anne-Louis, 203
Glaize, Auguste-Bartholémy, 147, 262, **81**
Gleizes, Albert, 247
Goethe, Johann Wolfgang von, 73
Goldwater, Robert, 237
Gombrich, Ernst, 18, 19, 20, 211, 227
Goncourt, Edmond Huot de, 192
 La Fille Elisa, 201
Goncourt, Edmond Huot de and Jules de, 50, 53, 60, 103, 151, 186, 202, 203
 death and, 63-4
 Germinie Lacerteux, 34, 50
 Henriette Maréchal, 46
 La Soeur Philomène, 43
Gothic architecture, 210, 212, 216-18, 223
Gothic sculpture, 65, 98

Goya y Lucientes, Francisco de, 255
 The Third of May, 31-3, 251, **15**
Grandville, Jean Ignace Isidore Gérard, 175
Great Exhibition, 226, 227, 229, 231-2, 234
Greco, El (Domenikos Theotokopoulos), 78-81, 255, **40**
Greenaway, Kate, 237
Greenberg, Clement, 243
Greuze, Jean-Baptiste, 88, 104
Gross, Dr Samuel David, 268, **125**
Groux, Charles-Corneille-Auguste de, 170, 175, 265, **106**
Guercino, Francesco Barbieri, 84
Guys, Ernest Adolphe Hyacinthe Contantin, 203

Haden, Sir Francis Seymour, 256
Hagemeister, Karl, 253
Halles Centrales, *see* Paris, Les Halles
Hauser, Henriette, 264
Haussmann, Baron Georges Eugène, 151, 167, 210-11, 262
Hazlitt, William, 104
Hegel, Georg Wilhelm Friedrich, 14, 82
Hell, imagery of, 96-100, 151
Helmholtz, Hermann Ludwig Ferdinand von, 209
Herbert, Eugenia, 229
Herbert, Robert L., 138
Herkomer, Sir Hubert von, 86-7, 122, 155, 256, 259, **44, 67**
History painting, 23-7
Hofmann, Werner, 114
Hogarth, William, 147
Holbein, Hans, the Younger, 19, 90
Holl, Francis Montague (Frank), 155
Hornor, Thomas, 97
Houghton, Arthur Boyd, 150, 257
Howard, Luke, 18
Huet, Paul, 19
Hunt, William Holman, 144, 150, 201, 232, 261, **79**
 The Awakened Conscience, 268, **130**
Hurel, Abbé, 82, 253
Huxley, Thomas Henry, 42
Huysmans, Joris Karl, 202, 237, 269

'Il faut être de son temps', *see* Contemporaneity
Impressionism, 28, 39, 53, 54, 137, 144,

Impression *continued*
 155, 157, 167, 170, 175, 178, 225, 226,
 235, 236, 239, 241, 242, 247, 263, 264,
 265, 267, 269
Impressionist, *see* Impressionism
Ingres, Jean-Auguste-Dominique, 105,
 198-9, 239, 250
Interior, theme of, 254
Israels, Josef, 197

Jakobson, Roman, 164-5, 182
Janis, Eugenia Parry, 205
Japanese art, 263
Japanese influence, 157, 160, 190, 206
Japanese print, 239, 240
Jeanron, Philippe Auguste, 46, 114, 127
Jefferson, Thomas, 115
Jerrold, Blanchard, 257
Joan of Arc, 255-6
Jones, Owen, 227, 233
Journal of Design and Manufactures, 227,
 230-31, 239
Journet, Jean, 130
Jouvin, Hippolyte, 264, 266, **102**
Joyce, James, 15

Kandinsky, Wassily Wassiljewitsch, 242
Kerr, Robert, 222
Kiesler, Frederick, 134
Kingsley, Charles, 151
Klee, Paul, 243
Knight, Richard Payne, 220
Kropotkin, Peter, 115
Kruif, Paul de, 192

Labour, *see also* peasant; worker monu-
 ments to, 133-7
Laforgue, Jules, 36, 39
Landseer, Sir Edwin Henry, 73, 121, 198,
 268, **129**
Lang, S., 220
Lantier, Claude, *see* Zola, Émile
La Thangue, Henry Herbert, 86
Laurens, Jean Paul, 71
Laval, Eugène, 215
Laverdant, D., 214
Leathart, James, 260
Le Brun, Charles, 240
Le Corbusier (Charles Édouard Jean-
 neret), 212, 219
Léger, Fernand, 245-6

Legros, Alphonse, 89-90, 92, 256, 258, **46,
 59**
Leibl, Wilhelm Maria Hubertus, 90, 121,
 256, **47**
Leider, Philip, 243
Leighton, Lord Frederick, 111
Leiris, Alain de, 82
Leleux, Adolphe-Pierre and Armand
 Hubert Simon, 88, 112
Leonardo da Vinci, 199
Le Nain, Brothers (Antoine the Elder,
 Louis the Younger, Mathieu the
 Chevalier), 111, 197
Les Halles, *see* Paris
Lessing, Gotthold Ephraim, 73, 240
Levin, Harry, 40
Lewes, George Henry, 35
Lewis, Sinclair, 192
L'Hermitte, Léon-Augustin, 117, 192
Lichtenstein, Roy, 246, 247
Liebermann, Max, 253
Littré, Maximilien Paul Émile, 41
London, 154
 Crystal Palace, 215-16
Loo, Charles André (Carlo van), 147
Lorrain, *see* Gellée
Loubon, Émile Charles Joseph, 88
Lukács, George, 45

Macchiaioli group, 121, 139
Magni, Pietro, 110-11, 258, **57**
Maître, Edmond, 192, 267
Malevich, Kasimir, 242
Mallarmé, Stéphane, 45
Malraux, André, 17
Manet, Édouard, 20, 50, 53, 64, 95, 103,
 109, 137, 139, 150, 155, 185-6, 190,
 192, 210-11, 241, 242, 247, 255, 265,
 266, 267
 city themes in, 158-67
 and Hôtel de Ville project, 181
 and photography, 44
 portrait of by Degas, 188, 267, **120**
 and sincerity, 36
 Zola on, 41
 At the Café, 165, 167, 264, **100**
 Ball at the Opera, 162-4
 Bar at the Folies Bergère, 164
 Le Bon Bock, 165
 Chez Père Lathuille, 162
 Christ Scourged, 82

Manet, Édouard *continued*
 Civil War, 75, 155-7, 255, **36**
 Concert in the Tuileries, 160, 263, **95**
 Dead Christ with Angels, 57-8, 82, 252-3,
 23
 Dead Toreador, 64, 72, 75, 253, **28**
 Le Déjeuner sur l'herbe, 38, 145, 251-2,
 261, 268, **19**
 Escape of Rochefort, 184-5, 266-7, **116**
 Execution of the Emperor Maximilian,
 31-3, 44, 50, 71, 251, **14**
 The Funeral, 92-5, 256-7, **48**
 Mallarmé, 187
 Nana, 162-4, 264, **98**
 Olympia, 203, 269, **131**
 On the Beach at Boulogne, 147-8, 262, **84**
 Portrait of Desboutin, 187
 Portrait of Zola, 189
 The Railroad, 162, 264, **97**
 Road Menders in the Rue de Berne, 170,
 175, 265, **107**
 Street Singer, 160, 263-4, **96**
 The Suicide, 75, 255, **35**
 The Tavern, 165, 264, **99**
Mantegna, Andrea, 253
Marcus, Steven, 199, 201
Markham, Edwin, 259
Martelli, Diego, 189-90, 267, **122**
Martin, John, 96
Martineau, Robert Braithwaite, 198
Marx, Karl, 60
Marxism, 96
Mathilde, Princesse, 202
Matisse, Henri, 239, 240, 242
Maupassant, Guy de, 66, 103, 201-2
Maurice, Rev. R. D., 130
Mayhew, Henry, 98, 100
Meissonier, Jean-Louis-Ernest, 109,
 257-8, **56**
Menzel, Adolph (Adolf) Friedrich
 Erdmann von, 76-7, 153, 194, 253,
 254, 255, 258, 268, **38**, **126**
Merimée, Prosper, 44
Metonymy, 182
Metzinger, Jean, 247
Meunier, Constantin Émile, 133, 155
Meurend, Victorine, 252, 264
Michel-Lévy, Henri, 188
Michelangelo (Buonarroti), 241
Michelet, Jules, 104, 115, 127
Mill, John Stuart, 41
Millais, John Everett, 137, 260, **75**

Millet, Jean François, 49, 54, 99, 113, 114,
 117, 120, 244, 259
 The Angelus, 88, 256, **45**
 The Gleaners, 117-19, 258, **62**
 Man with the Hoe, 122, 259, **64**
 Quarrymen, 120
 The Sower, 115, 258, **60**
 Two Peasants Tilling the Soil, 252, **21**
 Winnower, 112
Modernism, in architecture, 211-12, 215,
 216, 219
 and decorative arts, 228-31
Moholy-Nagy, Laszlo, 244
Mondrian, Pieter Cornelis, 242-3
Monet, Camille, 252, 253, **27**
Monet, Claude, 20, 28, 29, 50, 51, 53, 54,
 95, 137, 150, 189, 192, 209, 210, 265,
 267
 and Boudin, *see* Boudin
 and railways, 153-4
 Boulevard des Capucines, 169, 265, **104**
 Camille on her Death Bed, 63, 253, **27**
 Le Déjeuner sur l'herbe, 139-45, 261, 268,
 76, 77
 Le Déjeuner, 197, 268, **127**
 On the Beach, Trouville, 149-50, 262, **85**
 Quai du Louvre, 175, 265, **108**
 Railway Bridge at Argenteuil, 157-8, 263,
 93
 Rue Montorgueil Decked out with Flags,
 176-7, 266, **113**
 Unloading Coal, 157, 263, **90**
 Women in the Garden, 54-6, 141, 252, **22**
Monfried, Daniel de, 237
Monnier, Bonaventure Henri, 44
Montpellier, 17
Moore, George, 20, 82
Moore, Thomas, 268
Morny, Charles, Duc de, 259
Morris, William, 53, 115, 217-18, 230,
 231, 233, 234, 236-7, 239, 244
Motherwell, Robert, 243
Münch, Edvard, 254
Murillo, Bartolomé-Esteban, 33
Muybridge, Eadweard, 150

Nabis, 229, 237, 240
Nadar (Félix Tournachon), 175, 265, 266
Naïveté, 36-7
Napoléon III, 151
Neder, Johann Michael, 121, 194
Netti, Francesco, 255

Newman, Barnett, 243
Nicholson, Francis, 97
Nietzsche, Friedrich, 51, 53
Nittis, Giuseppe de, 168
Noland, Kenneth, 243

Obrist, Hermann, 134
Offenbach, Jacques, 154
Oldenburg, Claes, 179, 246
Oliver, Paul, 218
Oller y Cestero, Francisco, 89
Out-of-doors painting, see plein-air

Palizzi, Filippo, 121
Papéty, Dominique Louis Ferréol, 107,
 257, 53
Paris, 93, 151-5, 160, 162
 paintings of, 167-78
 theme of, 179, 181, 204, 262, 264-6
 Les Halles, 34, 210, 212, 215
 Opéra, 212
 Panthéon, 95
 Saint Eustache, 210
Park, theme of, 137
Parrhasios, 15
Passeri, Giovanni Battista, 138
Paxton, Sir Joseph, 215-16
Peasant, theme of, 111, 112, 113, 114,
 115-22, 124, 181
Perrault, Charles, 103
Perrier, Charles, 35
Pevsner, Nikolaus, 215, 217, 226, 232-4
Photography, 17, 44-5, 149-50, 157, 160,
 164, 167-9, 175, 176, 182, 186, 190,
 192, 198, 226, 238-9, 251, 252, 264,
 266, 102
Picasso, Pablo, (Pablo, Diego, José, Fran-
 cisco de Paula, Juan, Nepomuceno
 Crispin, Crispiniano de la Santissima
 Trinidad Ruiz Blasco), 192, 244
Picnic, theme of, 137, 139-47, 261, 262
Piles, Roger de, 103
Pils, Isidore Alexandre Augustin, 124
Pisarro, Camille Jacob, 36, 53, 153, 176,
 187, 209, 210, 266, 267, 111, 118
Plato, 13, 105
Plein-air painting, 51, 54-6, 130, 137-50,
 261-2
Pliny, 15
Plutarch, 94
Popular imagery, 17, 249, 2
Pound, Ezra, 84

Poussin, Nicolas, 24, 45, 58, 67, 138, 257,
 49
 Funeral of Phocion, 93-5
Poussinistes, 240
Praz, Mario, 203
Pre-Raphaelites, 103, 139, 142-5, 226, 229,
 236, 237
Prostitute, theme of, 34, 199-206, 268-9
Proudhon, Pierre-Joseph, 46, 60, 137,
 193-4, 266
 and Burial, 78, 81
 portrait of by Courbet, 182-4
 Du Principe de l'art, 258
Proust, Antonin, 159, 160, 252
Proust, Marcel, 15
Pugin, Augustus Welby Northmore, 212,
 217, 218, 222, 223, 231

Quaï, Maurice (pref. Quay), 240

Racine, Jean, 67, 104
Raffaëlli, Jean-François, 135-6, 155, 186,
 260, 267, 74, 117
Railways, theme of, 151-4, 157-8, 162,
 262-3, 264, 266
Raimondi, Marcantonio, 252
Raphael (Sanzio d'Urbino), 33, 45, 54,
 103, 198, 245, 252
Rauschenberg, Robert, 51
Realism, definition of, 13-23, 51-3
 definition of in architecture, 209-22,
 224
 sincerity and, 36-7
 time sense in, 28-33
 truth as value in, 35-8
 truth in, 267
Redgrave, Richard, 231, 233
Redon, Odilon, 45
Reff, Theodore, 188, 203
Reinach, Salomon, 250
Reinhardt, Ad, 45
Religious art, 81-4, 88-92, 255-6
Rembrandt Harmensz, van Rijn, 77, 103,
 137, 144, 192
Renan, Ernest, 41, 42, 57-8, 90
Renoir, Pierre Auguste, 28, 54, 95, 177,
 188, 192, 267
 portrait of by Bazille, 267, 121
 Le Moulin de la Galette, 25, 250, 12
 Le Pont des Arts, 20, 249, 6
 Le Pont Neuf, 175, 265, 109
 Portrait of Monet, 187

Revue générale de l'architecture, 214-15, 220
Reynolds, Sir Joshua, 144, 240
Ribera, Jusepe de, 253
Rimbaud, Jean Nicolas Arthur, 186
Rivalta, Augusto, 254, **32**
 Tomb of Vicenzo Drago, 70
Robbe-Grillet, Alain, 15, 51
Robert-Fleury, Joseph Nicolas, 199
Roberts, Keith, 144
Robertson, George, 97
Robinson, John, 222
Rodin, René François Auguste, 134-5, 182
Roger, Augustin, 88
Roll, Alfred Philippe, 187
Romantics, *see* Contemporaneity and
Roqueplan, Camille Joseph Étiénne, 88, 112
Rosa, Salvator, 138
Rosenblum, Robert, 239
Rosenquist, James, 246
Rossetti, Gabriel Charles Dante (Dante Gabriel), 201, 236
Rothko, Mark, 243
Rosseau, Henri-Julien Félix (Le Douanier), 246
Rosseau, Jean Jacques, 115
Rubens, Peter Paul, 30, 144, 253
Rude, François, 65, 254, **29**
Ruskin, John, 53, 115, 127, 137, 144, 201, 210, 216, 218, 221-2, 232, 233, 234, 238, 258, 262
 and Morris, 227

Sabatier, François, 130, 257
Sainte-Beuve, Charles Augustin, 36, 42, 43
Salon des Refusés, 33, 226, 251
Sand, George, 111, 115
Sandblad, Nils Gosta, 160
Sands, James, 97
Sartre, Jean-Paul, 142
Schapiro, Meyer, 120
Scharf, Aaron, 251
Schölderer, Otto, 267
Schuch, Karl, 253
Schuffenecker, Claude Émile, 242
Schwind, Moritz von, 254
Scott, Sir George Gilbert, 220, 221, 232
Scott, William Bell, 179, 266, 269, **114**
Scott-Brown, Denise, 219
Scully, Vincent, 220, 223-4
Second Empire, 46, 93, 202, 212
Seitz, William, 197

Selz, Peter, 244
Semper, Gottfried, 221, 232
Settignano, Desiderio da, 85
Seurat, Georges Pierre, 40
Shelley, Percy Bysshe, 104
Signac, Paul, 50, 235-6
Signorelli, Luca, 98
Sketch, 138-9
Slevogt, Max, 253
Smokers, theme of, 187
Solomon, Abraham, 152
Stella, Frank, 243
Stendhal (Marie Henri Beyle), 104
Stevens, Alfred, 253
Stobbaerts, Jan or Jean-Baptiste, 121
Stone-breaker, 35, 47, 117-21, 258
Streets, theme of, *see* cityscape
Süe, Eugène, 151
Suicide, theme of, 73-5, 255
Sullivan, Louis, 224
Summerson, John Newenham, 209, 213, 221-2, 223
Surrealism, 45, 243, 244
Sutton, Denys, 237
Synecdoche, 164-5
Szinyei Merse, Pal (Paul) von, 147

Taine, Hippolyte Adolphe, 23, 25, 41, 105
Tassaert, Nicolas François Octave, 46
Taste in arts, 226-35, 245
Tatlin, Vladimir, 134
Thoma, Hans, 121
Thoré, Théophile, 33, 42, 48, 127, 167, 257
Tintoretto (Jacopo Robusti), 253
Tissot, James Jacques Joseph, 262
Titian (Vicellio, Tiziano), 103, 199
Tolstoy, Leo
 character of Anna Karenina, 73
 character of Ivan Ilych, 66
 Anna Karenina, 150, 154
 Death of Ivan Ilych, 67-8
Tommasi, Adolfo, 153
Toulouse-Lautrec-Monfa, Henri Marie Raymond de, 237
Traini, Francesco, 98
Trübner, Wilhelm (Heinrich W.), 253, **25**
Truth, *see also* Realism, truth as value in; architecture,
 change in meaning of, 235-6
 flatness and, *see* flatness and truth
 to the nature of the material, 229-34
Turner, Joseph Mallord William, 138, 254

Urban, *see* city, theme of
Ussher, Archibald, 25

Valerius Maximus, 94
Valéry, Paul, 44
Van der Helst, Bartholomeus, 81
Van Eyck, Jan, 20, 45, 268
Van Gogh, Vincent Willem, 114, 115, 120,
 121-2, 155, 182, 186, 197, 244, 254,
 263
Vela, Vincenzo, 68, 133, 134, 254, 260,
 31, 73
Velasquez, Diego Rodríguez de Silva y,
 20, 45, 253
Venturi, Robert, 219
Verlaine, Paul, 186
Vermcer, Johannes, 20, 45, 249, 7
Veronese, Paolo Cagliari, 252
Vico, Giovanni Battista, 104
Victoria, Queen, 198, 268, **129**
Vigny, Alfred Victor, Comte de, 49, 154
Villeneuve, Julien Vallou de, 251, **18**
Viollet-le-Duc, Eugène Emmanuel, 209-
 10, 217

Wagner, Richard, 227
Wagrez, Jacques-Clément, 255
Waldmüller, Ferdinand Georg, 121
Wallis, Henry, 120, 258, **63**
Warhol, Andy, 246
Watteau, Jean Antoine, 252
Watts, George Frederick, 122, 259

Wedgwood, Josiah, 227
Wellek, René, 104
Wey, Francis, 39
Wheeler, Gervase, 224
Whistler, James Abbot MacNeil, 256, 267
Whitman, Walt, 224
Wilkie, Sir David, 147
Woolf, Virginia, 15
Wordsworth, William, 51
Worker, theme of, 34, 111-37, 157, 175,
 181, 246, 258-9, 260, 263
Wright, Frank Lloyd, 220, 224
Wyatt, Sir Matthew Digby, 227, 231, 233

Zandomeneghi, Federigo, 155
Zola, Émile, 28, 49, 50, 103, 115, 151, 186,
 192, 226, 267
 and Claude Bernard, 192
 Claude Lantier, 33-4, 60, 179, 210
 on Manet, 36
 and Manet, 41, 82
 and science, 43-4
 L'Assommoir, 66, 97, 98, 154
 La Bête humaine, 154
 Germinal, 98
 Madeleine Férat, 254
 Nana, 150, 202, 203, 264
 L'Oeuvre, 60-61, 95, 151
 Les Rougon-Macquart, 154
 La Terre, 115, 202
 Le Ventre de Paris, 210, 211

More about Penguins
and Pelicans

Penguinews, which appears every month, contains details of all the new books issued by Penguins as they are published. From time to time it is supplemented by *Penguins in Print*, which is our complete list of almost 5,000 titles.

A specimen copy of *Penguinews* will be sent to you free on request. Please write to Dept. EP, Penguin Books Ltd, Harmondsworth, Middlesex, for your copy.

In the U.S.A.: For a complete list of books available from Penguins in the United States write to Dept CS, Penguin Books, 625 Madison Avenue, New York, New York 10022.

In Canada: For a complete list of books available from Penguins in Canada write to Penguin Books Canada Limited, 2801 John Street, Markham, Ontario L3R 1B4.

Bernini

Howard Hibbard

Gianlorenzo Bernini was the greatest sculptor and one of the greatest architects of the seventeenth century. Today his work is everywhere in evidence in Rome – in the design of the colonnaded *piazza* before St Peter's, in a sequence of magnificent Baroque fountains, in lavish and fantastic decorative enterprises within St Peter's itself, and in a number of portrait busts and mythological and religious sculptures of unrivalled technical perfection and dramatic power. Bernini served Louis XIV as well as a succession of popes. His work expresses the spirit of his age perhaps more than that of any other artist in history.

In this new study Howard Hibbard reveals the gradual evolution of a revolutionary vision which embraced painting, sculpture, and architecture and ultimately merged them into one dramatic whole. Whilst the biographical aspect of *Bernini* must have an interest for any reader, the student will find that this lavishly illustrated book makes an important contribution to our understanding of the age of Baroque and of one of its greatest artists.

Palladio

James S. Ackerman

Palladio is the most imitated architect in history. His buildings have been copied all over the Western world – from Leningrad to Philadelphia – and his ideas on proportion are still current nearly four hundred years after his death. In this, the first full account of his career to be published in English, Professor James Ackerman investigates the reasons for his enormous and enduring success. He presents him in his historical setting as the contemporary of Titian, Tintoretto, and Veronese, but is constantly alert to his relevance for us today.

Byzantine Style and Civilization

Steven Runciman

For more than eleven centuries Christian civilization was dominated in the East by the imperial city of Constantinople, and a deeply religious conception of the universe is reflected in Byzantine art. Whether he was designing some great architectural monument like the cathedral of Saint Sophia, or the smallest enamel reliquary cross, or an article for secular use, the Byzantine artist wrestled with colour and harmony to interpret divine beauty to humanity.

In this liberally illustrated study Sir Steven Runciman draws on his profound knowledge of the period to show how early Christians acquired this belief in the purpose of art and how it survived changes in technique, fashion and resources for as long as the Empire stood.

Neo-classicism

Hugh Honour

David's martyr icons of the French Revolution, Ledoux's symbolic architecture of pure geometry, Canova's idealized erotic marbles – in such Neo-classical masterpieces the culminating phase of the Enlightenment found artistic expression. Neo-classicism was no mere antique revival. If it began with the elegant sophistication of Adam and Gabriel, it ended in the ruthless simplifications of Flaxman's rudimentary linear technique. This primitivism consciously evoked a Spartan world of simple, uncomplicated passions and blunt, uncompromising truths. And these virile and ennobling ideals inspired *avant-garde* painters, sculptors and architects as far apart as Jefferson in Virginia and Zakharov in Leningrad.